SCRIPT PARTNERS

"When I saw some of the people included in *Script Partners*, I said, 'I've got to go out and buy this book!'"
—Carl Reiner, Writer, Director, Actor, and Creator of *The Dick Van Dyke Show*

Some of the greatest movies and television series have been written by script partners. From Billy Wilder's legendary collaborations with Charles Brackett and I.A.L. Diamond to the work of the Coen Brothers, writing teams and their secrets of success are as intriguing as the scripts they create.

Script Partners, Second Edition brings together the experience, knowledge, and winning techniques of Hollywood's most productive partnerships—including Lucy Alibar & Benh Zeitlin (*Beasts of the Southern Wild*), Chad & Carey Hayes (*The Conjuring*), Patrick Massett & John Zinman (*Friday Night Lights* TV series; *Gold*), Andrew Reich & Ted Cohen (*Friends*), Cinco Paul & Ken Daurio (*Despicable Me*), and Scott Alexander & Larry Karaszewski (*Ed Wood*; *The People vs. Larry Flynt*).

Aspiring and established scriptwriters will learn how to pick the right partner and projects, co-create character and story, co-draft and rewrite a script, manage the creative and business relationship, and successfully collaborate in the film/TV industry.

This new edition has been expanded and updated to include additional interviews with cutting-edge writing teams, excerpts from award-winning scripts, a new chapter about co-writing the rewrite, and a must-read new chapter for film and scriptwriting students—"A Film School Survival Kit or How Collaboration Helps You Get In, Get Along, and Get Ahead."

Claudia Johnson & Matt Stevens met on the faculty of the FSU Film School and have been writing together since. Two of their scripts were

finalists for the Sundance Screenwriters Lab, and their recent feature, *Ruby*—based on Claudia's doc *The Other Side of Silence: The Untold Story of Ruby McCollum*—has been optioned by Invitation Entertainment. Their screenplay *Scrooge in Love* is based on their novella, *A Christmas Belle*, a sequel to Dickens' *A Christmas Carol*. They were twice named "Star Speakers" at L.A.'s Creative Screenwriting Expo for their co-writing workshops. Claudia left FSU to teach at USC's Writing for Film & Television Division, and Matt is a Senior Copywriter and Digital Content Specialist in L.A.

Claudia & Matt are available for workshops about collaborative scriptwriting. You may contact them at **scriptpartners@gmail.com**.

SCRIPT PARTNERS
How to Succeed at Co-Writing for Film & TV

SECOND EDITION

Claudia Johnson
&
Matt Stevens

NEW YORK AND LONDON

Second edition published 2016
by Routledge
711 Third Avenue, New York, NY 10017

and by Routledge
2 Park Square, Milton Park, Abingdon, Oxon OX14 4RN

Routledge is an imprint of the Taylor & Francis Group, an informa business

© 2016 Taylor & Francis

The right of Claudia Johnson and Matt Stevens to be identified as authors of this work has been asserted by them in accordance with sections 77 and 78 of the Copyright, Designs and Patents Act 1988.

All rights reserved. No part of this book may be reprinted or reproduced or utilized in any form or by any electronic, mechanical, or other means, now known or hereafter invented, including photocopying and recording, or in any information storage or retrieval system, without permission in writing from the publishers.

Trademark notice: Product or corporate names may be trademarks or registered trademarks, and are used only for identification and explanation without intent to infringe.

First edition published by Michael Wiese Productions 2002

Library of Congress Cataloging-in-Publication Data
Names: Johnson, Claudia (Claudia Hunter), author. | Stevens, Matt, (screenwriter), author.
Title: Script partners : how to succeed at co-writing for film & TV / Claudia Johnson & Matt Stevens.
Description: Second edition. | New York and London : Routledge, 2016. | Includes bibliographical references and index.
Identifiers: LCCN 2015043057| ISBN 9781138904583 (hardback) | ISBN 9781138904576 (pbk.) | ISBN 9781315687360 (e-book)
Subjects: LCSH: Motion picture authorship. | Television authorship. | Authorship—Collaboration.
Classification: LCC PN1996 .J627 2016 | DDC 808.2/3—dc23
LC record available at http://lccn.loc.gov/2015043057

ISBN: 978-1-138-90458-3 (hbk)
ISBN: 978-1-138-90457-6 (pbk)
ISBN: 978-1-315-68736-0 (ebk)

Typeset in Sabon
by Apex CoVantage, LLC

Printed and bound in Great Britain by
TJ International Ltd, Padstow, Cornwall

Dedicated to the memory of
Larry Gelbart, Fay Kanin, Hal Kanter, Aaron Ruben, and Harold Ramis
who contributed so much to Script Partners

Probably the most famous punch line of the countless ones that broadcast comedians have ever offered us owed its creation to two members of Jack Benny's writing staff, Milt Josefsberg and John Tackaberry.

Working together, Tackaberry came up with a straight line for a burglar pointing a gun at Benny and demanding, "Your money or your life."

Josefsberg, lying on the couch (it is mandatory in any collaboration that one of the partners lie on the couch), heard the line and said nothing.

Tackaberry waited an impatient moment or two, then said to Josefsberg, "Well, have you got a comeback?"

Not having thought of anything suitable yet, Josefsberg replied, "I'm thinking, I'm thinking."

Unwittingly, the process of collaboration had been memorialized as a punch line.

—Larry Gelbart

Contents

FOREWORD BY MARSHALL BRICKMAN — XI
INTRODUCTION AND ACKNOWLEDGMENTS — XV

Chapter 1	Why Collaborate? The Top Ten Reasons to Write With a Partner	1
Chapter 2	A Film School Survival Kit or How Collaboration Helps You Get In, Get Along, and Get Ahead	17
Chapter 3	Finding the Right Writing Partner	35
Chapter 4	Making the Creative Relationship Work	57
Chapter 5	Solving the Space–Time Conundrum	77
Chapter 6	Choosing the Right Project	95
Chapter 7	Co-Creating Character	117
Chapter 8	Co-Creating Story and Structure	137
Chapter 9	Co-Drafting the Script	161
Chapter 10	Co-Writing the Rewrite	183
Chapter 11	Making the Business Relationship Work	209

CONCLUSION — 235
AFTERWORD BY ANDREW REICH & TED COHEN — 237
BIBLIOGRAPHY — 239
INDEX — 245

Foreword

Whenever I am asked what advice I might offer to young people who want to break into film, I always say that there are already far too many people in film and what we really need are more people in health care.

Nevertheless, each year there are those who, armed with a combination of courage, ignorance, and hope (which is a form of both ignorance *and* courage), reject medical school, trade their LSAT manuals in for a screenwriting program and a coffee pot, and confront the blank page.

"Here comes another one," giggle the Muses, as they watch the poor fellow pore through his dog-eared Syd Field or Robert McKee in hopes of writing the next *Casablanca* or *The Lady Eve*. "Six weeks max," they say, "before he starts talking to himself. Eight and they'll pick him up naked in a bus station outside Cleveland, muttering about character arcs, climaxes, and whammeys."

Yes, it's a terrible business, this intersection of art and commerce and science and opinion and intuition and rules and contempt for rules; a business in which, to quote the poet, the best lack all conviction, while the worst are full of passionate intensity. And yet, despite the crater-sized pitfalls, there is something undeniably exhilarating about writing for the movies.

I don't refer to the delicious possibility of bankrupting a global corporation or the ability to make hard-bitten men weep (the exhibitors) or even the chance to move an audience in one direction or another. For me, the mysterious appeal has always been that it all starts from some low-voltage electrical activity in the recesses of somebody's brain, something you dream up inside your head.

It's an enormously powerful feeling, not to be underestimated: the seductive, infantile omnipotence with which someone alone in a room, though he appears to be staring off into the middle distance, is in fact inventing people, starting a war, perhaps, or if it's been an especially rotten day, destroying an entire planet. In what other line of work can a person make a beautiful girl fall in love with, say, a giant ant? Or bring to

the masses a detailed description of interplanetary travel, right down to the non-gravity suction-toilet?

As your psychoanalyst will confirm, this is not an insignificant capacity, this omnipotent control over an entire universe. It is, in fact, what separates us from the animals: The animal understands one act: survival. The human understands three, with a climax occurring somewhere around page 90.

When it all works, it can be satisfying, therapeutic, and financially rewarding. When it doesn't, and the infant who a moment ago controlled the world suddenly finds the world spinning out of control, it can be terrifying.

This is, perhaps, one of the reasons we collaborate. Larry Gelbart, in a slightly different context, described collaboration as "consorting with the enemy." In the current context, however, the description would be: "two people fighting the common enemy."

The enemy has many names. One is loneliness. In my romantic period, when I lived alone and worked at night, I believed the best work in any field was accomplished by people working alone at night: Mozart. Goya. Tolstoy. Jack the Ripper. Experience has made me wiser, and I can now admit that sometimes two people working alone can be better than one. Especially if it's the right two people.

There are as many reasons for writing teams as there are teams (actually twice as many reasons, if you think about it). Loneliness I have mentioned. The bringing to bear of different sensibilities and experiences to a subject is another. The sobering effect of someone who can expose your dementia to the light of reason so it will shrivel and evaporate like Dracula in the sun. The usefulness of conversation as a tool for exploring and developing ideas is yet another.

When I first started writing, alone in my room at night, I would type out imaginary exchanges with myself, having schizophrenically invented a doppelganger/collaborator with whom I could argue about ideas in dialogue form. One night, and I am not making this up, I typed out, "I'm hungry." On the next line I typed, "OK, how about Chinese?" On the next line I typed, "I'm sick of Chinese, how about a pizza?" On the next line I typed, "You are going crazy," at which point I went for a walk around the block.

Every writer harbors two personalities: the infant who generates the raw material and the editor who evaluates it. Both are crucial to the process and each is inescapably at war with the other. A balance must be struck, an internal negotiation which often has as much to do with blood sugar, hormone levels, and one's personal life as with wisdom, logic, and experience. If the infant gains too much control, you get a 300-page screenplay with too many speaking parts, giant ants, and no architecture. If the editor gets the upper hand, you wind up with 25 aborted starts and the conviction that you are in fact the fraud you always suspected, that all

the good ideas have been taken, that you have less talent than that pigeon staring at you from the window sill, and that your mother was right.

So the presence of another person functions as a stabilizer, like the two-man launch rule for ICBMs. The chances that two people will lose their mind at exactly the same time are exponentially smaller.

In a world fueled mostly by animal ego and self-interest it's encouraging to know that two personalities can accommodate each other to achieve a result. The whole can be—and often is—greater than the sum of its parts. This speaks well not only of the medium, but gives one hope for the very future of the civilization. Read and enjoy.

Marshall Brickman
Award-Winning Writer/Director & Script Partner
(with Woody Allen: *Annie Hall*, *Manhattan*,
Manhattan Murder Mystery; with Rick Elice: *Jersey Boys*)

Cecilia (Mia Farrow):	You do believe in God, don't you?
Tom (Jeff Daniels):	Meaning?
Cecilia:	The, the reason for everything, the, the world, the universe.
Tom:	Oh, I think I know what you mean: the two men who wrote *The Purple Rose of Cairo,* Irving Sachs and R. H. Levine. They're writers who collaborate on films.

<div align="right">—The Purple Rose of Cairo</div>

Introduction and Acknowledgments

Years ago, in the middle of co-teaching a screenwriting class at the Florida State Film School, we heard a knock on the door. We opened it.

Two frantic undergraduate students stood in the hall. "Tell us how to collaborate! We want to write a script together and we don't know how!"

"Hey," we said, "you're interrupting our class."

"It'll just take a minute!"

"You want us to tell you how to collaborate in *sixty seconds*?"

They nodded.

A ridiculous request. More ridiculous, we tried to answer. We tried to reduce all we'd learned as script partners to little more than a logline.

It would've been great just to hand them a book on the subject, but one hadn't been written—amazing when you consider that many of the most important and successful films of the past and present have been written by screenwriting teams.

And also amazing because the screenplay "is a form that lends itself quite readily and quite agreeably to co-writing," explains Charles Gaines, Ethan Hawke's screenwriting partner. "No other form of literature that I know of does that. I really think that, unlike novels, one of the great pleasures of scriptwriting is the option to do it with someone else, that it becomes a sort of shared labor that is much more fun than it is stressful. And it often results in a much better product than if one person's doing it by himself."

So we decided to co-write a book about co-writing scripts and demystify this extraordinary process, if that's possible. "The thing about the creative process," says Marshall Brickman, "is that if you could really

demystify it everybody would be doing it and who would fly the planes and run the government? I mean this."

We would write it for those who want to know how to work with a partner and for those who want to know how other script partners work. As William Goldman says in *Which Lie Did I Tell?* "I think the one thing writers are all interested in is how others do it."

Our fellow faculty at the Film School loved the idea. One colleague said she'd tried to co-write a screenplay, but the collaboration fell apart. "I wish I'd had a book to consult about how to do it," she told us. "Or do it better."

Another colleague agreed. "People are hungry to know how to write creatively with another person, how to bring out the best in each other, how to keep it fair, and make it successful."

We wanted to talk to the very best script partners in the business to find out the secrets of their success. So we were delighted when our research assistant called two former classmates from Yale, Andrew Reich & Ted Cohen, head writers of *Friends*, and Reich said, "This book needs to be written." They agreed to be interviewed. We're grateful to them for this propitious jumpstart.

A year later, our first edition of *Script Partners* was published, and the response and reviews were more than gratifying. *Script Magazine* praised its "witty and high style." We did book signings and collaborative writing workshops across the country and were thrilled to hear from other teams who said the book was enormously helpful to their collaborations. One pair called it "the marriage manual for writing teams."

Since the first edition was published (insert clock hands spinning and calendar pages falling), we've seen the rise of exceptional writing in episodic television—a second Golden Age.

"There hasn't been this strength of writers since the early '50s, *Playhouse 90*," agrees Jack Epps, Jr., co-writer of *Top Gun* and Chair of USC's Writing for Screen & Television program. "I mean, we've sort of come back to this period where there's this great writing, and I think it raises the bar for everybody. It also offers so many opportunities that it's really an amazing world right now."

We've also witnessed the growing popularity of short films and Internet content (web series, viral videos, etc.) and the rising number of writing teams in the biz and in film schools, including Florida State.

Hence, this second edition.

We've woven in interviews with writing teams on cutting-edge TV series such as *Friday Night Lights* and *Breaking Bad*, and added a new chapter "A Film School Survival Kit or How Collaboration Helps You Get In, Get Along, and Get Ahead," which explores the many ways film students benefit from co-writing scripts. And because screenwriting is rewriting, we've written (and rewritten) a second new chapter, "Co-Writing the Rewrite."

With these two new chapters, our second edition—like Spinal Tap's amp—now goes to 11.

We believe the collaborative skills examined here can pump up the volume on your career, whether you're a prospective or current film student or script partner.

These skills, we also believe, have an even wider application. Over and over, *Harvard Business Review* emphasizes the pressing and even urgent need for successful collaborations in the corporate world. As Rosabeth Moss Kanter writes, "Whatever the duration and objectives of business alliances, being a good partner has become a key corporate asset. I call it a company's *collaborative advantage*. In the global economy, a well-developed ability to create and sustain fruitful collaborations gives companies a significant competitive leg up."

While writing both editions, we were overwhelmed by the generosity of all the script partners we interviewed. They not only shared their time and wisdom—they shared their contacts. Scott Alexander & Larry Karaszewski suggested we talk to Robert Ramsey & Matthew Stone and Ed Solomon and gave us their contact information. Peter Tolan put us in touch with Harold Ramis.

When we told Aaron Ruben we'd love to interview Hal Kanter, Ruben asked his wife, Maureen, to bring him the phone. She did—a flimsy, cordless contraption Ruben hated.

"Don't we have a *real* phone?"

Maureen laughed and dialed Kanter's number.

"Hal!" Ruben said. "I'm talking to you on a toy phone!"

"That's why you sound so young!" Kanter countered.

We interviewed Hal Kanter, and he put us in touch with Fay Kanin.

(Sadly, since the first edition, Harold Ramis, Aaron Ruben, Hal Kanter, Fay Kanin, and Larry Gelbart have died, so when we talk about them in this edition, we use the past tense. But our gratitude for their contribution will always be present.)

We've been honored to interview 36 outstanding script partners: Scott Alexander & Larry Karaszewski, Lucy Alibar, Brad Anderson, Lee & Janet Scott Batchler, Marshall Brickman, Olivier Ducastel & Jacques Martineau, Jack Epps, Jr., Charles Gaines, Larry Gelbart, Chad & Carey Hayes, Fay Kanin, Hal Kanter, Nicholas Kazan, Harry & Renee Longstreet, Matt Manfredi & Phil Hay, Patrick Massett & John Zinman, Carolyn Miller, Cinco Paul & Ken Daurio, Harold Ramis, Robert Ramsey & Matthew Stone, Andrew Reich & Ted Cohen, Aaron Ruben, Ed Solomon, David Sonnenschein, Jim Taylor, and Peter Tolan.

It's a rich sample—film, TV, Internet, mainstream, indie, domestic, foreign, friends, lovers, siblings, spouses, serial collaborators, career collaborators, and long-distance collaborators.

For the new film school chapter, we interviewed faculty members and chairs of scriptwriting programs across the country—Jack Epps, Jr., at USC, Richard Walter at UCLA, Evan Smith at Syracuse University, Eric R. Williams at Ohio University, Bettina Moss at National University, Christina Kallas at Columbia University, as well as former FSU graduate

student Akil DuPont, who shared his co-writing experience on the award-winning thesis film he directed, *Underground*.

Entertainment attorneys Brooke A. Wharton and Eric Weissmann kindly took the time to give us the skinny about the business side of collaborative writing, as did agents Alan Gasmer, Dave Brown, and Jennifer Good.

Laurie Espinosa at the Writers Guild of America, West, granted permission to reprint the Writer's Collaboration Agreement, and Grace Reiner illuminated the agreement's usefulness and importance.

We thank all of them and those who helped us find them. A special second-edition thanks to Kris Burkett at USC for arranging our interview with Jack Epps, Jr.; Andrew Deane at Industry Entertainment and Rose Massett for scheduling our interview with Patrick Massett & John Zinman; Nancy Kissam for putting us in touch with Cinco Paul & Ken Daurio; and Ken Freimann at Circle of Confusion for helping to arrange our interview with Chad & Carey Hayes.

Eternal gratitude to our original and current editors at Focal Press—Peter Linsley and David Williams, respectively—for championing this second edition from the beginning.

And to our families for championing us from the beginning too.

Above all, we're grateful to the writers we interviewed for their generosity of time and spirit and their candor about the collaborative process. Their experience, insight, advice, and humor are the very heart of this book.

"Yes, I'm saying it out loud. In print," Dennis Palumbo (*My Favorite Year; Welcome Back, Kotter*) says in *Writing from the Inside Out*. "Writers are the smartest people in the room. Any room. Anywhere in town."

If we ever doubted that, we don't now.

> "She got gaps. I got gaps. Together we fill the gaps."
> —Rocky Balboa (Sylvester Stallone), *Rocky*

ONE

Why Collaborate? The Top Ten Reasons to Write With a Partner

What do feature films like *Some Like It Hot, Annie Hall, Top Gun, Fargo, There's Something About Mary, Amélie, Sideways, Beasts of the Southern Wild, Gravity, Dallas Buyers Club, The Conjuring,* the *Pirates of the Caribbean* franchise, and the *Despicable Me* franchise have in common besides their success?

They were co-written by collaborative screenwriting teams: Billy Wilder & I.A.L. Diamond, Woody Allen & Marshall Brickman, Jim Cash & Jack Epps, Jr., Joel & Ethan Coen, Peter & Bobby Farrelly, Jean-Pierre Jeunet & Guillaume Laurant, Jim Taylor & Alexander Payne, Lucy Alibar & Benh Zeitlin, Alfonso & Jonás Cuarón, Craig Borten & Melisa Wallack, Chad & Carey Hayes, Terry Rossio & Ted Elliott, and Cinco Paul & Ken Daurio.

Many episodes of successful television and web series are also co-written by teams such as Andrew Reich & Ted Cohen, head writers and executive producers of *Friends* and the 2014 web series *Robin Banks and the Bank Roberts*, and Patrick Massett & John Zinman, co-writers and co-producers of *Friday Night Lights* and *The Blacklist* (as well as co-writers on the films *Lara Croft: Tomb Raider* and *Gold*).

Each year the list of script partners and their successes grows longer. Why? Because as we and the writing teams interviewed here have discovered, collaborative scriptwriting is one of the most productive and successful ways to write (and the rewards often *transcend* success).

In fact, it can double your chance for success, as Harold Ramis discovered when he worked with different partners, from Douglas Kenney & Chris Miller (*Animal House*) to Peter Tolan (*Analyze This; Analyze That*).

"It just adds so much to the work," Ramis told us during a break from editing *Analyze That*. "Peter, for instance, will add just tremendously funny things and great scenes, great dialogue. And there's this synergistic benefit—it makes my work better, and together we're better

than probably either of us alone. I can enjoy writing alone, but I think I've never been as good as with other people. If I were limited by my own ability, my own imagination, I would be probably less than half as successful as I am," he confessed, laughing.

Despicable Me writers Cinco Paul & Ken Daurio agree via email. "Well, first of all, working with a partner is a lot more fun. And secondly, in writing comedy it's good to have another person there to help determine whether something is actually funny or not. It was really beneficial to us earlier in our careers when we were pitching a lot—with two people you can act out scenes, really make a show out of a pitch."

Their career is the very picture of success, including being chosen by Theodor Seuss Geisel's widow, Audrey Geisel, to write the film adaptations of *Horton Hears a Who!* and *Dr. Seuss' The Lorax*.

"We both know on some level we could do this by ourselves," Andrew Reich says when we interview him and Ted Cohen on the Warner Bros. lot. "We both could, but we're better together and prefer it that way."

Why should *you* or any writer who wants to work in this biz consider collaborating? Because—the envelope, please—the top ten reasons are . . .

1. Learning to Write With a Partner Can Get You Hired—Not Fired—in the Industry

How's that for a hook and setting the stakes? But don't take our word for it. Patrick Massett & John Zinman, during our interview at their Sherman Oaks production office, talk about the advantages of hiring writing teams for a TV series.

PATRICK: I like teams. I understand the benefit of a partner. So when I look at a partnership, I think if they seem like they're right for the job, then I'm totally wide open to hiring them.

JOHN: Yeah, I like partnerships, and it's a collaborative environment, so they're already people who are, you have to assume, disposed toward collaboration. So I think in the TV world especially, writing teams are a good bet. You've got to spend a lot of time with the people you hire. Are they gonna mix? Are they gonna be additive to the group? And if a partnership is additive, then they're gonna probably win the job over a single writer.

Massett & Zinman know from long experience that successful script partners have already learned how to play well with others, a crucial skill in the highly collaborative environment of a TV writers' room.

PATRICK: You can have eight great people in a room that all jive and then one person who doesn't, and it fucks the whole thing up.

JOHN: It really does.

PATRICK: That one bad apple thing? True that. Completely spot-on in regards to a writer.

JOHN: It can *crush* a writers' room.

PATRICK: It's an energy suck. It's a creative suck.

JOHN: Truly, you've got to fire that person *immediately*. You just do. It's hard to do because you don't want anyone to get fired. But some people are "no" people.

PATRICK: And they don't come back with an idea. That's one of the rules of the writing room. You don't like someone else's idea, you have to sort of—

JOHN: "No, I don't think Sharon should walk in and shoot him. I think Sharon should walk in and talk to him first and then go to the drawer and turn and explain why"—as opposed to notes like, "I hate that, I hate that idea."

PATRICK: There are writers who will sit in a room and say just that, period, end of sentence.

JOHN: Look, you have to have thick skin. You can't be in a writers' room and not have thick skin, but you also want to know that your colleagues have your back. One person who's pejorative or passive-aggressive—

PATRICK: Dismissive.

JOHN: Dismissive, demeaning, it just shuts people up, especially the younger writers. I mean, older writers are gonna be like, "Fuck you." Younger writers are gonna be afraid they're gonna get fired or be afraid that they're not good enough, and then you've got a bad room. Because one person is just being a dick. Of course, as producers you've gotta ask around too. Most people have reputations. [Laughter] It's a small town.

2. *It's a Dog-Eat-Dog Business—and Vice Versa—but When You Write With a Partner, There's Always One Person in Town Looking Out for Your Interests*

The misery curve for screenwriters is legendary. It's a daunting task to write a screenplay and even more daunting to write a good one. Conventional wisdom says it takes five to ten years to learn the *craft* of screenwriting, and five to ten screenplays before you finally sell one. There are exceptions, of course, keeping hope alive that perhaps, just perhaps, writing screenplays is easy.

It isn't.

And getting a screenplay produced is even harder. Screenplays are like sperm—there's a one-in-a-million chance they'll get made.

Jim Cash & Jack Epps, Jr., wrote seven screenplays before *Top Gun* was produced, and even that iconic film almost didn't happen. When Paramount shelved the script after a shakeup at the studio-exec level, Cash & Epps were beyond frustration. But their partnership kept them going, as Epps tells us at his USC office.

"Jim and I, when we were getting beat up— You just feel like throwing in the towel but you've got someone there to push you. There's somebody there to say, 'Hey, let's do this. Come on. We can do this.' And that really helps a lot."

Nicole Yorkin & Dawn Prestwich (*Judging Amy*; *The Killing*) spent their first four years writing scripts that didn't sell. The Farrelly brothers spent nine years hawking their screenplays around Hollywood before they made their first film. So screenwriters must find effective ways to keep discouragement from overcoming determination.

And writing together does just that, Lee & Janet Scott Batchler (*Batman Forever*; *Pompeii*) tell us over coffee in Pacific Palisades.

JANET: Sometimes we both get down at the same time. It just works that way. Sometimes we sort of pull each other through.

LEE: The best baseball player in the world has a batting slump.

JANET: And the best baseball players in the world are batting somewhere in the .300s. Nobody hits a thousand. We just have to keep reminding each other of that. We sort of have to goose each other to get going sometimes.

And in this tough business, writing partners have each other's back.

"You've always got one person in town who's looking out for your best interests," says Robert Ramsey, who wrote numerous scripts with Matthew Stone (*Life*; *Intolerable Cruelty*; *Man of the House*) in an office overlooking Griffith Observatory and the famous Hollywood sign.

Yes, you have to find the right writing partner, and once you start selling your screenplays you'll make half the money, but most writing teams believe that's a small price to pay. Bottom line: The advantages of sharing the writing outweigh the disadvantages of sharing the bottom line.

3. Two Imaginations Are Better Than One—Better Brainstorming and Creative Breakthroughs

There are some terrific techniques (clustering, for example) for exploring ideas alone on paper, but brainstorming (or "spitballing," as William Goldman calls it in *Adventures in the Screen Trade*) by definition requires more than one person. According to *Conceptual Blockbusting*, it was invented as a group problem-solving technique and given its name by

Alex Osborn, a leader in advertising, who outlines four rules for successful brainstorming sessions:

> Rule 1. No evaluation (internal or external criticism) of any kind is permitted.
> Rule 2. All participants should be encouraged to think of the wildest ideas possible (because, as Osborn believes, "it's easier to tame down than think up").
> Rule 3. Quantity of ideas should be encouraged (quantity helps control our internal evaluation, and quantity, he also believes, leads to quality).
> Rule 4. Participants should build upon or modify the ideas of others (because, in Osborn's words, "combinations or modifications of previously suggested ideas often lead to new ideas that are superior to those that sparked them").

We were amazed and impressed (with ourselves!) when we recently read these rules, because over the years we've developed a similar set of unwritten rules for brainstorming our screenplays.

Before we make an outrageous suggestion, we say, "I'm just playing." That's code for "Brace yourself, this could be bullshit," but it buys us a license to offer the wildest and possibly dumbest ideas without getting dumped on (Rule 1).

In our more insecure moments, if we think the idea is *really* outrageous, we'll say, "You're gonna hate this" or "Get out your barf bag," but we throw the idea into the mix anyway so we can explore it. Because, like Alex Osborn, we've learned that the more outrageous the idea, the better (Rule 2).

A wild idea can always be tamed—unless it turns out to be brilliant—but it can also release a whole herd of ideas (Rule 3).

And when we play off each other's ideas, we almost always come up with something better (Rule 4).

It's the "synergistic benefit" Harold Ramis referred to. "Another analogy I've used is like getting an assist in basketball," he told us. "One person puts the ball up near the hoop, and the other person slams it in. Or makes a great pass that results in a shot."

He, too, often offered an apologia before making a suggestion. "I preface my ideas with saying, 'This really is bad' or 'You're gonna hate this' or 'How lame is this?' or 'Is this too stupid?' You know, particularly in comedy. Comedy depends so totally on the approval you get from the audience, and your collaborators are your first audience, so you're just desperate to please them." He laughed.

Ramsey & Stone have used a similar tactic.

MATTHEW: We say, "This is probably a really terrible idea."
ROBERT: "This is probably the worst idea I've ever had."

MATTHEW: Happens all the time. Like 50 times a day.

ROBERT: It's the lunatic ideas that you feel safe sharing with your partner. If you're afraid he's gonna think this is stupid, then you're never gonna say it. Maybe he'll think it's great. You've just got to put it out there. The more risk, the more reward.

Massett & Zinman credit *Friday Night Lights* showrunner Jason Katims for creating that crucial sense of safety in their writers' room.

PATRICK: Jason loves writers, he really does. He respects them and trusts them and creates an environment of trust where you feel like you can take risks in what you're about to pitch. One writer was pitching that Tami Taylor [Connie Britton] had to deal with a chronic masturbator in class. Now that's not an idea that's gonna fly for Jason. [Laughter] But he felt like it was a safe environment and pitch whatever you wanted to. We all had a good laugh and we talked about it, but he understands what you need to be as a writer is vulnerable. You have to be open to your own emotions and your own feelings and your own experiences, and if you can't, then you're not gonna get the best. You can say whatever you want and know you aren't going to be ridiculed or fired for pitching bad ideas. There were no bad ideas. There'd be like, "Okay, I'm not quite seeing that, but what if you did this?" He never said no, did he?

JOHN: He wouldn't say no.

It's no accident that this method works. As *Conceptual Blockbusting* says, a study group at Harvard listed the following behavioral reasons why brainstorming this way is such a success:

Reason 1. Less inhibition and defeatism
Reason 2. Contagion of enthusiasm
Reason 3. Development of competitive spirit; everyone wants to top the other's idea

Less inhibition means more freedom and willingness to take risks—one of the great benefits of collaborative writing. As psychologist and creativity researcher Howard Gruber observes in *Creative Collaboration*, "What a collaboration does for you is, by spreading the risk a little bit, it encourages you to take more chances."

We're all told to be bold (there's magic in it), but it's easier when we write with others. It takes a great deal of trust—in yourself, your partner, and the creative process—but the rewards are profound. A greater

willingness to take chances expands and enriches the creative field for you. Increases your options. Opens your mind—and your script.

"It carves out a lot of territory for you to operate in," Ramis said.

The boldness comes in part from another benefit of collaboration—instant feedback. When you write alone, if you're anything like us, you're your own worst critic. You start to question your work and your judgment. You have no idea how your words come across.

"Having a writing partner keeps my pinky off the delete button," Scott Neustadter—who writes with Michael H. Weber (*(500) Days of Summer*; *The Spectacular Now*; *The Fault in Our Stars*)—tells *The Script Lab*. "I tend to erase everything I write to the point where I'll delete entire scenes and, on one or two occasions, entire files . . . But having a writing partner reduces that impulse—at least somewhat."

A co-writer can see the potential in an idea you might otherwise shoot down. This feedback energizes and encourages experimentation, creating a contagion of enthusiasm (derived from the Latin *en theos*, "with God," in case you doubted it was divine), which means more excitement about the script you're writing. And as you bounce ideas back and forth ("creative ping-pong," we call it), the excitement increases and breakthroughs happen.

Finally, better brainstorming develops a competitive spirit. As we'll explore in Chapter Four, a *healthy* competitive spirit inspires you and your partner to try and top each other and ultimately to offer your best.

Still, the sweetest moments for us will always be solving creative problems together. That's the real joy and reward of collaboration. We laugh, crow, high-five. We've even been known to jump up and do a victory dance—trusting we won't make fun of each other's moves.

4. One Plus One Equals Three—The Third Voice

"Collaboration is a merger of the aesthetic of two different people," says Nicholas Kazan, who wrote *Matilda* with his wife, Robin Swicord. "It's distinct from the individual aesthetic. And I think what happens in a good collaboration is that you form this other psychic or psychological identity."

That's one of the more marvelous and mysterious benefits of the collaborative writing process. Somehow, through the merging of the aesthetic, experience, and talent of two writers, a "third voice" emerges.

"It's not a singular voice, it is a shared voice," Epps explains. "There's the voice of the collaboration. Jim would like to say, 'There's Cash, there's Epps, and there's Cash & Epps.' And that was really true. That was a voice that we had together."

Or as Cash (who died in 2000) demystifies it in the *Los Angeles Times*, "The interesting thing is that out of our two strong egos we create a

third, combined ego which, or who, knows more than either of us alone. Something between us knows what's *really* right. The third person is the partnership. The nice thing is, we don't have to *pay* the third person."

Prestwich says the same thing about working with Yorkin. "We're actually very different voices as writers," she tells *Written By*. "When we come together to write, we create a third writer. Basically that third writer writes the script. It's this third writer who has so much more experience and knowledge than we have individually."

Scott Alexander & Larry Karaszewski (*Ed Wood*; *The People vs. Larry Flynt*; *Big Eyes*) have only written screenplays collaboratively, they tell us in the writing office they share.

LARRY: So it's hard to say what that individual voice would be anymore—there's definitely a third voice.

SCOTT: Sort of a mixture of real and ridiculous, funny and poignant, and absurdism. So we do tend to shove our scripts into that voice. Unless we're doing a two-week polish, in which case we're idiots for hire.

We create a third voice too when we write scripts together, and we've learned to welcome that third writer into the room.

So have Ed Solomon & Chris Matheson, who collaborated on *Bill & Ted's Excellent Adventure*, *Bill & Ted's Bogus Journey*, and *Imagine That*. "Try to be in love with that third entity," Solomon advises. "It's neither you nor them, neither your idea nor that person's idea, but it's that third thing which is a product of the two of you. Try to always keep your eye on that. Nurture *that*."

The whole *is* greater than the sum of the parts. And the partners.

5. Complementing (and Complimenting) Each Other Can Lead to Stronger Scripts and Greater Success

Talk to any scriptwriting team and they can tell you, chapter and verse, what they have in common. We met as colleagues at the Florida State University Film School, we're both originally from the South, we adore comedy, and we have the same sensibilities about what makes a good story. As we'll examine in Chapter Three, similar sensibilities are crucial for you and your partner, but your *differences*—the creative yin-yang—are just as important. It is this complementarity (what writing teams call "complementary strengths") that gives each collaboration its unique richness and range of experience, knowledge, and talent to tap.

In *Written By*, Jack Herrguth describes how he and Seanne Kemp Kovach (*Sister, Sister*) complement one another. "The fact that I'm a man and she's a woman, I'm white and she's African American brings different points of view to our partnership that enriches it."

And Billy Van Zandt, who writes and executive-produces with Jane Milmore (*Newhart*; *Suddenly Susan*; *Jack and Janet Save the Planet*), tells *Creative Screenwriting*, "I think the male/female dynamic, as far as a team is concerned, is important. Because I clearly don't know what it's like to be a woman."

Like Herrguth & Kovach and Van Zandt & Milmore, we're different genders. But male/female is only the beginning of our differences—pessimist/optimist, pop culture/literature, actor/playwright, no children/children, good dancer/bad dancer, neurotic/Zen (Matt's suggestion).

We complement each other too with our individual strengths as screenwriters—visual/verbal, dialogue/description, comedy/drama. This doesn't mean we don't share the work, but we often defer to each other's expertise. It's a nice safety net, but we have to say that over the years these distinctions have blurred as we've learned from each other.

"Our process was realizing our different strengths and weaknesses," Epps tells us. "And I think that's really, truly what a good collaboration is—knowing where you do best in that collaboration. For us it became what we later were able to call 'words and music.' That's what I called it. Some people are better at the lyrics, and some are better at the melody. I'm music, Jim's words, that's how it worked out. And that's why I think we were a good collaboration—because we were able to blend without competing. We layered each other very well."

In William Froug's *The New Screenwriter Looks at the New Screenwriter*, Cash explains their complementary strengths. "Usually, Jack works ahead of me, planning scenes. His story instincts are exceptional, and I give him all the room he needs to develop the main body of the work. He'll pitch several scenes to me at a time, and we'll talk about each one of them for a few minutes, turning them inside-out a couple of times, reshaping something, adding something else. His job during this is to make sure the story stays on track. My job is to make the scene interesting. He's looking at the whole sky; I'm looking at the incoming bogey."

An apt metaphor since they wrote *Top Gun*.

Lowell Ganz & Babaloo Mandel (*Splash*; *Parenthood*; *City Slickers*) are also well aware of their complementary strengths, as they tell *Written By*:

LOWELL: I know a lot about sports.

BABALOO: And I know nothing. I bring ignorance!

LOWELL: I tend to think every day is our last day in show business . . . or on earth. I've always said about myself, that I'm the first man in the lifeboat. I'm the guy who gets in the dress, pushing women and children out of the way.

BABALOO: He would, and he would travel with that dress . . . and he'd have a little stuffed baby. . . .

LOWELL: Seriously, to answer it . . . He has a great sense of tracking the audience—to take himself out of the movie and

> put himself in the theater.... Babaloo is also, aside from everything else, as good a joke writer as I ever met in my life. And I have an ability—I have a willingness—to construct scenarios and toss them into the air ... to just say, "All right! How about this for a construction on this act?" When we get stuck ... to just sort of get to it quickly and go through various solutions.

Like traveling with a dress and a little stuffed baby.

6. Collaboration Improves Mental Health (and It's Cheaper Than Antidepressants)

In *Traveling Mercies*, Anne Lamott describes a moment in the Idaho mountains when she needed to talk to a normal person about a parenting decision she had to make. "Needless to say, there was no one around remotely fitting the description of a normal person: I was at a *writing* conference."

We all know "normal writers" is an oxymoron, so writing and mental health may seem like an odd combination. But remember, we're talking about *collaborative* writing, and better mental health, we believe, is one of its greatest rewards.

Take anxiety. Please. Anxiety is so rampant in writers (especially women, but men suffer too—just ask Matt) that a conference sponsored by the Institute for Psychoanalytic Training and Research was devoted to finding ways to assuage it. One of the strategies that the conference predicted would be most successful was an effective creativity support group.

Writing with a partner is having your own creativity support group. As Aaron Ruben (*The Comic*; *Caesar's Hour*; *The Andy Griffith Show* writer/producer) told us while munching a cigar on the patio of his Beverly Hills home, "It takes the terror out of being in the room with that sheet of paper and typewriter and not one word is there."

That terror is all too common. "Every time, my first day of writing I think, *I can't do this*," Andrew Reich confides. "*I'm a fake. I'm gonna get found out this time that I really suck.* One of the things I've learned in collaboration is to trust Ted when he says, 'This is good enough.' I trust that."

Anxiety may attach to any creative project, but writing with a partner, we've found, is the best antidote. When we work together, we keep each other from sliding into self-doubt, the slough of despond. Again, we've developed a code, an emotional shorthand. When one of us starts looping about some gloomy thought, the other quotes some hilarious line (usually impersonating the actor) from a movie we love (usually *Tootsie*), and that gets us laughing and working again.

In fact, for us, laughter is the key to maintaining mental health when we work together. Even when we aren't together, if we're having a terrible day, we'll call each other and say, "Make me laugh!" Because, like

brainstorming, laughter is hard to do on your own. It's a social act that connects us to others. And satisfying the human need for connection is one of the reasons laughter increases mental—and physical—health.

Neuroscience is beginning to understand other reasons. Laughter is one of the few times we use our whole brain. According to *Psychology Today*, Peter Derks, Emeritus Professor of Psychology at the College of William and Mary, says that when we get a punch line, both sides of the brain are engaged (collaborating!), "the left hemisphere working on the joke's verbal content while the analytic right hemisphere attempts to figure out the incongruity that lies at the heart of much humor."

"After you laugh, you go into a relaxed state," explains John Morreall, president of Humor Works Seminars in Tampa, Florida. "Your blood pressure and heart rate drop below normal, so you feel profoundly relaxed. Laughter also indirectly stimulates endorphins, the brain's natural painkillers."

More to the point for screenwriters, laughter makes us more creative.

And Morreall agrees, "Humor loosens up the mental gears. It encourages out-of-the-ordinary ways of looking at things."

WD40 for the creative wheels.

7. A Partner Helps You Overcome Writer's Block, If Only Because It's Embarrassing When Both of You Are Staring at a Blank Page

But what happens when those creative wheels screech to a halt? Writer's block.

"I turn to my partner and scream 'Help!'" Paul Guay, who wrote *Liar Liar* and *Heartbreakers* with Stephen Mazur, says in an email interview with the Writers Guild.

"You just call up the other person or go talk to the other person, and you deal with the problem," Nick Kazan tells us at his Santa Monica bungalow, "and the problem usually goes away. Something that would keep you stuck and perhaps deeply depressed for a week or two is going to evaporate in a matter of minutes. So it's a great solace."

Without Ted Elliott, Terry Rossio claims to have "a permanent case of writer's block," as he says on their website, Wordplayer.com. His recommendation? "Get a writing partner, so there's somebody other than yourself you don't want to let down."

And a partner can offer insights, ideas, or inspiration and get your creative wheels turning again, as Scott Alexander & Larry Karaszewski have found.

LARRY: On the days when I just am brain dead—
SCOTT: That was yesterday.

12 Why Collaborate?

LARRY: Exactly. Your partner can spark you and push you forward. And then when he's not feeling up to it, I can say, "All right, we gotta get to work." There are very few times when we both shut down completely. It's happened.

SCOTT: I think it happens all the time. The thing with writer's block with teams is that it's more embarrassing because it's two people staring at the wall for hours and not a sound being spoken. You can cut the tension with a knife after a certain point. It's more humiliating because if a guy's alone and staring at a computer and doesn't know what to do, he'll just go off and make a sandwich or turn on the TV.

LARRY: It's hard to masturbate when Scott's around. [Laughter]

The Farrelly brothers and the Coen brothers *deliberately* get themselves into a corner with their stories, then take a few days or a week or even a month off until they find a way out.

In *Which Lie Did I Tell?* William Goldman insists their method is madness, but he admits that for them it *works*. "Not because they are brother writing teams, although that doesn't hurt. They certainly know each other so well, and can deal with each other's idiosyncrasies. But it's because there are two of them. I can't do it that way. If I get into a dark place, I can't say to my writing partner, 'Here, fix the fucker.' There's only me, trapped helpless in my pit, no way out."

If you've written alone, you know what Goldman is talking about. That trapped, helpless feeling. Your story gets stuck in the corner. You think, *No way out.*

What do the Farrelly brothers do when this happens?

"We just drive," Peter Farrelly tells Goldman. "You know, it frees everything up. We just get in the car and drive."

Madness!

Or is it? The truth is, we're big fans of driving. There's something about motion that's magic. But hurtling down highways sometimes isn't enough. Once, on a road trip from Tallahassee to Memphis, we tried to develop an idea for a screenplay, but the story kept getting stuck. One dark corner after another. That trapped, helpless feeling began to set in. Finally, one of us had the wisdom to say, "What about that *other* idea we had?" We set the first idea aside and started brainstorming the second. Bingo! We were off. The idea spun into story like silk off a spool. By the time we got to Memphis, we'd written an entire scene-by-scene for a screenplay.

We learned a couple of things on that trip: One, some stories deserve to stay in the corner (RIP). And two, though Peter Farrelly is right when he says driving frees everything up, Goldman's right too—we got out of the "dark place" because there were two of us in the car. When one couldn't see that we needed to change ideas and direction, the other one could. Then we started brainstorming. And found a way out.

Ron Osborn, who collaborates with Jeff Reno (*Radioland Murders*; *Meet Joe Black*; *Beauty & the Beast* TV series), tells the Writers Guild, "When we both hit a roadblock . . . you know it's major. Painful, in fact. I know of no shortcuts we use. I tell Jeff a close family member of mine's died, flee the office, and seek the comfort of strangers. He's usually solved it when I return."

Hey, whatever works. Script partners we've interviewed also recommend taking breaks, exploring alternative story setups and directions, and trusting the process and the other person. If all else fails, they remind each other that they've got deadlines to make and bills to pay. As many teams tell us, that's the quickest cure for writer's block.

8. A Partner Helps You Stay Motivated, Focused, and Productive

Just think of him or her as your writing workout partner.

"You have to show up because the other guy's showing up," Robert Ramsey says. "Matt's going to the office, I gotta get there. Otherwise, I would probably be the least productive person on earth."

"Having an appointed time to show up for work and someone whom you are accountable to on a daily basis makes each workday more productive," says Jim Taylor, who wrote *Citizen Ruth*, *Jurassic Park III*, *Election*, and *About Schmidt* with Alexander Payne. "And when one of us gets tired or discouraged, the other one can take over and keep things going. Plus, Alexander is a great cook."

Brothers Chad & Carey Hayes (*The Reaping*; *The Conjuring*; *The Conjuring 2*) tell us over wine at a Malibu restaurant overlooking Zuma Beach how being partners boosts their productivity.

CHAD: The creative process is— Recognize it's a discipline. It's an absolute discipline. We always tell young writers, "Write every day. Just challenge each other."

CAREY: So many writers have so many excuses to not write something. How do you get better at playing tennis? You play every day. Practice, practice, practice, practice.

And productivity can increase in areas beyond writing. For Alexander & Karaszewski, that includes taking calls, an essential part of the business.

SCOTT: This is a great trick that teams can do. Oftentimes someone will call us up, and we're talking to some person, and the second line will ring. One of the two of us will discreetly leave the call, and the caller has no idea they've lost one of us. So this is a good trick that collaborators can do.

LARRY: Invaluable. [Laughter]

9. Collaboration Makes You a Better Writer (and Maybe a Better Person)

Criticism may not be allowed during brainstorming, but at other times in the creative process, your writing partner can be an invaluable critic—your first audience. And his or her responses help produce a better script than you could have written alone.

Matt Manfredi & Phil Hay (*crazy/beautiful*; *Clash of the Titans*; *Ride Along*) agree, as they tell us in a loud, crowed deli in West Hollywood.

MATT: I think we get a better-edited first draft than we could writing separately, just because it's got to get by two people.

PHIL: Two very cranky people. [Laughter]

"It's almost like the script gets a second draft in the first draft process," Dawn Prestwich says.

And perhaps more important, working together—as most script partners tell us—has made them better people. Less ego involved and controlling. More open and trusting. The long-term effect of writing with someone else, we and others have found, is far more profound than expected. It's humanizing. We've learned to accept and welcome our differences and most of our idiosyncrasies.

"I think it makes us very tolerant people," Prestwich says. "It makes us understand the human condition a little bit better because we have such an intimate view of it."

The best scripts are about the human condition, so what better way to learn to write better scripts?

10. We've Saved the Best Reason for Last . . .

Finally, as Ted Elliott says at Wordplayer.com, "As you struggle as writers to perfect your craft, schlepping from studio to studio trying to make that elusive sale or capture that dream assignment, as you wend your way over the freeways that link Hollywood to Burbank, and Beverly Hills to Century City, there's a final, overwhelming way in which a writing partner can be beneficial. Two words: Carpool lane."

Okay, just kidding about this being the *best* reason (though it's a very good one).

When all our interviewees weigh in, the consensus best reason to collaborate is *a writing partner provides moral support*.

This is invaluable because, let's face it, writing is lonely, and loneliness is a morale suck if ever there was one.

Husband-and-wife team Andrew Schneider & Diane Frolov (*The Sopranos*; *Boardwalk Empire*) both had successful solo careers, but after

many years of writing together, they wouldn't consider returning to writing alone. "Now it would be almost inconceivable for me to be a solo writer," Schneider tells *Written By*. "It seems like such a lonely, hopeless position to be in."

"I can't think of a screenplay that I would want to write by myself, that I don't think Matt would be able to contribute to," Phil Hay says. "I feel he would always be helpful, so it never occurs to me to write a screenplay alone. It would be very lonely and upsetting."

"It's fun to have a great person to hang out with," Patrick Massett says. "Well, *you* guys know—someone to hang out with and bounce ideas off of. It's just a lot more fun to go crazy together than by yourself."

We *do* know. We've written screenplays alone, and we've written screenplays together, and we're not going back. But for our money—and experience—Jim Taylor says it best.

"Writing with Alexander at my side is much more pleasurable than working on my own," he tells us. Or as he tells *Scenario*, "Just the writing process itself, of writing on my own, is very unpleasant and unproductive, and it's just no fun."

Fun, in fact, is the reason Harold Ramis started writing with others—and continued throughout his career.

"Here's the secret: When I was in college, there were things I was interested in academically, but nothing was as much fun as sitting around a room with really funny guys and laughing all the time. I couldn't think of anything better to do. It started in a fraternity house, then moved off campus, and it occurred to me that people actually make a living doing this, but I didn't know it was possible until the end of college. My very good friend in college was a guy named Michael Shamberg, who is Danny DeVito's partner in a company called Jersey Films. And Michael and I literally shook hands and said, 'Let's never take jobs we have to dress up for, and let's only do what we enjoy.' Then again, this was the late '60s. We were prepared to be hippies and live communally. But young people still do that now, have always done it. You know you're gonna struggle anyway—you might as well enjoy it."

And when you're paralyzed by the struggle or failure—the *real* F word—a writing partner's moral support can make all the difference.

"What ends up happening is one person bolsters the other," Matthew Stone says. "Nobody's a bigger fan of each other than we are. We think we're fucking great. [Laughter] But I think that's an important thing."

It *is* important.

Craig Borten & Melisa Wallack struggled for many years to get *Dallas Buyers Club* made, during which Borten "struggled with substance abuse. All kinds. Everything. Melisa's a dear friend, and she helped pick me up," he tells *Written By*.

"It strengthened our relationship," Wallack adds, "me going to Craig's hovel once a year and telling him to get his shit together."

Thanks to her unconditional tough love and moral support—and Borten's seven months in rehab—he is able to say, "I'm reborn. This is my rebirth."

So working with a partner might not only save your career, it might save your life. And like many of the script partners in this book, you might find something greater than success—true fulfillment.

"What we do together has been not just professionally but personally very nourishing," Lowell Ganz says, "to have done it with, and to still be doing it, together."

We think you'll agree as you wend your way through your own scripts and career with your writing partner riding shotgun.

> "What is learning? It's paying attention. It's opening yourself up to this great big ball of shit that we call life, and what's the worst that can happen? You get bit in the ass. Well, let me tell you: my ass looks like hamburger meat, but I can still sit down."
> —Uncle Ben (Lewis Black), *Accepted*

TWO

A Film School Survival Kit or How Collaboration Helps You Get In, Get Along, and Get Ahead

When we wrote the first edition of *Script Partners*, we didn't include a chapter about the benefits of collaborating in film schools or scriptwriting programs. But in the intervening years, we've come to realize that this chapter—and book—could be truly helpful to students, whether you're planning to apply, you're already enrolled, or you're leaving soon for the industry.

Because the collaborative skills you learn here will enrich your experience in the academic world and the big world beyond.

And the rest of your life.

Case in point: At USC, a screenwriting student was struggling with her writing partnership in a feature class and went to see her professor, Jack Epps, Jr., for guidance.

"She came to see me and she said, 'You know, this is a problem with my life, and I've talked to my friends about this, and I really need to open myself up more to people.' I mean, it actually had a life-changing effect on her. She said, 'I can see that this is a problem, and I need to really work on it.' And I don't think she was just gaming me for the grade because there was nothing at stake. I think she was just realizing how in many ways she had sabotaged this relationship with her writing partner, and it was sort of a symptom of other relationships. So I think there are other lessons besides just writing a script. It's a life lesson—collaboration."

Want to Get Into Film School or a Scriptwriting Program?

Great! So do thousands of others. That's why most programs have a highly competitive and selective application process.

We should know. We served on numerous undergraduate admissions committees at the FSU Film School. It was a daunting task considering the tsunami of applications we received—for 30 spots a year.

We interviewed the finalists in person so we could select those who would be the best fit for the Film School's "intimate, hands-on and project-centered" program that provides "a comprehensive education in filmmaking," according to their website. And because students have to master all aspects of filmmaking before they specialize and have to work closely together on each other's productions, the ability to collaborate is of paramount importance.

For this reason, in addition to individual interviews, we conducted group interviews to find out who worked well with others. We asked each small group of applicants to sit around a table, and we gave them 15 minutes to brainstorm a pitch for a short film and decide who would perform each above-the-line position in this theoretical production.

It was amazing how quickly they forgot we were still in the room and how quickly some candidates revealed themselves—as egomaniac or combatant or control freak or born collaborator. If they clearly lacked collaborative skills, we knew they would not be a good fit for our program.

Some prospective applicants had already volunteered on Film School productions to gain experience and make sure that filmmaking was what they wanted to do. In these instances, we asked our students how well the applicants performed and collaborated on set—the academic equivalent of Patrick Massett & John Zinman asking about people's reputations before hiring them as writers.

"Their reputations are usually right," Massett says. "Rumors are usually accurate. It's pretty weird. [Laughter] They're usually pretty accurate. You hear things, and most of the time they turn out to be kind of true."

Hey, if Hollywood's a small town, an academic film program is Mayberry. Word gets around.

We went through this admissions process primarily for the sake of our students, to spare them having to work with "an energy suck" or "a creative suck" in class or during long hours in production and post-production.

So it's never too early to start learning the art of collaboration. The best way, of course, is experiential, but if you haven't collaborated before you submit your application, this book, with its insights and wisdom from successful script partners, is a very good place to begin. To give yourself a head start—and maybe a leg up.

So You Got In!

Great! Congratulations. And we hope your collaborative skills played a part. But you're just getting started, because you're going to encounter a variety of collaborative writing paradigms in school, depending upon the program you're attending.

Choosing to Write a Feature With a Partner

Not every scriptwriting program allows this. UCLA does not, Professor Richard Walter, Screenwriting Chairman of the School of Theater, Film, and Television, tells us in an email: "We discourage collaboration among writers in our school. There's nothing unworthy about collaboration, but we also want to support writers in developing their own unique voice. That said, there is some collaboration that occurs, usually in conjunction with production courses where an actual film is being produced. In the relatively rare instances where students do collaborate, they must form their own teams; we do not put the teams together."

Across town, USC took the same position—until Jack Epps, Jr., arrived in 2001.

"When I came here, co-writing wasn't done," Epps says. "And being a collaborator, I thought we should do a little bit of this. But here the basic philosophy is first build yourself as strong a writer as you can, that you need to be a really good writer. So collaboration is not where you should start. Collaboration is something you should consider. So we have a class where they can collaborate—and it's called Collaboration—so we do have that, but not for thesis projects because it becomes, 'Then how do we grade this? Then who's doing what?' But we do encourage it, and we also say, 'You've got the summer, go collaborate with somebody. And collaborate afterward.'"

When we interview Epps, he tells us that his most recent Collaboration class had eight self-selected teams, and each team worked on their own feature screenplay.

"One thing about USC is we're a 16-week semester, which is really great for writing a feature because it gives you time to develop an idea, to write a really good treatment and outline, then to do a little polish. To go through and do a cleanup draft at the end."

On the first day of class, Epps focused on how the students could screw up their script partnership.

"I talked about how to destroy your collaboration. 'Here's how you can ruin your collaboration!' And I have a list, with ego being at the top. Second is 'It's my idea,' 'No it's *my* idea.' You know, keeping score. And resentments. All those sort of simple things. Like any relationship gets destroyed because— We would call it a marriage, and a collaboration is a marriage of a sort because you're very tightly married together. And if you

don't have respect for the other person, it will collapse. It will turn into a very bad situation. I think by scaring the hell out of them the first class, they were much more respectful. I noticed that even when it was going south, they were still trying to not show it in the class. Because they didn't want to show that they were the one that was predicted to fall apart."

He also emphasized the business side of being script partners.

"They came into class as a pair. I had them sign an agreement between each other that they're a writing team, so it's clear what you own, what you don't own. In other words, you're doing this together. Because students are interested in marketing their product, and stuff happens with teams. Not every team got along. Some of them fought, and they were bad teams. It just wasn't a good marriage. But they still owned the property together. It also helps get their minds straight. They've got a partner here, and it's 50–50, and it's a collaboration, and it's a business deal."

And he took their script-partnership pulse early in the semester.

"I did have them check in, on the side, at the very beginning. I had them contact me to tell me how their collaboration was going. 'What's going on with your partner? How is the communication going?' And there were some problems, and I'd say, 'Okay, have you done this?' Trying to get them to communicate. So they could talk to me and complain a little bit, and then I'd say, 'Well, here's a strategy how to maybe work that out.' Without me stepping in the middle of it because that would hurt that relationship that was burgeoning. I was more their therapist."

In spite of being warned about how they could sabotage their partnership, signing an agreement, and going to Epps for counseling, some of the teams still fell apart. But the majority flourished and loved the class, and the quality of their scripts was better, due to the advantages of working together.

"A team just really can get there faster," Epps explains, "and they can cut to the good ideas faster because it's really clear what's working and what's not. If there's a good balance to the team. I think that's what makes a good team—you balance each other out. You can sort out the wheat from the chaff very quickly and say, 'Okay, this is the working idea.' And I think with a team, you're more willing to throw things away. You can discard things easier. There's less investment. I think when you're home writing and you're working on something, people get so deeply invested because 'I've written all this stuff, and now I'm invested in it,' and I think they continue to write a bad idea. Where with a team you'll say, 'That's not working' and 'Okay, we'll throw that away.' And then you'll work on something else fairly quickly."

A great benefit given the time limitations of semesters—and especially quarters—in academe.

Dysfunctional teams in Epps' course couldn't do this because they hadn't created "an environment of trust," to borrow a phrase from Patrick Massett. But the teams that had created this trust could quickly knock out bad ideas and work on good ones, and as a result knocked it out of the park with their finished features.

"They did some of the most amazing work I've had students do here," Epps says. "Because of the collaboration. And it was amazing the level they took each other to, and because of it, the standard within the room went another notch up higher."

And their success as script partners continued beyond Epps' course. "Collaborations came out of it. Long-term collaborations have come out of it."

Choosing to Write a Short Script With a Partner

When we started teaching at the FSU Film School, the program didn't allow students to co-write their screenplays. The hesitation was similar to USC's—"How do we grade this? Who's doing what?" But over the years the thinking has changed, and co-written scripts are now allowed, even encouraged.

The main emphasis at FSU is the short film because the Film School pays for all the production costs but limits the number of pages and minutes for each script and finished film. Co-writing scripts allows students to double their pages and minutes and budget, so "doubles," as the writing teams are called, are growing in popularity.

The benefits are not only financial but also creative, especially when the student script partners "balance each other out," as Epps says.

In 2009, FSU graduate student Akil DuPont learned the value of this balance. As he explains via email, he had a unique concept for his thesis film, *Underground*—"a slave story told through song." But because his prior student project had been less than successful, he was determined not to repeat the same mistakes.

"At the time, I was not a strong writer," he says. "The failure of my previous film in the Film School was due to the weak writing in the script. I knew that if I was going to take this good idea and make something out of it, I needed to have a good blueprint, and that meant I needed help with the writing."

DuPont decided to look for a screenwriting partner, "a co-writer to bounce ideas off of and flesh out the story." After a search throughout the Film School (and advice from his screenwriting instructor), he selected BFA student Ariya Watty because he felt her interests and writing style were in line with his concept.

"Our personalities meshed, and she understood the vision for the project immediately," DuPont says. "As Ariya and I began to wrap our heads around the story, we chose to use the classic three-act structure, which Ariya was very comfortable with."

Once they had the script's structural pylons in place, DuPont & Watty created bullet points for the story, fleshed out those beats into a treatment, and eventually expanded their treatment into a script.

"As we moved forward, my main focus was the weaving of the songs into the narrative," DuPont says. "Ariya's main focus was structure, heart, and dialogue (although we both had input in each other's focus). I wrote/

adapted the songs and would give her the notes. She would go back to the computer and execute our shared vision."

But that was just the beginning of their work together. They workshopped the script with classmates, faculty members, "and anyone who would listen/read it"—and ultimately created 14 drafts of the script before production began.

Their tireless efforts—and harmonious collaboration—paid off, as *Underground* became one of the most screened and lauded films in FSU's history. "The project ended up winning 21 awards in 28 film festivals, including two Student Emmys, so I think we hit our target."

Since graduation, DuPont has forged a career as a filmmaker, university instructor, and head of his own production company. But he continues to embrace the many advantages of working with a partner.

"Even now, as I have grown quite a bit as a writer since 2009, I still find co-writing and collaboration to be quite beneficial. When you have a partner in your writing—for development, giving notes and feedback, research, etc.—at a minimum you get another set of eyes on your work. And after you've looked at it for hundreds of hours, they can provide a fresh perspective and outlook. They can see things that you can no longer see. They can see new possibilities, new potential story paths, or prevent you from making a fatal mistake."

(For a more detailed description of their co-writing process and the final script for *Underground*, see the fourth edition of Claudia's *Crafting Short Screenplays That Connect*.)

Being Paired With a Partner

Sometimes you don't have a choice. You just don't. Like it or not, faculty members may pair you with a writing partner for one or more of the following reasons:

To bolster your writing skills

Professor Evan Smith of the Television, Radio & Film Department at Syracuse University tells us in an email, "When projects call for students to write in groups, sometimes we let them select partners, and sometimes we select based on complementary talents."

That way, a partner can help shore up your weaknesses, as Ariya Watty did for Akil DuPont while co-writing *Underground*. And you can return the favor with your own particular writing strengths.

To bolster the quality of the work

Eric R. Williams, Associate Professor of Screenwriting and Producing at Ohio University, says via email, "Many of our television writing classes require the scripts to be written in two-person teams" and "tend to put the teams together (once the students have chosen the show they want to write for)."

And similar to Epps at USC, Williams believes the quality of their student work has increased, especially in TV classes.

"For television I find that this makes for a tighter script," Williams says. "They hit their marks, they pay the story off when it needs to be paid off, the act breaks come just where they are supposed to. I think that writing teams seem to hold one another to certain expectations, rather than getting lost inside the story."

To bolster your collaborative skills

Evan Smith at Syracuse also says that faculty members pair students for writing projects because of "a desire to have them bolster their people skills by requiring that they learn to 'play nice with strangers.'"

Or with strangers in a strange land, in the case of National University in Los Angeles. Wanting to promote intercultural communication, sensitivity, and collaboration, the faculty created a cutting-edge course titled Cinematic Storytelling Across Cultures.

"It was an online international course, and students from Australia and the U.S. were paired as writers," Bettina Moss, Associate Professor and Lead Faculty for the MFA in Professional Screenwriting Program, explains in an email. "Their major assignment was a co-written treatment for a feature film. We plan to offer this course again in the future and will find international partner universities whose students would be a good fit with ours. We would then adapt the course in part to reflect the culture of the partner university and then have the U.S. and the partner university students paired and again deliver a co-written treatment."

And lest you think you won't be paired in writing partnerships outside academe, we have two words for you: "paper teams." A growing and disturbing trend in the entertainment industry, paper teams are two writers—usually inexperienced—who are forced by producers/companies to work together and split the pay. As we write this edition, the WGA is taking a strong position against this unscrupulous practice, and we hope paper teams will soon be a thing of the past.

The point is, partnerships put together by others ("arranged marriages," if you will), however well-intentioned—or ill-intentioned, in the case of paper teams—can be tougher to maintain than those put together by the partners themselves. So to make these collaborations work, you'll need the insights, wisdom, advice, and strategies of the script partners in this book. And we hope *Script Partners* helps your "marriage" as well, for as long as you both shall co-write.

Non-Pair Paradigms

Not all your writing collaborations in school will be two-person teams. The more may be the merrier in the following scenarios:

Workshops and Table Reads

Many scriptwriting classes are run as workshops—with or without table reads—and the most productive ones, in our experience as writers and teachers, are collaborative in spirit. When we teach solo or together, we try and keep the critiques in our workshops constructive and focused on one common goal—helping the writer strengthen the screenplay.

CLAUDIA: I ask students to tell the writer what is working for them in the script and what isn't. What is clear or unclear? This may be the most helpful feedback of all. What's strong and what could be stronger? They must be specific or it just isn't helpful.

MATT: If you're the writer, don't be defensive. Just listen. Be open to everything people say, no matter how crazy it might seem at the time.

CLAUDIA: Sometimes the note you dismiss turns out to be the key to your script. So take notes as people respond. Or record it.

MATT: And listen for consensus. If a lot of people are giving you the same note, you should probably give more weight to that feedback.

CLAUDIA: But run the responses—consensus or not—through your own creative filter and incorporate the notes that resonate with your artistic vision and dramatic purpose.

Maintaining an open, collaborative mind during a critique of your work is not always easy.

"Most students have a lot of problems with getting critiques and taking it personally and feeling that they're being attacked, as opposed to the work itself being critiqued," Jack Epps, Jr., says. "But the writers get an opportunity to improve it, so I think there's a lot of growth that happens there."

And if you're arranging a table read of your work, it's most beneficial and educational to bring in actors to read the script, as they often do at USC.

"We've worked with the School of Dramatic Arts and use some of their students to come in and give a read," Epps says. "That's really very informing because actors will interpret, and they will create a character, and they will play a character as opposed to just reading lines. They will perform, and that's a very different thing. And it's also interesting because sometimes they'll interpret a role not the way you wrote it. But that's interesting too because you see what happens if you don't have a lot of clarity or guidance to your writing, or your character is not fleshed out enough. They can get hijacked very easily."

So as you listen to a table read and your colleagues' critique, remember that constructive criticism is a gift to the writer. Your purpose is to create a script that works—and connects. To do this, you need other people.

The Writers' Room

And constructive criticism is a gift to the writers' room—a collaborative paradigm often emulated in TV writing courses. Which are growing in number and popularity, a reflection of the rapid increase in original episodic television production today.

For example, Evan Smith of Syracuse University says, "In our program, writing and producing students write either alone or as part of a group of several people, replicating the roundtable writing process often used in the industry."

Christina Kallas, Adjunct Professor at Columbia University School of the Arts Film Program, tells us in an email, "I am teaching a course called Production for Television: Inside the Writers' Room, which is focused on collaborative writing in a writers' room."

USC also believes in the educational benefits of a writers' room environment.

"I think it's a great educational tool because people get to hear other points of view," Epps says. "You realize there are other perspectives. And I think it helps to flex your creative muscles—to look outside just your first thought, to realize there are other solutions to problems besides your own. So I think it helps to get rid of preciousness also, which is a great danger for all writers. [Laughter] You begin to learn that your words are good, but they're not the only words. You learn that there are more ideas than your own, that people who know story and character can help you develop your idea."

It's also where you learn to engage and contribute.

"Your personality plays a bigger role in a writers' room than people might understand," Epps adds. "Because you're basically getting married into this family for a long period of time. And they've got to be people you want to be with, who are collaborative and will contribute, and when it's really late and everyone's exhausted, will come up with a new idea."

Like Massett & Zinman, Epps emphasizes that any sort of writers' room must be a positive environment.

"You have to create an atmosphere where people feel free to throw anything they want out and they're not going to be massacred for it. Because that opens up possibilities, and people take chances with ideas. There are no bad ideas, there's only the better, the best idea. I think that's the key thing."

So you have to learn not to be a destructive critic, a "no" person, or an asshole.

"You'll nip creativity in the bud if you have a critical environment," Epps says. "If somebody is being a little too critical or a little too nasty or just out of line, they'll be taken aside and told, 'We don't do that here. Find a supportive way.' You know, to create that environment. It takes a lot of courage to throw an idea out in the middle of a room full of people, but then the more you throw them out, the better they get because you start to realize the ones that stick, you want more of those."

USC students work together in the writers' room to hammer out a season story arc and break it into episodes. Individuals or teams may then choose the episode they want to write, or the instructor may assign one.

If your program, like USC's, gives you the opportunity to develop, write, and hone a script with the help of a writers' room, you'll end up with an invaluable calling card—a polished spec you can use to break into the exploding episodic industry.

Sketch Comedy

In USC's sketch comedy classes, writing students collaborate on a live *SNL*-style show they produce three times a semester.

This fast, furious, and funny show is only part of USC's serious commitment to comedy training. In the fall of 2010, Jack Epps, Jr., formally announced "a new concentration of interdivisional classes with a comedy emphasis, called *Comedy@SCA*," according to USC's *In Motion*. As "the inaugural holder of the Jack Oakie Endowed Chair in Comedy at the School of Cinematic Arts," Epps vowed to create "a unique environment where students can come to study, find their comic voice and hone their skills in writing, performing and directing comedy." This includes film, television, and interactive media.

The students collaborating on the live show quickly learn that sketch comedy is about survival of the funniest.

"Sketch comedy writing is very Darwinian," Epps says. "Best joke wins, best sketch wins, and best idea wins."

And the weaker ones go the way of the dodo.

To achieve the best joke/sketch/idea, students bring their jokes/sketches/ideas to the table.

"Just throw it in the room, and everybody tries to punch it up, tries to get more jokes in, do what has to be done," Epps says. "I don't care who you have to kill. I don't care what you've got to steal. You've just got to have the best sketch going for that show because as we get closer to showtime, everybody gets more desperate for more funny. You can't be too funny. No one's ever said, 'No, we won't do this sketch. It's way too funny. No more jokes here.'" [Laughter]

And because a joke's success can live or die on timing and delivery, table reads with comedy actors are crucial to the rewriting process.

"The rhythm on the page is very different than the rhythm that the actor will portray it," Epps says. "They're two entirely different things.

And that's one of the advantages of table reads. Table reads with actors are really good. Table reads with writers, not so good." [Laughter]

As students start staging sketches (getting the show "up on its feet"), the writers have more opportunities to polish and punch.

"Once the sketches get mounted by the actors, we get to see them, we get to hear them, the writers get to hear the sketches, they hear what falls, what doesn't fall, and they go back and rewrite it. And it gets mounted again, and it's very much an up-on-its-feet kind of thing. Then they look at it again, and they see, 'Okay, no, this isn't working, gotta go back.'"

That tuning and retuning doesn't stop until they go live in 3 . . . 2 . . . 1 . . .

"Look, you're rewriting up until right before showtime. You're putting a line here, a line there, and you really get to see the material played. It's a lot of fun, and it's great when it comes together. What's great about working in live television is when it's done, you walk away."

You're About to Walk Away and Enter the Industry

Great! So are thousands of others. We hope you've been building strong relationships in your school/program and developing your collaborative skills—*because all relationships in the filmmaking business are collaborative.*

Yes, for writers too. If you're lucky enough to work as a professional scriptwriter, you'll be collaborating with producers, directors, development execs, showrunners, etc. So before you graduate, look around your school—your fellow classmates are your potential employers or co-workers.

Or co-writers.

Even if you don't experience any of the collaboration paradigms we've discussed or if co-writing isn't encouraged or allowed at your school, academe is still the place where you might encounter your perfect future script partner.

Jurassic World director Colin Trevorrow met his longtime writing partner Derek Connolly while they were both students at New York University's Tisch School of the Arts.

"We were in a comedy writing class, where we thought the other was funny," Trevorrow tells *Blast Magazine*. "That kind of thing can immediately draw you to somebody else. You sort of see through everyone's sensibility. Like, I just get that guy's sensibility, but it's different enough from mine that I think it could be a good combination."

Because of that shared sensibility, Trevorrow & Connolly soon became friends (while also working as interns for *Saturday Night Live*), but they didn't start co-writing feature scripts for another ten years.

"Until then we'd just been friends, and had read each other's stuff," Trevorrow says at BleedingCool.com. "We had done a TV pilot

[*Gary: Under Crisis*] together with a third friend of ours from NYU, which is the thing that got us agents and managers."

But then Trevorrow started working as a solo screenwriter and eventually moved to Vermont. He wasn't satisfied, however.

"I really missed the creative energy I had from being in the city and working with somebody else so I called up Derek and he had this great idea for a buddy cop comedy called *Cocked and Loaded*. The two of us got together and wrote it together and it was the most fun I ever had writing anything. So I basically just broke up with myself and joined a band—a reverse Phil Collins."

Trevorrow credits Connolly's "unbelievable comedy mind" for helping to elevate their collaborative work.

"The stuff that comes out his mind is just ridiculous," Trevorrow says. "When we did *Cocked and Loaded* the reason it worked was that it had the momentum and the set pieces of a real buddy cop movie yet it was also shockingly hilarious. All of the hilarity comes from Derek. We have these really different skill sets that when you combine them, it goes to a different level than either of us are capable of."

Their career has also gone to a different level, from their low-budget indie hit *Safety Not Guaranteed*, which screened at the 2012 Sundance Film Festival, to the brontosaurus-sized blockbuster *Jurassic World* (they share screenplay credit with husband-and-wife team Rick Jaffa & Amanda Silver).

Scott Alexander & Larry Karaszewski also met in film school—the first day of their freshmen year at USC (years before Jack Epps, Jr., arrived). The two film majors became roommates and friends long before they became collaborators. Four years later, on a cross-country road trip during summer vacation, they were inspired—by Ann Landers—to write their first script together.

SCOTT: She was running a series of columns about a kid who was vandalizing a high school gymnasium. He'd fallen through the roof while committing the crime and had gotten paralyzed when he hit the ground. And his parents had sued the school district and won—they won a couple million dollars. So I mentioned this to Larry, and we started laughing about this tragic story, saying, "That would be a funny movie if it weren't some poor kid but some really slick thief, like a Morris Day kind of a guy."

Morris Day? Obviously, this was the 1980s. Like, totally.

The idea stuck with them. When they returned to USC, they started writing together two to three hours every night. Their goal of finishing a feature-length screenplay was unusual among their fellow film students.

LARRY: We weren't encouraged to write full screenplays. You were supposed to write the first 40 pages, or come up with just an idea.

SCOTT: So we had no ulterior motive in deciding to write the script. It wasn't like we thought we'd write it, sell it for a lot of money, and break in. It was like, "Hey, we don't know anybody who's written a whole script. I wonder if we could." We figured it was something none of our friends had done. "If we can get to page 120, wouldn't that be cool?" That was really it—it was just a goofy lark.

That goofy lark—a crime caper called *Homewreckers*—sold to Twentieth Century Fox for $300,000 one week after they graduated.

You might even discover a potential writing partner among the faculty members at your film school or writing program, as Jack Epps, Jr., did when he was a young filmmaker and student at Michigan State University.

"I figured if I wanted to make movies, I needed to know how to write movies," Epps says. "They had a communications department there—not much. I was a creative writing major, and they had one screenwriting class. It was taught by Jim Cash, and the class was full, so I talked my way into the class. That's how fate sort of works, you know what I mean? Jim was older than me, and he had a job at the local television station. He was a producer writing a lot of shows and much more experienced. He actually knew what script formatting was. [Laughter] That was really exciting. 'Wow, you know about script formatting!'"

Cash & Epps soon struck up a friendship and started reading each other's work. Epps then moved to California, and while working with another partner, he sold a script for the original *Hawaii Five-O* TV series.

"Yeah, I got to write, 'Book 'em, Danno.' [Laughter] It was actually fun to be able to do those things. So when Jim heard I'd sold something, he called up and said, 'Hey, we should write together.' Some time went by because I wasn't really looking for that, but I went back to Michigan to pick up some artifacts, and I decided to look Jim up. We sat down and sketched out ten ideas that might be good movies for us to write together."

But none of those movie ideas clicked for Epps—until he was driving back to California.

"This is how creativity is. Nothing really stuck with me. I said, 'I don't really see anything here.' And halfway across the country, I'm in the middle of Montana or something and went, 'Oh, that's what that— Oh yeah, I get it! I see what he was talking about!' And then we started what was a two-and-a-half-year process of writing multiple, multiple drafts of this project, until it got to a level that I thought we could enter the industry with it."

Six screenplays later, Cash & Epps did more than enter the industry—they stormed it, with such high-profile movies as *Top Gun*, *The Secret of My Success*, *Legal Eagles*, and *Dick Tracy*.

We can also personally attest to a film school being a rich environment for finding the right writing partner. We decided to write together when

we were faculty at the FSU Film School—even though we *hated* each other the first time we met. But we'll save the story of our improbable connection for the next chapter.

"Connection" is the operative word as you enter the industry. The Hollywood adages are true: "It's who you know," "It's all about relationships," and "Be nice to everyone, even the assholes." Your reputation and your collaborative skills are even more important now as a jobseeker. People in the biz look for people they want to work with because they know that better collaborations equal better work—and more fulfillment from the work.

Chad & Carey Hayes agree.

CAREY: It's not just writing. It's building blocks. It's relationships. Every step of the way.

He and Chad were on location in North Carolina for the entire shoot of *The Conjuring*, directed by James Wan. And the brothers started hosting Sunday oyster fests for the cast, crew, anyone who wanted to attend.

CAREY: It turned into a big, fun, great way for everybody to connect before we started work again on Monday. One of our producers had a friend that was doing another movie there at the same time, and the guy came to our place. He looks at everybody and goes, "This is fucked up!" We say, "Why?" And he goes, "You guys all get along so great. My movie *sucks*! Everybody hates each other." [Laughter] It should be fun. What the writing process has brought to us is this enjoyment—being on location, interacting with the actors, producer, director, and so on.

CHAD: That whole experience of *The Conjuring* was *the* most positive experience we've ever had. Lili Taylor [who plays Carolyn Perron] told all the young actresses, "Remember this. It's not always like this."

Plus, the better the collaboration, the longer it tends to last. That's why there was so little turnover in the *Friday Night Lights* writers' room, according to Patrick Massett & John Zinman.

PATRICK: It was fun. It was like everybody kind of entertained each other. It was a family. And John and I are always wondering if we're ever gonna have that experience again.

JOHN: I had a very, very strong feeling when *Friday Night Lights* ended of "this may never happen again." And "really note this because truly this may never happen again." I hope that's not true, but I am very aware that it's possibly true.

PATRICK: Not to say we haven't had great experiences with other writers on other shows since then, but that was really special.

JOHN: It was special.

PATRICK: I think "special" is a fucked-up word because it doesn't really exist, like a unicorn. But this was a unicorn. [Laughter]

So the better your collaborative skills, the better your reputation and the better your chances for success in the biz—and the rest of your life, as we said when this chapter began.

"Once you learn the art of collaboration, I think you realize that that's what filmmaking is really about," Epps says. "Once you've learned the art of collaboration, then you can do it throughout your life. I mean, you collaborate in many, many different ways, in many different areas of your life. It's something that is a valuable tool. It allows you to work collectively with people."

Which is where we came in: "It's a life lesson—collaboration."

And this is where you go out as you leave academe.

We ask Epps what advice he gives their scriptwriting students when they graduate, and his answer has the wisdom and inspiration of a great graduation speech:

> "The advice we give students is that you have to have a passion. You've also got to have a long-term perspective on this. And the people who succeed in the business are the ones who know this is their life's calling. This is what they're put on the planet to do. And as long as you're willing to put in the hours and the time, opportunity will come your way. But the key is you must be prepared when opportunity presents itself. Because opportunity is hard to recognize when you see it, and when it's there, it happens very quickly. So preparation is essential. You can't sort of fake it. You've really got to know it, and the only way to know it as a writer is by doing a lot of it.
>
> And I think you can't just take a single approach. 'I'll write my script and that's my ticket.' No, probably not. [Laughter] You have to go in different areas and cover a wider area to help promote yourself.
>
> So much of media and entertainment are online that it behooves people who are going into the industry to be working in these areas too. Look, everybody has a different goal, and it's important to figure out what your goal is, what you want to accomplish. Then drive to that with every ounce that you have.
>
> I also think that the web is an interesting place to post ideas to. If I were involved in starting my career

right now, I'd be making web series. I'd just be shooting web series on the weekends with friends. Just getting it out there. That's really essential. And funding comes from all different sorts of places—they'll pay on YouTube if you have a certain number of subscribers. There are also places like Vimeo, which has funded its own original programming. I think for a young writer especially it's a way to get your material out there. It's a way to also see how the public responds to it."

So regardless of what letter grades you've received in school, *ahem*, you should remember these seven Ps as you enter the industry—Passion, Purpose, Perspective, Preparation, a diversified writing Portfolio, Promotion, and of course Perseverance:

> "The key is to believe in yourself and to give it everything you've got. And writing is a 24/7 job. You're always writing. I don't care what you're doing, you're always writing somewhere in the back of your mind. Because you're a student of people. You understand psychology, you're interested in that, you love behavior. It's one of the great things about being a writer—the whole world is your research lab. But you have to have a passion, and you have to stay at it."

Now go forth and collaborate with the world.

Script Partner Points

- It's never too early to work on your collaborative skills, especially if you want to apply to film schools or scriptwriting programs.

- Once you're in, develop and deepen your skills as a collaborator by co-writing a short or a feature, as part of your program or on your own.

- If you get to choose your script partner for a writing project, look for someone with similar sensibilities and complementary strengths.

- An "arranged marriage" is trickier, so if a faculty member pairs you with a writing partner, review the advice in Chapter Four about maintaining a healthy, productive, creative relationship.

- During workshops and table reads of your scripts, listen to comments with an open mind. If you're giving feedback to classmates, keep it constructive and focused on helping them improve the script.

- Take advantage of episodic and sketch comedy writers' room courses. They prepare you for a successful TV writing career by training you to be a positive, engaged, and creative collaborator.
- Establish close ties with your classmates. They may be your future employers, co-workers, or co-writers.

- Remember the seven *P*s as you enter the industry—Passion, Purpose, Perspective, Preparation, a diversified writing Portfolio, Promotion, and Perseverance.

> "Actually, none of us on this planet ever really choose each other. It's all quantum physics and molecular attraction. There are laws we don't understand that bring us together and break us apart."
> —Annie Savoy (Susan Sarandon), *Bull Durham*

THREE

Finding the Right Writing Partner

Matt Manfredi mops up the iced tea he's accidentally spilled all over our table—and his lap. The waitress at Canter's Deli in West Hollywood returns to our booth with a stack of napkins and a fresh glass of tea.

"Try to keep this one on the table," she wisecracks over the racket of clattering dishes.

We crack up.

Manfredi is a good sport, but still red-faced from his *faux pas,* he lets Phil Hay answer our question about finding the right writing partner.

"It's such a big deal to throw your lot in with somebody to do this," Hay says. "And it's so hard to break up collaborations. I guess the advice that I would give to people who are considering collaboration is—it's really great if you find the right person."

But how do you do that?

It's a question many writers have asked us since we started our collaboration, and a question we've asked many collaborative writers. But it's a little like asking how you find a friend or a lover or any significant other. Collaboration is an intimate creative relationship, and whether you're looking for a partner to co-write a particular project or someone to share a writing career, finding the right person is a mysterious process governed by "laws we don't understand," as savvy Savoy says in *Bull Durham*.

We certainly don't understand the laws that brought us together as script partners. We consider it a Christmas miracle that it happened at all. As mentioned in Chapter Two, we *hated* each other when we met on the faculty of the FSU Film School.

CLAUDIA: I didn't hate you. I just thought you were a moral slime ball.
 [Laughter]

MATT: Over lunch one day, I made the mistake of telling Claudia and other faculty members about a freelance writing job I'd accepted for a "funny documentary" about nuclear waste—funded by the nuclear waste industry. And Claudia said in a high-handed way, "Ah, so you're in bed with the Devil." *Ouch.* I was so pissed I refused to share the sidewalk with her on the walk back to our offices (what, me petty?). I crossed the street, hung back, and sulked to my office thinking, *I can't stand her!*

CLAUDIA: But many months and doc drafts later, you discovered I was right.

MATT: Yeah, bigger *ouch*. It turned out the producers wanted me to write nuclear waste propaganda.

CLAUDIA: Which is about as funny as—

MATT: Our faculty meetings.

CLAUDIA: Mind numbing.

MATT: Soul sucking.

CLAUDIA: But otherwise fun! [Laughter]

However, in the midst of our mind-numbing, soul-sucking faculty meetings, sitting on opposite sides of the room because we couldn't stand each other, we both began to notice that we offered the same notes about student scripts and had similar sensibilities about what makes a good story. It was there that we said to each other for the first of countless times to come, "Hey, get out of my head!"

We gradually let our guard down, and Matt even felt comfortable enough to share a problem he was having with a feature script he was writing. A producer in L.A. had just optioned the project and was demanding changes to the third act. Claudia gave Matt some helpful notes—another beat in our improbable connection. So maybe it was safe to try lunch again. CUT TO:

A local greasy spoon where we became regulars and the waitresses knew our names and standing orders. Over heaping portions of collards and cheese grits, we started swapping story ideas.

CLAUDIA: I wanted to write a screenplay inspired by my experience as an expert witness for the defense in a criminal obscenity trial in Tallahassee (a local mom-and-pop video store had been busted for renting gay porn), but I didn't want to write about myself.

MATT: So over a series of lunches of deep-fried everything, we developed fictional characters and a framework for the script.

CLAUDIA: We discovered how much we liked the process of working together—and each other. And we both loved the story.

MATT: Claudia asked me to officially co-draft the courtroom drama. We figured each of us could bring a certain important perspective to the material (though no, I've never done gay porn).

CLAUDIA: I had the First Amendment and courtroom experience, but Matt was a more experienced screenwriter and a real taskmaster about our work habits. I call it his "steely fiber." [Laughter]

MATT: And our long, happy collaboration was born.

Collaboration Happens

"I don't know that anyone ever goes shopping for a collaborator," said Fay Kanin, who along with husband Michael co-wrote *My Pal Gus*, *The Opposite Sex*, and *Teacher's Pet*, an Oscar nominee for Best Original Screenplay. "Maybe they do, but not in my experience. Generally, it happens. It comes out of friendship, or someone puts you together with someone, and it works."

The collaboration of Woody Allen & Marshall Brickman began when someone put them together—and boy, did it work.

"We both had the same managers, Rollins & Joffe, who had developed Nichols & May into, well, Nichols & May," Marshall Brickman tells us over brunch in Manhattan.

As Allen's career took off and he started using more material for TV appearances, the managers suggested that he and Brickman give co-writing a whirl.

"So we started. Very formal, guarded. All business," Brickman says. "At first it was writing material for his act, then we tried a movie, a few TV specials. Woody had already done a few movies, collaborating on the scripts with his old friend Mickey Rose. I'm not sure what happened—this might have been around the time Mickey moved to California. So we tried a screenplay, which nobody loved, which is in a drawer somewhere—don't ask me about it because I'll never tell. And then we wrote *Sleeper*."

The rest is film history—*Annie Hall, Manhattan*, and *Manhattan Murder Mystery*.

But most of the writing teams we've interviewed were not put together. They've evolved out of close personal relationships. Friends and lovers and family.

Friends and Friends

"We were friends and started writing together," Andrew Reich says of his collaboration with Ted Cohen on *Friends*. "We knew each other so well. And that's crucial."

They became best buds and roommates at Yale, but they didn't start writing collaboratively until they were living on opposite sides of the country. After graduation, Reich went to L.A. and became a book agent, while Cohen went to Harvard and became a law student. Neither was happy with what he was doing. Reich eventually left the agent business ("I quit/ was fired," he laughs), and in 1993, Cohen took a break from his studies.

ANDREW: Ted said, "Hey, I'm gonna come out there for a vacation. Why don't we write a script?"

Reich suggested they take a whack at a spec for *The Simpsons*.

TED: It was just like, "Sure, what the hell." Not really expecting anything to come of it, but, "Yeah, why not?" We just wanted something to show to our friends that would make them laugh and make us laugh, and it was really for fun. It was so lovely.

Reich & Cohen never considered a career as co-writers until the first draft was finished. And no one was more surprised than they were that it didn't suck.

ANDREW: We thought, "This is actually pretty good. Wow, this is pretty funny. This could maybe get us an agent, and we could maybe try doing this for a living."

An accidental collaboration.

"You have to stumble into it," Scott Alexander tells us, "just like you have to stumble into your own style."

Sometimes that stumbling involves alcohol, as in the case of Patrick Massett & John Zinman.

"We were drunk," Massett recalls, laughing. "I'm not fucking kidding. John had sold a feature script. I had sold a feature script. I was just about to send my script out, and I had John read it, and he gave me some notes that were— I didn't use any of them. [Laughter] But he was very helpful. And my script sold, and so he said, 'Hey, man, we should go out and grab a drink.'"

They did—several, in fact. And while toasted, the two friends—who knew each other from working as actors in the theater—developed an idea for a science-fiction script.

"We wrote it, and people didn't really like the script, but they liked the writing," Massett says. "And that got us to [producer] Larry Gordon, who was over at Universal. We wrote a script for them that they absolutely loved. At the time, it was like a $250 million budget. Nobody had gone that high yet, so it was too much. But they said, 'What do you guys want to do next?'"

When we interview writer Charles Gaines at his "writing shack" in Nova Scotia, he tells us how his screenwriting partnership with Ethan Hawke began.

"We met years ago and got to be friends. And then— I had just read a book by David Roberts about Geronimo and the last days of the Apaches, and I had been struck with what a tragedy and fascinating many-layered story that was. And how it had never been told. So I sent this book to Ethan and I said, 'Read this.' And I didn't suggest that we do anything with it. I just said, 'Read it and just tell me what you think.' And he called me up like two days later and he said, 'Chuck! We gotta do this! We gotta make this into a movie.'"

Cinco Paul & Ken Daurio met in the late 1990s during a production of a church musical and became good friends. They sold their first screenplay the following year, and their second screenplay became the 2001 cult favorite *Bubble Boy* with Jake Gyllenhaal.

"We were friends first, and becoming writing partners naturally evolved from that," they tell us. "We highly recommend that method of finding a writing partner."

All good collaborations don't evolve from good friendships (God knows ours didn't), but they often endure because good friendships evolve from the collaborations.

"These teams that have lasted, they have to also be great friendships," Harold Ramis insisted. "You've really got to want to spend a lot of time with someone because obviously you're not working eight hours. You're processing everything that happens in your life, in the news, in the world. It all gets in there somehow. That's a big part of collaboration—what you talk about away from the work. At Second City, Joe Flaherty, Brian Murray, and I used to start our day by having breakfast and reading the newspaper together. 'Did you see this? Did you see that?' Even when we moved from Second City to National Lampoon—that was me, John Belushi, Bill Murray, Brian Murray, Joe Flaherty, Gilda Radner—we'd call each other when we were watching TV and say, 'You watching that? Check this out.' Because everything becomes potential material, either the actual content or your response to what you're seeing. That's how you forge a shared point of view, by processing lots of other stuff and by sharing your past with everyone."

This is one of the first things Ramis & Douglas Kenney & Chris Miller did before co-writing *Animal House*.

"We constantly recited a complete oral history of our educational experience," Ramis added. "All the people we remembered from college, all the teachers, every amazing event, every apocryphal event, everything that our cousins, brothers, uncles ever told us about college. We didn't know if it would be relevant or not to what we were writing, but it is this information sharing that provides the background for what you write."

Love and Marriage

"*C'est notre rencontre qui nous a décidé à travailler ainsi et pas le désir de faire des films qui nous a fait nous rencontrer,*" Olivier Ducastel & Jacques Martineau say in their email from Paris. Since *nous ne parlons pas le français*, a friend translates for us: "It wasn't our desire to make films that brought us together, but rather it was our meeting one another that led us to make films together."

An aspiring director, Ducastel studied film as an undergraduate and wrote a feature, but he couldn't raise the funds to produce it. Meanwhile, Martineau—who teaches literature *à l'université*—wrote his first feature for some friends in the film industry, but he didn't want to direct it. When he and Ducastel met in 1995, it was *l'amour* at first sight.

"It was for us, first and foremost, a relationship as lovers."

Ducastel read Martineau's script *Jeanne et le Garçon Formidable* (*Jeanne and the Perfect Guy*) and offered to direct the film with him.

"We did it, it worked well, and we've worked together ever since."

It certainly worked well for their film *Drôle de Félix* (*Adventures of Felix*), which became a U.S. art-house hit and one of the most successful French imports of 2001. And their farce *Côte d'Azur* was an international favorite in 2005.

Fay & Michael Kanin—one of the longest and most successful collaborations in Hollywood—did not choose each other as writing partners. They chose each other as spouses, and they both fell in love with a story from *The New Yorker* called "Sunday Punch" about a boarding house for fighters. Convinced it would make a good film, they bought the rights to the story and decided to adapt it during their honeymoon in Malibu.

"We rented a house right on the beach—I guess that's when we first fell in love with the beach—and we wrote the screenplay on spec," Fay Kanin told us at, well, her beach house. "Then we sold the script. That said to us, 'Listen, you can do this.' We had each written separately. Michael had written a couple of the B pictures at RKO, and I was a reader, but I had written some short stories with another reader. I had not written a screenplay yet that I'd sold, so we said, 'This is it. We could do this together. We've got a career here.'"

Harry & Renee Longstreet (*Fame* TV series; *Alien Nation: The Udara Legacy*) also discovered a career together, one that evolved from their marriage—and the ghosts of marriages past. A few months after their wedding, Renee was struggling to write a screenplay while working five—yes, five—jobs. She couldn't stand the thought of financial dependence, as she tells us when we interview them at their home.

RENEE: I'd had difficulties with my ex-husband stopping paying. Then he'd pay sporadically, then he'd get behind. It was just a nightmare, and I would never again be dependent upon a man to support me and my kids. Ever.

But Harry thought she should devote herself to her craft, and he offered to pay her to write. Renee refused.

RENEE: I said, "I'm not ever going to let you support me. What do you think, I'm going to let you be my *patron*?" He goes, "No, just let me be your husband."

She accepted his proposal and threw herself into her scripts. She also let Harry read pages as she wrote them.

RENEE: He would come home at night from work, and he'd read what I'd written. And he'd start to say, "Well, what about if you do this? Or what about if you do that?"
HARRY: I started to noodle with it.
RENEE: And then he said, "Could I do that scene with the drama teacher?" So he wrote that scene. And then he tried to write another scene. And then another.

Their career collaboration was under way.

You and your writing partner don't have to be married, but it's important to think of your partnership "as a marriage of a sort," as Jack Epps, Jr., calls it—and not to be taken lightly.

"It's really a marriage," said Hal Kanter (*Move Over, Darling*; *All in the Family*; and 33 scripts for the Academy Awards, garnering two Emmys) over breakfast at Sportsmen's Lodge in Studio City. "And you'd better make sure you've got the right woman or the right man, depending on whether you're a woman or a man—but not necessarily today!" [Laughter]

Larry Gelbart (*Caesar's Hour*; *M*A*S*H* TV series; *Tootsie*) waved the marriage metaphor away.

"I will avoid the marriage analogy because it's tougher than marriage," he told us at his home in Beverly Hills. "Because there's no sex! [Laughter] There's no way to kiss and make up."

Unless you and your partner are married or otherwise romantically involved.

Still, Gelbart agreed in spirit with Kanter. "You really have to love the other guy/girl. You really have to."

O Brother (or Sister), Where Art Thou?

And then there's brotherly/sisterly love.

Obviously, you can't go shopping for a sibling, but if you are biologically blessed, perhaps you will join the growing number of Hollywood heavy-hitters who have kept it all in the family like Chad & Carey Hayes:

Joel & Ethan Coen (*Fargo*; *No Country for Old Men*; *Hail, Caesar!*), Jay & Mark Duplass (*The Puffy Chair*; *Jeff, Who Lives at Home*), Nora & Delia Ephron (*Michael*; *You've Got Mail*; *Bewitched*), Peter & Bobby Farrelly (*Dumb and Dumber*; *Hall Pass*; *Dumb and Dumber To*), Peter & David Griffiths (*Collateral Damage*; *The Hunted*), Albert & Allen Hughes (*Menace II Society*; *Dead Presidents*), Christopher & Jonathan Nolan (*The Dark Knight*; *The Dark Knight Rises*; *Interstellar*), Jill & Karen Sprecher (*Thirteen Conversations About One Thing*; *Big Love* HBO series), Andy & Lana Wachowski (*The Matrix* trilogy; *Cloud Atlas*; *Jupiter Ascending*; *Sense8*), Shawn & Marlon Wayans (*Scary Movie*; *Scary Movie 2*; *White Chicks*), Chris & Paul Weitz (*Antz*; *About a Boy*), and Jerry & David Zucker (*Airplane*; *Naked Gun*).

Chad & Carey Hayes are not only brothers but also identical twins and have loved movies since they first watched *The Wizard of Oz* at five years old. They became involved in drama and theater and wrote their first screenplay—about twins, naturally—while high school students in Lake Tahoe, Nevada. Not sure what to do with the script, the brothers hit up a famous neighbor, country singer and actor Hoyt Axton.

CAREY: We went and knocked on his door one day. His girlfriend opened the door, and we said, "You don't know us, but we've written a movie, and we want to talk to Hoyt Axton about it." And we heard this deep, bellowing voice, "Hey, guys, come on back." We got to know him very personally. He was an inciting factor in our career because he was very encouraging. He read our script, and he called us up and said, "I'm going to L.A. to pick up my band. Do you guys want to come with me?"

CHAD: "And I'll introduce you to anyone I run into."

CAREY: "My agent and other people." And we're like, "Yeah!" He had a tour bus—

CHAD: —that he got from Willie Nelson called The Honeysuckle Rose.

CAREY: And we jumped in—he and his girlfriend, Chad, and I—and drove to L.A. And we're like, "Oh, my God." Then we just got that taste of Hollywood.

Blessed with good looks *and* talent, the Hayes brothers started working as actors after moving to L.A., but they still continued to write. Then when writing gigs also came their way, they had an epiphany about their career.

CHAD: We realized we couldn't do them both at the same time. And so, when we were in our late 20s, we made a conscious decision to stop acting and just focus on writing.

That career focus paid off. Their spec screenplay *The Amulet*, which they describe as "sort of like *Harry Potter* before *Harry Potter*," garnered great attention even though it never sold.

CHAD: It got us a three-picture deal at Fox, and our first movie was with [producers] Larry Mark and Scott Rudin. We were so naïve that when we finished the script a couple of months later, Larry calls us up and says, "Okay guys, we're gonna put the movie in turnaround." And we go, "Great! What's that?" [Laughter]

And funny story . . .

No one in the Farrelly family thought the future *Dumb and Dumber* guys would amount to anything. "Peter and Bobby were a couple of screw-offs. A+ screw-offs," their father, Bob Farrelly, tells *Newsweek*. "But the family is so close. Mariann and I both tried hard, and I think the word is *love*. L-O-V-E."

Raised in Rhode Island, the young jokesters may have been L-O-V-E-D by their family, but they didn't find the school system so affectionate.

"Due to the fact that we were horrible students, we ended up going to a lot of different high schools," Peter adds. "My parents were afraid for us. 'What the hell's gonna happen to you?!'"

Despite the family's fears, the siblings ended up pursuing higher education—creative writing for Peter, geological engineering for Bobby. Initially, Peter co-wrote screenplays with fellow grad student Bennett Yellin, and for about two years Peter asked his younger brother for feedback on their work, since he trusted Bobby's story skills and comedic instincts.

"Finally after a couple of years of this, I felt like we were taking advantage of him," Peter says at RandomHouse.com, "because he was doing a lot of the work but he wasn't getting any credit, so we ended up writing a screenplay with him, and it was our best one. He just wrote with us from then on, and after a couple of years Bennett quit."

After selling two *Seinfeld* scripts and several screenplays, the brothers got their big break with *Dumb and Dumber* (co-written with Yellin).

Henry & Phoebe Ephron (*Desk Set*; *Carousel*), a successful screenwriting team in Hollywood during the 1940s and 1950s, *expected* their daughters to succeed as writers.

"If one of us said something at dinner, Father would yell, 'Write it down!'" Delia Ephron recalls in *Book* magazine.

Collaboration begat collaboration, though Delia and Nora had established solo careers before they ever started writing together. An essayist, novelist, and screenwriter (*Heartburn*; *When Harry Met Sally*; *Sleepless in Seattle*), Nora first joined forces with Delia, a novelist and journalist in her own right, on the screenplay for *This Is My Life*, Nora's directorial debut in 1992. The sisters then conquered the male-dominated Planet Hollywood with hits like *Michael* and *You've Got Mail*, before Nora passed away in 2012.

Living together in New York after college, Joel & Ethan Coen began picking up jobs from producers who needed low-budget scripts written and rewritten. That experience led to writing the script for their genre-bending indie *Blood Simple* in 1984.

Even at an early age, the Brothers Coen experimented with the film form, shooting Super-8 remakes of feature films. But as they say in *My First Movie*, that didn't reflect a strong desire to become collaborative writers/filmmakers.

ETHAN: It was another way of goofing off. I don't know when it got sort of serious for me. Certainly later than Joel, since he went to film school, and I didn't. For me it was more an opportunity that presented itself through Joel's work than any long-harbored ambition I'd had.

JOEL: But these things are sometimes just pursuing what might be a casual interest in the path of least resistance. Even the decision to go to film school. Something that strikes you at that moment as being a bit more interesting than something else. It's not as if you really know what you're going to do with it. Or if you're going to do anything with it.

ETHAN: Yeah. There are other people you read about like Scorsese for whom it seemed like a religion from an early age. It certainly wasn't that with either of us.

And then there's Alfonso Cuarón, who wrote *Sólo Con Tu Pareja* and *Y Tu Mamá También* with his *hermano* Carlos. But for the Hollywood blockbuster *Gravity*, he turned to his *hijo* Jonás because . . .

The Script Partner Doesn't Fall Far From the Tree

"I have a long history of collaborating with family," Mexico City native Alfonso Cuarón says in *The Hollywood Reporter*, referring to his two films written with his brother, Carlos. "And now [my son] Jonás and I wrote *Gravity*."

Alfonso was inspired by his son's ideas for the innovative space-set thriller.

"I was very intrigued by his sense of pace in a life-or-death situation that dealt primarily with a single character's point of view," he says in the press notes for *Gravity*. "But, at the same time, placing the story in space immediately made it more expansive and offered immense metaphorical possibilities."

"The concept of space was interesting to us both," Jonás adds. "It is a setting where there is no easy way to survive, thousands of miles from what we call home, so it was perfect for a movie about surmounting adversities and having to find your way back."

Gravity marked the father and son's first official collaboration, and they discovered that this familial bond kept their writing odyssey on course and helped them create the screenplay at warp speed.

"We have a language in common, and the story just developed overnight," Jonás tells *The Hollywood Reporter*. "We were sitting together one night; we started discussing concept, and over the period of that long night, we had pretty much developed the basic bone and the map for the story."

Alfonso agrees. "The plus side of [being family] is we have so many experiences in common that you just can go through shortcuts to understand each other. It's great."

Great, indeed. *Gravity* dazzled moviegoers worldwide and garnered ten Oscar nominations, including Best Picture, and took home seven statues.

With the mother–daughter team of Winnie Holzman & Savannah Dooley, it took someone outside the family—Holzman's screenwriter/director friend Robin Schiff—to help them see the wisdom of working together. Schiff "had been working with ABC Family for a while, and they were asking her to write and direct a made-for-TV movie about [the YA novel *Huge*]," Dooley tells *The Huffington Post*. "She wanted to direct it, but she approached me to try to write it—I was still in college at the time."

Dooley only had one TV writing credit, *What Goes On*. Still, Schiff admired and championed her work, and they pitched it together. Dooley got the assignment, but two years and several drafts later the network decided to make *Huge* a summer TV series instead.

"At that point Robin Schiff was running their show *10 Things I Hate About You*, so they were looking for someone to step up and helm the project," Dooley adds.

And Holzman already had major credits of her own, including *thirtysomething*, *My So-Called Life*, *Once and Again*, and the musical book for *Wicked*.

"I had thought it was an idea that my mom might maybe want to, but I also knew she had reservations about getting back into TV."

That wasn't Holzman's only reservation.

"I sort of felt like, 'This isn't my business. I shouldn't get involved,'" Holzman tells Writers Guild of America, West. "Robin woke me up and said, 'Wait, are you sure you don't want to do this with her?' I suddenly went, 'Wait, I do want to do this!'"

Which surprised Dooley, she explains to *The Huffington Post*. "I wasn't expecting it, but she ended up deciding that because it was such an interesting subject, because it would be a good chance for us to work together, that she wanted to come, and that's how we ended up in this position."

ABC Family ordered ten episodes of the series about teens at a weight-loss camp, starring Nikki Blonsky from *Hairspray*.

Desperately Seeking Someone

But what if you don't have a partner-worthy friend, lover, spouse, sibling, parent, or child? If you can't find a collaborator among the people you know, get to know more people, obviously.

If you're in college—or in film school or a scriptwriting program, as we said in Chapter Two—wake up and smell the collaborations! Ramsey & Stone took film classes together at Northwestern, Reich & Cohen did improv together at Yale, and Manfredi & Hay did improv together at Brown. Follow their successful example. If you're not already in film or scriptwriting classes, consider enrolling. Or take classes in drama or join a comedy/improv group.

If you're not in college, *nil desperandum*. Take continuing education classes. Attend writers' conferences. Start a writers' support group. Join writers' organizations. And socialize.

"I used to think that it would be great if, instead of the kind of seminars the Writers Guild gives, that they gave tennis lessons because so much was happening on tennis courts," Carolyn Miller (*Mystery at Fire Island*; ABC Afterschool Special *Sometimes I Don't Love My Mother*) says over iced tea in her living room. "Maybe now it's the golf course."

Whatever venue you choose, as the group of writers you know expands, so do your chances of finding a script partner. But if you *still* can't find a collaborator among contacts and colleagues, consider this option:

> *Writer/director seeks scriptwriting partner. Goal: funny movies that are completely original and totally unlike Hollywood's endless parade of remakes. Ideally your forte is solid character development. Please contact me. Are we a match?*
>
> —Ad posted on the Internet

Hey, if you can find Mr./Ms. Right with an ad, why not the right writing partner? Whether you're seeking a career collaborator or a co-writer for one particular script, you can post notices—as many do—on scriptwriting forum message boards online. Possibilities include but aren't limited to the websites for Reddit, LinkedIn, Google Plus, Twitter, or Craigslist.

Tony Urban & Michael Addis, who co-wrote the comedy *Poor White Trash*, met on the Internet. A struggling screenwriter in Pennsylvania, Urban started emailing story pitches to industry people, including L.A.-based writer/director Michael Addis.

"Absolutely everyone turned me down, including Mike," Urban says on Wired.com. "Except Mike was more polite than everyone else, and asked me what else I was working on."

So Urban pitched another idea—a true story about a waitress mom who resorts to crime to send her son to college. Addis was hooked, and

the two writers "went AOL," trading ideas back and forth via email until they had a detailed outline.

"I started feeling like a real web junkie/shut-in," Addis says of the online partnership. "But the process was working."

Whether you look for the perfect partner among perfect strangers or people you know, it's best to look for someone with the following qualities that we—and the writers we've talked to—consider crucial to a good partnership.

Similar Sensibilities

"There are a lot of things to ask yourself when you are getting into a collaboration," says Carolyn Miller. "Certainly, do you care about the same things? Are you going to want to write about the same kinds of story?"

"We like really complicated stories," Savannah Dooley tells Writers Guild of America, West, about collaborating with Holzman. "Protagonists that are outsiders and people finding unexpected connections; things that feel very real with characters that are flawed. I love working with her. I could never ask for a better partner. This sounds lame, but she is another me, but better at this. We want to write about the same things and like the same kind of subtle moments. We are really on the same page."

Holzman adds, "We are frighteningly alike."

"We ARE frighteningly alike," Dooley says.

Though Ted Elliott & Terry Rossio differ in many ways ("let's not bring up politics, hmm?" Elliott says on their website), it was their shared sense of story that brought them together, as well as their shared career aspirations to be screenwriters, something Elliott strongly recommends in a partner. He jokes, "Try to avoid getting a partner who wants to be, say, a convicted murderer, or worse, a performance artist."

And we might add:

CLAUDIA: Or a moral slime ball.

MATT: Or a high-handed bitch. [Laughter]

And yes, a shared sense of story helped bring us together too, but it was our same sense of humor that got us over the hump of hating each other.

MATT: It's hard to have contempt for someone who laughs at your jokes.

CLAUDIA: It's true. Humor studies show—

MATT: Claudia loves her studies!

CLAUDIA: —that this is one of the most powerful ways to reverse a bad first impression.

MATT: Which is why I laugh a lot on first dates.

Such is the power of humor in creating human connection. And good collaborations.

In fact, the same sense of humor between you and your partner may predict, as nothing else can, a closeness and compatibility in your writing life.

One thing that made Robert Ramsey & Matthew Stone gravitate toward each other was their respect for each other's "whimsical perspective."

ROBERT: The guy cracks me up. That's always been really helpful. In writing comedy. [They crack up.]
MATTHEW: If Rob says something, and I laugh, it's funny.
ROBERT: That's a good sign.
MATTHEW: That's a good sign. It goes in, and of course, it's manipulated till it's not funny anymore. [Laughter]

Their sensibilities, from humor to work habits have been so fused that Ramsey calls it "the Vulcan Mind Meld." ("We're a little on the anal side too," Ramsey confides. "Matt's mother once said we're like *The Odd Couple*, only we're both Felix.")

For those looking for a partner to co-write comedy, Larry Gelbart offered stellar advice:

"Say something that you think is comedy, or you know to be funny, or try out your favorite joke, and if the other person doesn't laugh, *run do not walk* to the next candidate!"

There is the rare exception, of course, like Peter Tolan's "unlikely collaboration" with Denis Leary on the darkly comic detective series *The Job*. Tolan wasn't very familiar with Leary's work, but from what he did know, he thought the partnership was doomed.

"Our senses of humor and everything are completely different," Tolan tells us at his Pasadena home, where part of *Gods and Monsters* was filmed. "He has a really dark outlook on things, and I'm a little more versed in having that same outlook but making it palatable for a mass audience. He roughs up my smoother edges, and I smooth down his rougher edges, so the collaboration really works well. Definitely a surprise to me."

So it's possible that another shared sensibility such as a dark outlook can compensate for dissimilar senses of humor, even when you're writing comedy. But we've found that the same sense of humor is invaluable when we're writing together, even if we're writing drama.

Our first screenplay, *Obscenity*, is extremely heavy in places, especially when the main character's brother, Sam, is killed in a gay bashing. We dreaded writing that scene. We dodged it for weeks. And we were *totally* depressed the day we knew we had to write the damn thing. Fortunately, something struck us as funny—probably the long, mournful looks on our faces—and we started howling with laughter, the comic relief we needed so badly to get through the scene.

Other sensibilities we share also helped us with *Obscenity*—our taste in films in general and courtroom dramas in particular. We both love *To Kill a Mockingbird*, so when we were struggling to write the scene in our script where the jury announces the verdict, we said, "Let's see how Horton Foote did it." We looked at his screenplay, and inspired by his style, we wrote an homage.

"The same rule [about shared sensibilities] applies to a pair of writers who want to do drama, action, whatever, except without the laughs," Gelbart said. "What do you like? Who do you like? Which movies? Which this? Which that?"

Or what—or whom—do you *dislike*?

"It's probably more important that the two people share the same dislikes than the same likes," Marshall Brickman says, an opinion that clearly informs some of his and Allen's greatest comedic moments (the professor pontificating about Marshall McLuhan in *Annie Hall* leaps to mind). "That is, it's better if you hate the same things, rather than like the same things. It narrows things down a little."

Our shared dislike—okay, *hatred*—of hypocrisy fueled the writing of *Obscenity*. In the actual court case that inspired our screenplay, Florida's State Attorney busted the mom-and-pop video store in the name of morality, but he was really in bed with a major "family values" video chain that bankrolled his campaign so he could put their competition out of business. That kind of thing just pisses us *off*.

And our shared hatred of racism and social injustice fueled the writing of our most recent screenplay, *Ruby*, about the wrongful conviction of Ruby McCollum, based on Claudia's documentary feature, *The Other Side of Silence: The Untold Story of Ruby McCollum*.

Still, for all the likes and dislikes you and your partner may share, it's good to have "a dissimilar taste," Gelbart said. "You can be yin and yang. It's okay if the other person's take is interesting and it opens you up a little, and presumably the reverse is happening. But it helps if you occasionally say the same thing at the same time."

The Vulcan Mind Meld. Or as we like to say, "Get out of my head."

Complementary Strengths

You already know this is one of the top ten reasons to collaborate, so keep complementary strengths in mind as you search for a partner.

"I think collaborations are much more successful when people have different strengths," says Peter Tolan. "That way, nobody has everything. Nobody brings everything to the table. The best collaborations are when you shore each other's weaknesses up."

"You're looking for someone hopefully with complementary strengths," Janet Batchler says, "but that means that you have to have an understanding of your own strengths."

Or to quote the Oracle at Delphi, "Know thyself."

"I tend to be more discursive and more elaborative than Ethan does," Charles Gaines says. "Probably because he's read so many scripts, written so many scripts, co-written so many scripts with Rick [Linklater], particularly, and evolved so many scripts into actor material, he tends to be much more a 'less is more' scriptwriter than I am. And he tends to rely—sometimes I think overly rely—on just gestures. It seems to me that great screenplays—you think of the screenplays of William Goldman—are scripts that mix a certain amount of discursiveness and elaboration with pure gesture. And so I'm bold enough to think that our scripts have been advantaged both by Ethan's input and by mine. And I think that's really the only way that a good script partnership can work. You can't have one person that's always sucking hind tit, you know, and the other guy's always dragging him along. I mean, ideally, both people have got to be contributing complementary talents. Different but complementary talents. And I'm lucky enough to have that be the case with Ethan."

"It takes remarkable self-awareness to get into a collaboration," Tolan says. "I think you have to be remarkably self-aware to say, 'I can do that and that, I just can't do *that*.' Partners understand this is how a successful collaboration works, and they're able to feed it and keep it running."

Fay & Michael Kanin kept their successful collaboration running by playing to each other's strengths. "Michael was an artist, and you can see he was very good," she said, pointing to his paintings and sculptures around the living room. "So his strengths in terms of movies were the visual. And I was a people person. I really liked the characters and the dialogue and all of that. Not that he couldn't write dialogue, but I loved it. He did it."

The same is true of Jean-Pierre Jeunet & Guillaume Laurant (*The City of Lost Children*; *Amélie*; *Micmacs*). "Guillaume is very good with dialogue, so he writes the dialogue scenes and I write the visual scenes; it's like a game of ping-pong," Jeunet says in *The Script Lab*'s article "Top Ten Film Writing Partnerships."

Larry Gelbart and his co-writers on the classic 1950s TV variety show *Caesar's Hour* had similar sensibilities—"Sid knew that if you threw enough Jews up in the air, they'd all come down funny"—but there were important differences too.

"Mel Brooks didn't write jokes," Gelbart said. "Mel didn't and doesn't. His specialty is genius. He majored in genius. What Mel does is come up with whole pieces of business—a whole song, a whole dance. Not a concept but an execution of a concept. The concept is his mind, and anything can roll from there. I'm sure he can think of a funny line and a funny word and a funny name, but his specialty is just being the only Mel Brooks in the room. I do dialogue and I do characters and I can do plot and I'm *good* at it. But it's more convention. He is not conventional."

Marshall Brickman describes his and Woody Allen's complementary strengths in similar terms. "I tend to be somewhat more bound by logic than Woody Allen, and I say that as a criticism of me rather than of him. His approach to a problem or material in general is more intuitive than mine. I like to kind of back into things logically. He seems to have a genius for making some kind of intuitive leap which defies logic but solves the problem."

It's important to know your weaknesses too. As our favorite meat-punching, egg-gulping, flying-high-now boxer, Rocky Balboa, mumbles, "I got gaps." How else will you know what strengths you need from a partner?

Peter Tolan confesses that his gap is coming up with ideas—somewhat of a surprise from "the funniest man in Hollywood," as Billy Crystal has called him. But Tolan insists it's true. "If I could have a guy come in who was my collaborator, who just sat here and said, 'I have an idea for a screenplay,' I would love that guy. I'd collaborate with that guy because I am not fertile when it comes to ideas. I'm not spinning eight different plates in the air of fantastic screenplay ideas that I have. But if you come to me with a great idea, I'll say, 'Oh, I know what to do with that.' That's my strength."

Nick Kazan was well aware of his own limitations when he asked a friend, Margo Katz, to collaborate on a screenplay adaptation of the book *In Memory's Kitchen*, based on a cookbook compiled by Jewish women in a Czechoslovakian settlement camp during World War II. The women knew they were going to die and the recipes passed down through oral tradition would die with them, so they wrote the recipes down and smuggled them out of the camp.

"Not being Jewish and not being a woman, I didn't think I would be the ideal person to do all of this," Kazan says. "So I collaborated with Margo." Working from an outline they created together, Katz did the first draft, which Kazan rewrote. He then gave it back to her for comments. "It would be inappropriate for me to do the first draft, then for her to come behind and correct it," Kazan says, "because I just have more experience than she does. So yes, I wanted her perspective and her input."

Like Kazan, you need to be clear about what perspective and input—or other strengths—you're looking for in a prospective partner. You also need to be clear about each partner's role. Katz and Kazan were not equally experienced writers, so Kazan's experience guided the project. And equality wasn't the point.

It never is, according to Marshall Brickman. "A successful collaboration can never be equal or democratic. As we know, art is not a democracy, but an autocracy."

He freely acknowledges that Woody Allen was the dominant creative force behind *Annie Hall*, for obvious reasons—Allen was the star of the

film, and the character he was playing was more or less pre-formed from his stand-up act and other public appearances.

"The important thing was to get Woody Allen's sensibility onscreen in a coherent and satisfying way that had some dramatic logic," Brickman says. "Oh yes, and to be entertaining and if possible enlightening and observant about that slim slice of life from which we took our material, which was the slice of life we happened to be living or living in—New York, Manhattan."

They had a clear sense of purpose. Most successful partnerships do. So even as you search for someone with different strengths, make sure you share a similar vision.

"You have to have the same goal," Andrew Reich says. "If one person is just looking at this as a way to quickly cash in on something, and the other person just really wants to do good work, that's never going to work out. You have to have the same sort of focus on an end result."

How that result comes about, how the collaborative process leads to a finished script, can be as mysterious as finding the right writing partner.

"As in the marriage bedroom, you never really know what's going on unless you're there in the room," Brickman says.

Sometimes you're there in the room, but you'd *still* be hard-pressed to say how it happened.

"The biggest mystery of all," Phil Hay says, "is how it gets done."

Plays Well With Others

Since collaborative writing is such a close-knit creative relationship, you have a greater chance of working successfully together if you've worked out the bugs of *being* together. How you behave in good times—and bad. During arguments, for example (a subject we'll explore more fully in Chapter Four).

Disagreement is an important part of the creative process, so crucial to any collaboration that Andrew Reich recommends looking for "someone you've had arguments with or you know you can settle things with without throwing tantrums. If you're casual friends, how are you going to deal with each other in an argument?"

This may sound like a minor thing to consider when choosing a partner, but it's intricate interpersonal stuff that comes from knowing the person, your relationship, and yourself.

Peter Tolan can't argue. He can't even say, "No, that's not good." And he considers this his greatest weakness as a collaborator. "In a successful collaboration, you've *got* to be able to argue," he says. "I mean, you've really got to be able to say, 'I don't like this and here's why. Here's why this doesn't work.' And you've got to hope too that the other person is open to hearing that."

He doesn't mind when people argue with him (he can take it, but he can't dish it out), and he admires writing partners like his former co-writer Harold Ramis, who argued with grace and wit. "We had a very playful collaboration," Tolan says.

One of their arguments occurred while writing the remake of *Bedazzled* (an average schmo, played by Brendan Fraser, swaps his soul for a series of wishes granted by the Devil, Elizabeth Hurley).

"I wanted to do a 'call-back joke,' where the Brendan Fraser character goes to the Devil's club for the first time, and there are all these people dancing," Tolan explains. "And there's a guy just standing there with a really big rooster. Fraser asks, 'What's that?' and the guy says, 'Guess.' And that's the whole joke. It's obvious he's asked for a very large cock. So then in the original draft, he gives this final wish away to somebody that he's met. I wanted the audience—at the end of the movie—to see that person with a very big rooster."

After all, Tolan reasoned, given the opportunity, every guy in the world would ask for a very large, er, rooster. The first time he pitched the joke, Ramis laughed—because Ramis thought he was kidding. Then Tolan pitched it again. "I said, 'Hey, what *about* that idea?' Harold looked at me like *we're not doing that*. So it was, you know, playful. It was funny. But he definitely had a list of what he thought would work. That wasn't on it."

So what *should* be on a list of things to consider when choosing a partner is how well you both deal with disagreements and other sticky situations. That knowledge, of course, can only come from knowing each other and how you relate under pressure. Success in show business may rely on who you know, but creating a successful collaboration relies on *what* you know about who you write with.

A Writer You Respect (and Vice Versa)

Aretha was right. Respect matters most.

We ought to know. We went from zero to 60 on the issue, from contempt to respect. And only when we hit respect, only then, could we write together.

"That's the most important thing about a writing partner," Ted Elliott says. "Find a writer you respect, whose abilities you envy—and hope he or she feels the same about you. You should both feel like you're getting the better part of the deal."

"What I advise people to do is identify the most talented people around you and stick with them," Harold Ramis said. "It's one of the most obvious things about my own career path. I started *Animal House* kind of on my own. I wrote a treatment for a college film, which I called *Freshman Year*, and I was writing it for *National Lampoon*. I had my own very independent point of view, and it wasn't quite a *Lampoon* point of view.

They wanted me to keep writing it, but I suggested—which they loved, they jumped at—that I work with someone from the *Lampoon*. I got to pick my own collaborator initially, so I chose Doug Kenney, and what a fortunate thing for me. But if you're an acting student or in a film school, you're probably going to gravitate naturally to the most talented people around. And if you can hook up with them, great."

We've emphasized the importance of knowing yourself and your prospective partners, but it's equally important to know their work. If you don't, read something they've written. If your prospective partners are strangers, request a writing sample and offer one of yours. If you don't have respect for their writing (or vice versa), move on to the next candidate.

"I still have trouble to this day, in this non-collaborative period of my life, having any real respect for someone whose work I don't respect," Gelbart said. "It's not that I don't have respect for them. I drift away. I don't care about a relationship. And you have to have a relationship. You just really have to."

No respect, no relationship. But if you *do* respect the work, even before you have a relationship, there's a better chance a good one will develop.

Marshall Brickman didn't know Woody Allen that well before their managers put them together, but he already had great respect for his work. The future partners met while Brickman was a member of a folk music group called the Tarriers. "I played a lot of folk instruments—banjo, guitar, etc.," Brickman says. "That's me on the *Deliverance* album—you know, 'Dueling Banjos'—but another story . . ."

In 1963, the Tarriers headlined at the legendary Bitter End in Greenwich Village, and Woody Allen was the opening act. "Woody went on for his 20 minutes to usually a confused reaction from the audience," Brickman tells us. "They weren't sure what to make of him." But Brickman stood in the wings and marveled at Allen. "It was like discovering a great novelist or poet you never knew existed. Even at that early date his stuff was wildly brilliant, though as yet unfocused. He experimented with a variety of material in addition to the personal/psychoanalytic/relationship stuff."

Brickman, of course, was no slouch himself. He too was damn funny, which was why Rollins & Joffe thought Allen & Brickman would make a good team.

There is, however, such a thing as too much respect (see also: awe).

"I can't envision any situation from here on out where I would team up with someone," Gelbart said, "or go to work somewhere where I would be one of a group. By this time, there's too much respect paid and too much deference, so people are likely to say, 'It's wonderful!' when I know it isn't. That's the flip side of respect. Too much of it. Well, it only takes what, 50 years?"

So when it comes to respect, equality does matter. Mutual respect is the key.

"Don't think of the other person as the one who types," Gelbart said. "Don't think of the other person as the one who fills in what I don't have. Just think of yourselves as *one* and give them the same respect you give yourself. And you can be that honest about their shortcomings too, since any writer jumps at the chance to downgrade himself or herself."

Just Duet

In the end, collaboration—like love, friendship, or film—is experiential. No one, not even close friends or spouses or family members, can possibly know if writing together will work until they try it.

"I remember going for a walk at Zuma and talking about our *Simpsons* idea," Andrew Reich says. "All of a sudden, Ted said something, and I said, 'Then we could do *this*.' And he said, 'We could do this and *this*.' Funny ideas started flowing, and it just felt like *wow,* this is really a good idea! And *boy* is this more fun than I've been having sitting by myself trying to write. With Ted, there was that moment of *wow*, this is so much better. It just clicked."

So choose the most promising partner and see if it clicks when you work together. See if you say *wow*. That's the real acid test. Because the journey of a collaboration begins with one script.

Script Partner Points

- Know Thyself. Thy strengths and thy weaknesses. How else will you know what you need from a partner?

- Know Thy Partner. Look among those you know well—a friend, spouse/lover, or family member. If none is partner-worthy, get to know more people or post notices online.

- Know Their Work. If you must look for the perfect partner among perfect strangers, look for someone whose work you respect (and vice versa). Exchange writing samples, preferably in the genre you plan to write.

- Make sure you share similar likes and dislikes. As Ted Elliott says, it's probably best to avoid politics. It's probably also wise to avoid religion (unless thou art co-writing the next *Exodus* or *Noah*).

- As Larry Gelbart said, if you're planning to write a comedy, say something you think is funny. If your prospective partner doesn't laugh, run don't walk to the next candidate.

- Make sure you find someone you can argue and settle things with—without tantrums, resentment, or bloodshed.

- Make sure you share the same goals for your project and career.

- Just duet. The journey of a collaboration really *does* begin with one script.

"What the hell are we gonna do? Just because our relationship is in the toilet doesn't mean we can't work together, does it?"
—Richard Babson (Burt Reynolds), *Best Friends*

FOUR
Making the Creative Relationship Work

Congrats on finding the right writing partner! We hope you two will write happily ever after. And with all the advantages of collaborative writing, your future *is* bright.

But like any good relationship, yours will require care and feeding, so it's healthy, productive, and successful.

To quote Woody Allen, "It is clear the future holds great opportunities. It also holds pitfalls. The trick will be to avoid the pitfalls, seize the opportunities, and get home by six o'clock."

That's what this chapter is about (except the six o'clock part—that's the next chapter).

In order to avoid pitfalls, you need to know what and where they are. Like Jack Epps, Jr., who frontloaded his Collaboration course with all the ways his students could destroy their partnerships, we're frontloading this chapter with the list we've compiled from the script partners we've interviewed.

Top Ten Ways to Screw It Up

1. Allow your ego to get in the way.
2. Don't respect your partner.
3. Keep score. ("I wrote that." "No, *I* wrote that.")
4. Take it personally.
5. Be dishonest or distrust your partner.
6. Refuse to compromise.
7. Don't keep it fair (whatever "fair" means to you and your partner).
8. Harbor resentments.

9. Be an asshole.
10. Forget that the relationship comes first.

All of these will undermine your relationship, and the relationship has to come first. As Larry Gelbart said, "It's harder than marriage," but not just because there's no sex. It's because it's really *two* relationships—a personal one and a professional one.

If the personal relationship isn't working, chances are you and your partner won't be either.

"As Daryl and I developed problems in the marriage, we were writing together less and going in our own directions more," says Carolyn Miller.

Conversely, when the professional relationship isn't working, the personal relationship will be negatively affected as well.

"We had a movie at Disney Television that was a very sour experience," Miller says, "and it just impacted our relationship so much. Believe me, I wasn't happy about it either, but it became clear that for him, unless his writing career was going well, he wasn't going to allow himself to be happy about any other part of his life. And I thought there was more to life than that. It was kind of a turning point for us, I think, as a married couple."

The creative relationship is also hard because of the enormous time commitment, especially if you're "nine-to-fivers"—working all day together in the same space—like Scott Alexander & Larry Karaszewski.

SCOTT: What we do is like being locked in a prison cell with one person. You can just see that one person every day of your life, and you don't see anybody else. It's a very strange formalized relationship. There are probably very few analogies to it except prison.

LARRY: [Sarcastic] The glamour of movies. We'll just say it once in a while—"Isn't making movies great?" Ha! We're usually locked in some anonymous office building, looking at each other, having to deliver pages at the end of the day. Some runner will show up at the door and knock, and you have to hand him something! That's what making movies is.

SCOTT: But it seems to work.

LARRY: Yeah. We like the material. You know, we're very proud of what we do. And strangely enough, we're still friends. But we don't socialize that much anymore, simply because I see him all day. So it would be ridiculous if I said, "Hey, so what movie do you want to see tonight?" It just doesn't happen. When we get out of here, we head for the hills.

SCOTT: I mean, I see you more than I see my wife.

LARRY: Scary.

SCOTT: You just do the math.

So Andrew Reich was right to be concerned when he and Ted Cohen started writing together.

ANDREW: My worries were not, *Is this going to get us a job?* It was, *We're friends, and now we're working together—are we gonna be able to make that work?* I think that was a process that we were both luckily mature about all along, and we realized there are gonna be different issues when you're writing together than when you're just friends. You disagree with each other more than you would if you're just hanging out. How do you get past those moments, and how do you really listen to and respect the other person?

TED: [Deadpans] Strangely, you're the only friend that I have left. [Laughter]

Reich's initial concerns were assuaged because they were able to make it work. And you can too, with the help of the following strategies.

Top Ten Ways to Make It Work

1. Check your ego at the door.
2. Respect your partner.
3. Keep each other's best interests at heart.
4. Don't be competitive and don't keep score.
5. Keep it fair.
6. Don't take it personally (keep it about the work).
7. Compromise.
8. Find constructive ways to deal with disagreements.
9. Create rules to repair the relationship.
10. Maintain perspective (the relationship really *does* come first).

1. Check Your Ego at the Door

If your creative relationship is going to last, each of you has to find a way to set your ego aside.

"Ego is the great destroyer," Nick Kazan says.

"I think part of it in collaboration is getting rid of the ego," Jack Epps, Jr., tells us. "Really taking the I out of it. With Jim it was always we. We were doing this, we were doing this. And once the I comes into it, then really it's—That kills it."

Ramsey & Stone agree.

ROBERT: You don't have to surrender your ego to everybody on earth, but you do have to, to some degree, surrender your ego to that person.

MATTHEW: I hear a lot of people say that—well, not a lot of people—mostly I hear novelists say, "I could never work with somebody else. The purity of the voice." Well, if you can subjugate your ego to the partnership, it is your voice. It's your voice as a partnership.

ROBERT: Our goal professionally has been to create a voice—that Ramsey & Stone voice. It's a harmony.

The brotherly bond between identical twins Chad & Carey Hayes usually trumps ego.

CHAD: We're very fortunate—because we're brothers and siblings and we love each other—that there's just not a lot of ego involved in the process.

CAREY: Well, there's zero on my side. [Laughter]

2. Respect Your Partner

We've said it before and we'll say it again—respect is essential. Especially to the creative relationship. Like a great writers' room, mutual respect creates a safe, expansive, open environment where creativity can flourish.

Mutual respect made all the difference for writing teams in Epps' Collaboration class. "The people who worked together, who really respected each other, had much better experiences than those who didn't." And better screenplays, as he says in Chapter Two.

Script partners who respect each other also have more constructive and productive arguments, an inevitable and crucial part of the creative process (we'll deal with dealing with disagreements in a moment).

"It has to do with being able to listen and to respect the other one's opinions," Fay Kanin said. "And to fight. When it's necessary, to fight. But we never fought about the basics of the project. It was about, you know, whether the scene should go this way or that way, whether she should feel like this or she should feel like that. We would argue, but we never fought physically. The worst thing physically that Michael ever did was he went out once and slammed the door. That was shocking! [Laughter] But aside from that, we worked it out. We had great respect for each other. I think that's important in a collaboration."

"You really have to respect the person you're working with," Carolyn Miller says, "and you have to appreciate that if they don't agree with you, they're catching something that you're not. You have to hear what that is and work through it. It can be a painful thing, but it really makes you stretch."

As Ed Solomon says about creative disagreements with Chris Matheson, "If Chris feels adamant about something, we go with that. I respect him enough to know that it's right, even if I can't see it."

That respect, like trust, may take time to develop. So if your collaboration is new, it's reassuring to know that both respect and trust should increase as you work together.

Larry Karaszewski says, "For the first couple of years when you're working with somebody you don't know, you think, *Oh my God, that guy's an asshole! He doesn't know what he's talking about!* But at a certain point you realize, *Well, he does sort of know what he's talking about.*"

3. Keep Each Other's Best Interests at Heart

As we've said, many partnerships have grown out of close friendships, or in our case, a close friendship has developed. But this doesn't mean that you and your writing partner *must* be best buds.

"I have always thought of Woody Allen as a friend," says Marshall Brickman, "although I would not expect him to bring me chicken soup if I were in bed with a cold, nor, I assume, would he expect that of me. The relationship has always been cordial but not intimate. We do not discuss personal problems. But I feel he has my best interests at heart, as I have his."

That's the key. Cordial or close, you must have each other's best interests at heart.

The long, happy collaboration of Cash & Epps worked so well because they were *not* terribly close personally or geographically (Cash in Michigan, Epps in L.A.).

"Jim and I had lives that were very separate and we wanted to keep them that way," Epps says. "I didn't have to see him on Saturdays, I didn't have to become his best friend, he didn't have to invite me over to all his barbeques. For a long time we didn't see each other. I don't know whether it was eight, nine years. We weren't keeping track. And we were concerned if we got together, what if we didn't like each other? [Laughter] What if we actually thought, *Well, he's a real jerk*? Over the phone you can't tell. [Laughter] But then I went back a couple of times to Michigan—I had friends there and also to see Jim, who was a wonderful man. We did work together a couple of times because I was back there, and it was fine. But it was actually better for us on the phone, long distance. It was actually a better process."

4. Don't Be Competitive and Don't Keep Score

Whether we want to admit it or not, we writers are competitive. Granted, a healthy competitiveness can be a good thing. It can bring out the best in you and your partner.

The two of us often write better because we're trying to impress—and amuse—one another.

CLAUDIA: When I write a joke, I want Matt to guffaw. He's the funniest person I know.

MATT: And if I crack up Claudia, I know an audience will laugh too.

When Ted Elliott writes a scene, he doesn't just want to impress Terry Rossio, he wants to *floor* him. "I want him to be jealous," Elliott says. "Just a little, but jealous all the same. And that prompts him to write a scene that impresses me, floors me, makes me jealous."

But competitiveness can corrode your creative relationship if you start keeping score about your respective contributions to your scripts.

"There are some real dysfunctional partnerships out there," Matthew Stone tells us. "People keep tabs on what their contributions are. This and that. 'That person said no to my line.' We've fortunately not done that."

The truth is, the longer you work together and the more you meld your voice and aesthetic, the harder it is to know who wrote what.

When we ask Marshall Brickman about his and Woody Allen's individual contributions to their co-written scripts, he says, "It's not really possible to answer with any accuracy or insight. One person moves the conversation in a direction in which the other person can have an idea or think of a joke or plot twist that would not have been possible without the conversation. So who takes credit for what?"

Or as Stone says about working with Robert Ramsey, "I think that by the time the thing is finished, it's so completely both of ours that I would be hard-pressed to remember who came up with a certain moment, a certain scene even. It just doesn't matter because that's not the point."

5. Keep It Fair

When we wrote the first edition, we interviewed numerous script partners or teams, which made transcribing all the interview audiotapes (yes, analog) a formidable task.

CLAUDIA: I started sifting through the tapes and choosing the interviews I wanted to transcribe.

MATT: And I said, "Hey, why do *you* get to choose?"

CLAUDIA: I started to counter with a quote from Annie Savoy ("Actually, none of us on this planet ever really choose . . ."), but I knew Matt was right—we both needed to have a say in the matter.

MATT: So we sorted our Everest of audiotapes into short, medium, and long interviews, then took turns choosing the tapes to transcribe.

And we did the same thing for this second edition, dividing up our new interviews (yes, now digital), so the task of transcribing felt fair.

Fair does not always have to mean equal, but however you decide to divide up the work, both of you need to feel fairly treated. Resentment caused by a sense of unfairness will corrode or even end a creative relationship. To prevent this, you and your partner will need to agree on what "fair" means to you. And how teams accomplish this differs.

For example, we often take turns writing the first drafts of our screenplays. But Nick Kazan considers one partner writing the first draft of a script a risky approach (*In Memory's Kitchen* notwithstanding). "Those partnerships are really fragile because one person is doing all the writing essentially," he says. "The other person is certainly contributing but not doing the writing. So then it comes to divvying up the credit and the money, and you say, 'Well, maybe you should just get story credit with me.' 'No, no, no, I'm used to getting screenplay credit—I don't want to just get story credit' and 'That's not fair' and so forth."

In other words, keeping score.

But Kazan also acknowledges that a lopsided workload is less risky when both partners have successful independent careers. "The people I'm collaborating with by and large are extremely successful, so if that turns out to be unequal, I don't care what my credit is. If it's unequal, and I'm doing more of the work, I don't care either. That doesn't matter. It's the fun of doing it with a friend and being able to tell this story."

When all is written and done, you want to be able to say, as Renee Longstreet does after decades of writing and fighting with Harry, "I feel we've kept it fair. Oh yeah, I'd say we have. And it's been pretty damn fun."

6. Don't Take It Personally (Keep It About the Work)

Not taking it personally is easier said than done, especially when you consider that "everybody's neurotic and writers are *more* neurotic than most," Gelbart said.

Alexander Payne & Jim Taylor "never take any criticism personally," Taylor tells us, but he concedes that this isn't easy. "You have to have a certain sense of self-confidence—or very low self-esteem, take your pick—not to be insulted when someone doesn't like what you've written." And he agrees that the level of insult is greatly reduced if they argue about the work, not each other. "I'm happy to say that our collaboration is very amicable. I think we're both good at keeping our disagreements focused on what's best for the story."

So do Harry & Renee Longstreet.

RENEE: We never get personal.
HARRY: It's business. It has nothing to do with who we are or our relationship.

RENEE: We both had bad marriages. That's all I can say.
HARRY: Two bad marriages behind us. That helps.
RENEE: Both of us have an aversion to confrontation.
HARRY: Oh yeah, we had all the confrontation we'll ever need.
RENEE: Right. Sometimes I get really mad at you, but I've never said anything in 25 years that I've had to take back. Ever. We've never said to each other such hurtful things that we can't get past them. I once said, "Fuck you," and you still remember it.
HARRY: But it wasn't about creative—
RENEE: No. I've never said anything mean to you, and I don't think you've ever said anything mean to me. That's the best advice we can give—don't be mean.
HARRY: Keep it about the work and not about the people.
RENEE: Right. And if it does get about the people, don't be mean to each other. Don't say things you'll regret. Ever ever ever. Because that would have cleaned us out. We never would've been able to come back to the work.

But even arguments focused on the work can get personal, according to Matt Manfredi & Phil Hay.

PHIL: Our arguments genuinely are about creative issues. They're about, "I think this is a wrong choice for this character." That kind of thing.
MATT: So it's productive. You just consider it part of the process, and it doesn't get personal.
PHIL: Yeah. Some of them— It gets personal. [Laughter]
MATT: It gets very personal.
PHIL: But a lot of them are creative, and a lot of them are just venting, you know, frustration and rage. It's a very frustrating business.

We ask Alexander & Karaszewski how they've kept the peace, kept the friendship.

LARRY: What peace? What friendship? [Laughter] I don't think either of us takes it personally anymore.
SCOTT: I'm here, ain't I?
LARRY: I'd say that was a problem during the first few years. I mean, we had these fights that were just insane! People would storm out, and there was "Fuck you!" and this hateful, hateful, dirty fight.

Nicole Yorkin & Dawn Prestwich have also mellowed over the years. "When we first started writing, we would be very sensitive if the other

person didn't like our idea," Prestwich tells *Written By*, "and now that's just a blip on the screen."

7. Compromise

Writers can be headstrong mules, some of the world's worst control freaks. We want things the way we want them. That's one of the reasons we turned to writing—to create universes where we *do* have control. Still, to succeed as a collaborative pair, you must learn to let go.

"What you have to do is compromise," Fay Kanin said. "That's the word of collaboration—compromise."

Compromise is essential but also humbling, so some partners prefer to pretend that they're not compromising. As Olivier Ducastel & Jacques Martineau tell us, "Jacques always starts out by grumbling and saying that he'll never *ever* do what Olivier is asking, and then he does it, but in his own way."

Compromise is also humanizing, as Andrew Reich says. "I was used to directing things and just forcing, and I think working with Ted has been a good process of learning how to work together—which no one can do instantly."

We went through a similar evolution.

CLAUDIA: I used to be *such* a control freak (remember the audiotapes?), but thanks to working with Matt—and meditation—I've gotten better at letting go.

MATT: When I was directing a short film a while back, my nickname on the set became "Mr. Control." It was kind of funny but also telling—I had this need to oversee and control every aspect of the production. But collaborating with Claudia has made me more relaxed and flexible, open to compromise.

CLAUDIA: Studies show that—

MATT: Stop! [Laughter]

8. Find Constructive Ways to Deal With Disagreements

Even in the most compatible, peace-loving partnerships, disagreements happen all the time. Take it from Scott Alexander & Larry Karaszewski.

SCOTT: All the time.

LARRY: Yeah. All the time.

The challenge is to keep these inevitable disagreements constructive—or your collaboration could self-destruct. That is why, as we interview writing teams, we ask how they resolve their creative differences. Their strategies are wildly resourceful and can be a source of inspiration for you and your partner.

Egoless Arguing

Subjugating one's ego is never more difficult or important than in the heat and potential hurt of an argument. For that reason, Ted Elliott & Terry Rossio have created a strategy they call "egoless arguing."

"Simply enough, it means that the ideas do battle, not the people," Elliott says.

When one suggests an idea, they each point out pros and cons, so even the partner who came up with it is no longer ego involved. The idea must pass muster on its own merit.

"I've always believed in the hierarchy of good ideas," Harold Ramis said. "When you're right, one proof of being right is that everyone recognizes it. Particularly in comedy. You can't stand there and say 'this is funny' if no one else agrees with you. You know, argument is not an inherently negative thing in the pure dictionary sense of argument. It's just disagreement and discussion. There's no emotional component attached to it, but if you have to make a point by somehow browbeating the other person or screaming, chances are you're not right anyway."

Phil Hay describes creative arguments "that have to happen, that have to be resolved, but it doesn't matter who's on what side."

Ego isn't what matters. What matters is getting the work done as well as they can. He uses pitching as an example. Often when he and Matt Manfredi are preparing a pitch, they'll disagree on how much pre-planning they need to do.

"Someone has to take each role in the argument," Hay says, "and there are a lot of times where we switch in the middle without really realizing it. One person thinks we don't have to prepare that much, and the other person says, 'No, no, we have to plan the whole thing—this time it's important to have everything completely scripted.' And then halfway through, the person who wanted it scripted is like, 'Look, we've done enough.' And the other says, 'We don't know what we're doing.'"

Your personal stake shouldn't be in your individual ideas or what side you're on, but in the overall script you're co-writing.

Showing, Not Telling

When we're disagreeing about the way a scene should be written, one of us will occasionally say, "Let me play a minute," and type out the scene. Then the other can see that person's vision—and version—on paper. If it works, terrific. The proof's on the page.

Nick Kazan & Robin Swicord also use this strategy to avoid or resolve arguments.

"If Robin tells me that she wants to change the scene that I've written, I don't like that," Kazan says. "I don't want to hear that she doesn't like it. Whereas if she just rewrites it and shows me the new scene, okay, fine. Sometimes I may object and think it was better before, but more

frequently I say, 'Well, great. I liked it the other way, but I like it this way too!' Again, it's showing. So we'll get the script back and forth, not discussing it, because discussing it gets into ego. Once you say, 'No, I don't like what you did,' they say, 'Well, fuck you!' In fact, I just changed something back in the script we're working on, and I don't know what Robin's response is going to be. She was shortening it, and I thought it lost its value. So I put it back because I think it's funnier in the original form, that the rhythm works better."

Bargaining

Sometimes, however, showing your partner how you see the scene can still lead to disagreement, as it has with the Batchlers.

JANET: We hand each other pages, and we don't really talk about them. We do draft after draft, and we label at the top what scene it is or what sequence it is, and rewrite each other, until it comes to the point where I'm taking out his changes and putting mine back wholesale, or he's taking out my changes and putting in his wholesale—and then it's clear that we've got to discuss it. And then we get the kids out of the house, and we lock ourselves up in a room and we scream at each other.

And how do they resolve these screamfests?

JANET: We strike bargains. "I'll give you that incredibly bad line *if* you'll let me cut this, this, and this."
LEE: I won't say it's an incredibly bad line. "It's brilliant, and I'm right!" [Laughter]

When we ask Alexander & Karaszewski if they strike bargains to resolve disagreements, they disagree.

SCOTT: We yell at each other, and we cut backroom deals.
LARRY: We have never cut backroom deals.
SCOTT: Oh, sure we do. That's baloney.
LARRY: Even though you always shoot that down, we've never— I would love it. A lot of times that's the more civilized way of doing it.
SCOTT: There are backroom deals like, "Okay, you can have that, but I get—" There are. He just doesn't want to admit it. They are unspoken. There are unspoken deals.
LARRY: Yeah, I wish there were.
SCOTT: There are plea bargains.

LARRY: I would *recommend* backroom deals for people who want their collaboration to live. Here's the thing—our scripts are so long that when he's saying, "I love this scene, it's never getting cut," I'm thinking, *All right, I'll let him keep that scene today, but tomorrow I'll bring it up again.* And then he'll beat me back down, saying, "Oh, that scene's gotta be in the movie." After a month of doing this, and we're still on page 160 as opposed to 120, the scene goes.

Wearing Your Partner Down

SCOTT: Actually, I have a completely brilliant way of driving Larry crazy, which is I'll walk in with a big fat agenda, like, "I've figured out a way we can cut out pages 48 to 63. Don't even need them anymore." Larry is like, "What are you talking about?" "We should just lose this whole subplot, this whole thing." He'll say, "Oh my gosh—this is so amazing, this is so great, because the movie's running so long." And I'll say, "Nah, I don't like it. I wanna keep it the way it is." I'm backing off my own case.

Does this accomplish anything other than wearing his partner down?

LARRY: No. It accomplishes nothing whatsoever. It's frustrating.
SCOTT: [Laughs] So it's a good technique.

"Wearing your partner down" is how Harry Longstreet convinced Renee to change her title for a screenplay.

RENEE: The title of the movie was *The Adventures of Molly Revere.* Harry didn't like that title.
HARRY: It sounded like a real period piece.
RENEE: He wanted to call it *Lady Under Glass,* which was pretty damn good, but I wouldn't do it. This was the first of our arguments. He started a lobbying effort. I couldn't go to the bathroom without lifting the toilet seat and finding a sign that said, "*LADY UNDER GLASS* SHOCKS BOX OFFICE!" I'd find it in my cigarettes—there would be a slip of paper that said, "*LADY UNDER GLASS* OPENS TO SOCKO REVIEWS!" You remember that?
HARRY: Yeah. [Chuckles]
RENEE: So that's how we changed it. I was worn down. "Okay, okay, just do it your way. I can't fight with you any more. I can't fight with you any more."

HARRY: We both think we're right, so that's how we resolve arguments. One of us wears the other one out.

This technique is most effective when conducted with humor. And we only recommend it if you and your partner are very close and enjoy enough good will that you can wear each other down without wearing your relationship out.

Exercising Veto Power

It's not just for politicians. It's also for script partners who have already established tremendous trust and respect.

"We have a rule that if one of us says, 'I hate it,' it's done," Chad Hayes tells us. "You don't argue. You just don't. You can defend it a little bit. But if after a little bit, you say, 'I just hate it, I don't like it,' it's done. That was kind of our rule early on—just don't talk me into it because this is my gut reaction to it."

Nicole Yorkin & Dawn Prestwich agree. "It's a given that if the other person doesn't like it," Prestwich says, "you've got to find something better."

We're not talking about being a "no" person, we're talking about what Carolyn Miller said—"You have to appreciate that if they don't agree with you, they're catching something that you're not."

"I think this is sometimes what makes screenplays better," Chad says, "because it makes you both go to a different level, to choose and try something different."

Deferring to the Original Writer

Like the Batchlers and Kazan & Swicord, the Longstreets pass scenes back and forth, making notes and rewriting each other, but they also keep track of who wrote a scene first.

RENEE: The original writer of a scene is Writer A. The reader, the one making notes, is Writer B. If it's really a staunch disagreement, Writer A prevails.

HARRY: The original writer will always prevail.

RENEE: You have to defer to the original. Except in cases when I did all the typing.

HARRY: She cheats. She cheats. She slips in stuff. [Laughter]

RENEE: I admit it. I admit that I've done that.

HARRY: And I've caught her at it too.

RENEE: Yes. But, you know, I do the final pass because I'm the English major, so my spelling is always right.

HARRY: And I'm still dyslexic after all these years, so she'll fix all that stuff.
RENEE: I get final cut. But you've won lots of times. You've won as much as me.
HARRY: Sometimes I've—
RENEE: More!
HARRY: Right.
RENEE: Sometimes. [Laughter]

Deferring to Passion

This is one of the most common and successful peacemaking techniques.

When we can't agree, and one of us is more passionate, we'll defer to that passion, but only after we've discussed it and explored the reasons behind it. This digging deeper can lead to some wonderful creative breakthroughs or at least convince you the passionate partner is right.

Gene Wilder was wild about his "Puttin' on the Ritz" number in an early draft of *Young Frankenstein*. He expected co-writer and director Mel Brooks to love it too, as he tells *Scenario*. "I said to myself, now Mel's going to smile! And he said, 'Are you crazy? It's frivolous, it's self-indulgent. You can't just suddenly burst into Irving Berlin and "Puttin' on the Ritz"!'"

It was more than a painful moment for Wilder. "He took a chisel and cracked my heart."

So he and Brooks had their first big disagreement. "First I argued," Wilder says. "And we never argued. But . . . I argued softly. Then, I started arguing vehemently. Maybe for 30, 40 minutes. I had done research on this—I had gone to psychiatrists and everything—research about nerves and reflexes and how you could test them, and what kinds of movements would help, and then I translated that into comic behavior. And Mel just said, 'Okay, it's in.' I was stunned. I said, 'Why didn't you just *say* that?' He said, 'I didn't know! When you gave it to me and I read it I didn't know. So I thought, let's see how hard he fights for it. Because if you had said, "Yeah, well, maybe not . . ." then—out! But when you argued that much for it, I knew it must be right.' Well, it was a great relief, but boy, did he pull a fast one. I'm glad he did it. I knew it was right, but when he gave me such a jolt, I had to tell him the reasons *why* I knew it was right. Not just, 'Oh, it's wonderful, it'll be funny.' I had to start telling him all the reasons why, structurally, it was right, scientifically it was right, and theatrically it was right. So, that was a big hurdle, and we got over that one."

Thank goodness. Because it's difficult to imagine the film without the classic top-hat-and-tails number and The Monster/Peter Boyle's hilariously inarticulate refrain.

Deferring to the Director

Though Mel Brooks deferred to Gene Wilder's passion, often in writing teams with one partner directing the project, the director's vision prevails.

"I think another thing that helps in our collaboration is that Alexander is going to be directing what we write," Jim Taylor says, "so the final say has to be his. He will be the one who is on the set trying to make the scene work, so he's the only one who can really say if the scene is working. I'll fight him on certain things up to a point, but then I have to defer to his opinion."

This is the advantage of the "unequal dynamic" that Marshall Brickman insists is necessary for a successful collaboration. "What is desirable above all is a consistent, unique, original tone, sensibility, world-view, or point of view," Brickman says, "and if the two people are always deferring to each other—or fighting over choices—then you either get television or a very bland and unoriginal piece."

There were times in their collaboration when Brickman prevailed, but usually he deferred to Woody Allen. And they never had confrontations when they disagreed. "No," Brickman says, "it never got testy."

"Experienced writers recognize that the director is gonna be the guy out there on the line, the one who has to make the call about whether something's working or not," said Harold Ramis, who directed many of his co-written scripts, including *Caddyshack, Groundhog Day, Bedazzled, Analyze This*, and *Analyze That*. "That's the tension between writers and directors creatively that you see expressed in the Writers Guild's frequent complaints about the increasing power of directors and the disrespect shown to writers. It's always going to be William Shakespeare's *Hamlet* no matter who directs it. But on the other hand, movies are so collaborative, and the director does end up being the arbiter. So when I'm directing, I invariably write the shooting script. It doesn't mean I change everything, but I decide what stays in and what doesn't."

9. Create Rules to Repair the Relationship

If it does get testy between you and your partner, and—in spite of your best intentions—you both say things you regret, you'll need to find ways to repair the damage. This is especially important if you're not lovers or spouses because "there's no way to kiss and make up," as Gelbart said.

So non-conjugal collaborations like Ramsey & Stone have followed relationship rules recommended for conjugal couples.

ROBERT: I always use marriage metaphors when talking about our partnership, which is actually longer than either of our marriages.

MATTHEW: Well, with the marriage metaphor, we have a couple of little rules that aren't really written down. We don't really leave the office mad. [Laughter] Seriously, if we've had an argument that day, usually we solve the problem anyway by the time we go. But we'll say like, "I'm sorry, I was out of line when I said that" or "I didn't mean that" or whatever. It's not just by rote because you want to come in the next day and work, and you know you're gonna have these problems.

ROBERT: I'm probably not as good at marriage as I am at being a partner.

The adage "Don't go to bed angry" has saved many a marriage, but sometimes it's wiser to take a break before things get too toxic. Even if you're working long distance like Cash & Epps.

"We didn't fight or argue very much," Epps says, "but if we did, we'd hang up the phone and walk away because we weren't in a room so there was no investment like that. And we'd get back on the phone and we'd say, 'Yeah, I screwed up,' and move on."

10. Maintain Perspective (The Relationship Really *Does* Come First)

Last but not least, don't lose perspective.

SCOTT: It's just a screenplay.
LARRY: It's just a screenplay.

Harry Longstreet says, "There's an old joke: 'We're not curing cancer. It's not brain surgery. It's more important than that.' But that's bullshit. It's not more important."

It's certainly not more important than your creative relationship or your relationship as family, friends, lovers, or spouses, as Kazan & Swicord realized when they collaborated for the first time.

"Before we did *Matilda*, I was extremely apprehensive," Kazan says, "because Robin and I both have very strong opinions, very strong and different voices. And we fight—we hope in a pleasant way—to retain whatever aesthetic is in our material. So I just thought if this collaboration goes south, it's going to be okay. I'm going to say, 'Look, the marriage is more important than this. You're a wonderful writer, you finish it—go with God!'"

After Kazan completed the first draft, they began passing their rewrites back and forth. If Kazan changed one of Swicord's revisions back to his version, he wrote her a note explaining his reasons.

In response to one of his changes, she wrote Kazan a note of her own. "It said, 'Yes, I understand what you're saying, but I completely visualized this scene, and this is the way I've seen it.' And I got insulted," Kazan says. "The implication was that she had visualized it, and I *hadn't*—or that was the implication that I saw. I said, 'It's a movie—don't you think I visualize it also?' And she said, 'Look, you finish the screenplay. The marriage is more important,' and she gave back to me almost word for word this speech that I had prepared four months earlier. I burst out laughing because I had prepared the same speech but never said it to her! She was taken aback, like, 'Why are you laughing?' And I explained. I don't even remember how we resolved that sequence, but that was the only awkward moment."

What to Do If It Doesn't Work Out

"You know, collaboration means that you have to give in to the other person," Fay Kanin said. "And marriage means that too. When you do that for a long time, you find that. Though we worked it out, we had the usual argument—*hiss!*—argument, 'No, I think that,' 'No, I think that,' and one would yield to the other. But at a certain point we said, 'Enough already.' We talked about it, and we said, 'You know, the marriage has to go or the collaboration.'"

They chose the marriage.

"That didn't mean we didn't still help each other and advise each other," Kanin said. "I read all his stuff when he wrote alone, and he read mine. And when he did *Woman of the Year*—he wrote that with Ring [Lardner, Jr.]—Kate [Hepburn] and Gar [Kanin] and I were all part of that."

As their personal and creative relationship headed south, Carolyn Miller & Daryl Warner decided it was best to divorce—a metaphor often used by script partners when they split up.

"People that we know who have been in partnerships and dissolved those partnerships speak in terms of divorce metaphors," Robert Ramsey says.

And divorcing your writing partner can have similar consequences, Matt Manfredi & Phil Hay explain.

MATT: There are a lot of people we've developed relationships with. Down the line maybe we want to do something with these folks, and if Phil and I decide we aren't going to work together anymore, do they want to work with me or do they want to work with Phil?

PHIL: Or neither? Which spouse do you invite to Christmas dinner?

MATT: It's exactly that on a grand scale.

PHIL: It really is. So the best way to do it is to not split up.

MATT: There are certainly examples of amicable splits, but those seem to be people who have been working together for 30 years.

Like the Kanins did. Theirs was a mutual decision based on mutual respect—for each other and for the work. But often the decision is *not* mutual. One partner wants out. That's when it really gets tough.

"It's a very hard admission," Gelbart said, "as it is in any relationship—a friend, a sweetheart, whatever. Oh, let me say *lover*. I want to be more modern. It requires a lot of courage to say, 'We're busting up.'"

Aaron Ruben agreed. "It's like telling your wife or your husband, 'Honey, it's over. I've decided I want a divorce.'"

Ruben spoke from experience. Long before he was renowned for writing/producing *The Andy Griffith Show*, Ruben was offered a solo shot at writing for George Burns and Gracie Allen. So he decided to end his collaboration with Phil Cole.

"It was difficult for me," Ruben said, "because there was something very sad about him. He always had a very lugubrious look on his face anyway. And he smoked a curve-stemmed pipe. We'd come up with funny stuff, but always that sad look. And I said, 'Phil, my agent has offered me *The Burns and Allen Show*, but he can only bring one writer on.' And Phil sat there for a while. I could see he was very unhappy. And he said, 'Well, you should never have started the collaboration to begin with.' I said, 'Phil, what have you lost? You got nine weeks of work out of it. I'm sorry, I guess I just have to move on. My agent says it's time to move on.' Well, that was over with. I went to work for Burns and Allen, and it was great."

Larry Gelbart had to do the same thing. Twice.

"Both men took it hard," he said. "I was kind of like Shirley Temple. I realize that now. When I was 16, 17, 18, I thought, *What's all the fuss about? This is what I do*. But now that I look back and see what a person is at that age, I think that must've been quite a thing. And for me to say that to men older, to whom money was much more important—because I could always get an allowance if I lost a show—they were pissed. It's not that I was so ambitious. I wasn't doing a Sammy Glick thing where I'd found another rung higher than the one I was on. I just wanted to get out of the relationship—in one instance because we weren't contributing equally, and the other because the personal relationship fell apart. And so it became impossible to do the working relationship."

Gelbart underlined the importance of ending a collaboration as amicably and honestly as possible. "Honesty is very important," Gelbart said. "You can't fake a working attitude if you're disenchanted."

"It's the same as any real relationship," Peter Tolan says. "Be honest and say, 'Look, I've outgrown you' or 'I feel like I'm doing more than my share of work' or whatever it is."

There are times when the "whatever" is more about life goals than professional ones. Since we interviewed Ramsey & Stone for the first edition of *Script Partners*, their happy, productive, 23-year-long partnership came to an end.

"Matthew Stone walked into our office on the fourth floor of the Wiltern Building in the spring of 2008 and announced that he was leaving the partnership," Ramsey tells us in a follow-up interview for this second edition. "He and his wife, Gloria Zimmerman, were sick of L.A. and wanted to raise their young children on the East Coast."

Stone and Zimmerman both grew up there and wanted to be closer to their aging parents.

"He said he was tired of screenwriting and Hollywood," Ramsey adds, "and wanted to finish a novel he had started. I was shocked but not surprised. He had dropped hints for years about wanting to go home, which I had ignored. Classic denial on my part, I suppose. I guess neither of them felt a strong connection to L.A. the way my wife and I did. A few short months later, they sold their house in Carthay Circle and moved away. Our last gig together was a short, tactical rewrite on the third installment of *Big Mama's House*, which was going into production that fall. We made $250,000 for three weeks' work, and that was the end of Ramsey & Stone. Actually, it wasn't. We ended up optioning a spec script we had written the year before to the American Film Company. The script was called *Midnight Riders* about Paul Revere and the day the American Revolution began. We did a rewrite together by Skype based on the company's notes and made about $100,000 on that project. It never went into production, and the company eventually dissolved. The rewrite of *Midnight Riders* was the real end of Ramsey & Stone. Which was ironic because the theme of that piece was that one man can't do it alone."

When we ask about the emotional impact of the breakup, Ramsey says, "I was thrown into a full-blown midlife crisis by Matt's departure."

Sadly, sometimes even a very good collaboration can't be preserved.

But sometimes even a troubled one can. Should things get rocky in your own collaboration, you might consider couples therapy for co-writers. Seriously.

Screenwriter turned licensed psychotherapist Dennis Palumbo frequently counsels script partners. "Here's the good news: As with most couples, the issues disrupting a writing partnership can usually be addressed and worked through if each of the writers is willing," he says at PsychologyToday.com. "However, as any therapist who does couples counseling will attest, there's no one blueprint for achieving effective communication and fostering intimacy; each relationship, ultimately, is a mystery. The same is true for writing partnerships."

As you talk it out, you may well discover that your partnership is worth saving. Then you'll need to find ways "to feed it and keep it running," as Tolan says, "to evolve with it as opposed to evolving apart."

 Script Partner Points

- Know the pitfalls of collaboration and try to avoid them.

- Check your ego at the door.

- Respect your partner. Always, always, always.

- Keep each other's best interests at heart.

- Don't keep score of your respective creative contributions.

- Keep it fair, whatever "fair" means to you both.

- Don't get personal with your criticism and don't take criticism personally.

- Compromise (it's not a four-letter word).

- Don't forget, disagreements are an important part of the process. But keep them constructive.

- Try some or all of the ways that other writers resolve disagreements:

 Argue egolessly.
 Show how you envision a scene by writing it down.
 Bargain.
 Wear each other down. Humorously.
 Exercise veto power in a way that works for you both.
 Defer to the original writer if you divide up your scenes.
 Defer to passion but explore the reasons behind it.
 Defer to the director if one of you is directing.

- Maintain perspective. The relationship is more important than the script.

- If the collaboration doesn't work out, there must be 50 ways to leave your partner, but the best way is amicably and honestly.

> "Some choices must be made that are difficult. Nonetheless, we must make them. . . . The fate of the entire space–time continuum may rest on your shoulders!"
> —Professor Emmet Brown (Christopher Lloyd),
> *Back to the Future* screenplay, fourth draft

FIVE

Solving the Space–Time Conundrum

Once you've found the right writing partner, you have a new problem to solve—where and when will you work? It's a tricky enough problem for solo writers, but the difficulty is doubled for writing teams. You have to consider two sets of creative habits. Two circadian rhythms. And two lives packed with family commitments, relationship issues, social obligations, and that pesky problem of making a living.

For us, where and when we write together has evolved—a process itself. When we first started co-writing, we worked together in person in Tallahassee. Then Matt moved to L.A., and Claudia moved to Canada and Washington State and North Carolina and Virginia and back to Canada and then to L.A. (yes, there's a story there, but it's too exhausting to tell). So we're working in person again, but when we can't work in person, we work via Skype.

The evolution of your space and schedule may not be as extreme. Again, you can only discover by doing, but it doesn't hurt to give it some thought before you begin.

Why?

Because the place and the time that you choose to work can influence how well you write.

Unless you're another Larry Gelbart.

"I am really the best or the worst to talk to because after all of these years, I can work anywhere, anytime," he told us. "I worked with Bob Hope for four years—in planes, in jeeps, in limos, in tents, on trains, on planes. With a pencil, with a pen, with a typewriter, with all three at once. Now I switch from Beverly Hills to Palm Desert. Every week I spend four days down there, three days up here, but it's just a different computer monitor to look at rather than a different place. I'm just so *trained*. [Laughter] Paper-trained, it used to be. Now it's monitor-trained."

Lesser mortals, however, may profit from finding a specific workplace and time.

The Right Place

A writer's first concern, Tennessee Williams once said, must be "to discover that magic place of all places where the work goes better than it has gone before, the way that a gasoline motor picks up when you switch it from regular to high octane. For one of the mysterious things about writing is the extreme susceptibility it shows to the influence of place."

Unfortunately, what worked for Tennessee Williams didn't work for Hal Kanter when they rewrote Kanter's screenplay adaptation of Williams' play *The Rose Tattoo*.

"I had to go to his apartment every morning, a small crowded apartment that reeked of cat urine," Kanter explained. "I got to the point where I couldn't take it any more. Just the aroma in that place was enough to kill me! So I would work at home, and he would work at his apartment. Then we would meet and exchange pages and go over the pages again. And we got a script out, a final script I was proud of, but to my disgust, he insisted on getting sole screenplay credit. That's why I wound up with an 'Adapted by' credit. I should have taken it to the Guild—I would have won. But he was a fierce little fighter to protect his own turf."

Just as you need to click with your partner, you both need to click with the place where you work. On the macro level, this means finding the geographical setting where you both write best. It doesn't mean that you have to pick up and move, though you might decide that you want to. Wherever you live, you have all kinds of choices. Fay & Michael Kanin fell in love with the beach, so they moved there to live and to write.

When Peter Tolan & Harold Ramis were struggling to write a new sequence for the remake of *Bedazzled*, Ramis suggested they meet in Cape Cod. He'd secured a room in the old public library where they could work. But for them, the beach backfired.

"We set up the computer and sat down and looked at each other," Tolan recalls. "In five minutes, Harold said, 'You wanna eat something? You hungry?' And I said, 'Yeah, I could eat.' So we walked down a ways to the general store, got sandwiches, sat in rocking chairs in the front, and talked about everything except the movie. We went back, sat there for five minutes, looked at each other, and he said, 'You ever see the old part of the island?' I said, 'No, I haven't.' So we got in the car, drove there, walked around the dock for a while, looked around. 'Wanna see where I'm staying? Wanna see the house?' 'Sure, let's go!' Back over to the house, walked around for a while . . ."

We're certainly no strangers to work avoidance, but we're less likely to succumb when we flee those distractions that undermine our creative

process—texts, emails, phone calls, friends, family, neighbors, and their satanic leaf blowers. Then again, you and your partner might love the sound of leaf blowers. The shriek of small internal-combustion engines might be just what you need to jumpstart your writing. Far be it from us to tell others their process.

God knows, Gelbart wasn't bothered by noise. "I don't have to have silence," he said. "For the four years I worked on *M*A*S*H*, my office was right next door, right above the sound-editing department of Twentieth Century Fox. All day long I heard screeching brakes and gunshots and so forth. But I just did it."

The point is to find a place that works for you and your partner. Where you can focus, relax, and create. Download from the universe.

As Mihaly Csikszentmihalyi says in *Creativity*, "It is not what the environment is like that matters, but the extent to which you are in harmony with it."

On the micro level, once you've found the right geographical setting, what kind of space is most harmonious for you? A public place? Home? Office? Or you may find, over the long haul of writing a script, a combination works best.

Writing in Restaurants

As we said earlier, we started working together at a Southern-fried restaurant where, for us, the conversations and the clatter of dishes harmonized with the back-and-forth energy of our brainstorming.

Writer/director Brad Anderson tells us that he too seeks out public places when he starts a script with Lyn Vaus, who co-wrote *Next Stop Wonderland*, or Steve Gevedon, who co-wrote *Session 9*, or Will Conroy, who co-wrote *Transiberian*. "The process begins with endless brainstorming, throwing anything into the hopper, kind of like free association," Anderson says. "It usually occurs at the nearest bar."

Harry & Renee Longstreet have also found public places conducive to starting a script.

HARRY: In the old days we used to go to this one coffee shop. It was our lucky coffee shop.
RENEE: In the old days.
HARRY: And we were younger. We had a lot more brain cells because we were quick.
RENEE: We'd go in there at eight in the morning. We'd sit and have breakfast, and we'd do Scene One, Scene Two, Scene Three—*boom boom boom*—and by noon, we'd be done with the story.

Still others like Matt Manfredi & Phil Hay find public places conducive to starting their writing day (or postponing it). "We go nine to five pretty much," Manfredi says, "but sometimes the nine is at the bagel shop."

Andrew Reich & Ted Cohen start their writing day by taking long walks.

TED: We walk. We always walk at the beginning.

ANDREW: Somehow there's less distraction. And we both think better walking.

But they're leery of writing their scripts in restaurants.

TED: We never take our computers to Starbucks or whatever and sit there and work. That's actually a thing that I have a superstition about. I don't like to move around too much writing-wise. I like to have one or two places where I can do it, so yeah, we work at Andrew's house or we'll work here [at Warner Bros.].

Robert Ramsey & Matthew Stone didn't write in restaurants because they found it too distracting, as they explained when we interviewed them for the first edition.

MATTHEW: I see people writing in coffee shops. [Shakes his head] At a coffee shop, we would never get any work done.

But restaurants played an important part in their writing day because they always went out for lunch.

ROBERT: Think how much we could save if we just brought baloney sandwiches! But we always go to the same restaurant. We sit there and read the paper all through lunch. And we know that the people who see us every day never talking to each other are thinking, *They don't talk!* We've been sitting there talking to each other all day. We don't need to talk at lunch.

For them, this silence—like negative space in a painting—was crucial to the creating they did. And the place had to be the same every time. The day we interviewed them, they were in a mild crisis because their favorite restaurant had just gone out of business.

ROBERT: They closed it. We've been thrown into chaos.

MATTHEW: It was a health food restaurant.

ROBERT: It was so unglamorous. It was healthy. It was so wonderfully not Hollywood.

You may find that public places are perfect for breaks or breaking out stories or other brainstorming when you're starting a script or your writing day. Restaurants and coffee shops have been a big help to us, but like Ramsey & Stone and Reich & Cohen, when it comes to the actual writing, we avoid public places. Drafting the script, we've discovered, demands a more private space.

Olivier Ducastel & Jacques Martineau say the same thing, they just say it in French. "*Pour les discussions, nous l'avons dit plus haut, tous les lieux sont bons, même les plus bizarres . . .*" they tell us. "All places—even the most bizarre ones—are good for our discussions. As far as writing goes, we have to confess that Jacques only writes in his bed with his laptop on his knees. For him, any other space is uncomfortable and lacks the power to inspire him."

Ultimately, that's what the right place, public or private, should do—offer comfort and inspiration.

Your Place or Mine?

Like Dorothy Gale, some writers believe there's no place like home. Fay & Michael Kanin and Larry Gelbart preferred writing at home. The same is true for Ducastel & Martineau, Peter Tolan, the Longstreets, the Batchlers, Manfredi & Hay, Reich & Cohen, Carolyn Miller, and many others. It's familiar. Private. Cheaper than renting an office. A shorter commute—for one of you anyway, unless you live together. And it offers the comforts of, well, home.

Marshall Brickman describes such comforts writing *Sleeper* with Woody Allen. "We would meet at his house and talk, and his housekeeper would occasionally bring out a tuna fish sandwich and a brownie, and then we'd go for a walk and talk. It was like anything but work."

If you and your partner prefer working at home and you don't live together, you'll have to decide whose house you'll work in, or you can trade back and forth. Manfredi & Hay choose to work at Phil's house, "which used to be both of ours before Matt got married," Hay says. The space is familiar to them, and there are fewer distractions. Other people, even people you love, can be a major distraction.

Like Henry Morgan's wife when he and Aaron Ruben were working on a half-hour sketch-comedy show. They wrote in Morgan's New York hotel room with his wife nearby on the couch.

"She's sitting there swinging her leg, and whatever we came up with, she made a comment on," Ruben remembered. "Now that's strictly forbidden, or as Germans say, *streng verboten*. You don't do that. You leave writers alone. You don't even sit in the room with them, even if you're ready to laugh. You let them do their work. But there she is, swinging her leg and saying, 'That's not very funny.'"

By the end of the writing session, Ruben was fed up, but he agreed to work with Morgan again the next evening—on one condition. "I said, 'No wives, huh?' And Henry had a look like, *How am I gonna tell her?* Well, he did tell her. That's the cardinal rule of collaboration—no third person in the room. No. No way. No non-combatants."

When we were both living in Tallahassee, taking turns writing at each other's place, we tried to work when Matt's roommate or Claudia's family weren't home. Eventually, Matt got his own house, and we worked there frequently—at the dining room table in the main room, which was larger and lighter than the room he'd turned into an office. But most writers we've met prefer writing in a space set aside for an office. Some married teams, like the Batchlers and Longstreets, maintain separate offices.

HARRY: We used to write in the same room, but when we had more room, we got them separated.

RENEE: When we had a big six-bedroom house, we had two offices where we wrote next to each other.

But when we interview them, their offices are at opposite ends of their home—Renee's with a view of the mountains surrounding the San Fernando Valley, and Harry's more tucked away, lined with posters of the projects they've written. (They've since moved to Washington State.)

The Batchlers have two offices too. "Lee's is downstairs," Janet says, "a cozy cave with a wall of curved windows that somehow remind one of the bridge of the Starship Enterprise. I have a huge office/library/family room upstairs where I write and also where our assistant works, but not while I'm writing."

Ducastel & Martineau tell us, "We do have an office, but it isn't used for writing. Well, it's rarely used for writing." Bed, as they've said, is where Jacques likes to write.

So *where* you work in the house can affect how you write. Again, find the space that's best for you both.

Office Space

For Alexander & Karaszewski, there's no place like an office *outside* the home.

SCOTT: It does amaze me how many professional writers still work at home. It's a funny profession where you can be at the top of your game but, "Hey, I got a little computer in the back of my bedroom I work at."

He and Karaszewski now write together in their airy Beverly Hills office. But it was a journey to find the right space. A space odyssey. Until they made their first sale, they wrote together in the apartment they shared.

SCOTT: We were still living together when we sold a script.

LARRY: Yeah, we were still roommates. So after we got that big check, we instantly got our own apartments. And that's when we sort of made it become more of a job-like thing.

SCOTT: Larry bought Jane Mansfield's old house. [Laughter]

For a while, when they weren't working in a studio office, they went back and forth between Jane Mansfield's old house and Alexander's new apartment, but this soon interfered with their work and their lives.

SCOTT: Actually, around *Ed Wood*, we started having kids, and then it became, *Oh, God*. You can't be trying to work when some kid is running around with a rattle and trying to get your attention. So then we had to have an office to go to. If the studio makes us a deal that's remotely central to our two houses, we'll take it. Or now we're here in a rented space.

LARRY: We like having a neutral space. It works better because if you have a bad day at work, it doesn't affect your house. You don't have that big blowout and fight over some scene, and then he gets to leave and drive home, and you're stuck there. You're just in the funk.

You may also prefer the neutral space of an office. Both of your homes (assuming you're not living together) may be too distracting. Going back and forth might be too much trouble. It may be psychologically important to you, as it is for Alexander & Karaszewski, to keep home and work in separate spheres.

Or having an office outside the home may enhance your sense of professionalism, as it did for Ramsey & Stone. Their move to an office was important and symbolic.

MATTHEW: It took it away from being like something you did in your house. When we first started, we lived together and we wrote at home.

ROBERT: About three feet from Matt's bed. [Laughter]

MATTHEW: When we sold a project to Universal, they gave us an office. And that changed our lives. We got up in the morning. I would drive to Rob's house, go over the hill—

ROBERT: We'd actually bathe and go to work.

MATTHEW: Yeah, we'd bathe. We looked like normal people, except for the job.

ROBERT: That's when we started to feel legitimate.

MATTHEW: It's a long road, a feature-length script. It's a long road. So even if you're working for somebody, you're not gonna be talking to them for a few months at a time. It's a completely structureless environment you work in. So we do anything we can to create the illusion that it's a job.

Ramsey & Stone's daily trek to their office on Wilshire Blvd. not only made their work feel more "job-like," it also increased their discipline. They told us they required "dogged, habitual predictability" in their work habits. There were days when they didn't get much done, but they still went to their office and sat there until they got *something* done.

An office, of course, is no guarantee you'll *be* disciplined. When Alexander & Karaszewski got their first studio office at Twentieth Century Fox, discipline went straight out the window.

SCOTT: We were just so excited to be on the lot. We were inviting friends over every day and taking them to the commissary and saying, "Look, there's Mel Brooks."

LARRY: We were having five o'clock Bloody Marys.

SCOTT: Four o'clock.

LARRY: Four o'clock Bloody Marys.

SCOTT: It wasn't dark yet. We were making Bloody Marys for all the other writers on the lot every day. We were just two giddy kids. And it took us many years to figure out that you have to be professional, you have to sort of clock in, you have to keep your employers happy. And you have to make everyone involved in the movie think that you're writing the movie that they each want to make. [Laughter]

Like Water for Creativity

Over the years we've enjoyed retreating to waterfront places to write. The sound of the waves helps us think and create. The power of water is well documented: A fellow writer saw a piece in *The London Times* that said the negative ions in running water stimulate creativity. Einstein's greatest ideas reportedly occurred in the shower, and Greek mathematician Archimedes' principle of displacement occurred to him in the bathtub ("Eureka!").

"Bathtub," in fact, is the name of Lucy Alibar & Benh Zeitlin's fictional bayou community in *Beasts of the Southern Wild*.

"Benh and I knew that we wanted to tell a story about loss in this beautiful land," Alibar tells us in an email, "loss of home, of family, of security, and what you keep when everything is taken from you. He showed me sketches and photos, I took him to readings, and we talked over moments that we saw, phrases we liked."

Many of their discussions took place at the Russian–Turkish baths in New York, where Zeitlin was recuperating from a crushed pelvis he suffered in a traffic accident as he left Austin's SXSW Film Festival.

As Alibar & Zeitlin tell ComingSoon.net:

ALIBAR: (Laughs) I remember being at the Russian–Turkish baths, and you pull out that portfolio and showed me all those pictures. You were drinking beer and I was drinking juice and we had the mud.

ZEITLIN: Yeah, so that was sort of what it was. Me and Dan Janvey, who was the producer on the film, we saw the reading of [Alibar's play] "Juicy and Delicious" at somebody's apartment.

ALIBAR: Yeah, like somebody's office building.

ZEITLIN: Not even a stage reading, just a literal reading, so we started thinking about whether we could turn either "Mommy Says I'm Pretty on the Inside" or "Juicy" or some kind of combination of the two into a short film. As I was working on both things, I had this sort of moment of "This is the same story and these two things can be combined," and then I had a bunch of ideas based on that and then I pitched it to Lucy that this could be a feature film. I think that's sort of how it went down.

ALIBAR: Yeah, on the roof of the Turkish Baths, a very important fact.

So they had their own "Eureka!" moment.

But a bath or shower may be too intimate—and too cramped—for most writing teams.

SCOTT: [Deadpan] We've taken showers together. It gets things going. Even if you don't write a scene that day, your back is clean. He's got a loofah. It's fantastic.

LARRY: [Gapes at Scott] I don't know *what* you're talking about!

The Right Stuff

Once you've found the right place to work, fill it—to the extent that you want it filled—with objects that have significance for you (and carefully arrange them, if you're a fan of *feng shui*).

Alexander & Karaszewski and Harry Longstreet line the walls of their offices with posters of movies they've written. Lowell Ganz & Babaloo Mandel decorate their walls with pictures of their children and cardboard cutouts from their hit films.

Ramsey & Stone kept a small statue of Buddha on their computer, though for the life of them they couldn't tell us why.

MATTHEW: I'm not a Buddhist. He's not a Buddhist. Somehow or other we ended up with this Buddha, and he always stays on top of our computer. We could write with him not there. [Laughter] You bought him from somewhere, right?

ROBERT: I got him somewhere.

MATTHEW: I don't know why we do it. We put him on our computer, and he's always pretty much been there.

We used to put a small statue of Pinocchio on the computer when we first wrote in person together (and knocked him off when we wrote poorly), but after interviewing Ramsey & Stone, we upgraded to Buddha.

How you fill your space may seem unimportant or self-indulgent, but Csikszentmihalyi assures us, "The kind of objects you fill your space with also either help or hinder the allocation of creative energies. Cherished objects remind us of our goals, make us feel more confident, and focus our attention. Trophies, diplomas, favorite books, and family pictures on the office desk are all reminders of who you are, what you have accomplished. . . . Pictures and maps of places you would like to visit and books about things you might like to learn more about are signposts of what you might do in the future."

Though you might feel a bit sheepish unpacking all this stuff at Starbucks.

We may have jilted Pinocchio for Buddha, but one thing in our non-public workspaces hasn't changed—we always fill them with music.

CLAUDIA: We've started our writing sessions with Vivaldi's "Four Seasons" for so long now, it's become an almost Pavlovian signal that it's time to work.

MATT: Except we usually lose Claudia during the *adagio* movement of "Winter." She stares into the middle distance and says upbeat things like, "I want that played at my funeral."

Speaking of funerals, while scripting our character Sam's memorial service in *Obscenity*, we underscored our writing sessions with a particular piece—the sorrowful "*Nunc Dimittis*" from Rachmaninoff's "Vespers"—to put us in the right frame of mind. In fact, we became so attached to the music that we specified the song in the scene description, something we rarely do. It's not unlike those filmmakers who decide that the temp track

music they used during editing ultimately proves to be the best score for the finished film.

Liar Liar co-writer Stephen Mazur tells the WGA that he and script partner Paul Guay play music during their writing sessions "to drown out the horrifying silence."

The aural equivalent of the blank page.

"Used to think I could write only to the sounds of silence," Guay says. "Now I listen to all my CDs and albums (in separate rotations, in alphabetical order by artist, of course, limit one artist per day; if you're gonna be anal, do it right). This means a lot of Beatles, Simon and Garfunkel, Rolling Stones, Elton John, and 'Seasons in the Sun.'"

Manfredi & Hay have also found that music can help.

PHIL: We've had a lot of luck with Kruder & Dorfmeister, these two Viennese DJ re-mixer guys, and their music. I mean, ten hours just go by. It's very trancey. I think it's really geeky, and Matt doesn't condone it, I don't think. I will occasionally make a tape of music that I think is somehow appropriate or just in the vein or tone of what we're doing. I listen to it on my own time, or I try to impose it on Matt.

MATT: He hasn't done that. He hasn't done that.

PHIL: Yeah, I have.

MATT: This is gonna come up later. [Laughter]

The Right Schedule

Like Butch Cassidy (or Maria Von Trapp), writers are hard to pin down. We writers like it that way. We love our freedom. That's one reason we chose this profession. But Larry Karaszewski is right when he says, "You sort of have to clock in."

Whether you're writing on assignment or spec, you'll need to keep a regular schedule if you're going to deliver the script.

"This whole thing is about delivery," Gelbart said. "We're really gifted UPS men. FedExers, you know, because it's gotta be there. It's gotta be there. So you don't have a lot of time. But it's enough time for us."

You will have to decide—or discover by doing—what writing schedule works best for you and your partner. Yes, it's doubly difficult because you both have busy lives, but that is precisely why you must do it.

"You wind up having to put together some kind of time structure," Karaszewski insists, "which is one of the things that makes writing with a team different than writing by yourself. Because writing by yourself, you can let the Muse follow you wherever you go. You're awake at 3:00 a.m., you got a good idea, you can get up in your underwear and start writing. When you have a partner, you can't do that."

You will need to consider your commitments and circadian rhythms, then carve a "time structure" out of the chaos. And, hey, once that's done, the rest is simple.

"You just show up and do the work," says Marshall Brickman.

The Commitments

In the beginning, however, it wasn't easy for Allen & Brickman to show up and write. Brickman had quit the folk-music business ("I got frightened of the idea of reaching 30 and still having to carry guitars and banjo cases around," he says) and landed a job on *The Tonight Show* with Johnny Carson. Brickman rapidly became the head writer. Woody Allen, meanwhile, was starring in *Play It Again, Sam* on Broadway. Despite their hectic schedules, the two found a way to write together.

"Woody was on stage from 8:30 till about 10:15, 10:30 if the laughs were good," Brickman says. "So we used to meet between 10:30 and 1:00 a.m. and work on stuff. Very odd. Crazy, even. The kind of thing you can only do when you're young."

When we started writing together, we had to create a schedule around our full-time teaching and Claudia's family—no small feat since we both taught during the day, and Claudia felt strongly about being with her family at night. Fortunately, we were able to schedule our classes at similar times. This allowed us to write every day when we both had time off.

Even writing teams that don't have to accommodate outside work often have to accommodate family. The Batchlers worked out an elaborate schedule to write and take care of their two children when they were little.

LEE: Our deal was, Jan gets them up. I get their sunscreen on, and she gets them to school. After dinner I get their baths, get them ready for bed. So after 8:30, 9:00 p.m., I have to take an hour to get into another world. Then at 10:00, I'm ready to get to work.

JANET: He usually works till about midnight or 1:00 now. I would rather stay up late, but it's easier for me to get up in the mornings, so I take that shift. Staying up till 2:00 a.m. is no longer an option.

Having children has also changed the writing schedules of Alexander & Karaszewski.

"We generally work an eight-hour day, though the eight hours slide around a bit," says Alexander. "If we're involved on a production job where there's a movie getting made in the imminent future, then we'll work 10-hour days or 12-hour days or Saturdays and Sundays. But other

than that, we work a 40-hour week. And now we've both got kids. In the old days, we'd be in the office probably till about 8:00 every night, and now we wanna be home to see our kids before they go to bed."

In our first-edition interview, Ramsey & Stone told us they created a schedule that honored that delicate balance between work and home.

MATTHEW: We show up sometime between 9:00 and 9:30 a.m., and we usually, on an average day, leave around 3:30, 4:00 p.m. It's good. We both have families.
ROBERT: It's a great lifestyle.
MATTHEW: When we're really kicking butt and we're close to finishing something, we work seven days a week. We work Saturdays and Sundays. We pull a morning shift. Sometimes we'll even come in for a night shift a couple times a week, like 7:00 to 10:00 p.m. If you can just get that leg up on that scene for the next day, you can maybe figure out a problem.
ROBERT: We do burn the midnight oil every once in a while, but overall our schedule is pretty enviable.

So happy problems like production demands or those periods when you're "really kicking butt" need honoring too.

Ducastel & Martineau, in fact, let the writing process itself dictate their schedule. "As far as how long we work, there really is no limit, unless fatigue sets in," they say. "Really, it depends on where we are in the writing process. Generally speaking, we stop when we're tired."

But if they still have more ideas about the script they're working on, they'll push on because "it makes it easier the next day to pick up where we left off."

Chad & Carey Hayes are very disciplined with their writing schedule, partly because they're devoted multitaskers.

CAREY: We're up at 5:00 and write till 7:00, 8:00 o'clock, go to the gym for a couple of hours, come back, write. Sometimes till 7:00 at night, 8:00 at night. It's just to get the job done.
CHAD: Depends on where we are.
CAREY: Yeah, it really depends on the workload because we rarely do one project at a time. We're working on multiple projects, so we kinda split up the time depending on the due date and the work we did and all that.

Whether you're working on multiple scripts or just one, the important thing is to create a schedule that allows you to create and—when other commitments conflict—to remain flexible and find a way to keep writing.

When Manfredi & Hay's production schedule gets too hectic, they'll write nights and weekends, whenever they can find free time.

"Usually we don't like to do that," Hay says. "It's more productive to just try to limit ourselves to working five-day weeks. And we've figured out that a good day is four or five productive hours out of that day."

Though he and Manfredi have also discovered, as we have, that writing together allows them to work longer than they could solo.

"Collaborating extends the workday," Hay says, "because we can find anything—many things—to talk about other than writing."

So can we.

There's always something going on in our lives or the world that we can discuss. Distracting as this can be, we've learned to let ourselves talk before we start work. It's important connection time that greases the creative wheels by getting a dialogue going. It's not a bad warm-up for writing dialogue either. And as Harold Ramis said, it's the way partners forge a shared point of view.

But we've also learned to contain it, especially when we're drafting a script. We give ourselves half an hour or so to shoot the breeze, then we start writing. If extraneous matters come up, we say "Sidebar!" and turn over the egg timer we bought for this purpose. When the three minutes run out, we get back to work.

The Rhythm Method

But there's no gadget we can buy that can change our circadian rhythms. Claudia's a morning person, Matt thinks mornings are *heinous*. Matt's a night owl, Claudia's a drooling zombie by 10:00 p.m.

You can change locales to find the right place to work. You can change jobs to create the right schedule. But you can't change your own or your partner's hardwiring. If you try, it could create bad feelings all around.

"My ex-husband had some issues," Carolyn Miller puts it politely, "because I was more of a late riser than he was."

She couldn't help it, and he wouldn't respect it. This impasse became such a sore point in their collaboration, a career counselor had to help them work out a solution.

"We found a compromise," Miller says. "We determined to start at a certain time, and we worked between X hour and Y hour. And we'd have a long lunch break, just to recharge. Generally we would not work after dinner so that I could find my own pace, and he'd find his. It worked out, and it reduced a lot of stress."

If you and your partner are lucky enough to have the same circadian rhythms, count your blessings and create a schedule that capitalizes on that. Reich & Cohen are both morning people, so they do their best writing then.

ANDREW: We have four really productive hours from 9:30 a.m. to 1:30 p.m.

TED: Usually after lunch we never get anything done. [Laughter] After lunch we come back, and it's like, *Oh my God*. We've usually left the hard stuff, so we know we'll attack it fresh in the morning.

ANDREW: And we never work at night. If the script is here, and we're here, then we might work at night. But I can't write once it's dark out and I'm home. It's so depressing to me, I just can't do it.

If you also have the same circadian rhythms, but commitments prevent you from writing when you prefer, create the best compromise you can. And do the same if you have different circadian rhythms. We would prefer writing at opposite ends of the day, but we compromise by writing together during the six hours that seem the least heinous to both of us, from 11:00 a.m. until 5:00 p.m. Sometimes we'll work later or a little earlier if we're really cooking or we have a tight deadline, but never late at night or first thing in the morning.

Like so much else in a good collaboration, the key is mutual respect.

CLAUDIA: We're very respectful—well, I'm more respectful. [Laughter] It can be especially tricky when we travel to each other's home and we're working under the same roof. But there are advantages too. I love the early morning hours to myself. Often I'll look over our script and have some ideas by the time Matt makes his appearance.

MATT: And I do a lot of mop-up at night, long after Claudia's crashed. Sometimes I'll leave her Post-It notes on the screenplay. Something like, *We have a problem on page 35. Fix it!*

It's the best of both circadian rhythms.

If you're new to writing—or co-writing—all of this stuff about schedules, rituals, routines, and, well, *stuff* may sound like the lunatic fringe, but it isn't as crazy as it may seem. In *The Psychology of Writing*, Ronald T. Kellogg says there is "evidence that environments, schedules, and rituals restructure the writing process and amplify performance.... These practices encourage a state of flow rather than one of anxiety or boredom. Like strategies, these other aspects of a writer's method may alleviate the difficulty of attentional overload. The room, time of day, or ritual selected for working may enable or even induce intense concentration or a favorable motivational or emotional state."

Not so crazy, right?

The Long-Distance Collaboration

Absence makes the heart grow fonder, or so they say, but what does it do to the collective brain? When Matt headed west for L.A., we were about to find out. We weren't sure how—or even if—we would maintain our collaboration. After all, we'd written every word together, in the same room, huddled over the same computer. How would the process work 3,000 miles apart?

Very well, we've discovered during the many years we've collaborated long distance, whether we're co-writing scripts, plays, or books, especially since the advent of Skype. Until Claudia moved to L.A., most of our co-writing took place in cyberspace.

Scott Neustadter & Michael H. Weber swear that writing apart is the secret of their success, as they tell MakingOf.com in a video interview:

SCOTT: He lives in New York. I live out here in Santa Monica. We do all of our writing separately. We talk on the phone and email a lot in the beginning when we're doing the outline. And then we divide up scenes, and we just email them back and forth.

MICHAEL: We've never written in the same room. Even when you lived in New York, we didn't write in the same room. We sort of go off to our separate corners after the outline is ready to go. And just divide up and email.

SCOTT: The farther we are from each other, the better our stuff is.

MICHAEL: I think you should enter the space program and go into orbit, and then we'll really get a good one.

Long distance also served Jim Cash & Jack Epps, Jr., well by keeping them focused and productive during telephone work sessions. "At that time it was just very short phone calls because it was long distance, and AT&T was a monopoly and they charged a lot. So we never really did a lot of schmoozing: 'So what's happening?' 'Do we have to work today?' It was like, 'I'm paying for this phone call. Let's do something. This is expensive. Let's get to work.'"

It also helped with creative breakthroughs and overcoming writer's block.

"What was great about not being in the same room is we'd hang up the phone on an idea," Epps says. "We'd say, 'Okay, we've got to figure this out. I'll call you back in an hour.' We'd call back and both almost always have the same idea. We'd come back with the same idea. We both got to the same conclusion."

Even after *Top Gun* and other hits catapulted their career, Cash & Epps preferred to work thousands of miles apart because they didn't want to mess with a winning streak.

"We really were very concerned about not breaking it," Epps tells us. "It wasn't broken, so why would we have to go fix it? We didn't want to jinx it."

When Ed Solomon & Chris Matheson started collaborating, they both lived in L.A. and, like us in the beginning, wrote every word together. They decided to turn their series of comedy sketches about two high school kids, Bill and Ted, into a screenplay.

"We spent three days outlining and four days pounding out a first draft in longhand," Solomon says. "Then I typed half, and Chris typed half."

Their script for *Bill & Ted's Excellent Adventure* was optioned for $5,000 and sold for $15,000. But after the surprising popularity of that film and its follow-up, *Bill & Ted's Bogus Journey*, the team split, with Matheson moving to Portland, Oregon.

"That was tough, like any breakup," Solomon says. "But looking back on it, it allowed both of us to pursue our own individual voices." (Solomon, for example, wrote *Men in Black*.) "And in many ways it made our return to collaborating even more rich."

That return happened several years later, when Solomon called Matheson in Portland and proposed creating a series of three- to four-minute cartoons for the Internet called *Automatons*, based on an idea they'd conceived while working on *Bill & Ted*. Matheson agreed, and they began co-writing again—mostly by phone.

"We'd talk four or five days a week, for one to three hours," Solomon says. "I'd type, but we'd create every word together. We'd each make notes on hard copies of the scripts. We just kept writing, and after about 25 pages, we said 'Screw the Internet.'" They decided to turn *Automatons* into a feature.

Tony Urban & Michael Addis did not say, "Screw the Internet." They co-wrote *Poor White Trash* entirely by email.

"Michael and I created a very in-depth outline/treatment, breaking down every single scene," Urban says in *Screenwriting on the Internet*. "Then we split the script in half. He took the first part, I took the second, and we wrote it in a few days. The next few months were spent polishing."

They hadn't even met until Urban drove to the film set in Illinois, and they were "off to do rewrites."

As technology advances, you have an ever-increasing number of options for maintaining a successful long-distance collaboration—phone, email, Skype, FaceTime, Google Docs, Dropbox, Movie Magic Screenwriter's iPartner—with new options appearing all the time.

Ultimately, deciding where, when, and how you work is a means to an important end—working well together, even if you're working apart.

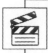 **Script Partner Points**

- Explore different places—home, office, coffee shop, restaurant, beach, etc.—to see where you both work best.

- Consider your commitments and carve a work schedule out of the chaos.

- Respect your circadian rhythms.

- Create rituals that encourage concentration and productivity.

- Write regularly instead of waiting for the Muse to speak to you and your partner at the same time.

- Fill your workspace with music and/or items of significance to you both, whatever will focus your creative energies and put you in the right frame of mind for a particular project.

- If working long distance, explore your technological options until you find a method that works well for you both.

"You must choose. But choose wisely. For as the True Grail will bring you life—the False Grail will take it from you."

—Grail Knight (Robert Eddison),
Indiana Jones and the Last Crusade

SIX
Choosing the Right Project

You've found the right workplace and schedule, be they ever so humble or complicated. Now you have a much more important decision—which script idea will you choose to write? You may be a new team or a team that's established. You may be writing spec scripts or the opposite of specs—assignments. Whatever your situation, you have to go through this process.

"Every once in a while we stop and say, 'What do we want to do next?'" Matt Manfredi says. "Do we want to write something for ourselves to direct or a spec script or a pitch?"

You don't want to choose poorly. You want to pick the *right* project. This, of course, means different things to different writing teams. It depends on who you are, what you want to write, and where you are in your life and career.

Specs

The wonderful thing about spec scripts (vs. work for hire) is that you get to write what you want and how you want to write it. But since a studio or production company hasn't commissioned the script, you may never be paid for all your hard work. Once your spec script is finished, someone *might* option it or even buy it, but there's no guarantee.

Still, there are some excellent reasons to write a spec—you want to get your idea on paper, you want to see how you both work together, you want the practice, or you want an industry calling card. So don't write it off before you write it.

To Spec or Not to Spec

We wrote our first script, *Obscenity*, because the story and issues compelled us to write it. The story was character driven and more indie minded, so we knew it wasn't a studio piece. We wrote it on spec.

Jim Cash & Jack Epps, Jr., made a similar decision.

"The first one we wrote on spec," Epps says, "and we got a great option to the point it was almost the purchase price. Which gave us enough money to make the second one, which then went to a bidding war and got close to being made but didn't, and I'm actually thankful it didn't."

Not something you hear every day from screenwriters.

"It wouldn't have been done well," Epps explains. "In many ways we were fortunate that it took seven screenplays, seven projects, before something got made because we had to work so much harder to get something made. And we learned so much in the process. If we had gotten something made early, we would've said, 'Oh, we know it.' Well, we didn't know it."

Mastering the craft of screenwriting can be a long learning curve.

Before their studio blockbuster *Batman Forever*, Lee & Janet Batchler also wrote their first screenplay on spec. Knowing they had a lot to learn about the craft, they did it just for practice—a good idea if you're beginners.

JANET: The first thing we did, just to see if we could do it, was to adapt a book which we didn't have the rights to, which was very stupid.

LEE: But we also realized that this was practice, that we weren't going to try to go out and sell it. But something that we always come back to is—if the story is no good, it doesn't matter how finely you polish it. So we looked around for a good solid story.

JANET: And we just said, "Let's try and see what it's like to put something into screenplay form, and to figure out what you leave out and what you put in."

Several years and screenplays later, the Batchlers found themselves barely surviving as writers in Hollywood. They hadn't sold what they wanted to sell and felt capable of doing far more than the world knew they could.

LEE: We were our own best-kept secret. We felt we were ready for a better agent. We wanted to play in the big leagues. And no one is going to invite you in until you show what you can do. We had to write a truly great script. A weekend read.

JANET: A script so good that they had to read it, so good they didn't have a choice. We knew we needed the idea that was good

enough, the story that was good enough, before we could write that script.

They were right. And after several months of searching, they landed on the right idea, based on real-life events: French magician Jean Robert-Houdin is sent to Algeria in 1855 to prevent a bloody civil war led by a self-proclaimed sorcerer.

The Batchlers spent a year and a half writing the script—nine drafts—but when it was finished, *Smoke and Mirrors* went out on a Tuesday and after a fierce bidding war, sold on that Friday.

It was also a bumpy ride to success for Andrew Reich & Ted Cohen. Like the Batchlers, they wrote their first script just to see if they could do it—and for fun. A few years and cancelled shows later, they weren't where they wanted to be as writers either.

ANDREW: We had worked on *Minor Adjustments* and *Mr. Rhodes*, shows that didn't go a full season and weren't that good. Our career was not on a huge upward path.

Then the right project for them came along.

Warner Bros. invited Reich & Cohen, then freelancers, to write one episode of *Friends*, with the understanding that the studio might offer them staff positions if they liked the script.

ANDREW: We had three days to write a show that was really our shot at a career.
TED: There was so much pressure.

A couple of days later, Reich showed a draft of their script to his ex-wife who "just kind of like, um, didn't love it."

ANDREW: She was kind of critical of it. I was already panicky, and it made me lose faith in it, and it was right before we were going to have our last day to go over it, and we were basically out of time. I remember being like, "I just don't think this is that good." I'm sure I was freaking out, and I was making Ted freak out, and I remember him going, "You know what? It's good. It's good. We don't have any more time anyway, and seriously, it's good." And we handed it in, and we got hired. And *that* I remember was a good lesson to trust the other person. I know to trust Ted more than my ex-wife. [Laughter]

Writing the script was as far from fun as they've been as co-writers, but gutting it out got them on the show.

Hey, if you've got a shot, take it.

Convinced their career *was* shot, Scott Alexander & Larry Karaszewski wrote *Ed Wood* on spec. They'd had earlier success with *Homewreckers*, then sold their pitch for *Problem Child* to Universal Studios, only to be replaced by a committee of no fewer than nine writers. The finished film was far from their original vision.

LARRY: We wrote *Problem Child* as sort of a black comedy for grown-ups.

SCOTT: We were picturing *War of the Roses*.

LARRY: Yeah, and it got dumbed down to a very silly kiddie movie. But it wound up being a big hit. And we wound up being corralled into doing the sequel. But weirdly enough, we had to write a sequel to the movie that was made as opposed to a sequel to the movie that we wrote, so it was a very awkward experience for us. And both movies were despised critically, so we actually had problems getting jobs after that. We were very disappointed by the whole working-for-Hollywood thing. We said, "If we can't get a job, we might as well just write the thing that we've always wanted to write." Back in college, we had talked about making a movie about Ed Wood, but we figured, "Who would make this kind of movie?" But fuck it—we didn't care at that point, so we went off and did it.

SCOTT: That was Larry swearing in your book. It wasn't me.

But they make a great point. To quote *Risky Business*, "Sometimes you gotta say, 'What the fuck.'"

And years later, after their screenplay about the Marx Brothers didn't get made, Alexander & Karaszewski returned to spec writing with *Big Eyes* so they could maintain control and direct the film themselves. Ironically, it took 11 long years for the film to get made, directed by Tim Burton (with their blessing).

Brainstorming an Idea

You may already have an idea. Or your partner may have one. This is often the case with collaborative pairs.

"A lot of times when we're finishing up a project, we'll start saying, 'What should we do next?' So an idea will just sort of come," Karaszewski says.

"Usually one of us has an idea," says Phil Hay. "Matt and I are just sitting around, and someone says, 'I have an idea for a movie.'"

But some gifted writers like Peter Tolan just aren't gifted at coming up with ideas, so their partner has to be the idea person. That tends to be the case with Olivier Ducastel & Jacques Martineau.

"Olivier brings ideas and always brings the desire to make a new film," they tell us. "Jacques is a bit lazy if you don't push him to work and to write. So Olivier always gives the starting impetus. He often gives a starting sketch, even if it's very vague. For example, with *Drôle de Félix* (*Adventures of Felix*), Olivier talked about wanting to film French landscapes and wanted to tell the story of a boy who would go in search of his father in Marseille."

Whatever the case in your collaboration, if one of you has an idea, run it past your partner. Give a starting sketch. For some teams, this part of the process is very informal. Others, like Manfredi & Hay, turn it into a mini pitch.

"We'll kind of present it," Hay says. "Usually when you get to the stage where you present it to each other, it's a pretty good idea because I have a million bad ideas all the time, and I'll realize in five minutes they're not good, and I don't bother Matt with them. But sometimes I think this is an idea that just might work."

Our style's a bit different. We'll pitch a lot of ideas, even ones that might be bad because they could lead to something better. With this buckshot approach, many ideas get shot down. Yes, this could be painful, so we've made up a routine to keep ourselves laughing. We pretend we're skeet shooting, tossing ideas in the air like clay targets. If one has potential, we explore it. But if one sucks, we shout, "Pull!"

This keeps us loose, less ego involved, more creative. The point is to get your idea out there, whatever your style. Kick it around with your partner. Brainstorm a bit. And yes, give each other the freedom to suck.

"We spend a couple of days throwing things around," Karaszewski says. "You don't really try to put any kind of constraints on it. You're just randomly throwing out ideas. And usually when it's good, it comes pretty quickly. Because all of a sudden you'll throw out an idea, and it'll lead to another idea, and it will just naturally sort of write itself in a weird sense."

Manfredi & Hay draw on their improvisation background at Brown when they brainstorm ideas. "Ideally, what happens is the old improv thing," Hay explains. "'Yes and . . .' is the rule. You always say, 'Yes and . . .' then 'and something.' So I'll say, 'I think we should do an action movie, and I've come up with a high concept, and here it is.' And Matt will say, 'Yeah, and I think here's who the main character should be.' Or combining two genres we want to do. 'We're gonna do a science-fiction movie. What if we made it a love story?'"

Making Sure It's a Movie

By exploring your idea's possibilities and the genre—or genres—that might serve it best, you're testing to see if it's really a movie.

"That's the first question we ask," Hay says. "Is this a viable movie?"

To answer that question, you and your partner will need to ask yourselves a whole bunch of questions.

Like Cash & Epps did:

"Our process from a collaborative point of view was to basically work the idea together," Epps says. "We spent a lot of time together working the idea. Figuring out what the movie was. What's the movie? What is this about? What is the story? Who are the characters? All the basic questions that all writers ask themselves, but we're doing it as a team and working together on trying to figure out the big picture. What is this thing? How does it work? How does it function? Where does it begin? Where do we think it will end? All that sort of stuff."

And like Alexander & Karaszewski do:

"What are the big scenes? We tend to be more plot-oriented in terms of the events of our movies," Alexander explains. "This probably comes from having written *Problem Child*, which at the end of the day ended up being about six or seven big set pieces strung together, and it was called a feature. So sometimes we say, 'What are the big trailer scenes?' That sounds sort of ridiculous, but we can be writing *Larry Flynt* and saying, 'Do we have the trailer moments? Do we have big moments that sort of define the movie?'"

And the Hayes brothers:

CAREY: We won't sit down and go, "Okay, the first beat of the outline." We'll sit and we'll start talking story. "Wouldn't it be kinda cool if this and who's that character and what's the conflict and where are we going and how do we want to button this and who's interrupting and who's changing it up and all of that?" And we'll figure out the story and you get into this rhythm. Then you go, "All right, we can kinda tell the story."

When their genre is horror, they know it's a viable movie if they have enough "scare moments."

CHAD: When we were out pitching *The Conjuring*, we literally pitched it like, "A happy-go-lucky family in a vintage station wagon pulls up into this long driveway down to a century-old farmhouse. There's moss on the trees, there's—"

CAREY: "But you get the strong sense that there's something inside the house watching them."

CHAD: "Then they joyfully burst out of the car, anxious to run into the front door. Everyone but the dog—the dog refuses to go inside. The guy looks at him and goes, 'What are you, an idiot? Come on inside.' But the dog won't. 'All right. Stupid dog.'"

CAREY: So you hang on moments like that. Scare moments.

CHAD: You pick those— And we'll go through the whole movie like that. Seriously, just like that.

From *The Conjuring*:

EXT. FARMHOUSE — HARRISVILLE RHODE ISLAND — DAY

A 1970's wood paneled station wagon, with New Jersey plates, drives down a gravel driveway.

 ROGER (V.O.)
 Here we are —

A hundred yards back, now much older, is the same two-story farmhouse and barn. Trees have grown. It's been well cared for.

The station wagon comes to a stop in front of the house. Getting out is the driver, ROGER PERRON, a lean man in his early thirties and his wife CAROLYN, who's simply dressed with her hair pulled up — also early thirties. [. . .]

EXT. FARMHOUSE — FRONT PORCH — RIGHT AFTER

Carolyn and the girls are next to Roger as he opens the door. Andrea dashes in.

 ANDREA
 I get first dibs on the rooms.

Cindy looks to her dad as she enters —

 CINDY
 Do I get to pick my own room, or do
 I have no choice in that too?

Roger's eyes meet Carolyn's — who seems amused.

 CAROLYN
 This is why some animals eat their
 young.

She gives Roger a quick kiss as she enters. He playfully slaps her on the butt.

Roger turns to see [their black lab] Sadie standing several feet back, staring in through the open door. There's a deep intensity behind her dark eyes — her body rigid. Roger's confused.

 ROGER
 C'mon, girl.

Sadie takes a reserved step backwards. Keeps staring.

 ROGER (cont'd)
 Sadie, c'mon —

The dog remains still — has no intention of getting any closer. Roger lets it go.

 ROGER (cont'd)
 Dumb dog.

Exploring the Genre

Answering all these story questions can take time. So can coming up with the appropriate genre(s). It took us a while to decide on the right genre for *Obscenity*. It was clearly a courtroom drama, but would it be more of a character piece? Or a high-stakes thriller? Horton Foote-ish? Or John Grisham-esque?

Brad Anderson and his writing partners also take time to explore the best genre for their ideas. "We riff off of what kind of movie we want to make, what genre, and how we must studiously avoid the clichés and hackneyed characters most often associated with that genre."

It's a fruitful part of the process, helping you find a fresh take on generic conventions.

"Pick a genre and take it to the moon," recommends Quentin Tarantino, who did exactly that with the gangster genre when he and Roger Avary wrote *Pulp Fiction*.

So did Manfredi & Hay when they wrote *crazy/beautiful* and turned the teen movie into a moving adult drama. And Alexander Payne & Jim Taylor reinvented the high school movie when they adapted *Election*. "I wasn't going to make a high school movie," Payne tells *Scenario*. "It was an adult movie set in a high school."

And the right genre for your movie may reveal itself as you research your idea. Cash & Epps thought they were going to write a war movie with *Top Gun*, but a jet ride changed everything.

"What we *thought* the movie was before I took that jet ride and what it was afterwards are two different things," Epps tells us. "After I took the ride I called Jim and I said, 'This movie is not what we think it is. It's not a war movie, it's a sports movie.' These are the greatest athletes in the world who do their athletics at 28,000 feet at high rates of speed in a way that nobody has ever done before. And that's what this story is about—a sport. It's a story about a guy who wants to be the star. There's only one star, there's only one quarterback, there's only one goal tender in hockey, there's only one of those guys, and the only way you win that position is you have to be the best. And the reason we had locker room scenes was not to show off guys' bodies but because in sports so much happens in the locker room. People don't really realize that the team comes together or falls apart in that locker room. The team then steps out on the field based on what they have built in that locker room. And then they play and they connect that together."

Connecting to the Idea

Once you've explored your idea and its genre(s), and you're sure it's a viable movie, make sure you're the right people to write it. The best idea can be the worst script to write if you don't find a way to make it your

own. In some way, on some level, you both need to find a connection to the material.

Phil Hay tells us that he and Matt Manfredi ask themselves, "'Why is it interesting to work on? Why do we need to do this?' For example, in doing *crazy/beautiful*, it was like, 'Why would we be good at writing a teen movie? We *wouldn't* be good at writing a teen movie, so we want to write a drama about teenagers that isn't a teen movie. We want to write a love story that is a serious adult drama, but the characters are teenagers.' That was what got us excited."

Alexander & Karaszewski were both excited about the idea for *Big Eyes*, the story of Margaret Keane (Amy Adams), whose abusive husband, Walter Keane (Christoph Waltz), took credit for her highly successful paintings of big-eyed children, so popular in the 1960s.

"My wife likes kitsch and had this book, *The Encyclopedia of Bad Taste*," Karaszewski tells Deadline.com. "And I was just flipping through, trying to get ideas of random things we could put on this planet. There were two pages about Margaret and Walter Keane that just grabbed me. I was completely unaware of this story, just like 99.9 percent of the world."

"Two things we found so interesting," Alexander adds, "the debate between high art and low art and the idea of Margaret as a metaphor for pre-feminism and then paralleling the women's movement, people are really responding to those ideas. It is nice people seem to like the movie and the ideas there."

And as Karaszewski explains to SlantMagazine.com, he also connected deeply to the material because of his own mother. "She stayed married to my father for 20 years in the same exact time period, and the only reason they didn't get divorced was that she was a Catholic girl, and it was a sin, and, you know, she certainly didn't consider herself feminist. But she wound up doing a very Margaret-like thing: grabbing all the kids in the middle of the night, driving away, getting a job, and working for herself. This was right around the same time period. So I think this is something that just happened to American women during this time. So Margaret's story hits home."

And Lucy Alibar connected to *Beasts of the Southern Wild* partly because of her father.

"What Benh and I talked about was 'losing the thing that made you,'" she tells us in an email. "I was seeing my dad sick and getting a sense of his mortality for the first time. And we both were drawn to stories of people who have been forced from their homes and trying to live elsewhere."

Sometimes it takes a while to find your connection to an idea. After co-writing *Analyze This* with Peter Tolan, Billy Crystal approached him with a new concept—a publicist has to get two stars/lovers back together to promote their latest movie.

"To be honest, I really didn't want to do *America's Sweethearts*," Tolan confesses. "I had just done, like, six years of *The Larry Sanders Show* and didn't want to do any more stuff about the business, inside the business."

But he'd enjoyed working with Crystal on *Analyze This*, so he finally caved—on one condition. "I said I'll do it if it's kind of an acerbic, biting, edgy, dark, mean-spirited movie. As long as people are behaving badly, that's when I see the humor of things—when people misbehave."

In other words, he found a way to connect to Billy Crystal's idea and make it his own. That's what you have to do. In this business, however, there's no guarantee it will *stay* your own, that it won't become the Project From Hell.

Tolan wrote a draft that he liked, but the studio at the time, Castle Rock, said they saw the project as more of a romantic comedy. "Which was like a knife in my heart," Tolan says. "I really don't do a lot of those. I'm not a real romantic."

Though he doubted Castle Rock really wanted to make the movie, he wrote a more romantic second draft—"a fool's errand," he calls it. Sure enough, the studio passed. Tolan felt some relief, but a few weeks later, Crystal called him with the news that he'd sold the project to Joe Roth, who ended up directing the film.

Tolan was less than thrilled. "I'm like, *Oh God, I have to work on this again!* And I said, 'Does he have notes?'"

Two weeks later, Crystal phoned again. The news this time? Julia Roberts was attached to the project. "I'm like, *Oh no,* because now it's not just a movie, it's a *Julia Roberts* movie, and that required a great deal of work."

Tolan stayed on the project through all the script incarnations. "It's like a curse!" he laughs. "Torture, really torture. And rather than go into all of the awful details, I worked through the actual production of the movie, which was very difficult from a writing standpoint."

In the end, Tolan lost his sense of connection, but you still need to find it before you begin. This is essential. You both need to care. If you don't, you'll get partway through the script and realize you don't give a damn. This is not a good feeling. It's akin to Wile E. Coyote running off a cliff and looking down and realizing he's gonna fall and crash. Chances are your project will too.

"That seems to me the only thing that can truly destroy a script," Phil Hay says, "which is why I feel the most important question we ask ourselves is, 'Why is this interesting? Why is this different? Why do I care?' Because it seems like the only real threat to having a script self-destruct is if you get halfway through it and you just don't care. And nobody cares."

We collaborate on our projects because we both care about the ideas. But there have been times—and this can get sticky—when one of us wants to co-write an idea but the other does not.

CLAUDIA: I had this idea for a script about a freshman quarterback, but when I pitched it to Matt, his eyes glazed over.

MATT: My subtle indication of disinterest in football.

CLAUDIA: I knew I'd have to write the script by myself—a miserable prospect. So I let it go.

If your idea isn't right for you and your partner, don't force it. Write it solo someday. Or explore other ideas until you find one that excites you both.

The Opposite of Specs

If you write and sell a script based on your own idea—and see it made into a movie you like—congratulations, you've reached Script Nirvana.

But the reality is closer to what Jack Epps, Jr., calls "the agony of originals. You know, you write wonderful originals, and they never quite make it to the screen because you basically get assignments, and assignments get made. And what you learn quickly is there's their idea, which they really like—or your idea, which they don't care about. So which one are they gonna make? And that becomes evident pretty fast."

Some successful studio writers long to script their own ideas and see the movie made (scratch a hired gun, find a frustrated spec writer), but many hit dead ends when they try.

As Ramsey & Stone told us in our first-edition interview:

ROBERT: We can't walk into a studio and just sell them our ideas. We have not perfected that particular activity. And it's very frustrating.

MATTHEW: Our impulses are decidedly left of center. So what happens is we take these impulses, and once in a while we kind of float these balloons to people that have money to see if they're feeling a little left of center today. Honey, they're not. We've been shot down many times pitching our own ideas.

ROBERT: You're having a meeting with somebody, and you're sitting there drinking your carbonated beverage. And they always ask you what you want to do. It's in the rulebook, that studio executive's rulebook I haven't seen. I know it's in there—page 37, I bet. It says, "Ask the writer what they want to do." And they politely dismiss it and move on. "Oh, that's interesting, now let's talk about what we want." Everybody has their own agenda.

MATTHEW: They've got stacks of scripts that need to be written. They've got projects. Julia Roberts needs something developed for her. "There's this new comedian. You've never heard of him, but he's going to be big, and we're trying to develop something for him." Okay, so who's generating these ideas? I don't know. They're coming out of the ether.

Since their own ideas didn't sell, Ramsey & Stone wrote other people's—like Eddie Murphy's concept for a prison comedy called *Life*. The impetus

for that project came from producer Brian Grazer, who asked the writing team to meet with the comedy star.

MATTHEW: At first we said, "Are you insane?"

ROBERT: We went down in the elevator thinking that's the most ridiculous thing we ever heard. Us writing a prison comedy for Eddie Murphy? They must be high. [Laughter] But then we got this call saying, "They're really serious. Do you want to do this?" We're like, "Uh, all right." And suddenly we're on a plane to New York to meet Eddie.

MATTHEW: And really, all Eddie Murphy had was, "I wanna do a movie about two guys who get stuck in prison. I don't know if they know each other."

Ramsey & Stone wrote an 18-page treatment for *Life* and then the full-length script, which made it to the big screen with Eddie Murphy and Martin Lawrence, directed by the late Ted Demme.

Connecting to the Material

The bulk of the work in the biz is writing other people's ideas, but you and your partner still need to find a way to connect.

Just as Alibar connected to *Beasts of the Southern Wild* because of her father's illness, Scott Neustadter related to John Green's bestseller *The Fault in Our Stars*—a romance between two teens with cancer—because his father was battling terminal pancreatic cancer. So he and Michael Weber campaigned to adapt the novel for Twentieth Century Fox.

Weber was initially concerned the project might be emotionally overwhelming for his partner, but as Neustadter tells *The New York Times*, "I was already doing cancer morning, noon and night. At least this way I was thinking about cancer and being productive."

Wash Westmoreland had similar concerns about Richard Glatzer, his husband and writing/directing partner on *The Fluffer*, *Quinceañera*, and *The Last of Robin Hood*. In December 2011, producers approached the team to adapt Lisa Genova's novel *Still Alice*, about a woman with early-onset Alzheimer's. But that same year, Glatzer had been diagnosed with the debilitating neurological disease ALS.

Westmoreland says in the *Still Alice* press notes, "Reading the first few chapters of the book, certain similarities resonated eerily with our own experience: the neurologist Alice initially visits asks the *same questions* Richard had heard at his early examinations when there were suspicions of a stroke; and the growing sense of dread as the diagnosis approached, the sense being cut down when life was at its fullest, was all too familiar. Did we really want to take on this movie right now?"

But they ultimately did take on the movie because they were both drawn to the compelling story and character.

"There was something undeniably inspiring in Alice—in her tenacity, her willfulness, the way she would never take it lying down," Westmoreland says. "Whatever the disease brought, she was determined to handle it in the most practical way possible. I don't know exactly in what chapter it happened, but the literary Alice we imagined from the page started to lose her dark curly hair as it turned a fiery red. 'Who do you think could do this?' I asked Richard. 'Julianne Moore,' he typed."

Their adaptation of *Still Alice* went on to earn Julianne Moore a Best Actress Oscar in February 2015. Glatzer died three weeks later from ALS.

Of course, your connection to an idea doesn't have to be at such a heart-wrenching level.

For example, when producer Larry Gordon asked Patrick Massett & John Zinman what project they wanted to do next, they knew immediately—and their reasons were, um, hormonal.

PATRICK: John had seen a very large cutout of a very voluptuous woman named Lara Croft sitting in the office. He goes, "We should do *that* next." I'm like, "Lara Croft!" I had no idea what it was. We hadn't played the game.

JOHN: I had no idea what it was either. I just knew it was a big title.

PATRICK: Yeah, and she looks hot, you know? She's got these giant guns and um . . . and uh . . .

JOHN: I will note that the visual there was he did actually reach for guns.

PATRICK: Pistols!

JOHN: Pistols! [Laughter]

Massett & Zinman sold their *Lara Croft: Tomb Raider* pitch to Paramount and within a few weeks turned in a first draft that got Angelina Jolie attached and the green light for production.

Top Gun was also set up at Paramount—by producer Jerry Bruckheimer, who optioned a *California Magazine* article about a Top Gun school in San Diego.

"There was no story," Epps says, "no character, no anything."

And no screenwriters yet. Jeffrey Katzenberg, head of production at the time, took the script idea to Cash & Epps.

"We had written *Dick Tracy*, and that brought us to the attention of Paramount and Universal," Epps says, "so Jeffrey wanted to do business with us. He had eight ideas—it was one of those breakfast meetings—and one of them was *Top Gun*."

Epps connected like crazy because he's crazy about flying. "I have my private pilot's license, and *Tracy* was not being made and had all sorts of

problems, so I figured that at least if the movie didn't get made, I'd get a jet ride out of it." [Laughter]

But *Top Gun* did get made—and became the top-grossing movie of 1986.

Another 1980s classic, *The Entity*, may not have been a blockbuster, but it was still a big hit with horror fans, including Chad & Carey Hayes. Who connected when producer Roy Lee pitched a remake of the original—about a woman who's sexually accosted by a spirit.

CHAD: Roy Lee goes, "Fox just called me, and they have two remakes they want me to find writers for. The first one is called *The Entity*."

CAREY: We go, "Stop."

CHAD: "Don't even tell me the second one. I'm doing that movie."

CAREY: "I'll do that movie." Because it stayed with us.

CHAD: It is truly terrifying. It holds up. Until Act Three. We've reconstructed and kinda taken some liberties.

The Hayes not only connected to the source material but also found a way to make someone else's idea their own. As they did when producer Toby Emmerich asked if they'd like to write a particular genre.

CHAD: He said, "You guys have any interest in writing a western?" We went, "Yeah! We're dying to write a western. We've always wanted to write a western."

CAREY: Didn't have a western.

CHAD: Didn't have it. So he goes, "Well, come up with something." So we came up with this idea that we call *Redemption*. And it's not your standard western by any means, but it could be very big, very scopey, because we're giant fans of *Dances With Wolves* and historical pieces that say something. And we pitched it to Toby, and he said, "Yeah, go write that." That came from just really wanting to do—

CAREY: The passion project.

CHAD: Passion project.

That's the secret to satisfaction and success when you take an assignment—making sure you're the right team for the project and making it yours. And being passionate about it. A script, as we've said, can be a long haul. You need to believe the idea's worth writing.

"Whatever a writer is doing," Lee Batchler says, "they should really believe in it, not just be trying to make a buck."

The gloomy truth is, if you take an assignment you don't believe is worth writing, you still have to write it. Ramsey & Stone were delighted

to make their first studio deal, *The Earl of Hackensack* (Rodney Dangerfield inherits a title in England), until they realized they didn't connect. They freaked, but at least they freaked together.

MATTHEW: It was collective terror. I suppose if there's comfort from running out of a burning building with somebody else, you have somebody's hand to hold. But that's about it.

ROBERT: We literally thought, *We can't do this.* Jeffrey Price & Peter Seaman [*Who Framed Roger Rabbit*; *How the Grinch Stole Christmas*; *Shrek the Third*] once told us something. They said, "You'll see it. In every project there's always a moment when you ask your partner, 'Can I give the money back?'" But this was worse.

MATTHEW: It was a job. And we got into the Writers Guild with it. But it was really hard. It was really hard learning what studios expect of you. It was an education. That was our Hollywood education.

You can always shelve a spec script that doesn't pan out. But when you're under contract, you do have to write the assignment—or give back the money. And as Garson Kanin told his sister-in-law when she wanted to do that, "My God, Fay, *never* give back the money!"

Crafting (and Maintaining) a Career

Ramsey & Stone became extremely successful writing other people's ideas, but they also learned the hard way that you have to be picky about the assignments you accept.

Yes, for writers there's no such thing as bad experience, just good material. And yes, that's part of the process, but this is your career we're talking about. If you're careless about the projects you choose, you could lose years of your professional life.

"I mean it, time is very precious in this business," cautions Carolyn Miller.

She's right. After all, time *is* money.

You and your script partner have (hopefully) learned to avoid the collaboration pitfalls, and as you become more successful, you'll want to avoid the career pigeonholes.

Ramsey & Stone put it this way:

MATTHEW: People will easily pigeonhole you. When the *Life* script was done, and the town knew the film was getting made, suddenly we got every script for Chris Tucker, Chris Rock. It was like, "Here are a couple of white guys who can write a movie for black guys!" And we had to say no to

everything because otherwise that would be it. That's what we would be doing.

ROBERT: The way we have sculpted our career is by being very particular about what we say yes to. We get a lot of offers. We say yes to a few things, and we try to do them as well as we can.

With *Ed Wood*, Alexander & Karaszewski escaped being pigeonholed as writers of silly kiddie movies. But after *The People vs. Larry Flynt* and *Man on the Moon*, they've found themselves flooded with biopic offers.

LARRY: It's weird to be in the position that we are because people will call us, and their idea of pitching us is just a person's name. "I've got a great idea for you—"

SCOTT: "Idi Amin!"

LARRY: "Idi Amin. What do you think? What do you think?" You know, sometimes it sounds good. Sometimes it's like, *Oh my God, Idi Amin?*

SCOTT: "Charles Manson! How about it?"

LARRY: So sometimes you say yes or no based on that.

SCOTT: I don't know if Idi Amin has a good second act. It's a hell of a third act! And then he eats his enemy! [Laughter]

Their biopic scripts have become increasingly demanding—*Ed Wood* took six weeks, *Larry Flynt* took ten months, *Man on the Moon* took a year, and *Marx Brothers* took three years (including obtaining rights). Although they recently returned to the biopic genre with *Big Eyes*, they've also become more selective and branched out with other projects. They adapted Stephen King's short story for *1408* and R.L. Stine's books for the *Goosebumps* movie. Plus, they've expanded into TV writing and producing with the series *American Crime Story*.

Following the bidding war over *Smoke and Mirrors*, the Batchlers also became very choosy. They turned down several projects at Warner Bros. simply because they didn't think they were the right writers for them. But when the offer came in for *Batman Forever*, they connected. They were intrigued by the idea of exploring the duality of the hero as well as the villains—"the psychological reality underneath it," Janet says. And their duality-driven pitch connected with director Joel Schumacher and producer Tim Burton, who offered them the job.

Chad & Carey Hayes have become so successful that they prefer to accept projects they believe will get made.

CHAD: We're like, "I would love to do this, but I don't think they'll ever make the movie." So why would you spend all

	this time? For us, a lot of it is, "Okay, that sounds really cool. We could sink our teeth into that. I could wake up at 5:00 in the morning and get working on that."
CAREY:	We don't have to talk each other into doing it.
CHAD:	Right.
CAREY:	Otherwise, it's just another writing assignment. That's a paycheck, but at this point, I write because I want to entertain. I love to watch a movie and go, "Man, I can tell you exactly where I was when we wrote that scene." As a writer, to have people emotionally moved, to see people in a screening either crying or scared is so rewarding.

But sometimes, in spite of all your success, you still don't have a choice about accepting an assignment. Consider the case of Fay & Michael Kanin, who built a long, prolific career generating and writing their own ideas—until the McCarthy Era. Because they were liberals (gasp!), and Fay had taken classes at the Actors Studio ("taught by many Communist actors, terrific actors," Fay said), Hollywood slapped them on the Greylist. It wasn't as bad as the Blacklist, but it kept them from selling their work.

"We were *not* Communists, but you were red-baited even if you were not," she said.

Then the director Charles Vidor offered them an assignment—to write *Rhapsody*. Though the Kanins vastly preferred writing specs, they accepted the job to save their career.

The studio execs objected and suggested that Vidor use a contract writer instead. But Vidor insisted, as Fay explained. "He said, 'Listen, don't give me all that. If you don't let me hire the Kanins, I am going to the press, and I'm gonna bust this wide open. I'm gonna give a press conference and say why.' He knew that he was safe because we were not Communists, so they couldn't use that defense. But you know so many people's lives were destroyed. Oh boy, we watched a lot of our friends— We watched marriages break up, and oh, it was a terrible time. A terrible time."

Fortunately, times have improved since the McCarthy Era, though ageism has created its own Greylist in Hollywood now, making it hard for older writers to find work. We can only hope that the passionate pushback by Meryl Streep, Patricia Arquette, and others in the industry will eradicate this unfair practice and prejudice.

You Got Nothin'

Okay, it happens. Don't feel bad. It happens to all partners eventually. It's never happened to you before, but now—no matter how hard you try—you just can't come up with an idea.

So relax. Take a shower. Go for a walk. Scroll through your file of older ideas. Maybe you have a good one but you've just forgotten.

"Occasionally," Phil Hay says, "we'll come up with an idea that seems pretty good or seems okay, and then we kind of forget about it for a while because we're doing something else. And then we come back to it. Like this comedy idea we might be pitching soon—a big, broad comedy. A year later, it just randomly recurred in a conversation."

An idea whose time has come. That's what you're looking for—an idea you filed away that clicks for you now.

There are real advantages to retrieving an old concept. Like wine, script ideas often improve with time. When you're not working on the story, your unconscious is. And it gives you insights about your idea when you least expect it.

"You get this idea, whether it's a character or whatever, and you don't do it right away. You sort of think about it," Fay Kanin said. "And every now and then I say, 'Gee, I thought of something for that.' And then we tuck it away. And then when we suddenly see an empty moment, an empty period, we say, 'Well, how about that idea?' By then we have talked about it on and off, and we have a lot of stuff already there."

If no good older idea flashes to mind, pull out your notebooks and journals and files. You never know when a stockpiled idea might work. Steven Soderbergh made an entry in a 1986 notebook: "A film about deception and lost earrings." Three years later, he wrote and directed *sex, lies, and videotape*, the film that "kickstarted the independent film movement of the 1990s," according to *The New York Times*.

Bennett Yellin, who co-wrote *Dumb and Dumber* and *Dumb and Dumber To* with the Farrelly brothers, tells *Newsweek* that Peter Farrelly always keeps a notebook of comic ideas. "If anybody says anything remotely funny, he immediately goes and writes it down. At the beginning of a script, he'd take out the notebooks and say, 'Here are ten jokes—now let's write the script around these.' Literally, this was the technique."

The Batchlers learned the value of keeping notebooks and files when they searched for an idea worthy of that "weekend read." They'd already presented several ideas to their writers group, who liked one idea, but the group's moderator, Jack Gilbert—director of the Warner Bros. Writers' Workshop—challenged the Batchlers to keep digging. He told them to come back to the next meeting with at least three more ideas.

"We spent probably close to a month digging through files, every time we'd jotted down an idea for a story," Janet says. "And one of them was the story of *Smoke and Mirrors*. We took that back a month later to the group, and everybody said, 'That's the one. That's the one we want to read.'"

In *Woody Allen: A Documentary* from PBS's *American Masters* series, Allen reveals that he keeps a drawer full of ideas scribbled on scraps of paper, and whenever he's ready to start a new project, he rummages through his notes until inspiration strikes.

The interviewer asks Allen to read one aloud. Allen does: "'A man inherits all the magic tricks of a great magician.' Now that's all I have there. But I could see, you know, a story forming where some little jerk like myself, at an auction or at some opportunity, buys all those illusions and, you know, boxes and guillotines and things, and it leading me to some kind of interesting adventure going into one of those boxes and maybe suddenly showing up in a different time frame or a different country or in a different place altogether."

If you don't keep ideas in a journal or notebook or file or drawer, start now. Jot down any ideas that occur to you. Anything goes, anything that remotely resembles a script idea. Or a partial script idea.

As a partygoer says in *Annie Hall*, "Right now, it's only a notion. But I think I can get money to make it into a concept. And later turn it into an idea."

And the best notions, concepts, and ideas often come out of the blue.

When Nick Kazan & Robin Swicord heard about a couple of housekeepers winning the lottery, *Loco for Lotto* was born. When they read Roald Dahl's book *Matilda*, they said, "This would make a great movie." So they wrote an adaptation, which later became the 1996 Columbia/TriStar release starring Danny DeVito, Rhea Perlman, and Mara Wilson.

Literary works can be excellent source material for adaptation, as can older films: Joel & Ethan Coen's *The Ladykillers* (2004) was a remake of *The Ladykillers* (1955). Nora & Delia Ephron's *You've Got Mail* (1998) was a remake of *The Shop Around the Corner* (1940). Stephen Mazur & Paul Guay's *Liar Liar* (1997) with Jim Carrey was an update of the Bob Hope film *Nothing But the Truth* (1941), which was an update of *Nothing But the Truth* (1929), which was an update of *Nothing But the Truth* (1920)! Rights issues can be tricky, so you'll need to secure them before you begin—unless, like the Batchlers' first project, your adaptation is just for practice.

But the best advice we've heard about generating ideas came from Fay Kanin quoting Orson Welles. "He said, 'Stop looking at my movies and start looking at life.' A lot of your ideas come out of your life."

The Longstreets have found this to be true. They spent a long day at home with a friend, producer Joel Robeson, trying to come up with an idea for a prime-time drama.

Renee tells us, "So we're thinking, we're sitting there for the day, and in that day the calls come from the ex-husband, the ex-wife. One kid has to be picked up from school. The kids come home, the teenagers, the this, the that. At the end of the day, Joel says, 'I know the hour drama I want to do. It's this. Your life.'"

So they went to CBS and pitched a dramedy, *We Interrupt This Life*.

An idea can even spring from an idle comment, as it did for us with our comedy *Psycho Bitch*.

CLAUDIA: I'd just returned from the first meeting of my summer screenwriting class.

MATT: And she was crabby.

CLAUDIA: I always capped this class at 18—I'm a real bitch about it—but that evening I'd let 21 students enroll. I don't know what came over me. I just couldn't say no. And I said to Matt, "The bitch within really failed me tonight."

MATT: The next day Claudia's comment was flashing in my head, so I told her it gave me an idea—a comedy called *Psycho Bitch* about a woman who releases the bitch within.

CLAUDIA: But she isn't within, she's her roommate—

MATT: —and wrecking her life.

Six months later, our *Psycho Bitch* script was a finalist for the Sundance Screenwriters Lab.

So if you can't find a story out there somewhere, follow Orson Welles' advice and examine your own life. What fascinates you? Compels you? Strikes you funny?

Finally, if you just can't get an idea—if the pitch within fails you—go back to Go and brainstorm again. Review the rules in Chapter One and go for it. It can be a dazzling process, as Larry Gelbart so vividly captured when he described brainstorming a sketch for *Caesar's Hour* with Mel Brooks, Mel Tolkin, Neil Simon, Sheldon Keller, Michael Stewart, Gary Belkin, and Sid Caesar himself. "The most vociferous, intimate, biggest group I ever worked with," Gelbart called them.

"You're at the table and first you start with premises. 'Let's do a domestic sketch. Let's do Sid and his wife, Nanette, Carl and his wife'—I can't remember names—'and Howie and his wife, Ellen Parker'—I do remember her name. 'Okay, they're what? They bought a car, she wrecked the car. We did that. Did this, did that. Okay, they're going to the theater. Oh, they're going to the theater—that's a good idea! Six people are going to the theater. The three guys work in town, the three ladies are out in the suburbs, and their husbands have to have tuxedos. So okay, we'll do a series of phone calls with people arranging with each other and then someone changing it and then having sort of a log jam. Let's try it, let's try it.' After pitching the premise, we'd sort of have a rough idea of where it was going, because it's always good to know where you're going."

Indeed. And when you come up with an idea that clicks for you and your partner and your career, all the scrolling and digging and brainstorming will have been worth the effort—because you'll have a project that's worth the hard work ahead.

 Script Partner Points

- When choosing the right script project, determine first what "right" means to you and your partner.

- Write a spec script if you want to get your idea on paper, to see how you work together, to gain more experience, to have an industry calling card, or to sell the damn thing.

- If neither of you already has an idea, brainstorm. Give each other the freedom to suck, to say something appallingly awful. This process may lead to a great idea.

- Explore your idea's possibilities and the genre(s) that might serve it best to see if it's a viable movie.

- Whether the idea comes from you or somebody else (like a producer or a studio), make sure you and your partner both connect to the idea on some level.

- If the idea does come from a producer or a studio, find a way to make it your own.

- As you become more successful, avoid career pigeonholes by being choosy about the assignments you accept.

- Keep notebooks/journals/files/drawers of ideas. Or kernels of ideas. Or germs of kernels of ideas. You never know what might sprout.

> "Just because you are a character, doesn't mean you have character."
> —Winston Wolf (Harvey Keitel), *Pulp Fiction*

SEVEN

Co-Creating Character

One day, Billy Crystal called Lowell Ganz & Babaloo Mandel and pitched an idea: Three guys from New York go on a fantasy cattle drive.

"Right away, more than anything that's ever been pitched to us, we said, 'That's funny!'" Ganz tells *Written By*. "'If we can't make that funny, then we can't make anything funny.'"

But they didn't start with the jokes about saddle sores or stampedes and other set pieces we laughed at in *City Slickers*. They started, as they always do, with one simple question.

"The first thing we do is we sit down here and we say, 'Who are they?'" Ganz says. "They can't just be generic."

"'Who are they and why are they?'" Mandel adds. "'What's lacking in their lives that this is going to fulfill?'"

Every script is a journey for the main character—or characters—and the audience too. A magic carpet that lifts them up and takes them for a ride and sets them back down. So Ganz & Mandel ask themselves, "Who are our eyes on this journey?"

Jack Epps, Jr., lists the questions he and Cash asked when they co-created characters. "'Who are these people? What do they have to lose? What's at stake for them? What's going on?' And just trying to understand who the characters are, their voices."

These are all excellent questions to ask as you and your partner embark on creating your own characters. And as you explore the answers, you'll be bringing your characters into existence.

Like Ganz & Mandel, you may create character first. You may start with story. Or you may create them simultaneously. (As F. Scott Fitzgerald once said, "Character is story.") The order doesn't matter. What matters is what works for you.

"With *Session 9*, Steve and I would riff on the kind of characters we wanted," Brad Anderson tells us. "We might toss in character traits, habits, and attributes. We might talk about people we both know who resemble the character. Eventually, it would get to the point where we would be arguing back and forth like, 'This guy would *never* do that!' or

'She wouldn't say that and laugh, she'd say it and cry!' Then you know you're on the right track. The characters are becoming fleshed out."

Think about that. It's amazing enough when a solo writer creates character, but you're co-creating. The two of you are inventing the same character.

"You begin to think along the same lines," Anderson explains. He and writing partner Lyn Vaus certainly got on the same page when co-creating romantic lead Erin Castleton in *Next Stop Wonderland* (about a lonely RN who suffers a string of suitors when her mother places a personal ad without her permission). Anderson & Vaus decided that Erin would randomly choose words from a book to interpret. "Big words like 'faith,' 'determination,' etc., lend her guidance and give her strength."

Writing a crucial scene toward the end of the third act, they had to decide on the word Erin would randomly pick. "She is at a crossroads in the story, in dire need of guidance, so this particular word was extra important," Anderson says. "What could it be? Lyn and I both went home and slept on it, and when we met the next morning, we had both independently come up with the same word—'linoleum.' It was weird to come up with the same word for one thing, but to both choose a word that was counterpoint to the notion of fate we'd established in the story and therefore funny. This was spooky."

Another Vulcan mind meld.

Co-creating characters is a mysterious and intimate process. No wonder writers have likened it to having a baby. Okay, we know scripts aren't babies, but now and then we feel a real sense of wonder bordering on parental pride when we look at the characters we've co-created. We marvel, *We did this?* They may be based on people we've met. They may be inspired by characters or actors we admire. They may leap fully formed onto the page. But all our characters begin, like Ganz & Mandel's, with one question, "Who are you?"

Coming up with the answer can be difficult, messy—birth imagery may apply—but it's a remarkable process. When you stop and appreciate that, it almost makes the labor worthwhile. And if the movie gets made, your characters just might support you in your old age.

Co-Creating Character From the Story Idea

Often in Hollywood the starting point for character development is a high-concept story idea, as it was for Cinco Paul & Ken Daurio with *Despicable Me*.

"The original idea of a villain adopting three little girls came from a Spanish animator named Sergio Pablos," they tell us. "Chris Meledandri was just starting Illumination and wanted us to be his house writers—he pitched us the idea and we instantly loved it. There wasn't much more

than that idea (apart from some really delightful images), so there was a lot of fleshing out to do. Mostly involving Gru's character, his backstory, the girls' individual characters, and the main storyline. We came up with the concept of 'deliciously evil' to describe Gru's behavior—we were careful to only have him do bad things that all of us secretly wish we could do. But the most important things we discovered were the power and appeal of his vulnerability, and how the girls unlocked that. That's the real key to his character and the appeal of the movies, in our opinion. Of course, there are also those minions!"

When Alfonso & Jonás Cuarón set out to co-create Ryan Stone (Sandra Bullock) in *Gravity*, the theme and the story idea dictated three vital qualities for the character.

First, she's female. "It was always important to us that the central character be a woman," Jonás says in the press notes for *Gravity*, "because we felt there was an understated but vital correlation of her being a maternal presence against the backdrop of Mother Earth."

Second, Ryan is a mother who's suffered a terrible loss, and her need to withdraw drives her desire to go into space, underlining the film's theme of isolation.

Third, she's not a seasoned astronaut because her journey in the film is her desperate struggle for survival when debris destroys the space shuttle in the opening scene. Jonás explains, "She, of course, had some training, but she is a mission specialist, not a pilot, so when the shuttle is destroyed, she is unprepared to deal with such an extreme situation."

Ryan's character was further nuanced by Bullock's collaboration with the filmmakers, but the three vital requirements were constants throughout the film's evolution.

So sometimes characters are born from the requirements of your story idea. And sometimes a secondary but crucial character is born from your main character's needs.

"For the rest to make sense," Alfonso says, "we also needed a mentor figure—someone who could guide her through the process and help her figure things out."

To accomplish this, they created the character of Matt Kowalski (George Clooney), her mission commander on his final space flight. Alfonso describes him as "the counterpart to Ryan. Matt is very much at ease in that environment; he is as expansive as Ryan is insulated. If you were going into space, Matt is the guy you would want with you."

Just as Ryan needs Matt Kowalski to figure out how to return to Mother Earth, Ron Woodroof (Matthew McConaughey) of *Dallas Buyers Club* needs the character of Rayon (Jared Leto) to overcome his extreme homophobia and become an AIDS activist.

Rayon is a composite character based on people that script partners Craig Borten & Melisa Wallack knew or had read about in their research. "There was no better way to put [Ron's] homophobia in place than to

have him face a transgender person," Borten tells TheWrap.com. "We had so much fun with this relationship."

There are also times when you may need to change your original character concept to meet the needs of your story, as Allen & Brickman did when they wrote *Annie Hall*. "They say that character is action and that all drama comes out of character," Brickman says, "but that's only partly true in this case, because the character of Annie came out of the needs of the plot rather than the other way around."

In their first draft, Annie was a lot like Alvy—from New York, self-absorbed, and appealingly neurotic. In the second draft, however, she became someone whose background was different from his, "which sowed the seeds for a plausible separation later," Brickman explains.

"It was necessary to give the story some forward motion and developmental potential which it really didn't have in the first draft—an assembly of rather brilliant and funny and original observations, scenes, and jokes, some of which remained but some of which had to go as the love story between Annie and Alvy took predominance over the more cerebral and literary material."

And speaking of cerebral and literary material . . .

To Bio or Not to Bio

Some collaborators start the process of creating character or flesh out their character by writing a bio. A synopsis of character traits. Renee Longstreet calls it "character notes."

RENEE: When we do character, when I do it for me, I write a whole page—I can show you 15 of them. I make a character, and I write everything I can think of. Does she like to play gin rummy? What does she like to eat?

HARRY: How does she dress? How does she talk?

RENEE: What's important to her? What is her background?

Renee shows us some of her character notes for the Lifetime movie *Mothers and Daughters*:

> **ANDREA LINDEN—age 44**
> **Community college art history instructor—Portland, OR.**
> Attractive naturally—not chic . . . dresses in comfortable clothes, Doesn't pay much attention to appearance, Doesn't exercise much, eats whatever she wants . . . one of those rare birds that other women envy.
>
> Single mother . . . widowed at 25; Alex was only 5 years old . . . raised child on her own. As Regina [her

mother] was disinterested/uninvolved ... and very unconscious as women of her generation often were. Andrea went the other way somewhat controlling, over sheltering, high expectations.

Parenting and working on career—getting degrees, etc. kept her too busy to involve herself with dating, etc. Likes men, has friendships, but not a focus for her.

Collector—pack rat, but in a good way—has collected rock posters, T-shirts, fad items ... hula hoops from the '50s ... TV star "art"—(Farrah throw rugs etc.) pop culture items.

TIME LINE—Andrea—born 1955

College—'73—18 years old—REED College on ROTC scholarship.

Pregnant—'75—they marry, she continues with school.

Alex born 1976—Andrea is 21 years old.

Mickey in military dies from aneurysm 1979.

Assorted jobs—keeps up her school, a class at a time—stays in Portland ...

Committed mother but has other priorities as well.

All the things Regina didn't provide for her, she has provided for Alex and even some for herself—horseback riding lessons ... Fills in the missing gaps.

Likes her students.

Misses her daughter—harbors some anger at both daughter, mother and sister. Jazz buff—has learned to play keyboard as an adult.

And the notes continue for the other characters too.

"No one ever has to see them," Renee says, "but I have to write them. So when I do the plot, I already know the person. I really do that. I really have to have my characters."

But bios aren't for all writing teams. When we ask Scott Alexander & Larry Karaszewski if they create bios, Alexander laughs and says, "Nah, that's for serious writers."

The Hayes brothers don't do bios either.

CHAD: But that process works for a lot of people—people that tend to be more analytical, that really need to define, who don't know any other way to develop character. Maybe it's just that we've been at it so long that it's a different process for us. We spent some time in North Carolina working with the film studies program over there, and we'd sit down with the students, and a lot of them say, "Well, yeah, but they said that there has to be this and this and this." And I just go, "No, there doesn't."

The Hayes' process is less rule-bound, more organic.

CAREY: When you begin writing, it's like running a race, right? You don't know exactly how you're gonna feel through that race, how much energy you're gonna have, what's your pace, who you're gonna run into, what the obstacles are, any of that stuff. You can kinda lay it out and go, "Oh, I hope it's obstacle free. I hope it's smooth. I hope the weather's great." But you run into these things as you go through it, so if you do a front character bio and then stick to that, you may lose that opportunity you had in discovery—because you don't know the whole story yet.

Again, you and your partner will need to try different approaches until you discover or develop a process for co-creating character that works for you.

What's in a Name?

Color us crazy, but for us a great deal. Before we started working together on *Obscenity* (also a finalist for the Sundance Screenwriters Lab), Claudia had created names for the main characters, Sam and Sara, from the Buddhist concept *samsara*, the vicious cycle of existence arising from ignorance and characterized by suffering. That's what the script is about, ignorance—in this case, homophobia—and the suffering it causes. Though an audience may never know where the names came from, this connected Sam and Sara—and us—to the story's deep subject.

And the name Maverick connected Cash & Epps to their main character (played by Tom Cruise) as they worked on *Top Gun*.

"When I went down to do research, all of the pilots got along," Epps says. "And as a writer I'm saying, 'Well, this is terrible. Where's the conflict?' [Laughter] 'Where's the problem? They all get along. They all talk about being supportive and leadership and protecting each other.' And then I went, *Ding!*—except for one guy who doesn't. What happens in this environment if there's one guy who doesn't get along? And so Jim and I said, 'Okay, we'll call him Maverick because that tells us the story of the character, and he'll just be Maverick, but of course we'll never use that name because it's so on the nose.' Everybody'll say, 'No, you can't use this.' [Laughter] So it just stuck."

Sometimes your character's name doesn't come easy. With *Obscenity* we struggled to find the right name for our antagonist, the State Attorney. Finally, we went through the Tallahassee phonebook (it's bigger than you think) looking for names that fit his well-rehearsed charisma and country-boy charm. And we came up with Wayne Mueller. It just *sounded* right (and the person he's loosely based on has the same initials). It made him real for us and helped us relate to a character we found hard to like.

To Like or Not to Like

You may have heard the conventional wisdom that good characters have to be good. Sympathetic. They don't. Fascinating, yes, but they don't have to be likeable for you—or an audience—to connect.

In this Golden Age of TV, there have been plenty of sympathetic characters like Coach and Tami Taylor in *Friday Night Lights*. But since *The Sopranos* premiered on January 10, 1999, we've also moved into a Golden Age of Antiheroes like Tony Soprano (James Gandolfini), Walter White (Bryan Cranston) in *Breaking Bad*, and Frank Underwood (Kevin Spacey) in *House of Cards*.

These are characters we initially connect to and sympathize with because the writers give them undeserved misfortune in the series pilot:

> Mobster Tony Soprano is having a major midlife crisis and violent anxiety attacks, and his antagonist mother refuses to go into a nursing home.
>
> High school chemistry teacher Walter White is diagnosed with stage-three terminal lung cancer, and treatment is going to cost $90,000.
>
> House Majority Whip Frank Underwood is screwed out of his promised promotion to Secretary of State.

Then, in the luxury of time and scope that is multi-season episodic TV, these characters slowly change, deepen, and darken until we're not sure if they're antiheroes or flat-out villains.

"I think what's exciting about television right now is the long, extended narratives," Epps says, "the very fact that you can build a show, that you can go so deep in terms of character and story in a way that a feature film doesn't. A feature film feels a little locked right now in terms of your hour and a half, two hours. But these rich TV narratives that develop the character and story longer are really interesting. Really fun."

But whether you're co-writing for TV or film, Alexander Payne's guiding character principles apply. "Appeal comes from truthful and complex characters," he says in *Scenario*. "I hate when movie people say, 'Your lead character has to be sympathetic,' which for them means 'likeable.' I don't give a shit about 'liking' a lead character. I just want to be interested in him or her. You also have to make the distinction between liking a character as a person and liking the character as a character. I mean, I don't know whether I like Alex in *A Clockwork Orange* or Michael Corleone in *The Godfather* as people, but I adore them as characters. Besides, 'liking' is so subjective anyway. So many American movies of the '80s and early '90s bent over backwards to make their protagonists 'likable' in a completely fraudulent way, and I detested them."

His philosophy of character is evident in the first film he and Jim Taylor co-wrote, the indie success *Citizen Ruth*. Their title character evolved as they wrote many drafts of the script. A knocked-up, glue-sniffing drifter who plays both sides of the abortion debate, Ruth became less sympathetic, more self-serving, and more active. And as she became less likeable, the writers felt more connected.

"That sort of character, who's like a bull in everyone else's china shop, is really fun," Payne tells *Scenario*. "It's great to have this amoral presence among all these people who think of themselves as supremely moral."

Jim Taylor agrees. "A big issue for us was she was this person who does all these things that are on the surface reprehensible, even repulsive—"

"But she's still an innocent," Payne adds. "You root for her."

Larry Flynt, publisher of *Hustler*, was so widely regarded as an exploitative sleazebag that director Milos Forman initially would not even read Alexander & Karaszewski's biopic script *The People vs. Larry Flynt*.

"My only association with the word 'Flynt' was exploitation," Forman tells *Written By*, "so I thought that some dirty company is asking me to do an exploitation film."

Alexander & Karaszewski were also disgusted with their main character.

LARRY: We had never met Larry Flynt. We didn't even want to meet Larry Flynt.

Still, they found a way to connect without changing the truth.

SCOTT: The movie only would work if Larry Flynt were despicable in the film. And so whitewashing him was totally beside the point to us. The point of the movie was, "He's disgusting, and yet he did something important."

As Alexander & Karaskewski depict in their screenplay, Reverend Jerry Falwell sues Flynt for parodying him in *Hustler*, and the First Amendment case goes all the way to the U.S. Supreme Court.

From *The People vs. Larry Flynt*:

```
EXT. U.S. SUPREME COURT — DAY

Pandemonium on the Court's steps. JOURNALISTS mob the exiting
participants, circling in groups around Larry, Keating, and
Falwell.
                        REPORTER #1
                Reverend, are you confident that
                you will win the case?
```

 REV. FALWELL
 Absolutely! There's no way the
 Supreme Court will side with a
 sleaze merchant like Larry Flynt.

 REPORTER #2
 Mr. Keating, why are you here
 today?

 CHARLES KEATING
 To show my support for those who
 believe that pornography should be
 outlawed. This smut is the most
 dangerous menace to our country
 today! All decent citizens demand
 ACTION! They want pornography where
 it belongs — IN JAIL!

Larry has the biggest crowd.

 REPORTER #3
 Larry, why'd you bother appealing?
 Why didn't you just pay the fine?

 LARRY
 Do you have to ask? We are talking
 about freedom!! Doesn't anybody
 know what that means anymore?!
 Doesn't anybody realize that if I
 lose, then you lose?!
 (his eyes are getting
 moist)
 I've been accused of hiding behind
 the First Amendment. Well, you're
 damn right I do! 'Cause I am the
 worst! But if the Constitution
 protects a crazy man like me . . .
 then it'll protect all Americans.

The reporters are silent. Larry is all choked up.

Whether characters are sympathetic or not, their appeal, as Payne says, comes from truth and complexity. Contradictions. And imperfections, though for Tony Soprano, Walter White, and Frank Underwood, this is the height—or depth—of understatement. That's what makes them compelling and compels us to write them—and binge-watch them.

Research

If you're creating characters from history or recent events, research is essential. It's not only the path to accuracy and understanding, it's the foundation of a fresh script about people audiences may already know.

Before Alexander & Karaszewski write their biopics, they do extensive research, organizing their findings into notebooks that line the walls of their office.

SCOTT: On our shelves, there are about 20 to 30 books about the Marx Brothers. And then up above are these giant notebooks that say "Marx Brothers." What happened was, we read 30 books, and we highlighted every single thing we thought was interesting in those 30 books. And then we hired a guy to come in and retype everything we had highlighted into a computer. Then it all got organized by chapters.

LARRY: There's "Old Relatives," "Lenny and their Mom," "Childhood," "Chico," "Chico's Family," "Chico and Gambling," "Chico and Piano," "Harpo," "Harpo and Piano."

SCOTT: By this point, that represents six months of work, and we haven't even written a word. And we haven't even figured out the structure of the movie at that point.

LARRY: There's two notebooks for the Marx Brothers, there's two for Larry Flynt.

SCOTT: They all have two. I mean, it's thousands and thousands of collated pages. It's just endless.

The research was exhaustive—and exhausting—but it proved invaluable when they were drafting the script. For instance, if they were writing a scene about Groucho and another character, they could go to that "chapter" and have the research at their fingertips. Or if they needed a funny line from Groucho, they could search "Groucho Quips."

When developing *Big Eyes*, Alexander & Karaszewski were fortunate to have Margaret Keane consult on the project after they earned her trust and promised to tell her side of the story. But creating the character of her ex-husband was trickier because he'd died in 2000, and they were unable to find any footage of the real Walter Keane, despite years of searching. And Keane's "completely mad" autobiography proved useless, as they tell SlantMagazine.com. "I read halfway through that," Karaszewski says, "and I was like, 'This isn't helping me. This isn't a real human being either, this is a delusional guy . . .'"

"The guy in our script is a consistent character from beginning to end," Alexander adds. "But the guy in this book was flying on Cloud 28. You should read it, just for the entertainment value. He has 'the gods of the arts pantheon,' and I don't quite know who these figures are supposed to be, but he's written a bunch of celestial beings floating in the clouds, with pillars like Michelangelo, Gauguin, and at the end of the book Walter is appointed and gets to be up there with the others."

So they did further research and based Walter Keane's character on numerous articles and photographs about him and this famous art-theft case.

The Hayes brothers also "approach research diligently," Chad tells us. "It's a big part of our writing process. If we like an idea, we research it. We begin to build on characters and moments, and that comes through research."

And like Alexander & Karaszewski, the Hayes had the benefit of consulting with the real-life inspiration for one of their main characters. Early in their research for *The Conjuring*, they began working over the phone with paranormal investigator Lorraine Warren.

"She's just a pro," Chad tells Collider.com. "She's 85 years old. And in our process of interviewing her we would spend hours on the phone. And she was so cute, because she would say, 'Wait, give me a little bit of notice before you call, because I just want to get all comfortable in my bed and get my tea.' She wanted to chat. [Laughs] We talked for three hours once."

The Hayes met Warren (played by Vera Farmiga) for the first time when she visited the film set for several days. "And it felt like we had known her for so long," Carey says. "It was really a happy moment for us."

Even if you're creating fictional characters, research is essential if they're beyond your own experience and expertise. Unless carefully researched, they might not be convincing.

Before writing *Life*, Ramsey & Stone had "never been that into research before"—except for reading secondary material and surfing the Internet. So to create convincing characters for their script's Southern prison setting, they traveled to Mississippi's infamous Parchman Farm, segregated until 1972. For a week, they conducted interviews and toured the facility, including death row.

MATTHEW: We got such incredible stories. Character names that you never could have come up with. And both of us being there, we had the experience at the same time—getting back to the theme of collaboration. It wasn't like one person was, "Oh, I know all about this world, and I'll tell you about it." We just really got immersed in it together, and from that point on, the script took on a real life.

ROBERT: It never would have had that flavor had we not applied ourselves in that way.

As Ramsey & Stone discovered—and as the saying goes—setting is character. After all, what would *The Shining* be without the Overlook Hotel? *The Hangover* without Las Vegas? *The Lord of the Rings* without Middle Earth? Sometimes the setting is so prominent it's right there in the title—*Casablanca, Manhattan, Network, The West Wing, E.R., Downton Abbey, The Grand Budapest Hotel.* You get the picture.

Research can help you make your setting as vivid and realistic as the other characters—and make the script come alive for the reader, your first audience. Which is why the Hayes brothers are so passionate about research.

CAREY: If it's not on the page, it's not gonna excite people to read it and feel like they're in it. It's the director's job to transport the

words from the page onto the screen. But it's our job to transport you, the reader, into whatever environment that's supposed to be there, whether it's India, whether it's Antarctica, whether it's Louisiana in the 1700s.

Or whether it's California during a massive earthquake. When the Hayes were rewriting *San Andreas*, their research into "the whole Cal Tech world" led to specific lines that characters say.

CHAD: In the movie, the quake that hits California, Paul Giamatti looks into the camera, and they ask him, "How big is this?" And he says, "This is so big that the East Coast will feel it." And that's true. The minute we found that out, we were like, "That's in the movie. That is in the friggin' movie."

CAREY: Everybody goes, "Is that true?" Yep!

We ask if they do their research together.

CAREY: Depends. In the macro picture, we research together because we want to know what pushes the story. But as we get into scene work—

CHAD: Depends how much time we have.

CAREY: Yeah. If it's in my scene, I'll just look that up or figure it out when I'm there.

We also find it extremely beneficial to do our research together. Even though Claudia had been an expert witness for the defense in the trial that inspired *Obscenity*, we spent weeks in the Leon County Courthouse transcribing audiotapes of the proceedings. This helped us co-create many of our characters—lawyers, witnesses, jurors, and judge. We heard their voices together. We knew what they said and the way that they said it. This gave them greater authenticity and richness.

We strongly recommend that you and your partner do your research together because it will make your job easier in the long run. Even if you have to hire a research assistant, or a studio hires one for you, do as much research as you can.

"You need to do it yourself because you need to know it," Karaszewski insists. "We have assistants occasionally who help organize it, but it's more about them typing up what we've highlighted and putting it together. I find it impossible to say I hired someone to do my research for me. It's sort of like saying I hired someone to take my test. We need to know all this information by heart, what's in those books, just so in the eight months it takes us to write the script, we don't lose it all."

Avoiding Stereotypes and Character Clichés

Peter Berg, creator of the *Friday Night Lights* TV series, also wrote the pilot script—"with really great characters," Massett & Zinman tell us.

PATRICK: They were kinda like archetypes. Tyra was the town slut, Street was the all-star all-American quarterback, and Lyla was the cute little cheerleader, and Riggins was the bad boy with a golden heart. All the archetypes were in place for all the characters. Saracen was the guy that was a step behind everybody, throwing up in the garbage can when he found out he had to start. But it takes— It was the writers' room that found seminal moments in each of the characters that gave them a chance to turn and to grow. I think the best example I always remember is, "What are we going to do with Tyra? What are we going to do with her?" And the moment she picked up either a baseball bat or a fire poker, and there was an abusive man in her house who was dating her mom, and she was fucking tired of it—as soon as we empowered her to pick that thing up and beat that guy's ass and get him out of that house, she suddenly began— She became a different character. Now she was someone we could believe would get her life on track and get into college possibly, and maybe get away from Riggins, maybe get into a healthy relationship with someone like, say, Landry. It opened up all the possibilities. And I think for all the characters we found moments like that. I think with Riggins, he was such an adored character—that came later in the show when he made a sacrifice, not the ultimate sacrifice but a huge sacrifice for his brother, to take the fall for Billy so he could stay home and raise his son. And Riggins went to jail.

JOHN: There's no way of knowing that Tyra from the pilot is going to become Tyra who was going to find in Tami a real role model and someone who could guide her to become a really strong female character. And that Riggins who says, "I'm not racist—I just don't like the guy," about Smash in the pilot is going to be really the most sensitive character on the show. He's sort of the bad boy. But really, he is the softest heart maybe of the bunch.

PATRICK: That became one of the great relationships—between Smash and Riggins.

JOHN: And that all came out of the writers' room.

PATRICK: [The showrunner] Jason would let the room work, come in, see the problems, and say, "Try that." We would make the adjustments, and he would come back and sit with us for a few hours and talk through it, and that would be it. He was very specific about what a character would and wouldn't say, what a character would and wouldn't do. The range of that character's emotional life. He had it in sort of a box, and if you stepped outside that box, he'd pull it back. For example, Coach would never cheat on Tami. That's a broad one, that's an obvious one. But there were little things he understood too about the characters that you didn't really understand until he said it. Like, "Coach wouldn't do this because because because . . ." So he really understood the box that each character lived in. And he understood their voices, so that's why it all feels like a cohesive piece.

When you and your partner create your own characters, be careful not to confuse "archetype" with "stereotype." An archetypal character is a prototype, a model, a perfect example. A stereotypical character is typecast, pigeonholed, labeled, fixed. And "to fix" a character is the opposite of "to turn" a character, as the writers' room did over the course of five seasons with the original archetypes on *Friday Night Lights*.

Writing in generalities and typicalities is a form of bigotry because it defines a broad group of people by a narrow group of characteristics. It says all women, men, blacks, Hispanics, gays—fill in the blank—are a particular way. And that is dehumanizing.

A stereotype, at best, is a character cliché. Boring. Been there, seen that. But when you "studiously avoid the clichés and hackneyed characters," as Brad Anderson says, your characters become unique. They begin to take on a life of their own instead of a life defined by generic convention.

"With *Next Stop Wonderland*, Lyn and I wanted to make the anti-romantic comedy heroine in Erin, later played by Hope Davis," Anderson adds. "So we made her smart (she hates romantic comedies), coordinated (she never trips in her high heels), and vaguely depressed (she sits at home listening to melancholy Brazilian jazz). This beat down the conventions in my mind to good effect."

If ever two minds come in handy, it's during the difficult process of detecting clichés and conventions. They're so ingrained they're often unnoticed. But what you don't see, perhaps your partner will. Clichés and conventions die hard, but they're more likely to do so with two of you beating them down and creating something fresh in their place.

Being aware and avoiding character clichés and stereotypes helped Manfredi & Hay when they created Carlos (Jay Hernandez) and Nicole (Kirsten Dunst) for *crazy/beautiful*.

PHIL: Either of them could easily have degenerated into stereotypes. Guy from Boyle Heights going to white high school. It could have easily been rich white girl/guy from bad neighborhood who gets into the wrong kind of stuff. And that didn't really interest us.

MATT: For us it was interesting to do the opposite and hopefully be a little surprising about it.

And *Friday Night Lights*' Coach Eric Taylor (initially named Coach Long) could easily have degenerated into a stereotype of a high school football coach. But Peter Berg and Jason Katims and the writers' room gave him surprising depth, wisdom, and compassion—evident at the end of the pilot after star quarterback Jason Street suffers a spinal injury and paralysis on the field.

From *Friday Night Lights*:

INT. RATLIFF STADIUM — LATER

INTERCUT: Both teams pray together on the field as Jason is stabilized. Players and coaches hand in hand. Coach Long on a knee leading the prayer.

 COACH LONG
 Give us strength to remember that
 life is so very fragile. That we
 are all vulnerable. That we will
 all, at some point in our lives . . .
 fall. We will all fall. We must
 carry this in our hearts . . . that
 what we have is special. That it
 can be taken from us and that when
 it is taken from us we will be
 tested. We will be tested to our
 very souls.

INT. ODESSA HOSPITAL

Music up.

SERIES OF SHOTS as Coach Long and his family move down the hospital hallway.

Coach Long hugs Jason's parents.

 COACH LONG (V.O.)
 We will now all be tested.

INT. ODESSA HOSPITAL — TIME LAPSE

Jason in recovery. Tubes and Halo braces bolted into his skull. Coach Long holding his hand. He's stable but paralyzed.

132 Co-Creating Character

```
                    COACH LONG (V.O.)
          It is these times. This pain. That
          we are able to look inside ourselves.
```

EXT. ODESSA HOSPITAL

Saracen pulling into the parking lot. Standing with the other players. [. . .]

Players from both teams start pulling up, getting out of their cars. Hundreds of young people.

A parking lot vigil.

```
                    COACH LONG (V.O.)
          We are now going to find out who we are. If
          you're interested in finding out who you are,
          I'll be here tomorrow. Will you?
```

Writing for (and With) Actors

If you're writing a role for a specific actor, that person or persona will shape and define your character. Woody Allen's persona shaped Alvy Singer in *Annie Hall* and Isaac in *Manhattan*.

And Eddie Murphy was intimately involved with the creation of his character, Ray Gibson, in Ramsey & Stone's script for *Life*.

ROBERT: We had no boundaries, except for what Eddie wanted. The whole development process was to service Eddie. Whatever Eddie wants.

MATTHEW: Oddly enough, whatever we came up with, he wanted.

Above all, Eddie wanted them to avoid stereotypes.

MATTHEW: He would say, "I'm not gonna pick cotton." Because that's what black prisoners did on these Southern plantations. He said, "You know what? I'm not gonna pick cotton because audiences are gonna see me picking cotton, and their assholes are gonna clench so tight, they're not gonna unclench until they leave the theater. We can't have that. They're not gonna laugh." So we said all right. "And no whipping." It became sort of like no slavery imagery, which was cool.

ROBERT: No watermelon.

MATTHEW: And no watermelon.

ROBERT: He occasionally coached us in how to write for a black person.

MATTHEW: Like what things would push the wrong buttons, even if it was factually accurate. Can't do it. He is so aware of his audience.

ROBERT: He knew what he could pull off and couldn't pull off.

MATTHEW: It's one of Eddie's absolute best performances. It was so fantastic to hear him saying stuff. The guy is a phenomenal improviser. But there were also times when he flat out did the script. I'm not gonna do Eddie Murphy for you, but it sounded just like the way we would say it here, reading it in front of the computer. It was like, "Oh my God, he's doing it so perfectly!"

Charles Gaines describes how Ethan Hawke's experience and instincts as an actor are invaluable to their process of co-creating character.

"Ethan is not only a fine writer and a director, he's a preeminently gifted actor," Charles says. "And what actors can bring to the writing of scripts is enormous because characters in film are not like characters in novels where you create them primarily by the thoughts in their head and by little pieces of nuanced dialogue. In film you've got to create a character by action. Actors are by nature experts at action, and they bring to the creation of film characters a sense of how to show and not tell. And how to distill the essence of the character into a series of gestures as well as dialogue. So it brings a whole new dimension to the creation of characters."

Charles did extensive research on the historical characters for their screenplay *Geronimo*.

"I had read a tremendous amount about all these characters, and I felt like I knew them pretty well. Ethan had not read about them, in some cases not at all, and in all cases very little. And so we would start out with a character by his saying, 'All right, tell me about this guy. Tell me who he is.' And I would go through what I had read and the way I perceived the character. We had a character named General Crook, who was a bizarre man. He'd lost an arm in the Civil War. And he was an abrupt, imperious man who brooked absolutely no disobedience, no second-guessing. We wanted to get across in this first scene with him some of those qualities. He was a big, physically imposing man, and he had been a stone stud during the Civil War. But as a result of losing the arm, he felt physically diminished and a need to always assert and show off the fact that he was still physically extremely competent."

In Crook's first scene, he clashes with a young lieutenant who believes Native Americans should be treated humanely.

"I was trying to describe to Ethan how I wanted Crook to seem impatient with this young man and to show his impatience with the Indians, and his impatience with the trouble they were causing the Army, and his deep desire to exterminate them," Charles explains. "So we sat around talking about how we were going to do this, and Ethan said, 'Chuck! Crook's got one good arm, and what if he's extremely good with this one arm, I mean, better than anybody? And he wants to show that off to our young lieutenant. And he also wants to demonstrate his impatience and deadliness. What if his office is filled with flies? Flies in the summertime

in Arizona are just everywhere. What if as he's talking to the lieutenant, he just casually reaches up and grabs flies out of the air?' Well, Ethan and I both know how difficult that is to do. You know, it's almost impossible to do it once. But Ethan said, 'What if he does it 15 times? And as he grabs the flies, he smushes them on his leg?' And I said, 'Great! That's just fantastic! We don't really have to say anything about this guy's character with that bit of action. It tells us everything we need to know.' Now that's an actor's response to a character definition problem. And there were hundreds of examples in the two scripts we co-wrote of brilliant little pieces of business that Ethan was able to bring to the characterization of characters in our scripts."

"Shortcuts to the imagination," as Thornton Wilder said. Brilliant little pieces of business that reveal the inner character.

Even if you're writing your script with no actor involved or attached, it can be helpful to write with an actor in mind. Imagining the same actor, even putting up pictures (at the risk of looking like a celebrity stalker), is a way to make sure you and your partner are both seeing and hearing the same character.

"An actor just helps me see a character," Jack Epps, Jr., says. "I get a visual image in my mind that I can hold onto and don't lose. The two of us share that image, and we share the rhythm and the dialogue and all that sort of stuff. It's a shortcut. We can sort of see that guy playing that role."

He and Cash could see Tom Cruise in the role of Maverick, and they visualized the actor throughout the process of writing *Top Gun*. "The whole time, from the very beginning," Epps says. "Because we had seen him in *All the Right Moves*. He wore a helmet, and he looked okay. [Laughter] You know, it's actually— It's a concern. Some guys in helmets look stupid."

While we were writing *Obscenity*, channeling Tommy Lee Jones helped us conjure the same mental image and voice for State Attorney Wayne Mueller. And imagining a young William Hurt in the role of Sara's love interest, Joe, helped his character come alive for us.

"A lot of times we talk about actors," says Scott Alexander, "so we're sort of picturing the same person. We'll just sort of free associate—'this is a Steve Martin kind of a guy, and this is kind of a Gary Farmer type.'"

Peter Tolan & Billy Crystal use a similar method when they co-create. "We sit down, and we say, 'What about this character? Who do you think this is based on? Who would play this?' Just so we can get an idea of the rhythm of the character."

For *Analyze This*, before Robert De Niro was even attached, Tolan pictured him in the film as he and Crystal co-created the characters. "I went to the producers very early on, and I said, 'Unless you get somebody

like De Niro to play this part, there's no reason to do this movie. Because the audience has to fully believe that this guy is a mobster. You get somebody else who doesn't have the same weight, you shouldn't even make the movie.' My job was to write the draft that got De Niro. Which I did."

Billy Crystal isn't credited as co-writer, but Tolan gives him a great deal of credit. "That came directly out of Billy sitting there and us talking about what the character would do. So actually he worked it out pretty well for us."

Tolan improvised all the characters with Crystal, who plays De Niro's shrink in the film. "I'd play a part, and we'd go back and forth, and he'd talk in his character's voice, and I would be everybody else. I would be De Niro. And when De Niro did it, he was really fantastic."

As they were writing *The Reaping*, the Hayes brothers imagined Hilary Swank as the main character of Katherine, a former missionary renowned for exposing and discrediting religious phenomena.

"We had pictured her in that role in hopes that she would do our movie," Chad says. "And when producer Joel Silver told us she was interested, we just kinda looked at each other. And then she said, 'Yeah, I'll do it.' It was great. Maybe it was because we were such fans of her work."

Huge fans of Julianne Moore's work, Wash Westmoreland & Richard Glatzer knew she would be perfect for their adaptation of *Still Alice*.

"The more we thought about it, the more perfect the casting," Westmoreland says in the film's press notes. "Julianne could not only project the scintillating intelligence and complexity of a linguistics professor but also the vulnerability and simplicity of the later stages. She'd be able to master every beat of the character's deterioration. She is quite simply one of the finest actors on the planet. We had met with her a few years before on another project, pitched hard to get her to do it and eagerly waited for weeks and weeks as she deliberated and finally passed. This time it was different. We sent a message to her about the project and she read the book even before the script arrived. A day or so later, we were on Skype. Within seconds she said, 'I'm in.'"

You may even find it helpful to channel late, great actors (just don't count on their being available for production). In an interview in the *Los Angeles Times*, Alexander Payne says he and Jim Taylor thought of Giulietta Masina—Federico Fellini's wife and frequent leading lady—while writing *Citizen Ruth*. And for *About Schmidt*—based on a book by Louis Begley and Payne's solo-written script *The Coward*—they conjured William Holden.

So even seeing dead people can bring your characters to life.

 Script Partner Points

- Co-create character by asking, "Who are our eyes on this journey? Who are they and why are they? What's lacking in their lives that this is going to fulfill?" Or come up with your own list of questions that help you both brainstorm character.

- Riff on your characters' traits, habits, attributes, and names. If it helps, write bios for them.

- Remember that your characters don't have to be sympathetic or even likeable. Just make sure they're complex and interesting. And find a way to connect to them, however sympathetic they may or may not be.

- Do as much research together as possible to deepen your understanding of your characters.

- Avoid character clichés and stereotypes.

- Try writing with specific actors in mind—or people you know—so you both can see and hear the same character.

- Characters may evolve as you write, so be open to the new directions they take you.

> "We're only interested in one thing, Bart. Can you tell a story? Can you make us laugh? Can you make us cry? Can you make us want to break out in joyous song? Is that more than one thing? Okay!"
> —Jack Lipnick (Michael Lerner), *Barton Fink*

EIGHT
Co-Creating Story and Structure

If you've answered Ganz & Mandel's question "Who are our eyes on this journey?" you'll need to answer a new set of questions: What is the journey? What is the path that your characters—and the audience—will be taking? What is the pattern of human change? In short, what is your story?

For us, brainstorming—or spitballing—the broad strokes of our story is the most exhilarating part of the process. Anything's possible at this point. And all the advantages of collaboration come into play—greater creativity, confidence, energy, excitement, experimentation, feedback, and laughter—as we bounce the story possibilities back and forth.

"Out of one weird spitballing idea comes another idea that is also weird but less so," says William Goldman in *Which Lie Did I Tell?* "And then out of some divine blue, someone is shouting, 'No, no, *listen to me*, I've got it—listen to me—' And there it is, the spine of the story, with all the sludge ripped away. You can see it, and it's going to be such a great movie you wouldn't believe it. At its best, what spitballing does is give you the illusion that just this once you have slain hunger and beaten death."

An appropriate image, because creating a story, exhilarating as it may be, often seems to require superhuman strength. Consequently, for many teams, including the Longstreets, this is the most challenging and critical phase of the process.

RENEE: The story is the hardest part of any writing. It is. For us, there's no comparison.

HARRY: If the story doesn't work, nothing's going to work.

To get your story to work, it's important to consider the materials you have to work with.

"A builder who does not know the material he has to work with courts disaster," Lajos Egri states in *The Art of Dramatic Writing* ("the most stimulating and best book on the subject ever written," according to Woody Allen). "In our case," Egri says, "the materials are *character, conflict,* and *premise.*"

Co-Creating Story From Character

One of the richest aspects of character to mine when you're co-creating story is your character's central want.

"As far as story's concerned, what a character wants is a screenwriter's jackpot," Claudia says in *Crafting Short Screenplays That Connect.*

It provides your character's intention, which drives the story and gives you the story's throughline:

In *Gravity*, Ryan Stone wants to return to Mother Earth.

In *Dallas Buyers Club*, Ron Woodroof wants to survive AIDS.

In *Top Gun*, Maverick wants to be, well, Top Gun.

In *Tootsie*, Michael Dorsey wants to be employed as an actor.

"The protagonist has a need or goal, *an object of desire*, and knows it," Robert McKee says in *Story*. "However, the most memorable, fascinating characters tend to have not only a conscious but an unconscious desire. . . . What he believes he wants is the antithesis of what he actually but unwittingly wants."

And needs:

Ryan Stone needs to come to terms with the death of her child.

Ron Woodroof needs to overcome his homophobia.

Maverick needs to overcome his troubled past with his father. "He's haunted by it," Epps tells us, "and it's also why he's got to continue to be the best. Because he's got a past that he has to live beyond, live up to and beyond."

Michael Dorsey needs to be humanized. And with a lot of help from Larry Gelbart ("I had been writing that show for about a year," Gelbart sighed), Dorsey *is* humanized—by being feminized. As he says to Julie (Jessica Lange) at the end of the film, "I was a better man with you as a woman than I ever was with a woman as a man."

We can say from experience that exploring your characters' wants and needs is immensely helpful when creating your story.

In *Psycho Bitch*, Mary wants to win Mr. Right, but she needs to accept herself first. In *Obscenity*, Sara wants to defend Sam's business from criminal obscenity charges, but she needs to overcome her own ambivalence about homosexuality. By the end of these stories, these wants and needs have been met, but not in predictable ways. And both characters are changed in the process.

Character Change . . . or Not

At the beginning of their story development process, Matt Manfredi & Phil Hay ask themselves how their characters are going to change, how they'll be different by the end. In other words, what are their character arcs?

"It's been ingrained in us," Hay says, "and we understand implicitly that characters have to change and something has to happen. The character should have the capacity to learn. Or else that character is going to be pretty flat."

Unless your dramatic purpose is showing a character incapable of growth—such as Ruth Stoops in *Citizen Ruth* or Jim McAllister in *Election*. "Jim McAllister is constantly, unconsciously, totally creating the crisis in his own life, so that he can break out of it. . . . He has to break out and do something new. He just changes his life, but he doesn't grow," Alexander Payne says in *Scenario*.

McAllister destroys his life as a high school teacher and creates a new life as a museum tour guide, but he ends up in the same psychological and emotional place. "That's our cruel joke," Jim Taylor adds.

From *Election*:

```
EXT. STREET — CONTINUOUS

CLOSE ON JIM AGAIN

                    JIM (V.O.)
          . . . when I think about my new life
          and the exciting things I'm doing, and
          I think about what her life must be
          like — probably still getting up at five
          in the morning to pursue her pathetic
          ambitions — it just makes me sad.

The limousine pulls out of the driveway and onto the street.

                    JIM (V.O.)
          I mean, where is she really trying to
          get to anyway? And what is she doing
          in that limo? Who the hell does she
          think she is?

Suddenly Jim HURLS his soft drink at the limo, and it BURSTS
against the back window. The limo SCREECHES to a halt.

Panicking, Jim turns and RUNS in the opposite direction.

INT. NATURAL HISTORY MUSEUM — HALL OF MINERALS — DAY

Jim stands before a group of SCHOOLCHILDREN, holding a large
rock in one hand.

                    JIM (V.O.)
          But that's all ancient history now.
          I've got a whole new life. That's
```

```
                    what's great about America — no matter
                    who you are or what you've done, you
                    can always start over.

                              JIM
                    So would that make this an igneous rock
                    or a sedimentary rock? What's the difference
                    between igneous and sedimentary anyway?

          A BLONDE LITTLE GIRL thrusts her hand in the air, vaguely
          reminding us of someone. Jim notices her but continues to
          search the group.
                              JIM
                    Anybody?
```

The Characters' Inner Logic

Characters in character-based franchises like James Bond usually don't change either. Their stories spin out of the hero's external need to overcome the villain *du film*. But when the Batchlers develop a script like *Batman Forever*, they also spin story out of their villain's needs.

"We really think it's important to plot the villain's story," Janet says, "because otherwise you end up with a villain who basically only does what the hero wants him to do, and not what would make sense from the villain's point of view."

This violates what the Longstreets like to call the "inner logic of behavior."

"I find the biggest fault of writers working in our business is they will try to fudge the story to get a plot the way they need it to go," Renee says. "This is the most important lesson I think we can teach—that the inner logic of behavior must be true."

Following your characters' inner logic is an excellent way to generate story. And if you don't, you risk destroying their credibility and developing flaws in your script.

"Big movies have enormous flaws," Renee says, "because they don't do inner logic. They force the story. You can't do it. You have to have *people*."

The same inner logic of character behavior is true of the small screen, as *Breaking Bad* writer George Mastras tells Indiewire.com.

"As long as the characters are doing things that make sense organically to their character and if the action of the story comes from the characters, I think everything else will flow from that and the scene will have an intensive reality to it . . . we may pound our heads a couple of days to get out of the logistical problems of things—but you can always bridge that gap if the character stuff makes sense."

At the end of the day—and a TV episode or movie—it's the people we care about.

"It's hard to come up with a plot that is so clever and so intricate that even if the audience doesn't care about the characters, they're fascinated

by the plot," Phil Hay says. "I think that almost never happens. And it's not even a laudable goal. As long as we can look at it and say, 'I care about these characters,' then everything's fixable. Everything can be worked out."

Character POV ("Who Are Our Eyes on This Journey?" Revisited)

Chad & Carey Hayes worked out the story for *The Conjuring* by shifting the point of view to the characters they cared most about.

CAREY: In the original treatment sent to us—to see if we'd be interested in the project—it was the parents' story. True story, mom and dad. And we're looking at it, and it's a very traditional haunted house story.

CHAD: Family buys the wrong house. So what do you do?

CAREY: Except for the part with Ed and Lorraine Warren, the paranormal investigators. We thought, *What if we shifted the POV?* It's almost like Ed and Lorraine step into Act Three of these people's lives. It's like calling 911, "I need help." Now you're starting the story where they step into their lives.

With this new point of view, the Hayes not only found a fresh approach to their genre movie—they also birthed a character-based franchise, with numerous story possibilities.

CHAD: We're suddenly like, *Wow, the Warrens have done thousands of cases.* We'd been looking for a franchise way in—James Wan did *Saw* and *Insidious* and all these other ones. So it was a way in, and then it was a matter of going through all their investigations. And once we ended up at New Line, they bought 27 of these Ed and Lorraine Warren cases.

Co-Creating Story From Conflict (and Connection)

Pick up any scriptwriting book, and you'll be bombarded by the importance of conflict.

"The basis of all drama is conflict," Syd Field says in *Screenplay*. "Without conflict there is no action; without action there is no character; without character there is no story. And without story there is no screenplay."

So if you need to brush up on conflict as the basis of drama, there are numerous books on the subject. All we can really add here is a fresh way of looking at conflict. It isn't some magic ingredient you must throw into the mix like eye of newt—it's a byproduct.

With all due respect to Syd Field et al., the basis of drama is doing (the word "drama" comes from the Greek *dran*, "to do"). In the best plays and screenplays, someone is trying to do something important. Lysistrata is trying to stop a war. Michael Dorsey is trying to work as an actor. But it isn't easy. Their will runs into walls on its way. And when will meets obstacle, conflict occurs. Knowing this, you can create all the conflict you want. You can create wonderful conflict-driven stories. But keep in mind that wonderful stories aren't just about conflict.

"*Romeo and Juliet* is the story of the conflict between two families," the novelist Ursula LeGuin has observed, "and its plot involves the conflict of two individuals within those families. Is that all it involves? Isn't *Romeo and Juliet* about something else, and isn't it the something else that makes the otherwise trivial tale of a feud into a tragedy?"

As Claudia explores in the Introduction to *Crafting Short Screenplays That Connect*, that something else is connection. Conflict is not incorrect, it's incomplete. There are moments of change in our lives that are simply not comprehended by conflict. They're connections, human exchanges, "people taking care of each other in small ways of enduring significance," as Stephen Jay Gould says in "Counters and Cable Cars." However fleeting or small, these moments create ties between us. Connection is just as essential as conflict—to our lives and the stories we tell—but it's been essentially overlooked in scriptwriting books.

The truth is, the best stories have both—conflict *and* connection.

"They're complementary forces woven together," Claudia says in *Crafting*, "like strands of deoxyribonucleic acid—the double helix of drama."

The development of our story for *Psycho Bitch* is an excellent example of this interweaving. The very title of the script—the first thing we had—suggested conflict. We knew The Bitch would be trouble for our protagonist, whoever she turned out to be.

She turned out to be the very mousy Mary DeLucas, who wants connection—"true love and a really expensive white wedding" with Mr. Right, Frank. But once The Bitch is unbound, there's no way she's letting Mary bind herself—and by extension, The Bitch—in "the holy bondage of marriage." She must derail Mary's plans, and Mary must derail the derailing and put The Bitch back in the proverbial bottle. Which Mary does at the altar and goes off on her honeymoon, where she discovers that the real villain is Frank, and the connection she needs in her life is The Bitch—who saves her.

Psycho Bitch was always intended as a high-concept script, more commercial and plot-driven than indie-minded *Obscenity*. That's not to say that we didn't work hard to create complex characters, but our approach to the material, our way of unlocking the story, was exploring its potential for conflict and connection. As we did, we found the story's major movements and moments.

So when you're unlocking your story, you may want to begin by looking at your main character's important connections—or central conflict, which often flows from your antagonist's intentions and your hero's responses.

Co-Creating Story and Structure 143

As Janet Batchler says, "A lot of the times with the stories we write, the villains start out driving the story, and the hero has to derail the villain's plan."

The same is true of story development on the TV series *The Blacklist* about fugitive Raymond "Red" Reddington (James Spader), who gains immunity by helping the FBI capture the world's most dangerous criminals/blacklisters. And he insists on working with FBI agent Elizabeth "Liz" Keen (Megan Boone).

After writing all five seasons of *Friday Night Lights*, Patrick Massett & John Zinman co-wrote and co-produced episodes of *The Blacklist*, including "The Stewmaker," and they add to what Janet says about villains.

PATRICK: I think it's a basic understanding of writing that your villain has to be equal to or greater than your hero. Otherwise, there's no tension. James Spader is a pretty formidable cat and the character of Reddington is a pretty formidable dude, so we had to dig deep to find really interesting blacklisters. Then the task of creating that villain is trying to come into something personal for the character, so it's not just good vs. evil. There's something personal about Red wanting to or Liz wanting to stop this person, or both, or Red wanting to stop this person for Liz. Some emotional component to creating the villain was, I think, essential. The Stewmaker was based on an actual guy. He worked for one of the cartels in Mexico, and he disposed of bodies.

In a chemical soup. And when Liz is kidnapped, and the Stewmaker is about to torture and kill her and dissolve her body, Red saves her and throws the Stewmaker into the chemical stew.

PATRICK: That's how we in general approached and were approaching the villains on that show.

JOHN: I think that the task was always grounding it in what Patrick was talking about, finding a larger-than-life villain and then finding the point of contact with Earth, you know? Because they're existing in a fantasy land, a very cartoonish realm, and if you can somehow tether them to something human, it will be more successful than if they're just a Batman villain. Because those are great too in that context, but I think what makes *The Blacklist* work is that it hovers somewhere between Batman and reality.

PATRICK: Well said.

Red saves Liz because they have a relationship, a connection, and that provides the heartbeat of this brutal series. So we as an audience can connect.

In short, a story can't live on conflict alone. And it is connection that often gives a story its deepest level of meaning.

The Hayes brothers understand this even when they're writing big action movies. And like the great Greek dramatists (shout-out to Sophocles), they understand that the most profound connection is family.

CAREY: We love writing family stuff. Otherwise, it's an action movie where you don't care about the characters. So our biggest thing is we want to bring—

CHAD: Heart and soul.

CAREY: Heart and soul. And we want to bring higher personal stakes. Like a parent will always throw themselves on the tracks for their kids. But instead of just saying that, we want them to understand why.

So as you're developing your story, it's useful to remember that the greatest conflict often comes from your character's important connections being threatened—or ended. A principle Cash & Epps used to powerful effect in *Top Gun* with the death of Maverick's best friend and co-pilot, Goose, when they have to eject from their F-14.

"What came out of early research and meeting with the pilots was whenever they talked about somebody dying, you could see every one of them just would— You could feel the pain," Epps says. "They just never let it go. And for Jim and me that became— Well, if we can make the audience feel that, just put them through that so they understand. That's why we didn't start the movie with a crash because that then says, 'Well, life is easy, anybody dies.' In fact, it's not easy, and so when it happens, it really hurts. We broke a rule of cinema—don't kill one of the favorite characters, don't *ever* do that, the audience will never forgive you. And so we did that to put the audience into the feeling of mourning, so they emotionally relate to what Maverick is going through. It was powerful. One of the best things about being a writer is to sit in the theater and watch the audience, you know, because I knew what was coming and I'd sit back and just watch the audience to see how they respond. And I'd see them just sit up in their chair in shock and stuff, and you go, 'Yeah, baby. They're in pain! I did it right!' [Laughter] The best compliment I've ever gotten about the movie was from the pilots who basically said, 'Now I can take my family and show them what this is about because I never could explain what we go through.'"

Co-Creating Story From Premise

Another approach to developing story is determining what your movie is really *about*. What is its premise? Lajos Egri lists different words that mean the same thing—"theme, root idea, central idea, goal, aim, driving

force, subject, purpose, plan, plot, basic emotion"—but he prefers premise "because it contains all the elements the other words try to express and because it is less subject to misinterpretation."

Simply put, premise is the proposition that your story will prove. Egri offers examples from Shakespeare:

"Great love defies even death." (*Romeo and Juliet*)
"Blind trust leads to destruction." (*King Lear*)
"Ruthless ambition leads to its own destruction." (*Macbeth*)

Once you know your premise, you know your main character and your story's essence, its purpose, what you're trying to say—powerful mojo when you're creating story. We recommend that you write it down because you can easily lose sight of it in the often-chaotic story development process.

Working as a collaborative team helps us keep premise in mind. When we get stuck during story discussions, one of us will say to the other, "What's this friggin' story *about?*" And we brainstorm until we find the answer. Articulating premise is never easy, and we don't always come up with something as elegant as Egri's examples, but once we've stated our premise, we're that much closer to understanding and creating our story.

Developing *Psycho Bitch*, we looked to premises of favorite comedies for inspiration:

A moment of courage can change the course of a person's life. (*Back to the Future*)

An unprejudiced heart can change the course of life in the valley. (*Babe*)

A man becomes a better man by literally walking in the shoes of a woman. (*Tootsie*)

We decided that our premise would be, "You must learn to love yourself—all sides of yourself—before you can find true love." This gave us Mary's character (mousy), her conflict (putting The Bitch back in the bottle), and our story's ending (true love and a very Vegas wedding).

Ultimately, we create our stories by exploring all three of the tools we have to work with—character, conflict/connection, and premise. We bounce from one to the other—creative pinball—until we've developed a clear, complex story.

Structuring Your Screenplay

"SCREENPLAYS ARE STRUCTURE," shouts William Goldman in *Adventures in the Screen Trade*. "The essential opening labor a screenwriter must execute is, of course, deciding what the proper structure should be for the particular screenplay you are writing." This, he believes, is "the single most important lesson to be learned about writing for films.... Yes, nifty dialog helps one hell of a lot; sure, it's nice if you can bring your characters to life. But you can have terrific characters spouting just swell talk to each other, and if the structure is unsound, forget it."

Before learning this invaluable lesson, *Shrek* screenwriters Ted Elliott & Terry Rossio wrote in longhand, passing a single pad of paper back and forth across the table at a Coco's restaurant in Orange County.

"While we worked from an outline, we hadn't yet discovered the importance of really nailing the structure before we wrote FADE IN," Elliott says at Wordplayer.com, "so there was a lot of tearing out and crumpling up and staring blankly at each other, wondering how we're going to pay for the coffee on the miserable salaries from our real, full-time jobs."

Gradually they discovered what Elliott calls "the real craft of screenwriting: structure." They started outlining until they got it right, until they set the major story moments, and sometimes until they figured out the structure of individual scenes. "We can now divide up the scenes and sequences and work independently," Elliott says. "Sometimes we're in the same room, on separate computers, sometimes not."

So co-creating a solid structure keeps you and your partner on the same page through the arduous process of drafting and rewriting.

The "Paradigm"

In *The Screenwriter's Workbook*, Syd Field seconds William Goldman. "Structure is the most important element in the screenplay. It is the force that holds everything together; it is the skeleton, the spine, the foundation."

While Goldman is careful to say that your first job is deciding what "the proper structure should be for the particular script you are writing," and describes in great detail his own struggle to find the right one for *Butch Cassidy and the Sundance Kid*, Field tells you flat out what it should be—a strict three-act structure he calls "a paradigm." If you've spent any time on Planet Hollywood, you can probably recite it in your sleep: Act One (setup/pp. 1–30), then Plot Point I throws the story into Act Two (confrontation/pp. 30–90), then Plot Point II throws the story into Act Three (resolution/pp. 90–120).

In Hollywood, first and third acts have gotten shorter, especially in comedies, and we've been down the Green Mile of more than a few three-hour-plus movies, but for the most part, Syd Field remains the industry standard. Many have complained that Field's ubiquitous paradigm has spawned generations of predictable screen stories. They're right, it has. Far too often stories are forced into it whether they fit or not—the narrative equivalent of Cinderella's sisters cramming their feet into the glass slipper. But this has more to do with the write-by-number nature of Field's paradigm and the assembly-line mentality of Hollywood than it does with the three-act structure itself.

"Hollywood is schizophrenic because it is a corporate culture that deals in an art form," Marshall Brickman explains. "Risk is not encouraged, it is frowned upon. If you have a toaster that works and sells, you do try and make as many of them as you can and keep them on the shelves. If you have

a formula for a kind of film, or enough elements of a formula (i.e., star) to feel comfortable, then you try and go with that. It's risk vs. investment strategy, and the prudent investment strategy has pretty much won, the irony being that after a while the stuff gets so repetitive and predictable and lacking in originality or personality that what happens is, well, look at the movie section of your local paper and see how many 'mainstream' movies you really want to go and see. Thank God for independent cinema and—God help me—Showtime, HBO, Lifetime, A&E, but don't get me started."

Brickman assures us, however, that there's nothing wrong with the three-act structure per se. "The three-act structure is not a 'formula' any more than a rectangular canvas is a formula for a painting. Just a very general framework into which you can put your ideas."

It's as ancient as Aristotle, who said in his *Poetics* that "tragedy is an imitation of an action which is complete and whole," adding that "'Whole' is that which has beginning, middle, and end."

Movies might be more original and less predictable if we replaced Syd Field's strict paradigm with Aristotle's more organic guidelines. And some of the more original movies like *Citizen Ruth* seem to be the result of writers doing just that. "We never tried to cram this story into some kind of a Syd Field notion of how a script should be, how a story should be told," Jim Taylor says in *Scenario*. "It had more to do with whether it felt right or not: that was really our only criterion—that it had some shape to it, however small."

But Scott Alexander & Larry Karaszewski acknowledge the importance of using the more traditional Hollywood structure, especially when creating less traditional stories.

SCOTT: You can take Syd Field's paradigm and shove it down our *Larry Flynt* script, and it works. You can say, page 10, he starts *Hustler*. Page 30, he gets arrested for the first time. Page 60, he gets shot and paralyzed and goes crazy. Page 90, he gets locked in the loony bin, and Jerry Falwell sues him, and Larry decides to go to the Supreme Court. Climax of the screenplay. And it fits into that formula. Now it's a completely ridiculous movie! I mean, it's dealing with a lot of strange characters and issues you don't normally see in a Hollywood star-driven production. But it has a normal form.

LARRY: We always joke that our form is very studio-friendly—it's our content that tends to be odd. Usually, when you see a more independent kind of movie, the form is odd and the content is odd. We manage to take this strange subject matter you don't usually see in a movie, and by putting it into that Hollywood form—I think that's the reason why our movies have been made by studios instead of independently—they feel comfortable. They do look at that structure.

Because they're "really trying to tell a normal movie," Alexander & Karaszewski look for their structure first. The characters in their biopics are already essentially established, so the challenge is deciding what *part* of that person's life they will tell, rather than telling a ponderous, all-encompassing "cradle-to-the-grave" story.

LARRY: We try and look for what's important. We try and figure out what's the happy ending. I think a lot of biographies aren't successful because they end with the guy dying. *Man on the Moon* ended with the guy dying, but—

SCOTT: But that was the joke.

LARRY: We say, "How do we take this person's life and go out on a victory?" It doesn't have to be a traditional kind of a victory. It just has to be, "What was the success for themselves?" Like Ed Wood—his greatest success is that he made the worst movie of all time. With Larry Flynt, it was that he beat Jerry Falwell in the Supreme Court. With Andy Kaufman, it happened to be his death. His death was his greatest work of art.

By answering those questions—"What part of the whole story are we telling?" and "What events are significant?"—they find their structure.

These are important questions too for fictional stories. Matt Manfredi & Phil Hay carefully consider "point of attack" when they're creating the foundation for a script. "It's always in terms of, 'Why are we starting the story here?'" Manfredi says. "'Why didn't this happen yesterday? Why didn't this happen tomorrow? Why is this movie occurring right now? Why are we coming into the story at the point we're coming in at?'"

They acknowledge the importance of structure in their writing ("the first thing after character is structure," Hay says), but they don't follow Field's paradigm as closely as Alexander & Karaszewski. When scripting *crazy/beautiful*, they had firm ideas of what the acts were, but for them and director John Stockwell, it wasn't the kind of movie that falls into the paradigm of turning points punctuated by big events.

PHIL: The story couldn't exist as a—*Bam!* First act ends! *Bam!* Here's the end of the second act!

MATT: I think it's a movie that takes a little more time getting to know its characters, getting to know this world and setting the tone. I think if you took out ten minutes in the beginning, it might fall into a very conventional structure, but I think it would lose something in that too. It would seem a little rushed.

The Hayes brothers don't feel tethered to the paradigm either.

CHAD: We don't really follow any of those rules. We get on these panels, and it really frustrates these university people because I'm an Econ major and a Psychology major. I just love movies, and we figured it out. And I don't worry about page 65, making a left turn. I don't think about that—we really don't. We don't think about any of that.

Beginnings and Endings

The Hayes may not strictly adhere to Field's structural rules, but they do feel strongly about the importance of a script's first ten pages.

CAREY: Grab 'em out of the gate!

CHAD: You gotta grab 'em. These guys are bringing home 15 scripts a weekend, ten scripts a weekend, and if you don't have them in ten pages, forget about it. Have outrageously great opening scenes. I know that sounds so flippant but choose what your opening is going to be.

CAREY: Don't wait for the reader to get into the story ten pages in. Engage.

CHAD: Yeah, you gotta engage no matter what.

CAREY: A lot of times we get this feedback like, "Shit, man, that was like Act Three. You opened on Act Three." No, we know Act Three is going to be way bigger than that.

The Hayes tell us the opening scene of their screenplay *Monkey Exchange* ("another film that hasn't been made but a script we're really proud of," Chad says). And the brothers' interplay provides a peek at their dynamic pitching style, which we'll discuss further in Chapter Eleven.

CHAD: It opens with— You think a bunch of people are playing softball. "Batter, batter, batter! Batter, batter, batter!" We set up all the relationships within the banter.

CAREY: Mixed league, guys and girls, pounding the mitts.

CHAD: And smoking. You slowly widen, widen, widen and realize we're on the top of a tanker ship out in the middle of the ocean.

CAREY: Like a cargo tanker. Guy hits the ball, creams it over this high fence. "You motherfucker! That's our last ball!" Then over top, everybody's looking, and the ball goes—and you see this *BRRGGSSZZZ!* It's a spaceship, and it crashes in the ocean. You think, "What the fuck was that?" As they're peering at it, it's bobbing in the water. It says Mercury One.

CHAD: It's the United States—
CAREY: Flag.
CHAD: NASA.
CAREY: Mercury One was the first craft launched by NASA to go into outer space. And that's the opening of the movie.

Sometimes you and your partner will know your beginning from the beginning, and sometimes you'll find it later in the process.

It took a while for Cash & Epps to find the beginning of *Top Gun*, but once they did, the screenplay's structure fell into place.

"All fighter pilots will tell you that a night carrier landing is the worst thing in the world," Epps says. "It's just so hard to conceive of anyone doing that. I've done carrier landings, and it's not even a postage stamp in black ink bobbing in the water. It's just unbelievable. So we always thought that was our midpoint. But we had trouble with the opening, trying to figure out how to open this movie. And Jim called and said, 'You know, I think that night carrier landing should start the movie.' And it was like a simple chain of events—suddenly everything just laid out. It just went *whoosh!* It all laid out, and it was written actually very quickly."

So you can't always create your structure from A to Z. And this may vary from project to project. Sometimes finding your ending is a great way to begin.

"We write randomly," Chad Hayes says. "Sometimes we write the ending first."

Alexander & Karaszewski do too.

LARRY: A lot of times it is about looking backwards. A lot of times it's knowing how you're going to end the movie and then figuring out how you're going to get there.

SCOTT: With *Man on the Moon*, we always knew the third act was going to be Andy gets sick, people think it's a joke. And he dies, people aren't sure. Closing scene—Tony Clifton sings the song, now the audience isn't sure. We always knew that's how we were getting out.

Complementary Strengths

We don't adhere strictly to Syd Field's paradigm either, but we do craft a meticulous structure before we begin writing. By working backward, forward, or zigzagging, however the Muse happens to lead us, we find what Claudia's friend Mark Spragg (*Everything That Rises*; *An Unfinished Life*) calls the "four big rocks"—the inciting incident, two turning points, and climax. It's comforting to have these in place. As Mark says, "Before I swim across a big lake, I want to know where the big rocks are."

As we co-create this design, our complementary strengths come into play. Claudia is more adept at developing the deep structure, the deeper emotional patterns of connection and disconnection. Matt is stronger at developing the surface structure like acts and plot points. Together, we make sure the beats are covered.

"Structure is my strong suit—if I have one, it's structure," Charles Gaines says about his half of the complementary-strengths equation with Ethan Hawke. "I mean, I do have a sense of how one thing leads to another and how you can divide any script or book or article, for that matter, into sections, and each one's got its own place. And knowing where those sections go vis-à-vis each other and how they should modulate each other is hugely important. And that's, as I say, that's my strong suit. And it's not Ethan's, and he never claims for it to be. So he would pretty much leave the structure to me, and we would work inside that structure."

Marshall Brickman bristles at the suggestion that he's stronger on structure than Woody Allen. "Somebody decided I was the structure man, but then this person disappeared or died or was killed, so I have never had the chance to confront him on this. *All* you have to do is look at either Woody Allen's movies without me or mine without him to see that probably each of us can do either thing."

But it was Brickman's eye for structure that spotted a hole in Act Three of *Manhattan*. There was no confrontation between Isaac/Ike (Woody Allen) and Yale (Michael Murphy), who both are in love with Mary (Diane Keaton). Brickman urged Allen to include such a scene. "I felt there was some dramatic or comic result to be gained from a showdown between the two characters."

Allen tried a scene where Yale and Isaac confront each other over the phone, but when he and Brickman screened the film, they agreed that the confrontation had to happen face to face. "So we did it," Brickman says, "and it stayed in. Whether the picture would have been better, worse, or exactly the same with its omission, we'll never know."

From *Manhattan*:

```
                    YALE
          I wanted to tell you about it. I
          knew it was gonna upset you. I — uh,
          uh . . . we had a few innocent meetings.

                    IKE
          A few?! She said one! You guys, you
          should get your story straight, you
          know. Don't - don't you rehearse?

                    YALE
          We met twice for coffee.

                    IKE
          Hey, come off it. She doesn't drink coffee.
          What'd you do, meet for Sanka? That's
```

> not too romantic. You know, that's a
> little on the geriatric side.
>
> YALE
> Well, I'm not a saint, okay?
>
> IKE
> (Gesturing, almost hitting
> the skeleton)
> But you — you're too easy on
> yourself, don't you see that?! You
> know, you . . . you — that's your
> problem, that's your whole problem.
> You-you rationalize everything. You're
> not honest with yourself. You talk
> about . . . you wanna — you wanna
> write a book, but — but, in the end,
> you'd rather buy the Porsche, you know,
> or you cheat a little bit on Emily,
> and you play around the truth a little
> with me, and — and the next thing you
> know, you're in front of a Senate
> committee and you're naming names!
> You're informing on your friends!
>
> YALE
> (Reacting)
> You are so self righteous, you know.
> I mean, we're just people, we're just human
> beings, you know. You think you're God!
>
> IKE
> I - I gotta model myself after someone!

Nick Kazan is quick to concede that Robin Swicord is the structure man, er, woman in their collaboration. "Robin is really quite structurally brilliant, I think," Kazan says. "She seems to know intuitively exactly where actions should fall to set up other actions, how the subplot should work, where this should come in, where that scene should come in, if this action is falling late or early. I don't know. I'm just fumbling through."

Ideally, your complementary strengths will help you create a structure that will keep you from fumbling through and your script from collapsing when you draft or, worse, when your script goes before the cameras.

Unfortunately, this isn't always the case, according to Jim Taylor. "Often movies go into preproduction before the script is ready, with the misguided idea that the script will somehow miraculously get 'fixed' before shooting, which almost never happens," he tells us.

Peter Tolan & Harold Ramis didn't realize the structural problems of their screenplay for *Bedazzled* until after the film was finished. And no one was more surprised than they were, since it was a "tremendously easy movie to write," Tolan says. "I told Harold that it would be a monstrous, huge, huge hit."

The scripting went well. The shooting went well. Everything was going *too* well. Tolan began to suspect something bad was going to happen. He was right. "Once we actually got it up and were putting it together, we realized the real problem—it's not an involving movie. Because at a certain point, the audience is going, 'Okay, I understand how this works—he gets a dream, and it gets screwed up.' So the audience is out of the movie trying to figure out how it's going to get screwed up, and they're second-guessing it. So people never really connected to it in the way, I guess, we wanted. So in some ways, it turned out to be a dumb movie with a real big trap."

The trap was predictability—the result, in part, of an episodic structure.

Kazan & Swicord had to avoid this structural pitfall when adapting Roald Dahl's *Matilda*. "At the end of every chapter, Matilda basically vanquishes one villain after another," Kazan says. "She humiliates her mother, and she humiliates her father. We had to structure it so that, although we had some of those humiliations at the end of each one, there was an answering threat from the authorities, saying, 'You got me this time, but now I'm really going to make your life miserable.' We had to give the appearance of escalation so that it wouldn't feel episodic."

Episodic structures don't have a monopoly on predictability. Heaven knows we've sat in movie theaters guessing how—and when—the plot would work out. And this isn't just true of bad movies. Sometimes even a vibrant, original film like *Y Tu Mamá También* telegraphs its own ending (plant a lab test in Act One . . .). Perhaps that's why some teams prefer to write their script without working everything out first and let the structure emerge as they go.

Flying Commando

When they wrote *Drôle de Félix* (*Adventures of Felix*), Olivier Ducastel & Jacques Martineau had only a "very vague" structure before they started drafting. "We just discussed it, and then Jacques wrote a first version of the script," they say. "In short, we think that to construct our stories, we do it in the scriptwriting. By that we mean the first building block is the drafted script. It's the only way we've found to do it. All the rest doesn't interest us."

Brother teams Joel & Ethan Coen and Peter & Bobby Farrelly will also start drafting without a structural safety net. Sometimes they don't even know where their story is going.

As we said in Chapter One, this approach makes William Goldman crazy. "The Coens drive me nuts a lot of the time. Everything I feel you must do, they don't," he says in *Which Lie Did I Tell?* "Example: I cannot explain too often how crucial it is for you to know your story before you start. For me, if I don' t know how a story is going to end, I don't know how to enter each individual scene preceding."

But that's not how the Coen brothers work. "We type scene A without knowing what scene B is going to be," Ethan tells Goldman, "or for that

matter, we type scene R without knowing what scene S is going to be. . . . Because we're doing our own thing, we can get stuck and literally grind to a halt and put it aside for a year even."

The Farrelly brothers have an equally unusual way of approaching their material, purposely writing themselves into a corner. "We think if we can go into a corner where there's no way out," Peter says, "and then we take a week or a few days or a month even, and find a reasonable way out without making it absurd, then nobody in the audience is going to sit there and get it within a minute and get ahead of us."

Don't get us wrong. Goldman's a big fan of staying ahead of the audience—he just uses a well-designed structure to do it. "The audience is so quick, so smart, they grasp things immediately," he says in *Adventures in the Screen Trade*, "and if you give them what they expect, if they reach the destination ahead of you, it's not easy for them to find it in their hearts to forgive you."

Outlines and Treatments and Cards—Oh My!

"We used to write into the darkness, and that didn't really work as efficiently," Matthew Stone told us in our first-edition interview. "I mean, it would work, but it would be many, many drafts later that it would work." So he and Robert Ramsey started outlining.

Likewise for Matt Manfredi & Phil Hay.

MATT: There have been times when we've worked without an outline and just started working and going.

PHIL: It's been a long time since we've done that.

Like Rossio & Elliot discovering the "real craft of screenwriting," many teams have discovered the advantages of co-creating an outline, especially if they're planning to split up the scenes, acts, or drafts.

PHIL: We worked out every scene of *crazy/beautiful* in excruciating detail, the beats of the scene, in outline form, then we found that it was easier to take separate scenes and go away and write them.

Usually when they outline, they create a scene breakdown.

MATT: More like a term paper outline. It's a little bit more like a narrative with bullet points—Act One and bullet. But each scene has a bullet, and the scenes that are obvious to us are just little sketches.

The scenes don't include sluglines (e.g., EXT. HIGH SCHOOL – DAY) at this point but may contain bits of dialogue for a specific beat or comedic moment.

The Hayes brothers rely heavily on an outline.

CHAD: We're big outliners because I would rather rewrite a paragraph of the outline than five pages of the script—you know what I'm saying? Because if it doesn't work in your outline, it isn't gonna work in your script.

CAREY: We'll write an outline in Final Draft. It won't be in Word. It will be in Final Draft because we'll do INTERIORS, EXTERIORS. If we have some dialogue, we'll just throw it in because it's already in your head.

CAREY: People always say, "How long are your outlines?" It varies all the time.

CHAD: Our outlines turn into scripts, basically. It goes from outline to scriptment to script.

Ramsey & Stone disliked outlining, but they conceded it was a necessary evil.

ROBERT: It's really an unpleasant part of the process. Writing seems so much more fun than outlining. Outlining is ghastly for us, actually.

MATTHEW: It never gets you all the way where you need to go, but it gives you that light at the end of the tunnel. I like to sit here with my little piece of paper that has the outline on it and start crossing things off when we're done with them.

ROBERT: Matt charts our progress because I've got the keyboard in front of me. He has the notes, and he's always keeping track of where we've been and where we're going.

How closely they kept track of where they were going depended upon the project.

MATTHEW: When we did book adaptations, we didn't have to outline them so extensively. We would write sort of beat sheets of structural changes.

For other projects, they created detailed outlines including descriptions of scenes. Sometimes they included sluglines and/or bits of dialogue, and sometimes they didn't.

MATTHEW: It varies.

The process varies too for Payne & Taylor. They wrote only the barest outline for *Citizen Ruth* before they started drafting because they knew "basically where we wanted it to end up," Jim Taylor says.

For *Election*, which had a very strong story that jumped around in time quite a bit, "we had to use some kind of outline to try and get it under control," Taylor adds. "But once we had decided what the basic structure would be, we put the outline away and rarely referred to it."

For *About Schmidt*, they used no outline at all. "The movie doesn't have much narrative, so we didn't do any outlining and just went where the character took us—as long as he was headed where we wanted him to go, which was Denver. He made it there fine, so I guess we succeeded."

Whether you like outlining or not, it's an invaluable tool when you work on assignment.

"Once you're working for someone, if they have an outline in front of them and everyone agrees with the outline, there are no surprises," Matt Manfredi explains. "Everyone knows what they're getting. And it seems to make everyone a lot more comfortable and prepared for what the script is going to be. It could be a better script that they get, but if it's not what they expect, it could be a problem."

In their 18-page treatment for *Life*, Ramsey & Stone included descriptions of scenes and bits of dialogue to show Eddie Murphy and producer Brian Grazer.

ROBERT: It was almost like a short story.

MATTHEW: We were wondering if we were gonna screw ourselves by actually writing this detailed treatment, and then they'd say, "Wait a second, this isn't what—" You are always taking that chance. But we needed it. We needed it as a communicative tool. It ended up being something Eddie signed on to just based on the treatment.

There was one tool that Ramsey & Stone didn't need or use—the note card.

MATTHEW: We did try once doing cards. That just didn't work for us because they can move around too easily. Scott and Larry do cards.

ROBERT: Those guys went to USC, though, so they actually learned how to do what they do.

It's true—Scott Alexander & Larry Karaszewski *do* use cards. Lots and lots of cards. When they're starting a project, anything and everything that sounds like a scene gets jotted down on a card.

SCOTT: The biopics have sort of corrupted this process, because in school I was taught that you want to have 35 to 45 cards on the bulletin board, and *The Marx Brothers* here has approximately 1,200 cards.

1,200? No, no, they're exaggerating. But there are tons of cards on their bulletin board.

LARRY: When you look at note cards, you get a real feel for how the movie is flowing, as opposed to a treatment when you're just sort of reading a big block of words.

They add and subtract cards, move them around, sometimes combining two or more into one.

SCOTT: It's just playing in the sandbox for a while.

Often they'll spend as much time working with the cards as they spend drafting the script.

SCOTT: We try to go into it—but we're kidding ourselves—that we know the first, second, and third acts. Particularly, we know what the end of the first act is and what the end of the second act is, so as you're looking at the cards you can just be visualizing the structure of the movie. You can see if the movie is pacing itself correctly. You can see if the first act looks top heavy.

They sometimes color code the cards for structural purposes, as they did while working on their adaptation of Michael Paterniti's offbeat book *Driving Mr. Albert: A Trip Across America with Einstein's Brain*.

LARRY: It's one of the few times we've had a script that has different time periods on a parallel track. And so for each one of those stories, we have different color-coded cards, so that allows us to see, "Oh my God, we're doing four flashbacks in a row—that might be a mistake."

They even put colored dots on cards that correspond to scenes featuring certain characters.

SCOTT: We did that with *The Marx Brothers* occasionally with their father, where we noticed that he's really a charming character at the beginning of the movie, and then he was just really dropping out, basically because their mother drove the act—their mother ran their lives for many, many years. So we would look at the cards and say, "Is there a way, every seven or eight cards, to at least have him make a little guest appearance?"

Using note cards has also been beneficial for Michael Colleary & Mike Werb (*Face/Off; Firehouse Dog*). "We start by talking for several days about how we see the story, the characters, and the overall shape of the

plot, taking notes along the way," Colleary tells the Writers Guild. "Then we scene-card. We'll do a card for every scene, beginning to end, sometimes in detail and sometimes a few words to describe a whole sequence ('museum heist'). Deadline permitting, we'll try to do a detailed step-outline from the cards, filling in more detail as we go. The outline is complete when we know what will happen in every scene."

We've used note cards as well. In fact, we've tried most of the techniques listed above. Part of the evolution of our process has been figuring out which visual tools help us most. For *Obscenity*, we broke the story into acts on Matt's computer, indicating what happens in every scene. But it wasn't the best method for us because huddling over the same computer was awkward—and a ticketable violation of personal space.

So for our next script, we tried the scene-card approach and laid the cards from start to finish across the floor. This allowed us to "walk the movie," reading and rearranging the scenes to make sure our story and our characters' emotional flow worked. Once we knew the order was right, we stacked the cards and typed a detailed scene-by-scene outline, including bits of dialogue and action description. We still use this approach. A scene-by-scene for us can run as long as 35 pages, but it's an invaluable blueprint that we refer to again and again as we co-draft our script.

Breaking the Story in the Writers' Room

If your goal is to write episodic TV and you haven't taken courses that simulate a writers' room, these glimpses into three of the greatest writers' rooms—*Friends*, *Friday Night Lights*, and *Breaking Bad*—are instructive. Though the three shows are radically different in subject and tone, when it comes to creating and structuring story for a season or individual episodes, the collaborative process is strikingly similar.

Breaking Bad writer George Mastras tells Indiewire.com, "We start each season talking about where the characters are going and pitch around big ideas for story arcs but the story builds organically from where the characters' heads are at. . . . 'Where is Walt's head at right now? How is he engaged and what's engaging him? Is he in the business? Is he out of the business? Where is he at right now and where is he at on the continuum of his character?' . . . It's a very collaborative, very vocal room and we debate what the characters would be doing and what their behaviors would be at that given point and come up with the story."

The same very vocal and collaborative spirit existed on *Friday Night Lights* when that room created story and structure. "All the writers always had something to contribute," Patrick Massett tells us. "The ball was always kind of up in the air. It never got stale because each writer really had something different to contribute to the storytelling, to the characters, to the plot, whatever was going on."

As for breaking individual episodes, "There was a very simple engine to *Friday Night Lights*," Massett says, "which was you had the core relationship between Coach and Tami and then you had the football. And it was either going to be a game or it was going to be a pep rally or it was going to be something you were going to build to in the episode."

As the writers on *Breaking Bad* approached each episode, they asked themselves a series of similar questions about where all the characters' "heads are at," as Mastras says. "And we build the story, we build each episode out and we break each episode in the room."

Andrew Reich clarifies what breaking an episode meant on *Friends*. "You start out, 'Okay, Monica and Chandler just got married. What's their story going to be this week?' And we come up with that. 'Okay, we've got a Monica/Chandler story. Now we've got the other four. Let's try and do a Joey/Phoebe story.' You have three stories, each broken into scenes, put into order. That episode is now broken. There's an outline, a rough outline. The outline Ted and I write if we're sent off to write an episode will be much more detailed. It'll have much more, like the shape of the scenes, whatever. But episodes being broken means that."

On *Breaking Bad*, the room also went through each episode scene by scene to figure out what each scene was really about. The room broke every episode so completely that "anybody could really write that script," Mastras says. "But we generally know [whose] episode it is while we're breaking it and we run it through the filter of all seven brains in there. Then, the story is boarded and whoever's writing that one outlines it and writes a draft."

On *Friday Night Lights*, the writers didn't know whose episode it was when they broke it because showrunner Jason Katims made the assignments.

PATRICK: He drew up a batting order. We got, like, episodes 3 and 6 and 14.

JOHN: He had some instinct about, "I think this would be a good episode for you guys." And the thing about that show, which made it to me rigorous and successful and easy all at the same time, was that every episode, every writer had a real sense of ownership of every episode because they were very thoroughly broken in the room, scene by scene. The content of the scene was discussed.

PATRICK: Emotional depth.

JOHN: What the emotional turn was. I've always thought of it as sourdough starter. Every scene had a little hunk of starter. When you left the room, when you got assigned a script, the document that the writers' assistants would produce—that detailed the discussion of the episode and the scene breakdown—always had that kernel, that little pivot of the

scene, at least a line of dialogue, an idea, an emotional target, so you knew what every scene had to accomplish. And it was really— You had to work to screw up a *Friday Night Lights* script.

Script Partner Points

- Co-create story by asking yourselves, "What's the journey?" Brainstorm your story in broad strokes. Anything goes at this point. Remember that bad ideas can lead to good ideas, so don't hold back.

- Explore your protagonist's wants and needs—internal and external, conscious and unconscious.

- Decide how your main character will change, or if he or she is incapable of change.

- Try spinning story out of your antagonist's intentions (villains are people too).

- Avoid character inconsistencies by following your characters' "inner logic of behavior."

- Find your story's major movements and moments by exploring the conflicts and connections between your characters.

- Decide what your story is really *about*—what you're trying to say, what proposition the script will prove—and craft it into a premise.

- Work backward, forward, sideways, however the Muse directs you, to find your story's inciting incident, turning points, and climax. There can be real comfort in knowing your structure before you start drafting your script, especially if you're new to the process.

- Experiment with outlines, treatments, and note cards to find the most effective method to co-create your story and structure.

- As you "break" your own script into a scene-by-scene outline, note where your character's "head is at" in each scene and what the scene is really about. What's your scene's "little hunk of starter"? This level of detail will prove invaluable when you co-draft your script.

> "What a feeling having you inside my head.... Indescribable—you knew just when to feed me the next thing, just a split second before I needed it. There was a rhythm we got into, like great sex."
> —Tom Grunick (William Hurt), *Broadcast News*

NINE

Co-Drafting the Script

Of all the questions people ask us about the collaborative process—and there are many—the most frequent one is, "How do you actually *write it* together?" They can see how two or more writers brainstorm and create character, story, and structure, but how two or more writers put one script on paper is perplexing.

And no wonder. It's the most intimate part of the process, a shift from foreplay to performance, to borrow Marshall Brickman's marriage-bedroom metaphor—"You never really know what's going on unless you're there in the room."

If you haven't co-drafted a script, it may be perplexing to you too. Who does what? How do you decide? And how *do* you actually write it together? Do you co-write every word? Divide up the scenes? Divide up the drafts? We—and every team we've talked to—have faced the same questions. And the answers differ for each writing pair and sometimes for each writing project.

"It's never the same," Patrick Massett tells us. "It's almost always on a project-by-project basis that we figure out the best way to accomplish getting the script done. I mean, there really is no formula that we always use. It seems to change and evolve, and sometimes we'll go back and use some system that we used earlier, but it just kind of seems like it's based on the project."

"There are several kinds of collaborations, and I've worked in all of them," Harold Ramis said. "At *SCTV*, I was the head writer, working around the big table writing group pieces. And I've worked with one or two others—what I call the Dick Van Dyke mode—you know, one person types, one lays on the sofa, and one paces. And then you switch. I've done Sectional Collaborations. With *Animal House*, first we did the Dick Van Dyke for three months to write the treatment. We sat in the room, made each other laugh, talked it through, one typed, and the other paced. And then we did this kind of Sectional Collaboration where we divided up the

treatment in thirds, and we each wrote a third and then swapped thirds. Someone wrote the first, someone wrote the second, someone wrote the third, switched them and rewrote each other, then switched them the third time, so we'd each written on each third of it. And then there's what I would call the Sequential Collaboration, where one person writes and then goes away and you rewrite. So it's collaborative in the sense that you're starting with something that they've done and rewriting it. They may or may not come back into the process and rewrite you. That's what Peter Tolan and I do—kind of sit in the room and outline and brainstorm, and then I let him do the ice breaking, which is probably the coward's way out. [Laughter] I let him do the heavy lifting. Then I rewrite him."

"Deciding the process is part of the process," says Nick Kazan. When we ask how he and Robin Swicord decide how they'll co-write each script, he laughs, "I don't know!"

Well, that's honest.

One thing he does know—they could never adopt the method used by Alexander & Karaszewski, "nine-to-fivers" who work in the same office at the same computer and co-create every word.

"Their work exists together, and it's a real symbiotic relationship," Kazan says. "I don't mean that they would be lost without the other person, but they certainly are accustomed to thinking in that way so that being in the same room makes sense."

Kazan admits that unless he's alone at his computer, his words won't flow. "When we sit and brainstorm a scene, Robin will brainstorm it. Basically, I don't know what to think—unless she shuts up, and I'm at a keyboard! I exist in a practical realm. It's what the characters say and do. Robin can see what they *ought* to say and do and get them to say and do it in an organic way, which would never lead you to believe that they were being nudged into saying and doing these things. But if I try to force them to do something, it's like they're being forced to do it, and they object! I work in a much more improvisatory way. It's like I have to have some freedom to be a bull in the china shop, and then I go, 'Oh God, that didn't work.'"

Again, there's no right answer, no recipe to follow.

"Everybody has to work in the way that they work," Kazan says. "We don't have a lot of choice."

In the end, you must work in the way that you work, but in the beginning, it may be helpful to know how other teams do it and how they answer the question . . .

Who Does What?

Whether you co-write every word or divide up the scenes or the drafts of your script, deciding who does what can be fairly simple—go with your gifts. As we've said many times, one of the great advantages of collaboration is complementary strengths.

Lee & Janet Batchler got lucky—the life partner they chose turned out to be a complementary writing partner. His yin to her yang.

"It just happened that way, that our strengths were complementary," Janet says.

And they divide up their script work accordingly. The more visually oriented of the two, Janet writes, you guessed it, the visuals. The action description. Not only is it her strength, it's her love.

"I really care about the visuals," she says. "I really care about the transitions from one scene to the next. I'm passionate about how you get from one scene to the next scene."

Understandably, she finds great satisfaction in seeing her carefully crafted descriptions translated to film exactly as written—like the scene in *Batman Forever* when Harvey Two-Face (Tommy Lee Jones) is introduced.

From *Batman Forever*:

```
EXT. FOREST ROAD — NIGHT

The Batmobile picks up speed.

OVERHEAD

The Batsignal in the sky.

INT. SECOND BANK OF GOTHAM, 22ND FLOOR — NIGHT

A spinning SILVER DOLLAR flips up into frame, blocking out the
Batsignal.

A hand catches the Coin and flips it again.

PAN UP THE ARM TO

the RIGHT HALF of a face: the rakishly handsome profile of
HARVEY "TWO-FACE" DENT. The other half of his face is hidden
in deep shadow.

                    TWO-FACE
              (speaking to someone at
              his feet)
          What do you think, sport? Are you
          counting on the "Batman" to rescue
          you?

Two-Face is talking to a middle-aged SECURITY GUARD, tied up
on the floor.

                    GUARD
          Are . . . are you gonna kill me?

                    TWO-FACE
          We might. Or we might not. You
          might say we're of two minds on the
          subject.
```

JANET: In the script, it's written exactly the way you see it on the screen. I remember at the premiere saying, "That's my shot! They used my shot. That is exactly what that shot looked like!"

LEE: And unfortunately, the director and DP will get credit for it way before you do!

JANET: And that's fine, that's fine. That's the stuff I love to do. I love to do that. Lee is much more the dialogue writer.

They admit their breakdown of duties defies most people's expectations of a male–female collaboration.

JANET: People think it's the guy who writes the action. I write the action!

LEE: I'm the romantic. I'm more of a feelings-driven person.

The emotional component of a script interests him most—how the writer can grab and move the audience and even change the way they think.

LEE: You get to the head through the heart. So I'm much more attracted to the emotional life of the character. That's how someone comes to life.

He finds himself becoming very absorbed in his characters' inner lives, basing them on people he knows or reads about or just imagines. Consequently, he confesses to being a much slower writer than Janet, taking as much as two hours to get in "the zone" of connecting to characters.

LEE: I'm sort of in that world, and then good luck for Jan trying to communicate with me!

In the collaboration of Jim Cash & Jack Epps, Jr., once they'd sketched out the characters and story, Epps became the movie's architect.

"I would go and pretty much lay out the movie," Epps tells us, "just lay it out. As Jim said, I'm the big picture guy, I see the big sky. So for me, I like to see the movie. I'm from Michigan. Detroit was a city of huge movie palaces. I mean *huge*. They had a lot of money in the '20s, so they built these big, big theaters. L.A. doesn't have theaters as big as they had in Detroit. And as a kid I'd go and watch movies in big theaters, so my instinct is to write for the big, big screen. Whenever I'm conceiving in my process, I'm thinking, *What's this big movie? How does it work on the big screen?* As a screen movie, not as television. The visuals. Sounds. Taking the audience on a ride. Taking them on an experience. Taking them away. And so I'd work out the movie, and once I knew what the movie was and what the scenes were, I would then call Jim and say, 'Okay, Scene One.'"

Then it was Cash's turn to bring his artistic strong suit to the script.

"Jim wrote the wittiest, just the best dialogue, and it actually leaped off the page," Epps adds. "His dialogue was great. And the huge frustration we both had is that— Look, everybody gets rewritten, so our scripts get greenlit, and then they bring on someone to do it, and they invariably do a dialogue polish. And the dialogue would go from fantastic to sort of okay. And it would drive us both crazy. Our favorite movie is probably *The Secret of My Success* because it didn't get changed. We wrote it so fast, and they had to shoot it so fast that basically we say, 'Well, yeah, that's Cash & Epps, pretty pure.' And Herb Ross was a great director, so you get a guy who really respects the word. He's not looking to change things, he's looking to capture it as it is on the page. Herb came from the theater, so he really appreciated the word."

We come from the theater as well, and we're both strong at dialogue. But Matt is more visual, and Claudia is more experienced at writing prose, so when Matt envisions an image or a bit of behavior, Claudia spins it into action description. When we're drafting a down-the-page action sequence, we plan the scene together, and Matt writes it because he's more fluent at this style of screenwriting.

Still, keep in mind Ted Elliott's warning, "Don't think that finding a partner who's good with action means you don't have to write action anymore. You had both better be thinking constantly about solving the problems, clarifying the characters, sharpening the dialogue, making the story work. A partner doesn't make writing a script easier. But a partner can make the script better."

And these complementary strengths begin to blend over time. That's one of the beauties of a long collaboration like Alexander & Karaszewski.

SCOTT: I probably come up with things more left-brain than he does.
LARRY: Yeah. That would probably be the way it comes out.
SCOTT: Left brain—and no brain. [Laughter]
LARRY: We sort of do everything together, so I don't know if it's really broken down that easy. And after working with each other for so long, I'm not quite sure if it's even left brain/right brain anymore. In the old days, I'd definitely say Scott was more the structure guy, and I was more the wild-card kind of a guy. I don't know if it's even that anymore. We just sort of come in and do the job.

So be careful not to pigeonhole yourselves. Weaknesses strengthen over time. The longer we write together, the better Matt gets at description and the better Claudia gets at down-the-page action sequences.

"When Daryl and I started working together, he definitely was the master at dialogue," Carolyn Miller says. "He was far better at it—he's a wonderful dialogue writer—so I had some learning to do. But I got much better at it with time."

The same proved true for Lee Batchler. Before he met Janet, he was training—with the Lehman Engel Musical Theatre Workshop—to be a composer in musical theater. He was told he couldn't write lyrics. But he persevered. And the more he struggled, the better his lyrics became. When at last he could write lyrics, he was told he couldn't write dialogue. Same story, more struggle. And now, with Janet, what he does for a living (in part) is write dialogue.

"A lot of people are victims of snap judgments," he says. "'This person is talented, this person is not talented.' Sometimes it takes a while for someone to get it. There are people who get it right away like Orson Welles, but very few of us are Orson Welles. It takes a long, long time to learn a craft."

Jim Cash worked on honing his dialogue skills for two years. "I thought of myself as an Olympian in training," Cash told the *Los Angeles Times*. "I wrote only dialogue for two years, filling notebooks with it. I audiotaped old movies and listened to them. You learn more about dialogue that way."

Like Lee Batchler and Jim Cash, you can "train" on your own, but a supportive collaboration is also an ideal place to learn from your partner, shore up your weaknesses, and take creative chances. In the long run, this will strengthen your collaboration as well—and the scripts that you write together.

The First Draft

The terror inspired by the blank page is well known. Fortunately, collaborating "takes the terror out of being in the room with that sheet of paper and typewriter and not one word is there," as Aaron Ruben told us.

But diving into a script can still be daunting, even for the most experienced writers like Larry Gelbart and the other writers in the room when they wrote *Caesar's Hour*. Each week was truly a blank page because it was a variety show. There was no long story or "bible" to tell them what would happen in the season to come.

"There was no season to come," Gelbart said. "It was six o'clock to come." Which made the number of pages they had to fill every week even more daunting. "*Caesar's Hour* really meant Caesar's *hour*. In those days you were only allowed six minutes for commercials so already we're talking about 54 minutes, and there was very little on the show that was not comedy. Perhaps you would have a soloist do something, so say that was three minutes, so the rest of it had to be comedy comedy comedy. And there were 39 weeks, not 22. So you wrote *hundreds* of hours of comedy material."

"We can't imagine," we confessed to Gelbart.

"I can't imagine because I don't have to," he laughed.

Whatever form you've chosen—TV episode or feature-length film—you have to fill it. Write that first draft, no matter how bad you think it is.

"You can write something terrible," Matthew Stone says. "If you're writing it, you can rewrite it the next day. God bless the computer—just get something down. You can rework it."

Lee Batchler agrees. "Your first passes at stuff, you write stuff that's garbage, and you know it's garbage. But there's a kernel of something there, and you go and try and discover it and enhance it and make it better."

"It's really about getting down something to work from," says Ted Cohen.

To get something down, the Hayes brothers write their first draft as quickly as possible, giving each other a writing quota—and the permission to suck.

CAREY: We'll blow through. We'll get a first draft done in a week. Just because we've outlined it. But it's rough.

CHAD: But that's also our challenge. We challenge each other—

CAREY: Ten pages a day.

CHAD: Ten pages a day.

CAREY: We each do ten pages—good, bad, ugly, doesn't matter. Just get the first draft done.

CHAD: We tell other writers, "Don't get hung up on what you don't know at the moment." They'll say, "Oh my God, I spent four days on that scene." I'm like, "Are you out of your mind? Do you know what the scenes are after that?" "Well, yeah." "Then write those and come back, because you're gonna get eight scenes past this one and realize you know what the setup is."

CAREY: It's always, write what you know first, figure out what you don't.

CHAD: In our scripts, we write an "I don't know what the eff I'm gonna do" placeholder. Because you know the gist of what your scene is gonna be. Don't let it slow you down. Write what you know.

With their warp-speed way of working, the Hayes brothers end up writing multiple drafts to get to what they consider a "first draft."

CAREY: We'll do a lot of passes on our first draft—could be 20, could be 30—because we blow through it. And scenes that are working, that we're not making any changes to, we don't worry about those. We skip over those next time we read them

because they're already there. They're fine. I talk to first-time writers, and they go, "Oh my God, I've done *six* drafts of this script!" I'll say, "Come here, I want to show you something." [Laughter]

During his many years in radio and TV, Aaron Ruben co-wrote one film, *The Comic*. His writing partner was the film's director, Carl Reiner, who was working like crazy one morning when Ruben arrived at their office on the Columbia lot.

"There he is pounding away on the typewriter," Ruben recalled. "I say, 'What are you doing?' He says, 'I'm writing something so we'll have something to rewrite!' That's what you have to do. Get something on paper so you can say, 'That stinks. Let's come up with something better.'"

And though it's freeing and frequently true that "all first drafts are shit," as Hemingway said, it's also freeing and true that "there's usually something pure and forceful or surprising and funny about a first draft," as Nick Kazan puts it, "and one of the things that can happen to screenplays is that they become perfected, and in being perfected they lose their eccentricity and humanity."

Larry Gelbart made the same point. "I don't agree completely with Hemingway's edict that all first drafts are shit. Very often he's right, but it overlooks the fact that there's a certain kind of energetic innocence in a first draft. You're coming at it the first time, and you're not daunted or you are daunted. And it's hard to retain that because as you polish, you do grind things down. But there's no question that you make things better."

So when you and your partner co-write your first draft, you've got all the freedom you want—to stink or swim. But first you need to decide which drafting process works best for you both.

Co-Writing Every Word

The co-creation of every word, line, scene, and sequence is a complex interplay of aesthetic forces. A creative jam session.

Gelbart employed the oft-used jazz analogy ("on behalf of those people too fearful to be clichéd," he laughed). "It is like improvisational jazz. It is. The idea is sort of the melody, the line that you want to follow. Then a soloist will take a line and go up and down and under and around and create another melody based on the original melody. You feed off one another." He and other great "soloists" co-created hundreds of hours of comedy material during the run of *Caesar's Hour*. "It was like a jazz session with people bouncing off one another, and each with his own style and voice, which made such color for the scripts, I think."

Gelbart offered a jazzy description of what a *Caesar's* session was like, once the writers had locked the idea. "We'd say, 'All right, let's start with Sid calling home and saying, "Hey, I got six tickets. This is the hottest show you

can get." And then we would pitch in sequence, you know, 'Sid says this,' 'Sid says that,' and 'Nah, that's no—yeah, that's good, no, nah, okay, fine.' We'd throw jokes, and Sid would nod he liked that one. If he didn't like one, Sid had a way of *uh-uh-uh-uh-uh* machine-gunning the joke as it flew out of the room, and you knew that joke was dead. So you pitch you pitch you pitch you pitch you pitch, and pretty soon you're saying, 'Okay, now they all know they're going. They all know they want to have dinner first.' Then you start making jokes about 'Where shall we eat?' 'Where shall we this?' 'What shall we that?' 'What are you going to wear?' 'What are *you* going to wear?' 'What are *you* going to wear?' 'Oh, mine's in the cleaners.' You know, you just take reality and heighten it or diminish it by replacing it with silliness. And before you know it, you'd have 15, 20 pages."

He stopped and looked across the table at us. "Sounds simple, huh?"

When Robert Ramsey & Matthew Stone wrote together, they sat at desks facing each other with the monitor between them so they both could see it. And they also used a musical analogy when they described their unique process in our first-edition interview.

ROBERT: I'm the typist. Matt's on the mouse. That's how collaborative we are—I'm on the keyboard, and he's on the mouse. You've never seen someone get so much work out of a mouse.

MATTHEW: *Whoosh, whoosh!*

ROBERT: He rules the screen with that mouse.

MATTHEW: I'm editing as we go.

ROBERT: It's like playing music. It's like he's on drums, and I'm on piano.

MATTHEW: I find that Rob can talk or think and type at the same time. I can't. If I'm typing then I'm not adding anything to the process. I'm just typing what he's saying. Once in a while, he goes to the bathroom, and I commandeer the keyboard and I write a few things in.

ROBERT: Early on I had a competitive advantage with the keyboard, just because I had gone through four years of journalism school where I had to sit in news labs and write a story in half an hour. And I worked at the newspaper, and you pound out copy. That created a habit that exists today.

MATTHEW: We co-write every word.

ROBERT: Every sentence. Every sentence is collaborative. It's pretty wacky.

MATTHEW: Some people say, "You take home this scene, and I'll take home that scene, and tomorrow we'll switch" or whatever. That's just never worked for us. We just have to be together in front of the computer.

ROBERT: We have one of most meshed relationships you'll probably ever encounter.

If this is your first time co-writing every word, don't expect the warp speed of *Caesar's Hour* or the *whoosh, whoosh* of Ramsey & Stone. Writing *Obscenity* together was slower than rush hour—hell, *any* hour—in L.A. traffic. Working from our detailed scene-by-scene, we co-drafted the script from beginning to end. We enjoyed the process, but it took a long time to finish the script because we lovingly labored—nay, agonized—over every line and even some punctuation.

The Batchlers had their worst disagreement over one *word*. "We just remember sort of looking at the clock and going, 'We spent an hour on a word,'" Janet says. They do not remember what the offending word was.

If we'd continued working this way, we would have written our next script much faster, but this was our first co-written script. And as Claudia's dad used to say, "The first olive out of the bottle is always the hardest."

So if you and your partner are new to this method and not facing a deadline, allow plenty of time. You're not just co-creating a script, you're co-creating your process.

Who Types, Who Paces?

"We were always asked, 'Well, which of you really did the writing?'" Fay Kanin said. "Oh, you get that a lot—'Which one of you was really the writer and which one just did the typing?'"

Now there's a question that ticks a writing team off! Of *course* you're both creating, no matter who's typing or pacing or sprawled on the couch.

Hal Kanter told us a wonderful story about co-writing an Edgar Bergen/Charlie McCarthy routine for an Academy of Television Arts & Sciences benefit. His partners on the project were *I Love Lucy* writer/producer Jess Oppenheimer and *Gomer Pyle/Get Smart* writer Norman Paul. The trio worked in the den of Oppenheimer's home—Hal sitting, Jess typing, and Norman pacing. "Norman always paced," Kanter said. At one point when the writers got stuck, Norman kept pacing and pacing and eventually paced out into the garden and all the way around to the front of the house. "A moment or so later the doorbell rang in front. Jess's wife opened the door and said, 'Norman! I thought you already came in.' And he came in and said, 'A great line occurred while you guys were out of the room!'"

Scott Alexander & Larry Karaszewski work in the sit/sit—or sit/lie—paradigm.

LARRY: Scott's got to be on the keyboard. I sit over here.

SCOTT: I never leave this chair. I do all of the typing. Larry lies on the couch. He's very comfortable over there.

LARRY: Zen writing.

SCOTT: We never switch.

LARRY: Except when I'm looking at porn on the Internet. He'll read *Variety*, and I'll click around. [Laughter] It's the way we've worked since day one. Back in college Scott had a computer. So we'd go to Scott's room, and Scott would be using his computer. I had no idea how to use one.

Matt Manfredi & Phil Hay prefer the sit/slouch-on-the-couch paradigm. But they do trade places, depending on who's in a better mood that day.

PHIL: Less crabby has to type.

MATT: Yeah.

PHIL: Less crabby is *willing* to type. Crabby's just sitting on the couch complaining.

MATT: We decide at the beginning of the workday, but our greatest arguments of all time were all about who's saying, "You're in a bad mood," "No, *you're* in a bad mood," "No, no, you *put* me in a bad mood, so you think I'm in a bad mood." [Laughter]

Generally, Alexander Payne & Jim Taylor always work "with one of us 'driving' at the keyboard, while the other one observes or comments or dictates or dozes off," Taylor tells us.

The Hayes brothers avoid dozing off by both standing as they write, using height-adjustable desks.

CAREY: You do not get tired standing up. Your feet get a little sore. You won't slump in your chair and go *zzz*. So if you're not tired, you're alert. And if you're alert, you're creative.

CHAD: But it really started post back issues. It was recommended.

CAREY: Me, because of my back surgery. I had to stand up. I went, *Wow, this makes a difference.*

Dividing Up Scenes

Matt Manfredi & Phil Hay co-draft every word when they write comedy, but they find it difficult to do this when they write drama. For *crazy/beautiful*, they divided up scenes and wrote them alone.

PHIL: We just felt you get closer to the truth in a more comfortable way, doing it yourself and then turning it over to the other person—as opposed to the two of us trying to be like, "Okay, the next line, as she's sobbing . . ."

MATT: There are certain times when you want it all out there before you have feedback. You don't want to filter yourself or the other person. You just want to get it out there and see how it looks. I think for some reason with a drama it seems especially this way. Whereas with a comedy, it's just, "Is this funny?"

PHIL: You're more vulnerable. And even though we still talk, and we aren't afraid of what the other person thinks—we know each other so well—it still is vulnerable. No matter how close you are with a person, that stuff is much more vulnerable, and you try to protect it more. That's not what you should be doing.

You may decide too that dividing up the scenes is the best way to work on a particular script. Or like the Kanins, the Longstreets, the Batchlers, and Reich & Cohen, you may prefer drafting all your scripts this way.

For the Kanins, dividing up scenes was essential because of their different work styles. "I am a *slow* writer," Fay Kanin said. "Because I diddle. I mean, I take all this time before I get down to the typewriter. Oh my God, my drawers get very clean. I do all the things, just *anything* to not do it. Wild horses couldn't get me to the typewriter until the very last moment."

Michael Kanin, on the other hand, was very structured, writing every day with his yellow pad and paper—usually from 10:00 in the morning till about 3:00 or 4:00 in the afternoon. "Then he stopped, he did what he wanted to do, and he slept well," Fay said. "Me, I'm sweating—*errrr!*—I don't want to get to the typewriter. But once I got to the typewriter, you couldn't get me away because then I began to fall in love with the characters and the whatever it was, and then I was a really terrible wife. I wanted only to write at that point. At the beginning I was a good wife." [Laughter]

For Andrew Reich & Ted Cohen, dividing up scenes on *Friends* was essential because of tight deadlines.

ANDREW: We had five days to write a script. We'd write the outline on the first day, split up scenes, so we'd have two days to write them on our own.

TED: At least at the beginning, if you can get down some kind of shape, it's easier to do on your own.

ANDREW: And then we'd have two days together to put it together.

The key to this method is careful outlining, "really nailing the structure," as Ted Elliott says. This means establishing the beats of your story and, if possible, the beats of your individual scenes before you divide them up to draft.

Before Manfredi & Hay could divide up the scenes for *crazy/beautiful*, they outlined them beat by beat, in "excruciating" detail. "Then we

found that it was easier to take separate scenes and go away and write the dialogue," Hay says.

Once your scenes are outlined, you'll need to decide how you'll divide them. Again, each team has a different approach.

ANDREW: We have our sort of arcane way of doing that. We don't say, "You write the first act, I'll write the second act." We try and find a fair way. We divide the scenes up—these are easy, these are medium, these are hard. If there are four hard scenes, we each take two hard scenes.

TED: We try and make it so we both have an equal amount of work to do.

After working alone on their scenes, they'd come back together for those last two days to create a draft they both liked.

From *Friends* ("The One With the Stripper"):

```
INT. ROSS'S APARTMENT — A LITTLE LATER (NIGHT 2)
(Ross, Dr. Green, Mona)
THEY ARE PRETTY MUCH WHERE WE LEFT THEM.
                    DR. GREEN
          So, explain yourself, Geller. You get Rachel
          pregnant and now you don't want to marry her?
                    MONA
          You got Rachel pregnant? Are you guys together?
                    ROSS
          No. Oh, no. It was just a one-night thing. It
          meant nothing.
                    DR. GREEN
          Oh, so my daughter means nothing to you?
                    ROSS
          No, no. She means a lot to me. I mean, I love
          Rachel.
                    MONA
          What?!
                    ROSS
          Not in that way. I mean, I'm not in love with
          her. I love her like a sister.
                    MONA
          Ew! You'd sleep with your sister?
                    ROSS
          Okay, maybe not like a sister. Like a friend.
```

> DR. GREEN
> And that's how you treat your friend? Get her
> in trouble and then refuse to marry her?
>
> ROSS
> Hey, I offered to marry her!
>
> MONA
> You offered to marry her?!
>
> ROSS
> (PLACATING) Yes. But I didn't want
> to.
>
> DR. GREEN
> Oh, you didn't want to marry my daughter? Why
> not? So you could be with this tramp?
>
> MONA
> Tramp?
>
> ROSS
> Oh, I'm sorry. (DYING) Dr. Green, Mona. Mona,
> Dr. Green.

With fairness and passion in mind, the Kanins divided their workload based on individual preference. "I would say, 'Well, I want to write that one and that one and that one because I like those,'" Fay said. "Michael said, 'Okay, then I'll do that and that and that.' So we wrote scenes separately and then alternated, took that mix and put it together in a screenplay, and the other one looked it over. That seemed to us a good way to work. We helped each other a lot."

Harry & Renee Longstreet work in a similar manner, letting individual preference—or resistance—dictate who writes what.

RENEE: We say, "You want to do that? Okay."

HARRY: Occasionally, though, it's "Ugh! Blechh! *You* do the first act!" Sometimes.

RENEE: Right. And I don't think we've ever had an argument over who does what.

After they write their scenes solo, the Longstreets trade, reading each other's work and making copious notes for the rewrite.

Carolyn Miller & Daryl Warner preferred alternating the scenes. "He'd do scene one, three, five, something like that, and I'd do two, four, six," Miller explains. "And then we'd exchange what we did. We'd go over each scene together line by line. The first act was always the hardest because you're establishing the tone, the characters, and all that. Act One is harder for collaborators because I might have a concept for a character that was different from his. So there was a lot of discussion. For the rest of the acts, it was easy because by then we knew the story and characters so well."

Lee & Janet Batchler write and rewrite as they go, usually working sequentially through the screenplay. One of them writes the first draft of a scene or sequence, and the other follows behind and rewrites. "Lee tends to do more of the 'blank page' work," Janet says, "with me taking the first rewrite most commonly."

But because of complementary strengths, sometimes Janet will write the first draft of a scene, especially if there's plenty of action. "It varies from script to script, depending on the content of the scene involved and the deadline we're working under," she says.

Cinco Paul & Ken Daurio tell us that they also consider complementary strengths when they divvy up scenes. "Typically we will outline a 30-page chunk, discuss the scenes together, then assign them to each other based on our strengths (Ken gets action scenes and physical comedy; Cinco gets scenes with romance, emotion, verbal comedy—but that's definitely not written in stone). After that we go off separately and write our scenes, then when we're done we'll piece them together and read the pages aloud together. That's the real test. The goal, of course, is to 'win' by having the best pages, making the other guy laugh. While we're reading, it will generally become clear what's working and what's not, and we'll rewrite each other by pitching out new lines or ideas. We actually started this process with the first script we ever wrote together, and it's worked really well for us. We write a lot faster this way."

Dividing Up Acts

Michael Colleary & Mike Werb usually divide up the work by acts and write on separate computers.

"We talk throughout the day, solving problems, trying out dialogue, proposing set-ups and pay-offs, making sure we are being consistent, etc.," Colleary tells the WGA. "When the first draft is complete, we'll trade pages, make notes on each other's work, discuss and incorporate the changes. Then we start over. Usually we'll do four to five passes on every draft before we're ready to submit."

When co-writing their remake of *The Entity*, the Hayes brothers decided to split up the first two acts, with Chad taking Act One and Carey taking most of Act Two.

CAREY: I took as much of the second act as I could—the second is a little thicker. Chad finished the first act, jumped over me, and finished the second act. So we didn't even touch the third act yet because we're mulling over really what we want to do. We weren't sure. But while we're thinking of that, we make the first two acts as tight as we can.

CHAD: We just keep polishing.

CAREY: We put them together, and we work on these things—it's the Microsoft Surface, which has an annotation program called OneNote.

CHAD: It's fantastic.

CAREY: You can annotate freehand. I want to circle, I want to cross out, I want to write notes on the side, and it allows us to do that. The way we have our computers now is on my desktop. I can have my new Final Draft that I'm making changes in, my revision mode, and on this side of this screen, I have his notes. And then on my little Surface thing, I have my notes. So I'm looking at my notes, his notes, and putting them into here without ever printing up a script. We haven't printed a script in years.

CHAD: We have two printers sitting in a box in my garage.

CAREY: Once we go through and annotate it, we'll say, "Okay, that's for the first two acts. We're up to page 75." And then he looks at my changes, I look at his. We've gone through, decided which ones we're keeping, and then we implement those changes and read it again.

They also implement a third set of notes using "a little trick," as they call it, the only part of their process that isn't high tech.

CAREY: Chad and I each have a stack of 3x5 index cards that we keep by our computers.

CHAD: We call them our Number Twos.

CAREY: Our Number Twos because in Final Draft, that's the—

CHAD: Number that moves to the description, from dialogue to description.

CAREY: "She looks at him incredulously." Or "He stands there dumbfounded." Whatever it is.

CHAD: We just go, "Oh, that's kind of cool. We should write that down."

CAREY: As you go through the script, you're getting thoughts that are not in that scene yet, but it's in your mind like a computer. It's a visual or something. I don't want to forget it. A lot of people will put it on the notes in Final Draft—there's a notes page you can use. But we have a stack of index cards that we make sure by the end of our script, end of our first draft, we go through every card and go, "Did we do this? Did we do that? Did we get this in?" Because these are our thoughts through the process that had nothing to do with the outline, had nothing to do with the writing.

CHAD: Most of the time, we find out we've already put them in the screenplay.

Massett & Zinman also divide up acts when they're drafting a six-act, hour-long TV episode or a three-act, feature-length screenplay, unless they have a strong preference for writing a particular storyline.

PATRICK: It's really like we gravitate to things. He's more of a European sports car guy, and I'm more of an American muscle car guy. It's just the same thing. On *Friday Night Lights*, we would just naturally gravitate to certain storylines that we liked. Or we would do it in acts. It just depended. If we felt strongly that we could write either storyline equally as well, then he would take the first three acts, and I would take the last three acts.

JOHN: And then we'd swap.

PATRICK: Yeah. And we'd talk about it and figure out what's the best way for us to both feel good and the most successful way.

JOHN: In the beginning of our partnership, when we first started writing together, we were in the same room all the time. We would outline the story, and then we would just write like I'm sitting here writing, and then I'd get tired, and he would come and sit and he would write. But as our partnership evolved, and I think as *we* evolved as writers, our process has become we will break a story together and then divide it in the way Patrick described, usually by acts. If it's a feature, maybe I'll write the first act, and Patrick will write the first half of the second act, and I'll write the second half of the second act.

PATRICK: Then we take our individual passes. We'll do notes together. I'll take a pass at it and give it to John, and we'll do another round of notes together, and then he'll take a pass at it. And we both kind of agree that it's as good as it's gonna get for now. Then we'll— You never really finish a script, you abandon it. [Laughter] So at some point when we decide to abandon, that's when I think we both sort of feel like we've done our best.

Dividing Up Drafts

When Charles Gaines & Ethan Hawke first decided to write their script about Geronimo, part of their process was deciding how to write it together, as Charles tells us. "Ethan said, 'How're we gonna do it?' And

I said, 'Well, why don't you come up to Nova Scotia and let's bang out a treatment just for ourselves?' And I said, with no shame, 'I gotta get paid for it if I'm gonna do it,' and he said, 'No problem. I'm happy to front the cost and pay you whatever your going rate is. And we'll come up and work on a treatment, and then I'll go away, and you write up a draft. And then I'll come back, and we'll tweak that draft and then go from there.' And so that's what we did. He came up and we worked out a treatment together that we were both happy with, and then he went away, and I wrote this monster script. This 300-page thing. And he came back and was thrilled with it."

Director Christopher Nolan co-wrote all three films in *The Dark Knight* trilogy with his brother Jonathan (Jonah) and David Goyer, but their process varied from film to film to film.

"On *Batman Begins* David and I sat down and talked a lot about the history of the character," Christopher Nolan tells Indiewire.com. "I talked to him about the film and he came up with a story and very quickly wrote the first draft because he had to go off to direct the [*Blade: Trinity*] film. So he managed to squeeze it in. I then took that draft and rewrote it and involved my brother in that process as well. I would talk to him about what I was doing and get him to look at particular scenes. You know Jonathan contributed a lot to [*Batman Begins*] as well, although he's not credited on the film. So when it came to *The Dark Knight* what I decided was to do it in a similar process. David and I came up with the story together and we handed that story to Jonah. He spent a very long time wrestling with that first draft of that movie which was extremely difficult. I then came on and wrote with him, sometimes on my own, sometimes with him and we tossed drafts back and forth. *The Dark Knight Rises* was the same process. Though Jonah was busy at that point and so I wound up doing more on my own. But, because he's my brother he's always at the end of the phone so he could squeeze in a little bit more."

Woody Allen & Marshall Brickman would do extensive preparation together before Allen began drafting scenes. "What we created was the story (ideas for scenes, ideas for jokes, the structure, if any); the characters (except for Woody Allen, whose character is pretty much fully formed outside the project—that is, we were aware of what the audience's expectation was and what he could plausibly portray, i.e., not the head of Interpol, except in a broad comedy); what the people do; where the story is going, etc."

But when it came to drafting, "Woody Allen mostly creates his own dialogue, and who better than he?" Brickman says. So after a few months of discussion, Allen would pound out the first draft—"on his old Royal typewriter, which he probably still has," Brickman says. "Then we'd kick it around and do another draft."

Like Allen, Billy Crystal often stars in the film versions of his co-written scripts, and he brings his improvisational gifts to the process as well. But after his initial brainstorming with Peter Tolan, Crystal stays out of the

process until the second draft. Tolan tends to do much of the "heavy lifting"—getting the first draft down on paper. Then the pages are passed to Crystal.

"Billy does his thing then," Tolan says. "He goes in and tweaks and fixes and moves things around and gets it more to what he thought it was going to be. He says, 'Well, this is good' or 'Why don't we do this instead?'—chop, change—and at the end of that whole process, we get a screenplay. And it seems to work for us. We don't get into situations where it's like, 'What the hell is that?' Billy's a very good collaborator and a very funny guy, endlessly entertaining."

Dividing up drafts also worked for Cash & Epps, since they worked long-distance. "I'd give Jim the scenes," Epps says. "He then would take them and basically write his first draft, pretty much staying with exactly what was laid out. If he made changes, he made changes because he didn't have to call me and say, 'I've made a change.' He just would do it. And I'd respond to it. Then he'd send me a draft, and I'd sit down and look at the draft and say, 'This is great.' I had distance because while he was doing that, I'd go do something else. So we had off and on, which was great for us because we got to then walk away from it. And when I'd get the first draft back from Jim, I'd see it with very fresh eyes."

We've worked in similar ways since living on different sides of the country. After we created and outlined the stories together, Matt wrote a funny but bloated first draft of *Psycho Bitch*, and Claudia wrote a harrowing but bloated first draft of *Ruby*. We affectionately call our first drafts "loose-and-baggy monsters" (second shout-out—to Henry James), which we then cut and reshape in the rewrite process.

Just remember that this approach only works if one of you *wants* to write the first—and frequently the most challenging—draft alone. Otherwise, it may feel like a burden, sparking resentment and possibly ownership issues. If that's the case, you'd be better off dividing the scenes or the acts, or co-writing every word.

Or like Tony Urban & Michael Addis when they wrote *Poor White Trash* and Peter Tolan & Harold Ramis when they wrote *Bedazzled*, you could split the difference—and the draft.

"Harold and I sat together two or three times," Tolan says, "and we chose what we felt were the best choices that we had. Then we split the screenplay in the middle."

"Because structurally *Bedazzled* was so episodic—it was a series of wishes—it was easy to split," Ramis said. "And once we sort of knew where the overarching story was going, it was just convenient. Peter literally wrote 60 pages and sent it to me, and I wrote the second 60 and sent it to him."

"It took me about—I screwed around—it probably took me two or three months to do my half," Tolan says. "So then he did his half and married the two together. He made some changes in my half to make them

agree with what he had done, and he sent me the script. I read it, and it was really funny."

The danger of this approach is a possible tone shift in your script. "In Harold's half, it does sort of get spiritual because Harold's a really spiritual guy," Tolan adds. "He's always looking for the underlying spirit of a piece, no matter what he does. And that's just where he's at."

Acting It Out

"Acting out the dialogue and hearing it out loud is a key advantage to writing with someone," Brad Anderson says.

We agree. Matt is a better actor (Claudia makes no claim to being an actor at all), so he reads the lines aloud while we're writing a scene. This method works wonderfully for us, and we recommend that you and your partner do the same, whether you're actors or not. It allows you to hear the characters' voices and connect to their emotional flow. It also helps you identify clunky lines as well as any beats of dialogue that may need to be cut or rearranged.

Alexander & Karaszewski consider this the greatest advantage of co-writing.

LARRY: The dialogue thing is probably the biggest reason for a collaboration because you basically have to audition the lines. If they make someone laugh, or someone thinks it's a good line, or they seem fairly amusing, that helps. You have to say them out loud.

But do they *act* them out?

SCOTT: Oh, yeah. We're both hams, so we act out the lines. If the line is trying to be funny, then we'll try to deliver the line to make it funny. Then Larry gets to kick back on the couch, and I get on the computer for a few minutes and type it all in.

Chad & Carey Hayes bring their years of acting experience to the table and act out their dialogue as they co-draft.

CAREY: I think that gives us an advantage, to be honest with you.

CHAD: Because as actors, we used to approach scripts, and if you keep stumbling on lines, there's probably something wrong with the way they're written because it's not a natural organic process of how you deliver your speech.

When Robert Ramsey & Matthew Stone wrote together, they also stretched their thespian muscles, as they told us for the first edition.

ROBERT: We use accents and stuff.

MATTHEW: That's sometimes what comes out, and we write it down that way.

ROBERT: I'd never want to see that. I'd never want anyone to see that.

MATTHEW: We don't stand up and— Well, every once in a while we do, but we're not like Carrot Top with the props and the bag of things. We just sort of sit here.

ROBERT: It's the kissing that's the hardest part. [Laughter]

Script Partner Points

- Faced with the daunting task of writing your first draft, remember that collaborating takes the terror out of the blank page (or at least it's a collective terror). Just get something down.

- Decide which drafting process works best for you, your partner, and your project:

 Co-writing every word
 Dividing up scenes
 Dividing up acts
 Dividing up drafts (or dividing them down the middle)

- If you co-write every word in person, find a comfortable and productive way to work together—one types/one paces, etc. Try to avoid one types/one sleeps.

- Tap into complementary strengths when drafting—e.g., one of you may be better at writing action, one may be more proficient at writing dialogue.

- Strengthen your weaknesses by occasionally taking a whack at an aspect of drafting that isn't your strong suit.

- Throw caution (and pride) to the wind by acting out your dialogue, especially if you're writing a comedy.

David (John Cusack):	You thought my first draft was cerebral and tepid?
Helen (Dianne Wiest):	Only the plot and the dialogue. But this—
David:	Was there nothing in the original draft that you feel was worth saving?
Helen:	The stage directions were lucid. Best I've ever seen. And the color of the binder. Good choice.

—*Bullets Over Broadway*

TEN
Co-Writing the Rewrite

Before you and your partner dive into your rewrite, take a moment. Pause. Congratulate yourselves on completing your first draft. And celebrate.

Seriously. Put down this book and go celebrate. Even the most successful and prolific screenwriters like the Hayes brothers do this.

CHAD:	We celebrate the process.
CAREY:	We celebrate the steps. We finished the first draft—
CHAD & CAREY:	Celebration.
CAREY:	Because if you wait until it gets made—it may never get made—you never celebrate.
CHAD:	Or it may not turn out the way you wanted it to.
CAREY:	So celebrate the steps along the way. I think that's important because that makes you feel good as a writer. "Okay, we jumped that hurdle. We went around that obstacle. We continue on."

But before you continue on with your script, put it away for a few days or a week or more (if your schedule allows). This break has real value because it will give both of you perspective and fresh eyes when you dive back in. That's what "revision" means—"re-seeing."

Screenwriting Is Rewriting

When we interview Jack Epps, Jr., he's just finished the manuscript for a new textbook titled *Screenwriting Is Rewriting: The Art and Craft of Professional Revision*.

He's right—screenwriting *is* rewriting.

This truth is so important, so fully acknowledged in the industry, that the Sundance Screenwriters Lab has Fellows ritually burn their screenplays as a symbol of their understanding that a writer's work is never finished, and a script can always be improved.

"Hopefully, rewriting just makes things better and better," Jim Taylor tells us. "Sometimes it makes things worse, but if you have the time and energy, I think it's good to revisit your script as many times as you can."

Before you and you partner begin, however, it's helpful to have a strategy for your rewrite. You may want to follow the revision advice in Epps' new book or in Linda Seger's *Making a Good Script Great*. Or create your own unique approach.

Epps explains his and Cash's usual (but unusual) approach for long-distance rewriting, once he'd laid out the movie and Cash had written the first draft.

"At that point, we'd get on the speakerphone—pre-Internet, we had a computer program called Carbon Copy that connected us by the phone line—and we'd start to rewrite together. We'd put the script up on the screen and start to go through it scene by scene and line by line, and we'd be on the phone for six to eight hours a day. If there were scenes to rewrite, we would divvy them up, and I'd go write a scene and he'd go write a scene and say, 'Okay, come back in two hours and let's see what you've got. Send me your scene, I'll send you my scene.' We'd send scenes and then we'd look at them and go, 'Okay, let's take this, let's cut and paste, that works, let's piece this together now, okay, tighten this, and now we've got a scene out of it.' And then we'd try to rough in that draft as much as we could to get it so it works pretty well. And then go over it again. We were very big rewriters. It's just something we enjoyed as a process together."

Dedicated nine-to-fivers Alexander & Karaszewski have also developed their own idiosyncratic approach to revision.

LARRY: We're different from other people—we like these absurdly long first drafts.

SCOTT: We're like that 800-pound guy in the *National Enquirer* who lost 100 pounds and is calling up all his relatives.

LARRY: "I just lost 100 pounds, and I feel great! I'm down to 700!"

Because their scripts often run 200 pages, they're faced with cutting upwards of 80 pages (except in the case of the Marx Brothers script,

which was so long they excised the equivalent of an entire feature). Once this scriptendectomy is done, they spend months polishing, "trying to perfect lines, trying to shorten things more," says Alexander.

LARRY: You come up with ideas of how to do it. "This scene has this idea, and this scene has that idea. Why don't we just have one scene that has those two ideas in it? And this scene has eight good lines but ten mediocre ones. This scene has five good lines." Every single word has got to fight for its life.

SCOTT: It's like reducing a stock—hopefully the soup gets richer.

If one of you is a crackerjack editor, you may decide to defer to that complementary strength, as the Batchlers do with their "unshowable" first drafts, which are usually 140–150 pages.

"I do more of the editing because I'm a really good cutter," Janet says. "I can edit very fast. I go in and say, 'We have a half page of dialogue, and we can do it with one visual. This speech could actually be cleaner if it was only one sentence long.' I'll say, 'We can go from this point in the middle of the scene to the next scene and let the audience fill in the gaps. Let the audience do the work, and we can just go there!'"

That's why she loves transitions—the right cut between scenes can make your script read more like a movie, throwing the story and the reader forward. If script length allows, Janet also crafts something compelling at the bottom of every page. "Something really provocative where you go, 'Oh my gosh, I have to see what the next line is'—to make you turn that page and keep reading."

Either editorial approach—making cuts together or separately—can get sticky. Inevitably, each of you will be trimming something the other one wrote and possibly loves (not that you're keeping score). At tough times like this, check your ego at the door and remember William Faulkner's reminder that, in writing, you must kill all your darlings. And keep in mind the common good—a good script. This can also ease the pain.

But it still ain't easy, as Manfredi & Hay acknowledge.

PHIL: We try not to take offense if one of us writes something that fails.

MATT: Sometimes we fail to not take offense. [Laughter]

Claudia did not take offense when we substantially cut her 250-page first draft of *Ruby*.

CLAUDIA: Matt encouraged me to include any aspect of my 19-year-long research that we might end up using, so that sucker was fat. And we basically had to cut the script in half without doing damage to the historical and emotional truth.

MATT: Our strategy was to tighten the structure of our five sub-stories and make sure the beats intersected our two A stories—one in the past, one in the present—where they had the greatest dramatic impact.

CLAUDIA: Then we streamlined our two A stories and worked through the individual scenes, making them—and the entire script—more economical and evocative.

With *Geronimo*, Charles Gaines & Ethan Hawke also had to find a way to cut their first draft in half.

"It was 300 pages," Charles explains, "so in an effort to find ways to cut it, we decided—and this was Ethan's idea—we decided structurally to change it so that at the beginning and at the middle and at the end, we have three different-age versions of Geronimo, his voiceover narrating parts of this enormous, epic story we were telling. We were telling 40 years of history in this script, and that was a brilliant idea. It reduced the script, and in some ways it gave us a much more interesting character in Geronimo because you see him go from narrator one, which is a young, in-his-prime, unapologetically savage and fierce warrior to, in his middle age, a much more subtle man who has had to make accommodations to the white man and who has had to live on the reservations, who is still fierce but in a more muted way and in a much more political way. He's gotten savvy, so you see the savviness of Geronimo, which is enormous in the second narrator character. And in the third narrator character, Geronimo is six months away from being dead. He's in his 70s, and all of his life is behind him. And so he's got this amazing sweetness, that sweetness and perspective that the late Geronimo did have. There were many books by people who knew him and interviewed him in that latter third stage of his life. Not so many in the first two. [Laughter] In this latter stage of his life, his sweetness and his spirituality and his deep understanding of suffering and of the benefits of suffering that can be accrued by man, all of those things are apparent. So we got these three different looks at Geronimo and these three different voiceovers of his life and what happened to him. And so to the extent that each of those modifies and leans on the others, you get a much more three-dimensional character than you do otherwise. And Ethan brought that to the script. It was very valuable, I think. Not only did it cut the script, but it made it much better in terms of the character and drama. We were trying to define Geronimo's arc in action, and I think did a fairly good job of it, but this brings a much more nuanced portrayal of his arc."

Focusing on character and arc was also part of the strategy for Craig Borten & Melisa Wallack as they revised *Dallas Buyers Club*. Borten wrote the original screenplay based on his 20+ hours of interviews with Woodroof in 1992 (Woodroof died a month later). For several years, the project went in and out of development, and when it looked like Borten

had run out of options—including the contractual kind—he teamed with Wallack to revise the script. Together, they conducted additional research and streamlined the story's scope to focus on Woodroof's journey.

"Ron's evolution was pretty amazing," Wallack says in the *Dallas Buyers Club* press notes, "and it was his discoveries and insights into himself as well as into AIDS research and medications that pointed the script in the direction it ultimately went."

"We broke it down into different people representing different points of view," Borten adds.

To represent the LGBT POV—and help dramatize Woodroof's evolution from bigot to advocate—Borten & Wallack created the character of Rayon.

"What we discovered was that we wanted to service this unlikely friendship with Ron and Rayon and let that be the emotional throughline," Borten tells *Written By*. "They're both outcasts in the world and how do they come together? We just thought this is a great way to put it in Ron's face, to make him face his own fears. He can't look away."

While working on narrative focus and developing Rayon's character and Ron's arc, Borten & Wallack also addressed issues of tone.

"We both decided the script Craig had written was great, but it was dark," Wallack explains to *Written By*. "It had to have levity. Ron was a very engaging, funny, off-the-wall person. That was one of our primary focuses. We can't write a dark, dark movie only about AIDS. We need to speak to something else. What drew people to him? The longer we wrote it, the more we liked Ron. We looked at what we were going to keep and what we were not going to keep. It was a long process."

After nearly a decade of revisions and stop-starts, their screenplay for *Dallas Buyers Club* got Matthew McConaughey attached and finally went into production in 2012.

With *Ruby*, *Geronimo*, and *Dallas Buyers Club*, the projects themselves dictated the best approach for the rewrite. So you and your partner may also find that the specific needs of your script will help you devise your plan of attack.

Whatever your strategy and however long the rewriting takes, your goal is to make your "unshowable" script showable. And once you've done that, celebrate!

Then gird your loins, because once there's interest or an option or a sale, there will be . . .

Too Many Notes!

There's no question that a great note can make a film better—much better—like the note given to Alan Ball that Lester Burnham (Kevin Spacey) should *not* have sex with 16-year-old Angela Hayes (Mena Suvari) in *American Beauty*.

Ball initially balked because he thought the note came from a puritanical place. But the head of DreamWorks at the time, Walter Parkes, convinced Ball by pointing out that in Greek drama, the hero "has a moment of epiphany before [. . .] tragedy occurs," as Nick Kazan so beautifully puts it in his article "True Beauty" in *Written By*. Ball realized that Lester's refusal to have sex could be that ennobling epiphany, and he changed the script.

Great screenwriters embrace great notes.

"We may sit in a meeting with you," Carey Hayes says, "and you go, 'You know what, I had an idea about how to end this movie and call me crazy but—' And we're like, 'Whoa, God, that's great! You just went from here to *The Sixth Sense*. What a great idea!' It just happened in our DreamWorks meeting. Some notes were like, 'Damn, I wish I'd thought of that!' So we're not the end-all. We're very collaborative."

But notes can also be the bane of screenwriters' existence.

"It used to be that there wasn't such a thing as studio notes," Nick Kazan tells us. "They'd say, 'You know, I think you should have more of the girl in there'—and that was it! They did have writers on the lot, and they did have some people who just did story and some people who did dialogue, etc. But there was an integrity to the work, and when you went to see the movie, you felt like you were seeing your work."

That environment changed in the late 1960s after William Goldman's spec screenplay for *Butch Cassidy and the Sundance Kid* sold for a record $400,000.

"People said, 'This is way too much money to pay for a screenplay. We should be hiring people to write screenplays and get them to do what we want,'" Kazan explains. "So staff started to come on. And then there was a lot of money, and that allowed for more staffs, and people started getting their own little pet projects. Then Paramount began writing voluminous notes, and they started publishing these note sessions. Everybody would get together with the writer, and they would have a huge session, and everybody would say whatever they wanted. Then somebody would transcribe the notes and send them out, and you'd get these documents that were 30 pages long! One friend of mine, a producer who was then dealing with a subsequent regime because these people from Paramount spread out all over to various studios, would habitually go in and say, 'These notes are very interesting. Could we just go over them? What does this one mean? And what about that one?' Half of them would get crossed out because no one knew what they meant, so then there were only 15 pages instead of 30! But it's ludicrous to think that anyone could execute that many notes and still stay inside the scenes and characters. Obviously, you can't do that. God bless 'em, most studio executives are very smart. They're very nice people. They obviously mean well, but they feel as though they're not doing their job unless they're telling you how to change what you've written."

Carey Hayes agrees, "Everybody in that room, when you're getting notes, no one is being paid to be silent." [Laughter]

And writers pay the price, according to Ramsey & Stone.

MATTHEW: You are the writer at the beginning, but by the end of it, suddenly the guy who was cutting the checks wrote it.

ROBERT: It's a steady process of being co-opted.

Mark Twain once said, "Glacial epochs are great things, but they are vague—vague." Studio notes often are too. This is one of Ramsey & Stone's biggest complaints.

MATTHEW: We've learned one thing about taking notes from the studio, which is you must butt heads with them to some degree just to get them to explain themselves. It's not about disagreeing with their notes. If you don't press them, they get lazy and they say these by-rote things that could apply to any script.

ROBERT: The dialogue is very consistent between studios. There's a rulebook. I haven't seen it, but I can see the evidence of it constantly in my interaction with creative execs around town.

MATTHEW: To get a note that says, "The main character is not pro-active enough." I'm not being argumentative when I say—

ROBERT: "What the fuck do you mean?"

MATTHEW: "What do you mean? Where? Are you talking about this scene?" You've really got to pull it out of them. Taking notes is a whole art unto itself.

So count your blessings that you have a partner to help you decipher what has been said.

MATTHEW: When we come back, we've taken notes. "Yeah, I heard him say that. I thought he meant this." And Rob will think the executive meant something else. We get to sort of say, "Oh, you thought that? I see. Maybe they meant *this*." And it actually helps us. It's like, "You were there, you saw the accident too—what did you see? What happened?" If I was on my own and I was taking these notes, I'd be a lot more confused.

For this reason, Lowell Ganz values having Babaloo Mandel by his side during their "creative negotiating" with producers, directors, and actors. "It's always very wonderful either during the meeting or afterward in the

parking lot to know there's somebody that was actually there the whole time," Ganz tells *Creative Screenwriting*. "Not your wife when you come home later who doesn't understand why you're so upset, but somebody who's actually there, who you can just look at and go, 'We're not crazy, right? I wasn't talking nonsense—I mean we both heard the same thing, right?' So that's a good thing."

Once you both agree what was said, the trick is to apply the notes without doing irreparable damage.

"Try and give them what they want," Ramsey says, "without building a house for them that will fall down."

"We have learned not to fight notes," Cinco Paul & Ken Daurio tell us via email. "It's our job to address them the best we can. And if they're stupid notes, at some point that will be obvious (hopefully not too late)."

With Cash in Michigan, Epps took meetings and notes for the team. "I'd bring them back to Jim, and he'd go, 'These idiots! I cannot believe these stupid— How dumb can they be?' And I'd go, 'Jim, don't. You're beating me up, man.' Then I brought him into the note meetings on the phone. I said, 'Now you have to be in here because if you want to cuss them out, go ahead. You can just let 'em have it. It's fine with me!' But he was always very nice."

But what do writing teams like Patrick Massett & John Zinman do when they disagree so strongly with a note that they want to push back?

PATRICK: That's been an evolution. I think as you get more established you understand and believe in your ideas more. With maturity and experience, you feel stronger about standing up for your ideas to people who could fire you, basically. But we also believe that the best idea wins. We don't believe that it has to be ours.

JOHN: It's better when it's our idea that wins. [Laughter]

PATRICK: So I think in the early years we were more like, "Sure, whatever you need." And then as time has gone by, we push back on bad ideas as much as we can. Because it's also our job to say there's probably a better way. There may be a better way to accomplish what you're looking for.

JOHN: But that would be a situation where we're certain. It's really, I think, a degree of distaste. If it's "Oh no, this is just wrong, we have to fight," then you fight. If it's "Maybe we're just being— Maybe this is subjective," then you can acquiesce a little bit and try to find the spirit of the note. Because sometimes the note might not be the note. And finding a place in that note that you can be comfortable and will make them happier is— That's the collaborative process. And if you can get there, that's great.

PATRICK: Filmmaking is a collaborative art, so it can't always be our way, even though it's right. [Laughter] But sometimes you just have to push back and look for the breaking point. And sometimes with TV you can just outlast them.

JOHN: That's true.

PATRICK: You just don't do the note, and the cameras are rolling, and it's "Oops, forgot to get it that way!" [Laughter]

JOHN: In the movie business, you can just note yourself to death. Literally. Well, not literally because you're not gonna die, but the project will die.

Peter Tolan probably wishes *America's Sweethearts* had died after he suffered through a staggering number of notes and rewrites.

"I can say safely that I rewrote the last scene in *America's Sweethearts* 35 times," he says. "Thirty-five different attempts at it—just endless! Every imaginable pitfall. Without getting specific, a lot of things happened. I felt that right around 28 I had it. And then an event happened that caused that to go down the toilet, and I had to start all over again. On and on it went. It was actually pretty funny."

Renee Longstreet has to laugh too when recalling a particular script note that came from the head of a television network. "I won't say his name, but he said to Harry, 'I don't care if it is bad structure, I want the climax up front.' That's one of my favorites. I said, 'Oh God, I don't want to be married to *him*!'" She and Harry crack up.

So maintain your sense of humor—and perspective.

For Ramsey & Stone, it also helped to remember that they were being paid. "You are an employee of sorts," Ramsey says. "You hope that they're hiring you for your point of view, but at some point their point of view is absolutely as valid."

And stay open. Sometimes even the *worst* note can be helpful.

"We got some notes from a CBS show that were *insane*," says Carolyn Miller. "We wanted to kill them! I said, 'Ugh! This is just going to change everything. It's a major re-conceptualization of the story.' It was a terribly painful process, but it forced us to rethink a lot. And we came up with what I think was a much more interesting script."

There are times when radically rethinking your script is exactly what's needed, but you're too close to the story to see it—the forest for the trees and all that. When a directing teacher at the Sundance Filmmakers Lab read our script *Obscenity*, she loved it. "I found it a page-turner from the moment Sam was murdered," she told us.

Terrific, we thought, *except Sam doesn't die until the end of Act One*.

Act One was too "bucolic," as she diplomatically put it. She suggested we start the script with Sam's murder.

From our earliest conversations about *Obscenity*, we'd thought of the gay bashing as our first turning point, but after getting these thoughtful

notes, we saw what a powerful opening scene it could be. We also realized that opening with the murder would give us more time to explore the emotional impact of Sam's death on Sara and to explore the events leading to her decision to continue his controversial court case. We were able to see the story anew.

We'll be honest—redesigning the screenplay wasn't easy. But once we'd solidified our new structure, rewriting was exhilarating. Everything seemed to fall into place. We had such unexpected and amazing new insights that we jokingly called them "cosmic transmissions." And once we were finished, we had a much stronger script.

The truth is, you never know who might give you a great note—producers, directors, agents, friends, family, or fellow writers. Even studio executives. As Janet Batchler says, "The person you think is never going to offer anything of value can come up with a solution to a problem."

And speaking of cosmic transmissions and people you'd never expect to be helpful . . .

We'd heard of spirits from the afterlife dictating manuscripts (specifically the Seth books by Jane Roberts, who went into trances and spoke as a personality named "Seth"), but we'd never heard of spirits dictating screenplays. Until we spoke to David Sonnenschein, who wrote the first draft of *The Knife and the Rose*—and brought on Stuart Geltner to help with the rewrite.

The script is based on the true story of a Brazilian healer named Arigo, who "channeled" spirits to make medical diagnoses and prescriptions. Sonnenschein had extensively researched Arigo's life, conducting numerous interviews with the living, but for the revision process, he and Geltner—both trained in transchanneling—wanted to get a sixth sense about their subject.

They pulled out the Ouija board. Face to face, the alphanumeric board between them, the writers placed their fingers on the planchette and asked Arigo's spirit their questions. They relaxed and waited for something to happen.

"Our question really was, 'Is there anything that you, Arigo, in this spirit realm, would like to convey to us that may contribute to this script and our efforts in portraying your life in cinema?'" Sonnenschein explains. "So it was really a direct question to a deceased real person."

The planchette moved in response to that and several other questions. When Geltner saw one letter being pointed out, he was able to "hear" the whole word, and Arigo began to "speak" rapidly to them. They dictated his comments into a tape recorder.

"We went for about half an hour, 45 minutes, a lot of stuff coming," Sonnenschein says. "It corroborated much of what we'd already been doing, but there was an extraordinary emotional connection for us as writers directly to this source. That really helped define and refine our intention as writers to go really, really deep into this and throw away things that didn't matter or that were not on track."

They used some of Arigo's own "words" from the channeling session as dialogue in the final scene of their film. And thanks to his comments, they focused their story, trimmed a superfluous subplot, and refined his voice in the script.

Which just goes to show you—everyone's dying to give you notes. Even the dead.

Rewriting During Preproduction

If your script sells and the movie is greenlit, celebrate! But understand that your rewriting may be far from over. For starters, studios often arrange a table read with the actors who have been cast.

"We love to be at table reads," Chad Hayes says. "We love it, love it, love it. We record it. At studios now, it's visually recorded usually. And we're making copious notes, and we love it when actors— They don't give everything, but they give a lot in these readings. You get a sense of where the actors think the characters should be. On *The Conjuring*, there was a big panel, which was fun, everyone meeting for the first time, talking about characters, talking about, 'I think I would do this, I think I would do that, is that a possibility?' Then it's really, by that point, it's the director taking control of what his thoughts are."

When director/co-writer Benh Zeitlin cast Quvenzhané Wallis as Hushpuppy in *Beasts of the Southern Wild*, the young actress inspired Alibar & Zeitlin to rewrite her dialogue.

"Her presence was immediate and vital right away," Alibar tells us. "She brought an openness and truth to the character that blew me away. She was a strong indicator of truth in the dialogue—if the line sounded false when she said it, it's because it wasn't written well, and that became immediately obvious. Great actors can always show you your weak spots, so you have plenty of time to change them."

Brad Anderson's lead actors are frequently his writing partners as well—Lyn Vaus played the main role in his first film, *The Darien Gap*, and appeared in *Next Stop Wonderland* and *Happy Accidents*; Steve Gevedon performed in *Happy Accidents* and *Session 9*. After Anderson writes the "first pass of the dial," he relies on his collaborators' acting skills for subsequent revisions. In a series of rewriting sessions, he takes notes as they "riff off" his script.

"Each person inputs his ideas," he says. "Lyn and Steve, more than myself, both have a way with jokes and clever quips. I write down what I find funny and ignore the rest. There is a lot of acting out. There's a lot of wrangling as well. It can get pretty brutal and self-effacing. These are less writing sessions than they are mild brawls. And you often get ideas for how the characters behave, what they do. At this stage, direction can be added to the script that helps bring it to life."

When Milos Forman signed on to direct *The People vs. Larry Flynt*, he helped Scott Alexander & Larry Karaszewski with their script revisions. Their process of what they call "finessing the moments" involved Forman's performance of the dialogue.

SCOTT: Here's the problem with working with Milos—Larry and I are two fine actors as you can clearly see. And when you work with Milos, he insists on playing all the parts. You know, let's get real—he's Czechoslovakian. I can deliver that line. I can sell that line to the back of the theater. And then you've got Milos stumbling over it, and like, I don't know if it's a good line.

LARRY: Aw, I disagree with that. Milos is great. He's even better than the actors at the end of the day. There were times when we'd sit in his room, and he would just read the script of *Larry Flynt*.

SCOTT: Milos doing Larry Flynt's Kentucky accent, that was something. That was priceless!

LARRY: It was awesome. It was a great performance.

The Hayes brothers also had an awesome experience with their director, James Wan, on *The Conjuring*.

CHAD: When we first met James, who came on board, he loved the script. It was just his thing. So New Line set up a lunch for us to sit down and just kind of work on chemistry. Is it going to work? Can we work together? And we had so much in common because the fact is he also wanted to do it period—set in 1971.

And it was Wan who came up with the hide-and-clap game that pays off in one of the film's most terrifying "scare moments."

CAREY: He brought that to the script.

CHAD: James had always thought— He goes, "I just think it's scary." We like hide-and-seek, but the whole clap thing was his idea. You follow the claps, and he knew where he wanted to put the hands. And when he pitched it out to Carey and me, we were like, "Oh, that's so great!"

CAREY: And then the hands are gonna come out of the closet and go like this— [Claps]

CHAD: And then the hands will come out of the shadow behind Lily Taylor where there's no space, there's no room for anything there.

CAREY: She's right up against the closed door, so how is somebody behind her?

The Hayes' experience with other directors' notes—especially about dialogue—hasn't always been so positive, but they take it in professional stride.

CHAD: We learned very early in our career that when a director comes on board, even if they have dialogue notes and even if you think it's lame, as a writer you have to learn the movie has become the director's movie, right? It's not your movie anymore—it's the director's film. So if you want to stay on the movie, you really find a way to work with the director. Even if you don't agree with the dialogue. The greatest advice we ever heard in our lives is that it can be fixed in post. [Laughter] We learned the hard way. No names, but . . .

Massett & Zinman name names.

JOHN: Simon West.

PATRICK: Paramount loved our *Lara Croft* script and thought it was the bomb. Then [director] Simon West came on and literally handed us a piece of paper no bigger than a napkin or not much bigger than a napkin and asked us to fly to London to do a rewrite, which was a Page One. So the script, the original script that we actually wrote, that got the green light and that Angelina Jolie glommed onto, was pretty much thrown out. And we had to sort of start from the beginning with Simon, and we wrote that. We're talking about writing quickly, two weeks in a hotel room in London.

PATRICK: And Simon just completely fucked up the second version.

JOHN: Yeah, I won't pull punches on any of this. Simon fucked up that movie.

PATRICK: He fucked up the franchise. That could've been an *Indiana Jones*.

JOHN: Our original script was one of our favorite scripts that we've written in our careers. And I'm sure it's not as good as we remember—I mean, we were 17 years younger, 17 years less experienced—but it was pretty damn good. And all of Paramount, whoever the people in charge, there was a good script there, and that was a failure of institutional courage. They should've told Simon that this is the script that we hired you to direct, and that shouldn't happen as often as it does. All over the place.

PATRICK: Yeah, Simon—

JOHN: Maybe we shouldn't talk about this.

PATRICK: I don't care.

JOHN: It happens, and I understand why it happens because once you get to that place, you need the director. I mean, the train has left the station, and hundreds of thousands of dollars are now being spent every day, and if the director bails, it's a colossal hemorrhaging of money. So you need to keep the director happy, but that kind of power being put in one person's hands when you've got a $100 million movie is a recipe for disaster. Sometimes the train doesn't go off the tracks, but when it does, it does.

And sometimes the train is moving so fast there's no *time* for rewriting, as Charles Gaines discovered when he co-wrote the script *Stay Hungry*—based on his first novel—with director Bob Rafelson. A very different experience from co-writing with Ethan Hawke.

"Bob's a director, and directors are looking for different things than actors are," Charles says. "Sometimes the same thing but often different things. And Bob was a much less copacetic partner than Ethan. First of all, he was much more impatient because we had to get a draft in to Universal. He was already spending money on preproduction for the film—his own—confident that he was going to get it picked up by the studio, but not positive. And so the sooner he got it to the studio, the quicker he got his money. And whereas I would have taken much longer, and I think we would've had a much better script, he was always pushing, 'Okay, that's good with that scene.' 'Well how about if we do—' 'No, no, no, it's fine. We can always go back to it later.' Which you never do. [Laughter] Once you've got your funding, once it's been greenlighted by a studio, the pressures of the filmmaking business itself come so severely to bear that there's no time to think about anything else but that." . . .

Rewriting During Production

. . . "Bob's version of tweaking the script after that would be on the set where Sally Field would say, 'This is a bullshit line—I can't say this line,'" Charles continues. "And Bob would send me off for 15 minutes to rewrite it. But that is as far as we got to tweaking. So Ethan had all the time in the world, and I think to feel that generosity of time is a huge help to any co-written project. Because you're not only co-writing, you're co-feeling each other out, getting to know each other creatively and searching for that synthesis day by day, and the more time and amplitude of time you've got to do that in, the better. Better for the project and better for the relationship."

Then there's the slow-moving train of animated features.

"Animation has a production schedule of 3–4 years," Cinco Paul & Ken Daurio tell us, "so we are constantly rewriting these movies every day

during that time. It can get exhausting. Generally we divide and conquer here as well. If there are new scenes or big changes, Ken handles those, while Cinco addresses all the other notes throughout the script."

If you didn't co-write your feature with the director, and you and your partner are not in animation, the odds of your being invited to rewrite during production are slim. But there are some terrific exceptions, like the Hayes brothers, who were on set for the entire shoot of *The Conjuring*. Their input was not only welcomed but encouraged—by James Wan and studio execs.

CHAD: This is what I loved about the New Line executives. We're sitting around with nothing but time, we're waiting for the next take, and they're, "Oh, we're shooting this tomorrow? Do you guys feel like there's any way to make it better? Is there *any* way to make it better?" And we're like, "Wow, let's use the time and—" We love that challenge. Now, do you get paid for that? No.

CAREY: There was nothing ever major. But it was that pathway of discovery. "Ooo, Vera Farmiga has got this amazing voice to play Lorraine. The banter between her and Patrick Wilson—wow, we can bubble that up a little bit."

CHAD: Or "Wow, the little girl is a great actress."

CAREY: "Let's give her some more stuff." Or the producer says, "Listen, we gotta shave a couple days off here. If we cut this scene, how do we protect the integrity of the story?"

CHAD: Or "We can't do these two locations. What's the information here compared to what we've already shot? How can we fit it in, so it still takes care of it?"

And one important pathway of discovery led to the scene in *The Conjuring* that the Hayes are most proud of.

CHAD: Carburetor scene.
CAREY: Yeah.
CHAD: When Patrick talks to Ron.

In other words, when Ed Warren (Patrick Wilson) talks to Roger Perron (Ron Livingston) while they work on Perron's car.

CAREY: Ron Livingston wants to thank Patrick for coming out and doing this, and he says, "I can't take the credit—it was all Lorraine." But he's protecting Lorraine because he says, "Every case takes a little piece of her." And Ron's kinda like this— [Puzzled expression] But our whole approach was,

here's the patriarch of his family—Ron Livingston—and he's passing the baton to Ed Warren.

CHAD: Please take care of my family—

CAREY: To take care of my family. That's the subtext of that scene.

CHAD: —and I'm grateful.

CAREY: That scene came alive on location. Both actors came to us independently asking questions because that scene was important to both of them. We backed up and went, "I never looked at that scene as—"

CHAD: "What else could we—" We rewrote that scene to be what it was. That was awesome. But again, that's writers being on set, having a relationship with the actors, the director not being paranoid about why the writers are talking to the actors. It was very, very room-friendly.

In the world of TV—especially sitcoms—the (hopefully friendly) writers' room is where the major rewriting begins. And it extends exhaustively throughout all phases of production, as Andrew Reich & Ted Cohen explain.

TED: The revision process starts with presenting our draft to seven or eight other writers and producers, then having general discussions about what changes are needed.

ANDREW: You go through it and you make the jokes better. You tighten scenes, all that kind of stuff.

After the table read with the entire cast, the writers revise again. This process continues as the actors rehearse.

ANDREW: After seeing it up on its feet, we go back, do another rewrite, then see it again the next day, go back, do another rewrite. Then there's a day of camera blocking where typically we just send one or two writers down to the stage to see if things are still funky. Do a little more rewriting. And then it's the show night.

But the rewriting doesn't stop there. During the taping, if a joke doesn't make the studio audience laugh, the writers "huddle" to come up with one that will.

ANDREW: That's the *most* pressured part of the job. You're on stage, and the audience is waiting, and the actors are waiting, getting impatient, and it's probably an area or a joke where

you've tried two or three things throughout the week already. It's probably going to be one of your problem jokes. It's just like, "Okay, we're going back to this." Or it'll just surprise you. Something's been funny all week. Dead silence. And then it's figuring out, okay, why?

TED: There's safety in numbers, which is nice. Usually there's six or eight people, and you know you're all working on it together, so I think it makes each person feel freer to just pitch something even if it's not necessarily fully formed because maybe it will lead to something else and something else.

ANDREW: It's absolutely on the spot.

On *Friday Night Lights*, the writers' room didn't rewrite the scripts, Massett & Zinman tell us.

JOHN: The room didn't rewrite. Jason might.

PATRICK: Yeah, that's what I meant by the unifying voice. Jason would always take and just tweak every script a little bit just to make sure.

But the writers were often on set in case some rewriting was necessary.

JOHN: I think it's very valuable to have a writer on the set on most shows because things go wrong, especially— TV shows have to get produced in eight days, especially a show that's going to be out a lot. By "out" I mean on location, not on home sets or on a stage. Things go wrong. Permits get lost or get delayed. It rains. And if you don't have a writer there, decisions are made that might be expedient from a production standpoint but destroy story, and when you get into post, you're going to be needing to reshoot. And that gets more expensive. So sometimes you want to save money by not sending a writer to set, but you end up, in my opinion, spending double that in the reshoots you're gonna have to do because there wasn't a writer there.

PATRICK: Writers are part of the progenesis of the story. They hear it from the beginning. They've heard every conversation of why we should and shouldn't do things. So if something comes up for an actor on a production shoot, they say, "We've talked for 16 hours about that problem—here's how you fix it."

JOHN: The more important thing, when there's a writer there, actors are gonna ask questions, and that can only be a good

thing. It can sometimes be a frustrating thing, but it's always gonna be a good thing. And if there isn't a writer there, the actors are still gonna have those same questions, and they're either gonna answer them on their own or they're just not going to act on them. So the opportunity for something bigger or better happening is either lost or is gonna go in the wrong direction. So it's good all around.

JOHN: Yeah, because the actors are—

PATRICK: Scared. [Laughter]

JOHN: Well, they're scared and talented and smart, and they have been investing a lot of emotional energy into creating this character and interpreting the words that we're creating, and they might see inconsistencies that we're not seeing or see an opportunity we're not seeing. And that does sometimes get contentious because an actor might say, "Well, my character would never say that." That gets writers, and we're like, "Well, actually, your character *would* say that, and I know that because—"

BOTH: "It says so right here! In the script." [Laughter]

When actors make important contributions to character and story, having writers on set is invaluable, as Peter Gould—co-creator with Vince Gilligan of *Breaking Bad* spinoff *Better Call Saul*—tells the *Los Angeles Times*.

"To me, one of the glories of television specifically is that the show talks back to you, that you learn from what you're shooting," Gould says, "and certainly the characters on the show surprised us a lot. One of the examples that comes to mind is Michael McKean's character Chuck. We conceived him in a particular way. We conceived him as really kind of a helpless burden on Jimmy. And it was a way to get into the character's head. But when Michael came on the set, he didn't change a word really, but he brought a pride to the character, he brought kind of a gravity to the guy that really surprised me. I was on the set when we shot the first scene and I was like, 'Wait, there's another dimension.' And we went back to the writers' room, and this is a good argument for having writers on the set, we went back to the writers' room, we started looking at the show again. How does he really feel about his brother? What's going on under here? And what happened was that it changed the arc of the show. It completely changed where we went for, like, maybe the last four episodes. And it's really because Michael brought a dimension to the words that we had written."

This respect for writers—and their involvement in all phases of production—has helped lead to such superb programming. And so has respect for what they've written.

"I think that's part of why television is so strong right now," Jack Epps, Jr., says. "Because there isn't that endless development process where everyone's

trying to make everything homogenized and it takes all the edges off. And television has a lot of edges, and things aren't getting smothered in notes, and it's able to come on the screen. I wish the feature-film industry would take a lesson from television and realize the importance of the writer's vision and voice to the final product, and I wish they would embrace that more. The sense today that it's a director's medium doesn't do feature-length films as much good as it did at one time. But I don't see that changing."

Rewriting Others

As noted, the preposterous preponderance of studio notes has been steadily growing since William Goldman struck gold with *Butch Cassidy* in the late 1960s, but the practice of throwing scads of screenwriters and rewrites at a project dates back to the black-and-white days.

Take, for example, the #1 screenplay on the Writers Guild's list of the 101 Greatest Screenplays—*Casablanca*. The classic 1942 Warner Bros. film was based on the unproduced play *Everybody Comes to Rick's* by Murray Burnett & Joan Alison. Twin-brother writing team Julius J. & Philip G. Epstein worked on the screenplay adaptation, as did Howard Koch and an uncredited Casey Robinson.

But even as the cameras rolled, the script still wasn't finished. They had no definitive final scene, despite assistance from the entire stable of Warner Bros. screenwriters.

"Warner had 75 writers under contract," Julius Epstein told *Hollywood Hotline*, "and 75 of them tried to figure out an ending!"

"The ending of the film was in the air until the very end . . ." Howard Koch added. "I was working every day on the set . . . I think we never really had the ending for sure . . . We thought of many possibilities and finally decided on the one that was in the film. That has proven to be the ending that the audience accepts."

As time goes by . . . this practice continues. Although studios no longer employ huge stables of screenwriters, they often contract multiple writers to work separately on the same script. That's how many Hollywood writers make a living today—rewriting others' scripts. Do they get credit for this? Not always. But they get paid.

When Chad & Carey Hayes were approached in 2013 to rewrite *San Andreas*, the producers said they liked the scale and journey of the original screenplay written by Carlton Cuse, but they were looking for something more.

CHAD: They gave us a script, and they said, "Please just go read it and then let's talk about it truthfully."

CAREY: "What would you do?"

CHAD: "What would you do with this script?" So we read it and said, "It's really fun—it's a great adventure." But there were some

things the Hayes brothers would throw into it, because that's what we do and our nature of what we like to do.

CAREY: Chad and I both read it independently, and then we got together, and we talked and made our notes. And we just both felt that there wasn't enough—

CHAD: Emotional stakes.

CAREY: Emotional stakes. Family.

Or as they say in Chapter Eight—"heart and soul."

CHAD: And we pitched that out to them, and they felt like, "Wow, okay, that's a significant change."

But even with their significant changes, they did not receive any screenplay credit for the finished film. Cuse did, as the Hayes brothers have just learned the day we interview them.

CAREY: The writer before us, Carlton Cuse—

CHAD: Really good writer.

CAREY: Great writer, great writer. But what we brought got the movie greenlit.

Even so, they're amazingly Zen about the situation because they understand it's just part of the biz—and the collaborative nature of filmmaking.

CAREY: It's a collaborative thing where everybody brings a little bit to it.

Sometimes that little bit is as little as rewriting one line of dialogue, as Ethan Hawke asked Charles Gaines to do. Hawke was on location co-starring in the Antoine Fuqua remake of *The Magnificent Seven* and sent an email to Charles:

> My character is an ex-rebel soldier—"Goodnight" Robicheaux—and I am training some townsfolk/farmer types to shoot rifles, and my lines feel generic to me—"Come on get some gravel in your guts!" What would one of Stonewall's men say? What's important about firing a rifle accurately at another human being?

A consummate hunter—and co-writer—Charles replied:

> I think the line ought to be "Get some gravel in your craw"—that makes reference to the part of a gallinaceous bird's anatomy that, when the bird takes gravel into it, grinds up anything it comes in contact with. I can

definitely see Stonewall saying that. The trick to hitting what you are shooting at with a rifle is to HATE it. So I might make the line, "Get some goddamn gravel in your craw and by God *hate* what you're shooting at!"

And Ethan answered:

This is so perfect and helpful—I'm breaking my arm patting myself on the back for having you as a friend. I ran yr thoughts by the 7 and everyone agreed this was a much better line. Thanks, pal.

Or as little as rewriting a couple of scenes, as the Hayes brothers did for the *Poltergeist* remake.

CHAD: We worked on that for a little bit. We did a couple of scare scenes.

CAREY: As writers, you go, "Okay, how are we doing this different? How are we making it better?"

CHAD: On the rewrite process, when we get thrown these things, the truth is, can we elevate it to a point where we think it's good? We read a lot of stuff, and some things come our way, and we just go, "I think it's pretty good—I don't know why you want to change it." That's happened before. Or they go, "We know it's good, but we want to move it into a PG13, away from a PG, so how would you—"

CAREY: "Or get it to an R."

CHAD: "Or get it to an R." Stuff like that.

"Early in our careers we often made the mistake of trying to rewrite too much," Cinco Paul & Ken Daurio say, "when the producers really just wanted it to be funnier. So we learned the hard way the importance of really sussing out what the producers want."

Good advice for you and your partner if you're hired for a rewrite—big or small.

And you'll also want to find a way to connect to the material, as you have with your own projects.

This was essential to Cash & Epps when they accepted a rewrite assignment. "First off, as writers, we had to really like it," Epps says. "It had to be something that talked to us. So we see a movie and we could see how to fix it. Rather than just, 'Okay, I need to pay my gardener bill.' So you really have to understand it and feel it."

And they understood it and felt it with *Sister Act*.

"*Sister Act* really spoke to us in a big way," Epps continues. "And you have a lot of studio notes at that time and— It goes back to this concept of you write the original, the first draft, and you hand it in, and everybody's

not happy with it because they've got notes! [Laughter] Now you get a rewrite and everyone is desperate, so you're to the rescue. You're the rescuers, so they're happy to have you there. So you start throwing out fixes—they're oh so happy that you're giving them fixes. You can throw ideas very quickly about how to fix this and what this has to be. For instance, in *Sister Act* they sent this sister to Indiana in the script, to a convent in Indiana, and the first thing we said is, 'Why would you want to do that?' [Laughter] I mean, keep her in New York, and the concept is she changes it and opens it up. So she takes the other sisters who've been sequestered and suddenly throws them into the city, and part of the fun of it is how she— Plus, there's no tension in there when she goes to Indiana. And then for us, it was a matter of breaking down our process and deciding what our plan of attack was to do the rewrite—and address the studio notes at the same time we're addressing any ideas that we have working with the director and the producer."

The Hayes brothers break down their rewrite process for us, an approach which begins with receiving the original writer's screenplay.

CAREY: Then we literally go from the beginning all the way through the movie, each scene, and we bold our notes, what we're changing. And then we cut out scenes we're not using, so it becomes a scriptment because we're not throwing out the baby with the bathwater—it's a rewrite.

CHAD: And we've done that together, so as we—

CAREY: That'll be side by side, talking, looking at it.

CHAD: But we both have agreed on the notes and what the scene needs, so if he has it or I have it, we're already in agreement. So I'm like, "Oh okay, the note says, 'Let's put this at the lake house, take it from the urban out to the country, and let's introduce the next-door neighbor here.'" Whatever that ends up being.

So if you and your partner are offered an assignment rewriting others, you'll need to break down your own process and decide on your plan of attack. And if you can establish yourselves as reliable, fast, and effective rewriters like Cash & Epps and the Hayes brothers, you too will work in this town again. And again.

But the flip side of rewriting others is . . .

Others Rewriting You

As Larry Gelbart quips in a *New York Times* interview, "In California, they've got writers by the six-pack. If you're around long enough, there's no project that doesn't contain your work—rewritten."

CHAD: It's a reality of what it is. Sometimes it happens because you're unavailable, and they need you, and then you're like, "I just don't have the time." That's a high-class problem. Sometimes it's a creative difference where you get to a point where maybe you need fresh eyes on it. The thing is, it used to bother us, but the point is we rewrite so many other people that we just have to accept the fact that, okay, we will be rewritten at some point.

CAREY: And you can't take it personally. I mean, you can, obviously. But at the same point, you just have to respect the process.

In her Introduction to the published script of *When Harry Met Sally*, Nora Ephron is less sanguine about "The Process," which she defines as "a polite expression for the period when the writer gets screwed"—and she describes in delicious detail. "When you write a script, it's like delivering a great big beautiful plain pizza, the one with only cheese and tomatoes. And then you give it to the director, and the director says, 'I love this pizza. I am willing to commit to this pizza. But I really think this pizza should have mushrooms on it.' And you say, 'Mushrooms! Of course! I meant to put mushrooms on the pizza! Why didn't I think of that?' And then someone else comes along and says, 'I love this pizza, too, but it really needs green peppers.' 'Great,' you say. 'Green peppers. Just the thing.' And then someone else says, 'Anchovies.' There's always a fight over the anchovies. And when you get done, what you have is a pizza with everything. Sometimes it's wonderful. And sometimes you look at it and you think, I knew we shouldn't have put the green peppers onto it. Why didn't I say so at the time? Why didn't I lie down in traffic to prevent anyone's putting green peppers onto the pizza? All this is a long way of saying that movies generally start out belonging to the writer and end up belonging to the director. If you're very lucky as a writer, you look at the director's movie and feel that it's your movie, too."

Or as Stephen Geller, who adapted *Slaughterhouse-Five*, tells Imagine-News.com, "Writing a screenplay today, unless you are directing it, is like putting a meal in the middle of a forest. Every kind of animal is going to come up and fight over it—grab food, throw food, crap on the plate. That meal is so destroyed by the time everyone has had his or her way with it, you're lucky if you see forty percent of that film."

Still, the Hayes brothers remain philosophical.

CHAD: You have to understand it's part of the process. It's like when Carey and I were writing *The Reaping*, we literally were hired and let go three times on that movie.

CAREY: Yeah, it was crazy.

CHAD: It was really crazy.

CAREY: A director who wouldn't want to meet us. Just had his own vision and knew we weren't gonna like it, so brought his own writer.

CHAD: That writer came on. And then the studio read whatever that writer wrote and went, "No, let's go back to what Hilary Swank responded to." Because she was already on board and on a pay-or-play, so you had to protect that. So we brought that up to a level. And then he was allowed to bring on another writer, and so then he rewrote what we did. And then they weren't crazy about that, so they brought us back on again. And we did that.

CAREY: And we ended up with sole credit on that movie!

CHAD: It's kind of like you have to sort of give and take in the development process of what the movie's going to be before they shoot it. It's not your film. You're not financing it. You're just putting your voice on it.

So check your ego at the revolving door, because insisting that your script is your baby—

CAREY: *That's* suicide—

CHAD: It's a business.

CAREY: —because you won't work.

CHAD: It's called show business.

 Script Partner Points

- Before you and your partner begin your rewrite, take a moment. Pause. Congratulate yourselves on completing your first draft. And celebrate.

- Then put it away for a while (if your schedule allows) to give you both fresh eyes. Remember that "revision" means "re-seeing."

- Create an effective strategy/plan of attack for your revision. This is time well spent in the long run.

- Look closely at your main character's arc, then add or subtract whatever you need to make it a credible and compelling emotional journey.

- Make sure your subplots are structured so the beats intersect your A story where they have the greatest dramatic impact.

- Be open to all notes, whoever may give them, and listen for the random brilliant suggestion.

- If you're hired to rewrite others, try to "suss out" precisely what the producers want before you dive in.

- Throughout the craziness of getting endless notes and rewriting others and being rewritten, try to remain Zen about the process—and the business.

> "Rough business this movie business. I may have to go back to loan-sharking just to take a rest."
> —Chili Palmer (John Travolta), *Get Shorty*

ELEVEN
Making the Business Relationship Work

"I used to say, 'Don't write with a partner—I don't like teams,'" confesses Brooke A. Wharton, a Hollywood entertainment attorney and author of *The Writer Got Screwed (but didn't have to)*. "But that's changed now as I've seen really mature teams that have come together, where they've taken two careers that were good and made a career for both of them that was great."

While that great career certainly depends upon a strong creative relationship, a strong business relationship is essential as well. "You have to think of your collaboration as a small business," she says, "and the basic principles that happen in any small business apply."

Having represented a number of top teams in the industry, having seen "the good, the bad, and the drug-addicted ugly," she's able to quickly list those qualities that are crucial to successful collaborations, as she does when we interview her:

"There's complete honesty in the partnership.

The representation—agents, managers, lawyers—recognizes both partners and doesn't think one partner speaks for the other. All information is passed uniformly and quickly and clearly almost at the same time to both.

There are no issues ever about money. All expenses are split 50–50. Always. There are never any fights about that.

There's a sense of helping between the partners, the acknowledgment that maybe at one period of time, one person may not be feeling as well or may be going through something. There's an understanding that the other will pick up the slack instantly.

> There's an understanding that no meetings will be taken with any studio person or any producer or for any potential project if both partners are not there.
>
> There's a genuine respect in terms of what both parties contribute.
>
> Both parties equally share whatever business relationships they have. For instance, 'I just spoke with this agent. I want you to also come over, if this is something you want to do.'"

It's clear that many of the same qualities that feed the creative relationship and keep it running apply to the business relationship as well—respect, honesty, trust, and communication. The absence of any of these, Wharton warns, could destroy the collaboration. So could the following:

> "Failure to communicate about who's called about what project. One person taking off in a direction with a piece of work without communicating that to another. Or taking off with a piece and trying to represent it as their solo piece.
>
> Money issues such as not sharing profits and expenses.
>
> One of the parties trying to present themselves as superior in the relationship—that will destroy it instantly.
>
> One person thinking they're hot stuff and bringing a partner in just to help them write—the 'I'm doing you a favor' kind of relationship. These teams work for a certain amount of time, but eventually that attitude drives the recipient away."

Industry Perception

If your collaboration is on the rocks, but there's a will and a way to stay together, it may be best to do so for business reasons. Why? Because the industry perceives you as "a unified one," as Wharton says. This is especially true if you're part of a team that has written for years and achieved some success in the biz, like Ramsey & Stone.

"Breaking up an established writing team does damage to the brand," Robert Ramsey tells us in our follow-up interview. "Producers don't know what they're getting anymore. You have to start all over from scratch."

"You get labeled as a team," agrees former film/literary agent Dave Brown, now Literary Manager for Echo Lake Entertainment. "If I offer producers one of the writers, they say, 'Why do I want 50%?' Because they're thinking that the whole was two, so now they're only going to be getting half."

"If you've been a team for any length of time, you have almost no reputation anymore as an individual," Lowell Ganz says in *Creative Screenwriting*. "The only reputation you would have is with people who know you very well and very personally and would be willing to take a chance that you might not be a total dunderhead as an individual. The business is littered with halves of teams that decided they were going to start over and were stunned to find out that anything they did was going to be judged more harshly."

"I tried to go it alone," Ramsey says, "and managed to get myself into a room with Brian Grazer to pitch my take on an idea he had about a guy who learns that his best friend's wife is having an affair. I froze in the room like a deer in the headlights. The absence of Matt Stone's voice when my own had faltered was the most unendurable silence I have ever known. Brian Grazer and his development people stared at me with a mixture of pity and contempt. It was a crushing defeat. Brian eventually hired somebody else to write the script, and the resulting movie was called *The Dilemma* starring Vince Vaughn."

Your abilities and contributions to the former collaboration may also be called into question. "When the team breaks up, everyone always assumes that the other guy's the talented one," says Matt Manfredi. "If they have a meeting with me, as soon as I leave, it would be, 'I bet Phil's the guy with all the skills.' And it would be vice versa when Phil leaves."

The same is true for television writers, according to Jennifer Good, TV Literary Agent with Paradigm Talent Agency. "This town is used to teams splitting up, but it can be rough," she says. "Execs and showrunners seem to be very skeptical about 'who was the real talent in the team.'"

Many producers and others in the industry will insist on seeing solo work before they'll hire a past collaborator for future gigs.

"You have a problem when you're trying to put somebody up for an open assignment with a great writing sample that has both writers' names on it, and the producer or executives are only going to be getting one of those names for the job," Brown tells us. "You can say, 'Hey, listen, he really did 90% of the work.' They're saying, 'Yeah, but we don't know that.'"

So if you have to break up with your partner, and the only scripts you have are co-written, you'll probably have to write new spec scripts and build a reputation as a solo writer.

"The only way a team that breaks up can start new careers is if they can show what they can do on their own," says Alan Gasmer, former Senior Vice President of the William Morris Agency and now Chief Content Officer at Alan Gasmer & Friends. "For example, I represented a team of women writers who broke up, and one has gone on as a successful executive producer in television, and the other became a successful feature writer. So you never know. But you have to be able to demonstrate in a script by yourself what you can do to be able to forge a new career."

"If both writers have new, fresh material, they should eventually be fine," Jennifer Good says, "but it can take a lot of work and reinvention."

After her divorce, Carolyn Miller had to reinvent herself as a solo writer. "Credits are everything in Hollywood, and for so many years my credits were tied to Daryl's," she says. "I was really worried nobody would listen to me seriously because I had no solo script. So I had to re-establish myself. That's one reason I went into writing for new media—it was a brand new arena."

Okay, so what if, even knowing the disadvantages of going it alone, you and your partner decide you just can't work together? Brooke Wharton advises that you keep your decision under wraps until the movie's a wrap.

"In every contract a writing team signs with a studio, there's a section which says the studio has the right to yank the project if one member of the team is incapacitated," she explains. "So if there's something going on with a team, you don't want it to get exposed. I think partners should generally try to resolve their differences. Until the project is finished. Think about it. The studio's invested, let's say, hundreds of thousands of dollars for a draft and set of revisions from a writing team. From their point of view, if half of the team is down, they wonder if they're gonna get the project that they paid for."

Again, it goes back to industry perception. You and your partner are a unified one, not two separate talents. In the eyes of most producers, agents, and managers, two brains aren't better than one, they *are* one. This may explain why the industry usually doesn't have a preference for taking on teams—two writers for the price of one—when it seems like such an obvious bargain.

"I don't think they think that way," says entertainment attorney Eric Weissmann, founder of the Beverly Hills firm Weissmann Wolff Bergman Coleman Grodin & Evall, and now head of his own Eric Weissmann law firm in Encino, California. "The industry cares about the work product and the success. And if a writing team composed of a nymphomaniac and a gorilla has a hit movie, they don't care!" He laughs.

Now there's a combo we'd love to see—and knowing Hollywood, we probably will.

"I think they encourage anybody," says Scott Alexander. "It's about whether you can deliver or not. If you can deliver, they're fine with that."

Manfredi & Hay agree.

PHIL: As a writing team, you're just an entity in that you're responsible for doing the work.

MATT: With studios, agents, managers, *everyone*, it's just a given that there are teams and there are not teams.

On the agent front, Gasmer confirms this perception. "I have two cousins that are a team. I have husbands and wives who are teams. I have friends that are teams. I've handled teams in TV. I've handled teams in motion pictures. But the bulk of my clients are individuals." When we ask Gasmer if he prefers to represent solo writers or teams, he says, "It doesn't matter."

"To me, the word on the page is what matters," Dave Brown says. "I don't care how it gets there as long as it isn't stolen!"

The same attitude prevails in the world of television writing.

"It's a wash on the team thing," Jennifer Good says. "For each time I hear that a showrunner wants a team because they want more bodies in the room, I hear that a showrunner doesn't want a team because there may be too many bodies."

Among television executives, the preference for writing teams also goes in and out of fashion, according to Gasmer. "Sometimes they'll call and say, 'We're looking for a team' or 'We're looking for a male-female team' or 'We're looking for a female team.' For a while there, I was representing two female teams for television, and I knew that it would be easy, that I could get them a job, just because that was in vogue at the time."

After his solo-pitching fiasco, Robert Ramsey tried a couple of new team combos—one with a female, one with a male.

"I collaborated for a year with Laura Kightlinger, who had briefly been on *Saturday Night Live*, and for a couple of years with Jon Kesselman, who had made the low-budget comedy *The Hebrew Hammer*," Ramsey tells us. "Both were fascinating experiences that led nowhere. Collaborative writing requires the same determination that one would summon for any significant relationship. I just couldn't stick with anybody in my diminished state. My confidence was shattered. Then my dad got sick, and I devoted a couple of years to taking care of him before he died. That was the hardest time of my life. I was approaching 50, which is old in the comedy racket, my writing career was moribund, and the impending death of my father sapped all my emotional resources.

"Finally, a friend named Scott Sturgeon approached me with a script idea that he wanted to write with somebody, and I said yes. That script didn't end up generating any business, but our ability to write it together solidified our partnership. We have been toiling together ever since. We are currently writing a comedy for an independent producer. It's not studio money, but it's something. And we're trying to sell a half-hour pilot to HBO. I am committed to him, and he is committed to me. We are a team."

Dealing With Agreements

New writing partners seldom anticipate problems in the creative relationship, much less imagine that it might end. Like newlyweds, who wants to think about dismal endings when the romance is beginning? They'd rather devote their energies to their new partner and project—a kick-ass script that actors, directors, and producers will kiss ass to attach themselves to!

But in the business relationship, there's no honeymoon, as several experienced insiders tell us. Most sticky business issues surface when teams are new.

"The immature bickering stuff happens with people who are in film schools or just taking courses or just starting out," Wharton says. "That's where you get the fights and the nastiness and the *this* and the *that*. 'I've got a contact, and I'm gonna take it, and I'll never talk to you again.' That

kind of thing which is like, 'Oh, please. Go home, leave me alone. If you really think it works that way, I'll see ya later.'"

For this reason, Wharton recommends that new script partners anticipate these problems and protect their respective rights by signing an agreement that lays the groundwork and goals for their collaborative project. "The written agreement is important for that early stage—the first five years, first ten years, something like that. Because in the first five years of a career, everyone is sort of learning how things work. And people tend to be a little more aggressive and unrealistic at that point."

Eric Weissmann is more emphatic. "I recommend *most firmly* that they sign an agreement that defines exactly what it is that they're collaborating on and exactly what it is that they have rights on," he says. "Particularly if they're friends because sometimes friendships end. People have different recollections of what happens. It is a very frequent problem, almost in every nonprofessional collaboration, because the people don't have the money for a lawyer. They don't think about it, and they're friends, and they're all excited about what they're writing."

You may be thinking, *What's the big deal? What could go wrong?* Unfortunately, lots of things. Consider this scenario:

> *Joe comes up with an idea for a script and asks Bill to collaborate with him. Bill ends up writing most or all of the screenplay because Joe is too busy with his job (or he's lazy or loses interest). After the script is finished, Bill tells Joe, "Hey, I did all the work, so when this sells, you only get a quarter of the money instead of half." Joe balks because the story was his idea in the first place.*

Sound familiar? We've heard this one several times. As we've said, it's the kind of conflict that can happen when partners haven't defined what fair means to them. And it's the most common fight Wharton sees. In addition to demanding more money, a partner who did most of the work may also insist upon an exclusive "Screenplay by" credit, with only a "Story by" credit for his (we predict) soon-to-be ex-partner.

"This is ridiculous," Wharton says, "because if it's actually going to be a studio movie or a movie with a Writers Guild signatory [a company adhering to fees/working conditions as set by the Guild], the credit would be determined by the Writers Guild."

Consider this variation:

> *Paul and Carol collaborate on a script. Feeling that she's contributed more to the project, Carol starts shopping the script around as her own. An agent shows interest in representing her and the project, so Carol offers to pay Paul to "just go away."*

"I've seen this happen a million times," Wharton tells us. "The common thing with these situations is there's an ego sort of fight about who did all the work and who was more influential in getting it done and who deserves more money. The problem is one person tries to take all the credit and all the money without acknowledging the other person."

Then there's this possibility:

> *Erica and Donna write a script together. Meanwhile, Donna's career takes off, leaving Erica still waiting tables. Donna thinks, "Hmm, that was a good idea we had, but I can do it better solo." So she writes a new screenplay loosely based on that idea. "That's my idea," Erica objects, and Donna counters, "No, it's different."*

You might think, as we did, that if you copyright the script under both of your names, you're protected from this kind of thing. Not according to Eric Weissmann. "Having joint copyright owners just means that each person can make a deal for the property, give rights to a third party on a non-exclusive basis," he explains. "But it doesn't say who gets what and who gets what credit, etc."

Still, both of you should *always* copyright your co-written work. For more information, you can visit the U.S. Copyright Office website at Copyright.gov or call 202-707-3000 or 1-877-476-0778 (toll free).

Another common sticky issue is control, not just over who makes the decisions about the sale of a script but also what form it will take:

> *Hal and Marcia start writing a script, but they decide to go their separate ways. They have different visions for the project. Hal wants to turn it into a comedy and potentially a TV series. Marcia wants it to be a feature with the lead character dying at the end, nixing its potential as a series. Who gets to decide?*

"All that happens when this happens is neither of them can do anything because they've just held each other up," says Grace Reiner, former Senior Director of Negotiations and Policy Planning for the Writers Guild of America, West. "And that doesn't solve anything for anyone. It's so much easier if they'd agreed, for instance, that Writer A should go and sell it and do it however he or she wants to. And if Writer A is going to try and sell it, it's only going to get sold if there's approval from Writer B. That should be put in some kind of document that Writer A, in fact, has the authority to do this."

With all these possible problems (and this is hardly a comprehensive list), it's no wonder the experts recommend putting your agreement in writing, especially if you're a new writing team. If you have the money to run it past an attorney, that's even better. But at least get something

down on paper and each keep a copy. And do it before you start work on the project.

"That's the most appropriate time and the easiest time to anticipate and pinpoint potential problems," Reiner says. "The writers should try to figure out at the time when they're still getting along, 'What would we want to do with this property if we weren't together?'"

Weissmann seconds the motion. "During the romance, it's very easy to get things signed. Once they're pissed off at each other, it's not so easy."

Think of it as a prenuptial agreement—the paperwork is there in case the partnership sours.

"Prenup. That's a perfect description," Weissmann says. "Except there's a little bit less of a romantic aura in the collaboration agreement. And part of the prenup agreement generally is not that she has to have sex three times a day," he adds, laughing. "There's not a performance clause, whereas in the writing agreement there can be one."

Reiner draws a further distinction between a prenuptial agreement and a collaboration agreement. "A prenuptial agreement is 'What happens to our property if we break up?' But with collaboration, the piece of property is the *result* of the partnership. It's not just 'Who owns the car when we're done?' It's more like a child and two people saying, 'This will be the product of our relationship. How are we going to raise it and nurture it? Who's going to get custody? Let's try to resolve those things while we still like each other. And hopefully we will *always* like each other.'" (So scripts *are* babies!)

All this being said, we have to admit that in all the years we've been writing together, we've never signed an agreement outlining the terms of our partnership. We're like Manfredi & Hay, who tell us, "We have a gentlemen's agreement."

The same is true of most of the writers we've interviewed.

"Alexander and I don't have any formal agreement," Jim Taylor says. "But all our contracts stipulate that the money will be split 50–50."

Ours do too, including the one for this book.

When we ask Ed Solomon if he and Chris Matheson have ever had a written agreement, he says, "Honestly, it's never crossed my mind, but I can see how for some people it would be a good idea."

So can we. So can Jim Taylor. "It's probably a good idea to have something in writing before you begin a spec script," he says, "so there are no questions later on."

In other words, do what we say and not what we do, especially if you and your partner are just starting out.

"Professional people are less likely to have a problem," says Eric Weissmann, "even when they go their separate ways. I've represented a number of very important career collaborators, and there's never been a problem. But I still advise it."

According to Brooke Wharton, legal wrangling occurs less often with experienced teams because "they're so grateful to have discovered a formula for their success that they don't want to mess with it." As a result,

they tend to steer clear of the ego issues that lead to fights in the first place. But she still recommends an understanding between the parties. "Some sort of understanding, whether it's oral or written," she says. "As an attorney, of course, I'd like to see it written. But that never happens."

And splitting up does.

Carolyn Miller & Daryl Warner never signed a formal collaboration agreement, and that became an issue when they divorced. At the time of their split, they had several outstanding projects in various stages of completion. Some were still circulating in the industry. "Then there was another project that we had written—I think we had gotten through one rough draft," Miller says. "And the question was 'What do we do with that script and who has ownership?' So we worked out an agreement. We actually went to a mediator for the divorce, rather than a divorce attorney, and he suggested that each of us have a two-year period to finish the script. I think we would share story credit, and the one who finished it would get the screenplay credit." But neither of them ever followed up on the script. "It's old business," she says, "and we've moved on."

Agreeing on the Agreement

What should you include in a collaboration agreement? Eric Weissmann recommends that you address four basic issues:

> "Define what it is that you're collaborating on, specifically saying, 'It's the story of Santa Claus on roller skates' or whatever it is.
>
> Say who is to do what, like if one of you just has the idea and the other is supposed to put it down in writing.
>
> Say what each partner's share of ownership is—Is it 50–50? Is it 75–25?—or whatever.
>
> Say who has control of the script."

When David Sonnenschein first started developing television projects with Stuart Geltner, they created "a very simple written agreement" that laid out the specifics of their relationship. "It set us up as equal partners," Sonnenschein says. "We made choices together—that we would receive remuneration 50–50 and share credit. The actual writing collaboration was extremely balanced. The agreement was project-specific, and we let it transfer over to the second project because it's just so simple. No agents involved. No risk and no money exchanged."

But the setup for their next project—*The Knife and the Rose*—was more complicated. We've already said that Sonnenschein wrote the first draft of the screenplay, which he planned to produce and direct. Then

he raised development money to bring Geltner on for the rewrite. "It was much, much different than the other way with the TV projects," Sonnenschein says. "I was in charge, and he was for hire in this kind of legal-business sense. It's like having director's final cut—in this sense, the writer's final cut is mine on the screenplay. He had to listen to me a lot talking about my vision as a writer/director so that he would be free to create yet be within the realm of my vision."

Sonnenschein set up their new agreement in writing, pulling pieces from other contracts and drawing upon past experiences as a producer/director/writer. "We actually took a little while to negotiate it," he says. "Stuart will get a full writing credit with me. We will be co-writers on this, and he will receive more money when the financing is in place. We both showed the agreement to lawyers because this was something that's a piece of a big project, and we definitely wanted to be clear on it."

As any script partners should be.

Dave Brown has seen similar agreements among his clients. "What's common is somebody has written a script, and they say to another writer, 'Hey, can you come in here and rework this with me?' And it's not a whole lot of work—it's really a polish. But the original writer says, 'I'm gonna put your name on it, so it's "Co-written by," and we agree you'll only take, like, 30%.' So that'll happen. Or maybe one's a director/writer and one's a writer, and they say, 'All right, let's write this project together. You're gonna direct it.' So there's a financial agreement that he's gonna be attached to direct, as well as receive 30% or half of the purchase price or whatever."

To help you set up the terms of your business partnership—whatever they may be—the Writers Guild of America, West, has created a document called the Writer's Collaboration Agreement, which the Guild has kindly allowed us to include in this chapter. But you don't have to be a WGA member to use it.

"It's for everybody," Grace Reiner says. "Because it's not mandatory, we have no problem with anybody using it. If it can reduce conflict, that's better for the world. And it's intended to do that."

You may want to complete and sign the WGA form as is or use it as a guide, tailoring it to suit your needs.

"Change it, modify it, delete, add," Reiner says. "It's just a template that addresses the kinds of things that you may be talking or thinking about later if you were not to do this together. It makes things a million times easier than the times where we [the WGA] have had to tell a writer after the fact, 'We can't really do anything for you.' Because the Guild doesn't get involved between team members. It's not as though there's an avenue of recourse if you don't have a collaboration agreement through the union, because there isn't. So it's immeasurably easier if the parties agree up front on what their expectations and plans are. We don't care what your agreement is—we just think you should write it down."

WRITER'S COLLABORATION AGREEMENT*

AGREEMENT made at _____, California, by and between _____ and _____, hereinafter sometimes referred to as the "Parties".

The parties are about to write in collaboration an (original story) (treatment) (screenplay) _____ (other), based upon _____, hereinafter referred to as the "Work", and are desirous of establishing all their rights and obligations in and to said Work.

NOW, THEREFORE, in consideration of the execution of this Agreement, and the undertakings of the parties as hereinafter set forth, it is agreed as follows:

1. The parties shall collaborate in the writing of the Work and upon completion thereof shall be the joint owners of the Work (or shall own the Work in the following percentages: _____ _____).

2. Upon completion of the Work it shall be registered with the Writers Guild of America, west, Inc. as the joint Work of the parties. If the Work shall be in form such as to qualify it for copyright, it shall be registered for such copyright in the name of both Parties, and each Party hereby designates the other as his attorney-in-fact to register such Work with the United States Copyright Office.

3. It is contemplated that the Work will be completed by not later than _____, provided, however, that failure to complete the Work by such date shall not be construed as a breach of this Agreement on the part of either party.

4. It is understood that _____ (both writers) is a/are/are not "professional writer(s)," as that term is defined in the WGA Basic Agreement.

 (It is further understood by the Parties that _____ (and _____), in addition to writing services, shall perform the following additional functions in regard to the Work:

* The Provisions herein are not mandatory, and may be modified for the specific needs of the Parties, subject to minimum requirements of the Writers Guild Basic Agreement.

5. If, prior to the completion of the Work, either Party shall voluntarily withdraw from the collaboration, then the other Party shall have the right to complete the Work alone or in conjunction with another collaborator or collaborators, and in such event the percentage of ownership, as hereinbefore provided in paragraph 1, shall be revised by mutual agreement in writing.

6. If, prior to the completion of the Work, there shall be a dispute of any kind with respect to the Work, then the parties may terminate this Collaboration Agreement by an instrument in writing, which shall be filed with the Writers Guild of America, west, Inc.

7. Any contract for the sale or other disposition of the Work, where the Work has been completed by the Parties in accordance herewith, shall require that the Work shall be attributed to the authors in the following manner:

8. Neither party shall sell, or otherwise voluntarily dispose of the Work, or his share therein, without the written consent of the other, which consent, however shall not be unreasonably withheld. (It is agreed that _____ is authorized to contract on behalf of the Parties without written consent of the other, on the condition that s/he negotiate no less than _____ for the work.)

9. It is acknowledged and agreed that _____ (and _____) shall be the exclusive agents of the Parties for the purposes of sale or other disposition of the Work or any rights therein. Each such agent shall represent the Parties at the following studios only:

 X agent Y agent

The aforementioned agent, or agents, shall have _____ period in which to sell or otherwise dispose of the Work, and if there shall be more than one agent, the aggregate commission for the sale or other disposition of the Work shall be limited to ten percent (10%) and shall be equally divided among the agents hereinbefore designated.

If there shall be two or more agents, they shall be instructed to notify each other when they have begun negotiations for the sale or other disposition of the Work and of the terms thereof, and no agent shall conclude an agreement for the sale or other disposition of the Work unless he shall have first notified the other agents thereof. If there shall be a dispute among the agents as to the sale or other disposition of the Work by any of them, the matter shall immediately be referred to the Parties, who shall determine the matter for them.

10. Any and all expenses of any kind whatsoever which shall be incurred by either or both of the Parties in connection with the writing, registration or sale or other disposition of the Work shall be (shared jointly) (prorated in accordance with the percentages hereinbefore mentioned in paragraph 1).

11. All money or other things of value derived from the sale or other disposition of the Work shall be applied as follows:

 a. In payment of commissions, if any.
 b. In payment of any expenses or reimbursement of either Party for expenses paid in connection with the Work.
 c. To the Parties in the proportion of their ownership.

12. It is understood and agreed that for the purposes of this Agreement the Parties shall share hereunder, unless otherwise herein stated, the proceeds from the sale or any and all other disposition of the Work and the rights and licenses therein and with respect thereto, including but not limited to the following:

 a. Motion picture rights
 b. Sequel rights
 c. Remake rights
 d. Television film rights
 e. Television live rights
 f. Stage rights
 g. Radio rights
 h. Publication rights
 i. Interactive rights
 j. Merchandising rights

13. Should the Work be sold or otherwise disposed of and, as an incident thereto, the Parties be employed to revise the Work or write a screenplay based thereon, the total compensation provided for in such employment agreement shall be shared by them (jointly) (in the following proportion:

)

If either Party shall be unavailable for the purposes of collaborating on such revision or screenplay, then the Party who is available shall be permitted to do such revision or screenplay and shall be entitled to the full amount of compensation in connection therewith, provided, however, that in such a case the purchase price shall remain fair and reasonable, and in no event shall the Party not available for the revision or screenplay receive less than _____% of the total selling price.

14. If either Party hereto shall desire to use the Work, or any right therein or with respect thereto, in any venture in which such Party shall have a financial interest, whether direct or indirect, the Party desiring so to do shall notify the other Party of that fact and shall afford such other Party the opportunity to participate in the venture in the proportion of such other Party's interest in the Work. If such other party shall be unwilling to participate in such venture, the Party desiring to proceed therein shall be required to pay such other Party an amount equal to that which such other Party would have received if the Work or right, as the case may be, intended to be so used had been sold to a disinterested person at the price at which the same shall last have been offered, or if it shall not have been offered, at its fair market value which, in the absence of mutual agreement of the Parties, shall be determined by mediation and/or arbitration in accordance with the regulations of the Writers Guild of America, west, Inc. if permissible pursuant to the WGAw Constitution.

15. This Agreement shall be executed in sufficient number of copies so that one fully executed copy may be, and shall be, delivered to each Party and to the Writers Guild of America, Inc. If any disputes shall arise concerning the interpretation or application of this Agreement, or the rights or liabilities of the Parties arising hereunder, such dispute shall be submitted to the Writers Guild of America, west, Inc. for arbitration in accordance with the arbitration procedures of the Guild, and the determination of the Guild's arbitration committee as to all such matters shall be conclusive and binding upon the Parties.

DATED this _____ day of _____, 20____.

As you'll notice, the WGA agreement is set up for one venture, so you can complete a new agreement for each project or change the language to include several or all of your collaborative scripts.

"Certainly the team can modify the agreement to be all-inclusive, to say something like, 'This will be the template for all of our deals,'" says Grace Reiner. "You can certainly do that. And just add, 'Until we both agree mutually that some deal is different.'"

If one or both writers are members of the Guild, Reiner recommends filing a copy of the completed Writer's Collaboration Agreement with the WGA. Non-members may also submit a copy, but "we don't necessarily recommend it," she says, "because it's harder for us to file it for non-members. We can keep things for safekeeping, but that's about all we can do with it."

Money Matters

As Eric Weissmann has said, your agreement should specify the percentage of money you both will receive, and the WGA's template above has a section to do so. With occasional exceptions, as we've mentioned, professional partnerships—especially career collaborations—split the money 50-50, even though the creative contribution of the partners is not always equal.

"In terms of division of work, it's not always a 50–50 type of thing," Brooke Wharton says. "Sometimes one person has the ideas and the inspiration, and the other is really more of the labor. It's a fluid kind of thing as to how it creates a unified whole."

In all her years working with professional collaborations, Wharton has witnessed only two situations where the script money was not split in half. The first involved a team that came together for one project—one person on the team was a director, and the other was the writer. "The money was split so that the director actually only got what would be considered half of the story fee," she says, "so about 13.5% of the total money."

The second involved a team that had worked together "for a long, long, long, long, long, long time," Wharton says. "One of the partners got very sick and was unable to complete the project or participate in any way. So both writers came up with some sort of understanding about how much work had been done, and the writer who was ill was paid a certain amount. Then the other writer completed the work and got the majority of the money."

For Wharton, when it comes to specifying who gets paid what, the paperwork that's most important to professional teams is the contract created for their writing assignments or spec sales with the studios or buying entities. "That's where things are reduced to writing," she says. "The studios are always cautious about teams in terms of the paperwork,

in making sure that everything's going to be 50–50 between the writing partners. Especially if the teams have their own loan out companies [personal service corporations created by the writers]. There's all the paperwork in terms of 'this is a bona fide corporation, and you won't be coming back and suing us.'"

For some partners, however, seeing only 50% for themselves on the bottom line can become an issue.

"In television, I worked with a lot of teams, and they would always complain about the fact that they were getting half the money everybody else is," says Peter Tolan. "That's your choice, though. Clearly, in a lot of team situations, your partner brings to the table the things that make you successful. But maybe you shouldn't have a partner. And a lot of people go off on their own and are successful—or they're not."

Andrew Reich & Ted Cohen tell us that many script partners working for *Friends* split the sheets over splitting the check.

TED: These were all teams where both people were equally strong and equally valuable and totally necessary. So they were teams where people wanted to have more pay and respect.

But those partners who have stayed together have done so because, for them, the advantages of collaboration outweigh any financial disadvantages.

ANDREW: Others are making twice as much money as we are, but we don't want to split up.

Manfredi & Hay claim there's even an emotional reward for sharing the bottom line.

PHIL: Because you're a team and you literally split every paycheck, you have the same kind of livelihood. It's really nice to have someone who is going through exactly the same peaks and valleys of their career as you. You're on the same level. You're going through the same stuff.

MATT: [Straight-faced] And since Phil and I get a 75–25 money split, it's good that I always know there's someone who can loan me money. I appreciate that. [Laughter]

Sharing the Expenses

Bickering about money can be destructive to your partnership, so it's important to keep the financial stuff fair. Make sure you share the expenses incurred by your projects. It's usually best to split them down the middle

so neither of you feels financially burdened. Then again, keeping track of every cent can be a bookkeeping challenge. You'll have to decide what works best for you.

We're fairly relaxed on the subject. Inevitably, one of us incurs greater expenses on a particular project, but we've found that over time, things even out. So we don't nickel and dime each other to death. We'd resent that as much as lopsided expenses. However, if one of us runs up a big tab, we'll keep track of those costs and settle up.

Again, the key is keeping it fair. If one of us feels financially burdened, we say so (nicely), and we discuss ways to keep our expenses more fairly balanced.

Sharing the Credit

In its *Screen Credits Manual*, the Writers Guild of America defines a "team of writers" as "two writers who have been assigned at about the same time to the same material and who work together for approximately the same length of time on the material."

The WGA also has specific guidelines as to how script partners receive credit. "When credit is accorded to a team of writers, an ampersand (&) shall be used between the writers' names in the credit to denote a writing team. Use of the word 'and' between writers' names in a credit indicates that the writers did their work separately, one usually rewriting the other. This distinction is well established in the industry through custom and practice."

So if you see credits that read "Writer A & Writer B and Writer C & Writer D," the translation would be, "Writers A & B worked together on the script, and Writers C & D worked together on the script, but the two teams did not work together."

If disputes arise about the assignment of TV or film credits, the Writers Guild may be asked to intervene with Credit Arbitration. The WGA also automatically conducts an arbitration any time a director or a production executive requests writing credit on the project. The process involves the selection of three Guild members to serve as the Arbitration Committee. Working anonymously and independently, the three arbiters review copies of all available material (scripts, stories, treatments, source material, etc.) as well as any statement of position by the participating parties. If the Arbitration Committee is unable to reach a unanimous decision, the majority rules—if two of the three arbiters make the same decision about how credit should be awarded, that decision stands.

Having served as an arbiter, Carolyn Miller admits that assigning credit can be a challenging process. "You receive this document that explains how you gauge credit," she says, "and that's really interesting because—Is it dialogue? Is it structure? Is it story? To sort it all out is not an easy thing.

Very often it gets sort of subtle. For instance, it may be that writers ask for shared credit, and you may think, *No, I want to give teleplay credit to one person and story credit to this other person.* And you can do it any way you want."

But Miller believes the process works, that it protects writers, especially in cases where production executives ask for writing credits they haven't earned. "There was a time when producers were gobbling up credits to get more money from these episodes, which is ugly," she says. "It happened to me once. They claimed credit they did not deserve. All they had done was change some character names and changed a little bit of dialogue."

But the Guild's arbitration process doesn't sit well with some of its members. "The Guild has confusing and unfair guidelines they use to determine writing credit on features," says Peter Tolan. "And despite regular legal actions taken against them by members, actions which are eventually dropped, they don't seem willing to entertain more realistic guidelines. I am not part of a writing team except sometimes in the eyes of the Guild. They'll go, 'Clearly you were working with this person, and so we're going to treat you as a team.' But no, I certainly don't go into anything as part of a team. I come out of it that way a lot of the time with the Writers Guild. They'll make that determination, and so that affects me sometimes financially."

For financial reasons, Reich & Cohen negotiated separate producer credits on *Friends*.

ANDREW: Two separate contracts. Exactly the same. Everything.

But they continue to share writing credit.

ANDREW: When we *write* a script, we have an ampersand—it's written by Andrew Reich & Ted Cohen—but our *producer* credits are separate, and we're paid as two entities.
TED: And that's strictly for money purposes.

When they were hired to write for *Friends*, they were "story editors."

ANDREW: The ranks of writers on sitcoms are staff writer, story editor, executive story editor, co-producer, producer, supervising producer, co-executive producer, and executive producer.

They rose through the ranks to executive producer, but they insist that their way of writing together hasn't changed.

TED: Our relationship as collaborators has been the same whether we were staff writers or the way it is now. It's just sort of how we present ourselves. We've always been a team business-wise, and I think we always will.

More Than One Agent

Every career-long collaborative pair that we've talked to has one agent representing both partners. But script partners who are also established as solo writers or only occasionally write scripts together may have different representation. Nick Kazan and Robin Swicord have different agents, so do Ed Solomon and Chris Matheson.

If you and your partner choose to remain with different agents, you can clarify their respective roles by using the Writer's Collaboration Agreement. Item 9 allows you to specify where each agent may shop your co-written script and how long they have to sell it.

But in co-agenting, as in co-writing, the workload may not be equal. "Sometimes one person is just a stronger agent," Dave Brown says. "He's got more energy, more connections. I think it's a good agent who says, 'You understand this project better. Maybe you were more involved in the development process. I got your back. Let me know what you need. You take the lead.' And I don't have a problem with that."

Some agents might. "There may be a little bit of a problem if one is a major agent, and the other one is a smaller one, and the major agent wants to be able to run with the package," Eric Weissmann says. "Then the smaller agent may be a little scared that the major agent may steal the client."

And neither may be crazy about splitting commissions. Would this deter them from taking on a co-written script?

"Well, that *could* be a problem, but agents are whores," Weissmann laughs. "As long as they have something to sell."

"Listen, it's Hollywood," Dave Brown says. "There are egos galore and only so much room for them. So you'll have an agent who feels like, *I have to do this with another agent? I can do it myself and not split my commission and take the whole pie. Is it worth my time, or can I pass it off?* I think there are agents who will pass the buck. Some agents out there we all know are really looking at the bottom dollar and nothing else."

Though some agents balk, splitting commissions is becoming more commonplace because of the increasing number of writers also represented by managers. "While the majority of TV writers just have agents, managers seem to have become more prominent," Jennifer Good says. "We've gotten used to it."

And having different agents can be beneficial to you as a team.

"It can be helpful because you have two agents who are two different levels of contacts," says Brooke Wharton, "and who are gonna be out there and be representing the work."

"Half the time I've worked with another agent, it's gone very smoothly," Brown says. "Ideally we're on the same page. We've put together a submission list. We go through the list of producers and studio executives. Basically like, 'You take this one, I take this one, you take this one, I take

that one.' And then *boom*, we're also gonna make calls and we're gonna have a pickup time for, say, a spec script. It has worked."

Good agents will want to make it work because they've made a commitment to their clients and want to keep them satisfied.

"My agent is a great guy," Nick Kazan says, "and he believes—correctly—that if I'm happy and working hard and doing what I want to do, then I'll continue to be productive. If I'm not, then I can burn out because so many people burn out. There are certainly enough horrible experiences to make anybody burn out."

Pitching

If you want to sell your script or series, odds are you'll have to pitch it. The most common venue is the pitch meeting—presenting your idea to studio executives and/or producers you hope will buy it. And for many script partners, pitching ranks right up there with studio notes.

"I hate pitching," Renee Longstreet says. "I hate it."

Carolyn Miller explains why this is often the case. "Pitching is just so alien to writers. I mean, why do you write? You don't want to be an actor. Performing isn't something I would want to do. But that's what you have to do—get yourself in character and tell a story orally that really is engaging and sort of get the structure down and try to do it quickly and look like you're comfortable doing it."

Though former actors, Patrick Massett & John Zinman aren't crazy about pitching either.

JOHN: It's a necessary evil. It's really stressful, and it's incredibly labor-intensive. It's a lot of work to break a movie out and create a pitch, pitch it, and you probably won't get the job because in this market, you're competing against a lot of top writers. So you might have to do ten pitches to get the one job, and each one of those pitches represents an enormous quantity of work. So there's a lot of speculative work in this business, much more so than— We used to have an average of getting a job every three or four pitches. I would say it's about one in ten now. Closer to that.

PATRICK: That's because the market's changed.

JOHN: That's the market.

PATRICK: Ideas have gotten better.

JOHN: And the market's gotten harder. Less movies.

PATRICK: More bullshit. It's just the industry has changed. It's gotten away from the vision of artists and creators and directors and writers to the vision of marketing.

JOHN: They're just making far fewer movies, just the amount of films they have in development, it's just greatly reduced. It might be that there was a lot of fat, but that fat was *delicious*. [Laughter] You know, it's just not there anymore, and you gotta fight for the jobs now. It's a much more constricted marketplace.

Because pitching *is* a necessary evil, there are times in this biz when writers spend almost as much time pounding the pavement as they do pounding the keyboard.

"It really is a work-a-day kind of grind," Phil Hay says. "Grinding it out and going to meetings and coming up with pitches."

Fortunately, a team has an advantage, according to Alan Gasmer, because "they can play off each other. One starts and then jumps in, and the other finishes and sums. It varies the pitch, and it allows the person they're pitching to to focus on each different person at different times, so it's a little bit more fluid and more— Showbizzy is the way to put it."

Scott Alexander & Larry Karaszewski use the same word when they describe pitching together.

SCOTT: To use the vaudeville analogy, we've created this creepy showbizzy act that we can perform on command. I don't think they get that if it's one nervous guy coming into their office.

LARRY: It's a tag-team match. Someone once referred to one of our pitch meetings as a World Wrestling Federation tag-team match.

SCOTT: And when we're both on the phone, they say it's like "The Morning Zoo" on AM radio.

Each team, we've discovered, has a different approach.

"That's the strange thing about pitching," Phil Hay says. "No rules apply. Everyone does it so differently." He and Matt Manfredi benefit from their background in improv because, as Hay says, "Pitching is such a weird piece of theater."

Chad & Carey Hayes also credit their performing experience with their theatrical pitching style—and great success.

CHAD: We've actually sold most of our films on pitches.

CAREY: Yeah. And for us to go and pitch it, which we *love* doing—

CHAD: It's our favorite part.

CAREY: It's the acting part in the job. And by pitching it, we need to know that story A to Z. When we sold *House of Wax*, we went and pitched it, and the woman goes, "Just go write me that movie. The one you told me, don't change it, just go write me that movie."

CHAD: Well, we have a reputation—because we love it so much and have a passion for pitching—that we pitch full movies, and we really do.

CAREY: We can't do a 15-minute pitch.

CHAD: We don't.

CAREY: Ours are, like, 25 minutes long.

CHAD: We give you tremendous detail and kind of make you feel like, *Whoa, I just saw the movie.*

That's your goal in a pitch meeting—to make your audience see the movie. And the Hayes brothers want their audience to hear it too.

CHAD: We put sound effects in. We've done crazy things like when we set up *House of Wax*. We literally told them the opening of the movie.

CAREY: And we played music.

CHAD: We played this music how we saw it in the movie.

CAREY: Really creepy music.

CHAD: With this guy moving this beautiful woman's body with wax, and it was very classical—

CAREY: And then we ended it, and I had this monster pair of rusty scissors. I just went *SSZZHH! SSZZHH!* And he's like, "What are doing with those?" I'm like, "I'm not gonna hurt ya. It's just a sound." So all through the pitch, it'd be like *SSZZHH! SSZZHH!* Because that was the signature sound one of the characters was just obsessed with.

Cinco Paul & Ken Daurio add another level of theatricality to their pitches. "Both of us sing," they tell us via email. "We were in a band together before we started writing together, so we would always try to make singing a part of our pitches; i.e., we would create scenes in which characters in the movie were singing to each other. Or more often, one character is singing and the other is being annoyed by it. It was a fun way to liven up the pitch. One exec said, 'A pitch from you guys is like dinner theater.' We took it as a compliment. We're optimistic like that."

During their pitch for the Disney film *College Road Trip*, they serenaded execs with the 1980s hit "Double Dutch Bus," including melody *and* harmony. Clearly, this unique "dinner theater" approach works for them, and roughly 90 percent of their pitches over the last decade have involved musical numbers.

Manfredi & Hay, however, prefer a simpler approach. A pitch, they've found, can bog down in detail or become sidetracked. Big believers in brevity, they usually give only a broad outline of their story and characters.

"Less is always more," Manfredi says. "We've learned the hard way sometimes that if they want to hear more, they'll ask. No one wants to sit through half an hour or 45 minutes of a pitch."

But that's exactly how long Alexander & Karaszewski presented one of their scripts.

SCOTT: With *Larry Flynt*, it was a 45-minute pitch, and we worked out an extensive outline just for Larry and me to refer to. You know, flash cards. But we didn't actually work out, "All right, you're gonna say this, and I'm gonna say this." Both of us were familiar enough with the material that we could just go in and do a song and dance.

LARRY: If you have that little outline, while one person is talking about something, you can quickly glance and get what's next. It might only be three words, but "Oh, yeah, yeah, yeah—and then he gets shot!" And while I'm doing that, he can very quickly look at the cue cards, so he's preparing what's next.

SCOTT: I'm not sure that if a person is solo, he could do that as well. Because then it's like watching the president give a bad speech where he keeps looking down.

Working from a detailed "pitch sheet," Nick Kazan & Robin Swicord pitched *Loco for Lotto* for "45 minutes or an hour," Kazan says. "It was a long story. We had it worked out on the microscopic level."

Lee & Janet Batchler also write out a "pitch chart" of their entire story.

JANET: We tend to pitch pretty long. Sometimes up to 20 minutes. We're not five-minute pitchers.

They may also use photos and illustrations, as they did with one particularly visual project requiring numerous special effects.

JANET: If we have something we know they're not going to be able to grab a visual image of, we'll say, "Here, this is what we're talking about. Think *this*!"

The Batchlers also tell us that their respective strengths affect their pitching dynamic.

JANET: I do most of the talking. I can stay on the storyline, and Lee will sort of wander off. So I do the play-by-play, and he does the color. Or he'll do the visual aids.

LEE: Or if we have to set an emotional context, I'll set that, and Jan will keep driving it through the plot. She's better at pitches than I am.

Carolyn Miller says Daryl Warner "hated pitching more than just about anyone." She doesn't love it, but she knows preparation is the best defense against stage fright, so they would rehearse their pitches again and again. "We'd probably over-prepare," Miller says. "We'd figure out what we needed to tell them, then we'd figure out which of us would say what. If we were going in to pitch several ideas to a production company, we'd give each story five minutes or so. The network pitches are worse—they could be 20 minutes long. It feels like an eternity. You're watching everyone in the room to see if they're paying attention or dozing off."

Or catatonic, as it seemed to Harry & Renee Longstreet when they pitched *We Interrupt This Life* to the head of development for CBS and her two assistants.

"They're seated across from us, and we're doing our tap dance, and they're stone-faced," Renee recalls, laughing. "I mean, there's not a smile. There's not an eyebrow that moves. Nothing. And we're doing our whole *la-la-la-la-la*. We walk out and we go, 'Oh my God, if anything ever fell on deaf ears, that did.'"

But when the Longstreets got home, they found a message on their answering machine—CBS asking them to write the pilot.

With Jim Cash in Michigan, Jack Epps, Jr., pitched solo for the team. We ask if execs ever asked, "Where's the other guy?"

"Yep. That was fun," Epps says. "There was a whole big thing—they didn't think Cash existed. 'You're just trying to double your quote, aren't you?' I said, 'Oh no, he exists. Make the check out to Cash!' [Laughter] So that all sort of helped us create this little myth because no one was doing that at that time. It was nice to have a little myth floating around."

In the midst of all the different approaches and opinions we've heard about pitching with (or without) your partner, one constant advantage of collaboration remains—moral support.

This moral support is important not just when you're writing your scripts, as we've said from the beginning, but when you're selling them too. Because this business, this "terrible business, this intersection of art and commerce and science and opinion and intuition and rules and contempt for rules," as Marshall Brickman describes it, is usually harder than anyone thinks.

"A partner is helpful any way you look at it," Dave Brown says. "You're in the damn room with a bunch of these people looking at you, and you're saying to them, 'You've got the checkbook to make my dream come true. I hope you like it.' So it's cool when you've got a friend next to you."

Someone you want riding shotgun.

PATRICK: I think that's part of the reason we've been able to stick together for so long. Because I think my partner's an awesome guy to go through life with.

JOHN: [Smiles at Patrick] Likewise.

 Script Partner Points

- Remember that many of the same qualities that feed the creative relationship and keep it running apply to the business relationship as well—respect, honesty, trust, and communication. The absence of any of these could destroy your collaboration.

- Avoid potential problems by completing a collaboration agreement that lays out the terms and goals of your business relationship, especially if you're new partners. Think of it as a prenup—the paperwork is there in case the partnership sours.

- Make sure your agreement covers at least four points:
 A description of the collaborative property
 Each partner's creative contribution
 Each partner's share of ownership
 Who has control of the script (whether one or both of you)

- Keep track of expenses—not to keep score but to make sure you both feel fairly treated financially.

- If you have different agents or managers, discuss with each other and with your reps who will do what and for what duration. Consider including the terms of this arrangement in your collaboration agreement.

- Keep in mind that pitching—weird theater though it may be—is a necessary evil in the industry. And you might even enjoy it!

- Play with different approaches to pitching (long, short, rehearsed, improvised, tag team, visual aids, sound effects, etc.) until you find a presentation style that works best for you both.

> "Deep in most of us is the potential for greatness, or the potential to inspire greatness."
> —Jean Brodie (Maggie Smith),
> *The Prime of Miss Jean Brodie*

Conclusion

When we signed the contract for the first edition of this book, we toasted each other with a bottle of Dom Perignon, which we bought at a local sub shop and drank out of plastic cups (the guy behind the counter shouted back to kitchen, "Hey, we sold the Dom!"). And when we finish this second edition, we'll break out the bubbly again.

While we'd *never* endorse drinking, we—like the Hayes brothers—do endorse doing something ceremonious at each important step in the process.

The point isn't booze. Really. The point is to create a ritual that seals the deal and celebrates the commitment you've made to each other and to your project. That commitment is what gets us through the journey.

Looking back, we know this book wouldn't have happened if either of us had tried writing it solo. Because while we've been writing, we've also had to deal with, well, *life* (don't we all?). We'll spare you our particular parade of horribles, but when one of us had to stop and deal with a crisis, the other "picked up the slack instantly," as Brooke Wharton put it. And we always gave each other moral support.

So this book isn't just an exploration of the collaborative process—it's a testament to collaboration itself, the way that "two personalities can accommodate each other to achieve a result," to quote Marshall Brickman.

We hope we've brought you closer to understanding—and trying—this remarkable process. And making it your own. As we've said all along, there's no right way to write together. There's only the way that works for you and your partner. And we hope, with the experience, wisdom, and advice of the writers interviewed here, you'll write a very good script. Maybe one that will sell and become a movie you love.

"It was beyond our wildest dreams to get a movie made and to get a movie made that actually reflects what we wrote, and it feels good," Phil Hay says. "But I don't think you ever get to the point where you can relax. You just keep going, and if you're having a good time doing it, you just keep doing it and try to do good work."

Because what you're doing is important, as Stephen Mazur's writing partner, Paul Guay, tells the WGA. "All of the great stories and all of the

wonderful heroes I encountered as a child and as a teenager were created by writers. I loved writers for what they had given me; I wanted to be one; and I wanted to create things, to bring joy, as they had. Also, I think most people waste their lives; good writers, it seems to me, don't waste theirs. What they do matters, and sometimes even lasts."

In this cold, troubled world, it's no small cheese to write well together. To inspire greatness in each other—and in others. To co-write a great script. We agree with Brickman that it "speaks well not only of the medium, but gives one hope for the very future of the civilization."

Co-write and enjoy.

Afterword

by Andrew Reich & Ted Cohen

Andrew's Top Ten Reasons for Working With Ted

1. He's funnier than I am.

2. He's better at story than I am.

3. He wrote my favorite *Friends* line of all time (Rachel: Joey has a secret peephole! He takes naked pictures of Monica and he eats chicken, and he looks at them!)

4. He never says, "I told you so."

5. He's patient with me when I'm cranky and say things like, "This all sucks. We suck."

6. He's less lazy than I am.

7. He's always willing to come over to my house to work, which is good, because I'm really lazy.

8. When I'm writing on my own, I have the urge to call him about once every ten minutes.

9. If he hadn't had the idea to write together, I'd probably still be an agent. (God help us all.)

10. When I give him this list, he'll have notes that will make it better.*

* He did. He told me my original number 6—"He's not a stupid jackass like everyone else"—made me sound too hostile.

Ted's Top Ten Reasons for Working With Andrew

1. He's funnier than I am.

2. He's better at story than I am.

3. He knows the best places to eat heavy ethnic food that forces you to take a nap after lunch.

4. He has a comfortable couch on which to take aforementioned nap.

5. He has the best library for jump-starting a writer's-blocked brain (including a 12-volume Victorian hardcore pornographic novel).

6. He has a sweet doe-eyed dog who makes us feel loved even when we're convinced we're no-talent frauds.

7. He actually likes doing the computer-related things—like formatting—that make me want to kill myself.

8. He knows when I need to be told that an idea is good even if he knows it's no good.

9. He doesn't care if I have terrible, earth-shattering gas.

10. He has unerringly good judgment, and is an unswervingly good friend.

Bibliography

Books

Adams, James L. *Conceptual Blockbusting: A Guide to Better Ideas.* Reading, MA: Addison-Wesley Publishing Company, 1986.

Allen, Woody. *Four Films by Woody Allen.* New York: Random House, 1982.

———. *Side Effects.* New York: Ballantine Books, 1986.

Aristotle's Poetics. Translated by Gerald F. Else. Ann Arbor: University of Michigan Press, 1978.

Crowe, Cameron. *Conversations with Wilder.* New York: Alfred A. Knopf, 1999.

Csikszentmihalyi, Mihaly. *Creativity: Flow and the Psychology of Discovery and Invention.* New York: HarperCollins Publishers, 1997.

Dworkin, Susan. *Making Tootsie: A Film Study with Dustin Hoffman and Sydney Pollack*, 30th Anniversary ed. New York: Newmarket Press, 2012.

Egri, Lajos. *The Art of Dramatic Writing: Its Basis in the Creative Interpretation of Human Motives.* New York: Simon and Schuster, 1960.

Ephron, Nora. *When Harry Met Sally.* New York: Knopf, 1992.

Field, Syd. *Screenplay: The Foundations of Screenwriting.* New York: Dell Publishing Company, 1984.

———. *The Screenwriter's Workbook.* New York: Dell Publishing Company, 1984.

Fitzgerald, F. Scott. *The Crack-Up.* Edited by Edmund Wilson. New York: New Directions Publishing, 1956.

———. *The Great Gatsby.* Harmondsworth, Middlesex, England: Penguin Books, 1968.

Froug, William. *The New Screenwriter Looks at the New Screenwriter.* Los Angeles: Silman-James Press, 1992.

Goldman, William. *Adventures in the Screen Trade: A Personal View of Hollywood and Screenwriting.* New York: Warner Books, 1983.

———. *Which Lie Did I Tell? More Adventures in the Screen Trade.* New York: Pantheon Books, 2000.

Johnson, Claudia Hunter. *Crafting Short Screenplays That Connect*, 4th ed. Burlington, MA: Focal Press, 2015.

John-Steiner, Vera. *Creative Collaboration*. New York: Oxford University Press, 2000.
Kellogg, Ronald T. *The Psychology of Writing*. New York: Oxford University Press, 1994.
Lamott, Anne. *Traveling Mercies: Some Thoughts on Faith*. New York: Pantheon Books, 1994.
Lax, Eric. *Woody Allen: A Biography*. New York: Alfred A. Knopf, 1991.
My First Movie: Twenty Celebrated Directors Talk About Their First Film. Interviewed by Stephen Lowenstein. New York: Pantheon Books, 2000.
Palumbo, Dennis. *Writing from the Inside Out: Transforming Your Psychological Blocks to Release the Writer Within*. New York: John Wiley & Sons, 2000.
Seger, Linda. *Making a Good Script Great*, 3rd ed. Los Angeles: Silman-James Press, 2010.
Soderbergh, Steven. *sex, lies, and videotape*. New York: HarperCollins Publishers, 1990.
Twain, Mark. *Life on the Mississippi*. New York: Signet, 2009.
Wehner, Christopher. *Screenwriting on the Internet: Researching, Writing, and Selling Your Script on the Web*. Studio City: Michael Wiese Productions, 2001.
Wharton, Brooke A. *The Writer Got Screwed (but didn't have to): A Guide to the Legal and Business Practices of Writing for the Entertainment Industry*. New York: HarperCollins Publishers, 1997.
Williams, Tennessee. *Where I Live: Selected Essays*. Edited by Christine R. Day and Bob Woods. New York: New Directions Books, 1978.

Articles

Alexander, Scott, Larry Karaszewski & Milos Forman. "Scott Alexander, Larry Karaszewski & Milos Forman." By Lisa Chambers. *Written By* (April 1997): 42–47 and 77–79.
Borten, Craig & Melisa Wallack. In *Dallas Buyers Club* Press Notes, 3–8.
Cuarón, Alfonso & Carlos Cuarón. In *Y Tu Mamá También* Press Notes, 10–11.
Cuarón, Alfonso & Jonás Cuarón. In *Gravity* Press Notes, 3–8.
Doskoch, Peter. "Living Happily Ever Laughter: Learn to Harness the Power of Humor." *The Buffalo News* (November 24, 1996): 10.
Ganz, Lowell & Babaloo Mandel. Interview by Neal Feinberg. In "Dynamic Duos: Writing Partners Share the Ups and Downs." *Creative Screenwriting*, vol. 3, no. 1, 45–47.
Giles, Jeff. "The Farrellys' Wild Ride." *Newsweek* (July 3, 2000): 54–59.
Katz, Susan Bullington. "A Conversation with Lowell Ganz & Babaloo Mandel." *Written By* (May 1999): 24–29.
Kazan, Nicholas. "True Beauty." *Written By* (March 2000): 24–37.
Payne, Alexander & Jim Taylor. "Adapting and Directing *Election*: A Talk with Alexander Payne & Jim Taylor." By Annie Nocenti. *Scenario Magazine*, vol. 5, no. 2, 104–109 and 189–190.
———. "Writing and Directing *Citizen Ruth*: A Talk with Alexander Payne & Jim Taylor." By Tod Lippy. *Scenario Magazine*, vol. 2, no. 4, 99–103 and 228–231.
Scarbrough, Marsha. "It Takes Two: The Write Relationship." *Written By* (April 1998): 20–26.

Van Zandt, Billy & Jane Milmore. Interview by Neal Feinberg. In "Dynamic Duos: Writing Partners Share the Ups and Downs." *Creative Screenwriting*, vol. 3, no. 1, 50.
Westmoreland, Wash. Director's Statement. In *Still Alice* Press Notes, 4–5.
Wilder, Gene. "Writing and Acting in *Young Frankenstein*: A Talk with Gene Wilder." By Annie Nocenti. *Scenario Magazine*, vol. 4, no. 1, 95–98 and 184–188.

Scripts

Alexander, Scott & Larry Karaszewski. *The People vs. Larry Flynt*. New York: Newmarket Press, 1996.
Allen, Jay Presson. *The Prime of Miss Jean Brodie* (based on the novel by Muriel Spark).
Allen, Woody. *The Purple Rose of Cairo*.
Allen, Woody & Marshall Brickman. *Annie Hall*. In *Four Films by Woody Allen*. New York: Random House, 1982.
———. *Manhattan*. In *Four Films by Woody Allen*. New York: Random House, 1982.
Allen, Woody & Douglas McGrath. *Bullets Over Broadway*.
Avary, Roger & Quentin Tarantino. *Pulp Fiction*.
Batchler, Lee & Janet Scott Batchler. *Batman Forever* (original draft).
Berg, Peter. Pilot, *Friday Night Lights* (first Draft, November 18, 2005).
Boam, Jeffrey. *Indiana Jones and the Last Crusade* (story by George Lucas & Menno Meyjes).
Brooks, James L. *Broadcast News*.
Coen, Joel & Ethan Coen. *Barton Fink*.
Cooper, Adam, Bill Collage & Mark Perez. *Accepted*.
Curtin, Valerie & Barry Levinson. *Best Friends*.
Frank, Scott. *Get Shorty* (based on the novel by Elmore Leonard).
Gale, Bob & Robert Zemeckis. *Back to the Future* (fourth draft, March 11, 1980).
Hayes, Chad & Carey Hayes. *The Conjuring*.
Payne, Alexander & Jim Taylor. *Election* (based on the novel by Tom Perrotta). *Scenario Magazine*, vol. 5, no. 2, 64–103.
Reich, Andrew & Ted Cohen. *Friends: The One with the Stripper* (first draft, September 27, 2001).
Shelton, Ron. *Bull Durham* (May 1, 1987).
Stallone, Sylvester. *Rocky* (January 7, 1976).

Internet Sources

Alexander, Scott, "Interview with Scott Alexander," *Hollywood Lit Sales*. http://hollywoodlitsales.com/archives/alexander.shtml.
Appelo, Tim, "Why 'Gravity's' Alfonso Cuarón Was Kicked Out of Film School." http://www.hollywoodreporter.com/news/gravity-alfonso-cuaron-jonas-cuaron-666375.
Barnes, Brooks, "Reviving the Coming-of-Age Movie: The Screenwriting Team Behind 'The Fault in Our Stars,'" *The New York Times*. http://www.nytimes.

com/2014/06/01/movies/the-screenwriting-team-behind-the-fault-in-our-stars.html?_r=0.

Battaglio, Stephen, "Emmy Round Table: Show runners examine the ever-changing television landscape," *Los Angeles Times*. http://www.latimes.com/entertainment/envelope/la-et-en-show-runners-changing-television-landscape-20150529-story.html#page=1.

Buffam, Noelle, "Top 10 Film Writing Partnerships," *The Script Lab*. http://thescriptlab.com/features/the-lists/1025-top-10-film-writing-partnerships?showall=&start=3.

Champlin, Charles, "Writers Team Up Miles Apart," *Los Angeles Times*. http://articles.latimes.com/1986-10-18/entertainment/ca-6131_1_writers.

Colleary, Michael & Mike Werb, "E-mail Interview with Michael Colleary & Mike Werb," Writers Guild of America. Edited by Robert J. Elisberg. http://www.wga.org/craft/interviews/collearywerb.html.

Connelly, Brendon, "Safety Not Guaranteed's Colin Trevorrow on His Old Scripts That Might Yet Get Made," BleedingCool.com. http://www.bleedingcool.com/2012/12/20/safety-not-guaranteeds-colin-trevorrow-on-the-old-scripts-that-might-yet-get-made/.

"Delia Ephron: Keeping the Family Tradition Alive," *Book*. January/February 2001. http://www.bookmagazine.com/issue14/inthemargins.shtml.

Douglas, Edward, "Interview: Taming the Beasts of a Southern Wild," ComingSoon.net. http://www.comingsoon.net/movies/features/91670-interview-taming-the-beasts-of-a-southern-wild.

Elliott, Ted, "Me & My Ampersand," *Wordplayer*. 12 October 1999. http://www.wordplayer.com/columns/wp18.Me.and.My.Ampersand.html.

Everett, Cory, "Interview: Inside The 'Breaking Bad' Writers Room With George Mastras," Indiewire.com. http://blogs.indiewire.com/theplaylist/interview-inside-the-breaking-bad-writers-room-with-writer-director-george-mastras-20130813.

Farr, Louise, "20 Years To The Finish Line," *Written By*. http://www.mydigitalpublication.com/publication/?i=194062&article_id=1620565&view=articleBrowser&ver=html5&pre=1#{"issue_id":194062,"view":"articleBrowser","article_id":"1620565"}.

Farrelly, Peter, "An Interview with Peter Farrelly," *Bold Type*. Interviewed by Anson Lang. 5 June 2001. http://www.randomhouse.com/boldtype/0698/farrelly/interview.html.

Fleming Jr., Mike, "Hard Road to Oscar: 'Big Eyes' Scribes Paint Picture Of 11 Years Being Knocked To The Canvas," Deadline.com. http://deadline.com/2015/01/big-eyes-scott-alexander-larry-karaszewski-tim-burton-amy-adams-christoph-waltz-1201341984/.

Florida State University College of Motion Picture Arts. http://film.fsu.edu.

Gapinski, Natasha, "Gotta Have a Gimmick?" *Absolute Write*. http://www.absolutewrite.com/novels/gimmick.html.

Goldberg, Jessica Ruth, "Endearing time-travel comedy impresses at Sundance," BlastMagazine.com. http://blastmagazine.com/2012/01/26/endearing-time-travel-comedy-impresses-at-sundance/.

"Jack Epps, Jr. Holds Endowed Chair in Comedy," *In Motion*. https://cinema.usc.edu/inmotion/pdf/InMotionFall10.pdf.

James, Caryn, "Sex, Lies, and Videotape (1989)," *The New York Times*. http://www.nytimes.com/movies/movie/56241/Sex-Lies-and-Videotape/overview.

Kanter, Rosabeth Moss, "Collaborative Advantage: The Art of Alliances," *Harvard Business Review*. https://hbr.org/1994/07/collaborative-advantage-the-art-of-alliances.

Lusinski, Natalia, "Interview: Scott Neustadter," *The Script Lab*. http://thescriptlab.com/features/tales-from-the-trade/1299-interview-scott-neustadter.

Lyons, Margaret, "Watch Woody Allen Dip Into His Idea Drawer," Vulture.com. http://www.vulture.com/2011/11/woody-allen-idea-drawer-american-master.html.

MacFarlane, Steve, "*Big Eyes* Interview with Screenwriters Larry Karaszewski and Scott Alexander," SlantMagazine.com. http://www.slantmagazine.com/house/article/big-eyes-interview-with-screenwriters-larry-karaszewski-and-scott-alexander#.

Mazur, Stephen H. & Paul Guay, "E-mail Interview with Stephen H. Mazur & Paul Guay," Writers Guild of America. Edited by Robert J. Elisberg. http://www.wga.org/craft/interviews/mazurguay.html.

Oliver, Myrna, "Jim Cash; Professor, Half of 'Top Gun' Screenwriting Duo," *Los Angeles Times*. http://articles.latimes.com/2000/mar/29/news/mn-13804.

Palumbo, Dennis, "Should You Write With a Partner? Writing partnerships: the Good, the Bad, and the Ugly," *Psychology Today*. https://www.psychologytoday.com/blog/hollywood-the-couch/201502/should-you-write-partner.

Pushkar, Robert, "Stephen Geller Doing It His Own Way in Rhode Island," ImagineNews.com. http://www.imaginenews.com/Archive/2004/OCT_2004/01_FEATURES/08_GELLER.html.

Reno, Jeff & Ron Osborn, "E-mail Interview with Jeff Reno & Ron Osborn," Writers Guild of America. Edited by Robert J. Elisberg. http://www.wga.org/craft/interviews/renoosborn.html.

Rose, M. J., "The Net Effect of Moviemaking," *Wired*. 7 December 1999. http://www.wired.com/news/digiwood/0,1412,32773,00.html.

Rossio, Terry, "Writer's Block," *Wordplayer*. October 1997. http://www.wordplayer.com/letters/lt30.Writers.Block.html.

Scott, A. O., "Bad in the Bones: How Walter White Found His Inner Sociopath," *The New York Times*. http://www.nytimes.com/2013/07/28/arts/television/how-walter-white-found-his-inner-sociopath.html?_r=0.

"Screen Credits Manual." Writers Guild of America. July 1999. http://www.wga.org/creditsManual/screen1.html.

"Script Analysis: Scott Neustadter and Michael Weber," MakingOf.com. https://www.youtube.com/watch?v=mBzDd2p3-D8.

Shaw, Lucas, "Why 'Dallas Buyers Club' Took 20 Years to Hit the Big Screen," TheWrap.com. http://www.thewrap.com/dallas-buyers-club-matthew-mcconaughey-writers-20-years-battle/.

Stein, Eliot, "Howard Koch, Julius Epstein, Frank Miller Interview," *Hollywood Hotline*. http://www.vincasa.com/indexkoch.html.

Strouse, Lainie, "Secret Burdens, Huge Challenges," Writers Guild of America, West. http://www.wga.org/content/default.aspx?id=4204.

Trumbore, Dave, "Screenwriters Chad and Carey Hayes Talk THE CONJURING, Finding the Film's Point of View, Real Life Paranormal Incidents and the

Appeal of Horror," Collider.com. http://collider.com/chad-hayes-carey-hayes-the-conjuring-interview/.

Turan, Kenneth, "Alexander Payne: An Eye for American Idiosyncrasy," *Los Angeles Times*. 22 May 2002. http://www.latimes.com/entertainment/ movies/ la-052202turan.story.

Zalaznick, Samantha, "Winnie Holzman And Savannah Dooley Talk 'Huge,'" *The Huffington Post*. http://www.huffingtonpost.com/samantha-zalaznick/ winnie-holzman-and-savann_b_627774.html?.

Index

ABC Family 45
About Schmidt (book; Begley) 135
About Schmidt (film) 13, 135, 156
Accepted (film) 17
Actors Studio 111
actors, writing for and with 132–5
Adams, James L.: *Conceptual Blockbusting: A Guide to Better Ideas* 4–7
adaptations 113
Addis, Michael 46–7, 93, 179
Adventures in the Screen Trade (Goldman) 145–6, 154
advertising 46
ageism 111
agents 227–8
agreements 213–23
Alexander, Scott 8, 11–13, 28–9, 38, 58, 64–8, 82–9, 98, 100, 103, 110, 121, 124–6, 134, 147–50, 156–7, 162, 165, 170–1, 180, 184–5, 194, 212, 229–31
Alibar, Lucy 1, 84–5, 103, 106
Alison, Joan: *Everybody Comes to Rick's* 201
Allen, Gracie 74
Allen, Woody 1, 37, 49, 51–4, 57, 61–2, 71, 81, 88, 112–13, 120, 132, 138, 151–2, 178
All the Right Moves (film) 134
Amélie (film) 1
American Beauty (film) 187–8
American Crime Story (television series) 110

American Film Company 75
American Masters (television series) 112
America's Sweethearts (film) 103–4, 191
ampersands, in credits 225
Amulet, The (film) 43
Analyze That (film) 1, 71, 134–5
Analyze This (film) 1, 71, 103–4
Anderson, Brad 79, 102, 117–18, 130–1, 180, 193
Andy Griffith Show, The (television series) 74
Animal House (film) 1, 39, 53–4, 161–2
Annie Hall (film) 1, 37, 49, 51–2, 113, 120, 132
annotation programs 176
anxiety 10
archetypal characters 130
Archimedes 84
arguments 52–3, 60, 64
Aristotle: *Poetics* 147
Arquette, Patricia 111
arranged marriages 23
Art of Dramatic Writing, The (Egri) 138
assignments 105–9
Automatons (film) 93
Avary, Roger 102
Axton, Hoyt 42

Babe (film) 145
Back to the Future (film) 145
Back to the Future (screenplay) 77
bargaining 67–8

Batchler, Lee & Janet Scott 4, 49, 67, 81–2, 88, 96–7, 108–13, 140, 143, 163–7, 170–2, 175, 185, 192, 231
Batman Begins (film) 178
Batman Forever (film) 96, 110, 140, 163–4
Beasts of the Southern Wild (film) 1, 84–5, 106, 193
Bedazzled (film) 53, 71, 78, 152–3, 179–80
beginnings 149–50
Begley, Louis: *About Schmidt* 135
Belkin, Gary 114
Belushi, John 39
Bergen, Edgar 170
Berg, Peter 129–31
Berlin, Irving 70
Best Friends (film) 57
Better Call Saul (television series) 200–1
Big Eyes (film) 98, 103, 110, 126
Big Mama's House (film) 75
Bill & Ted's Bogus Journey (film) 8, 93
Bill & Ted's Excellent Adventure (film) 8, 93
bios 120–2
Blacklist 111
Blacklist, The (television series) 1, 143
blank page 11–13, 166
Blast Magazine 27
BleedingCool.com 27
Blonsky, Nikki 45
Blood Simple (film) 44
Borten, Craig 1, 15–16, 119–20, 186–7
Boyle, Peter 70
brainstorming 4–7, 98–9, 137
Breaking Bad (television series) 123, 140, 158–9, 200
breaking up 210–13
breakthroughs 4–7
Brickman, Marshall 1, 37, 49–54, 61–2, 71, 81, 88, 120, 146–7, 151–2, 161, 178, 232, 235–6
Brooks, Mel 50, 70, 114
Brown, Dave 210, 218, 227–8, 232
Bruckheimer, Jerry 107
Bubble Boy (film) 39

Bull Durham (film) 35
Bullets Over Broadway (film) 183
Bullock, Sandra 119
Burnett, Murray: *Everybody Comes to Rick's* 201
Burns and Allen Show, The (television series) 74
Burns, George 74
Burton, Tim 98, 110
business relationships 209–33
Butch Cassidy and the Sundance Kid (film) 146, 188, 201

Caddyshack (film) 71
Caesar's Hour (television series) 50, 114, 166–70
Caesar, Sid 114, 169
California Magazine 107
call-back jokes 53
Carbon Copy (computer program) 184
careers, crafting and maintaining 109–11
Carrey, Jim 113
Carson, Johnny 88
Casablanca (film) 127, 201
Cash, Jim 1, 4, 7–9, 29, 59–61, 72, 92–3, 96, 100–2, 107, 117, 122, 134, 144, 150, 164–6, 179, 184, 190, 203–4, 232
Castle Rock 104
character-based franchises 140
characters: change in 139–40; creating 117–36; inner logic of 140–1; intentions of 138; names for 122–3; point of view of 141; sympathetic 123–5
Cinematic Storytelling Across Cultures (course) 23
circadian rhythms 90–1
Citizen Ruth (film) 13, 124, 135, 139, 147, 155
City Slickers (film) 117
clichés, characters as 129–32
Clockwork Orange, A (film) 123
Clooney, George 119
Cocked and Loaded (film) 28
co-drafting 161–81
Coen, Joel & Ethan 1, 12, 42–4, 113, 153–4

Cohen, Ted 1–2, 37–8, 46, 55, 59, 65, 80–1, 90–1, 97, 167, 172, 198–9, 224–6, 237–8
Cole, Phil 74
collaboration agreements 213–23
collaborations: business 209–33; choosing projects 95–115; co-creating story and structure 137–60; co-drafting scripts 161–81; co-writing the rewrite 183–207; creating characters 117–36; film school 17–33; finding the right partner 35–56; location and scheduling 77–94; making it work 57–76; reasons for 1–16
collaborative skills 23
Colleary, Michael 157–8, 175
College Road Trip (film) 230
Collider.com 127
Collins, Phil 28
comedy 26–7
Comic, The (film) 168
ComingSoon.net 85
commitments 58, 88–90
competition 61–2
complementing and complimenting 8–11
compromise 65
Conceptual Blockbusting: A Guide to Better Ideas (Adams) 4–7
conflict 141–4
Conjuring, The (film) 1, 30, 100–1, 127, 141, 193–4, 197–8
connections 30
connection, story and 141–4
Connolly, Derek 27–8
Conroy, Will 79
control 215–17
copyright 215
Côte d'Azur (film) 40
"Counters and Cable Cars" (Gould) 142
Coward, The (screenplay) 135
Crafting Short Screenplays That Connect (Johnson) 22, 138, 142
Craigslist 46
crazy/beautiful (film) 102–3, 130–1, 148, 154, 172–3
Creative Collaboration (Gruber) 6
Creative Screenwriting (magazine) 9, 190, 211

Creativity: Flow and the Psychology of Discovery and Invention (Csikszentmihalyi) 79
credits 225–6
criticism 14, 63–5
Crystal, Billy 51, 103–4, 117, 134–5, 178–9
Csikszentmihalyi, Mihaly 86; *Creativity: Flow and the Psychology of Discovery and Invention* 79
Cuarón, Alfonso & Jonás 1, 44–5, 119
Cuarón, Carlos 44
Cuse, Carlton 201

Dahl, Roald: *Matilda* 113, 153
Dallas Buyers Club (film) 1, 15, 119–20, 138, 186–7
Darien Gap, The (film) 193
Dark Knight, The, trilogy (films) 178
Daurio, Ken 1, 2, 39, 118–19, 175, 190, 196–7, 203, 230
Davis, Hope 130
Day, Morris 28
Deadline.com 103
Demme, Ted 106
De Niro, Robert 134–5
Derks, Peter 11
Despicable Me franchise (films) 1–2, 118–19
DeVito, Danny 15, 113
dialogue, acting out 180–1
Diamond, I.A.L. 1
Dick Tracy (film) 29, 107–8
Dilemma, The (film) 211
directors, deferring to 71
disagreements 52–3, 60, 65–71
discipline 13, 84
divorce 73–5
Dooley, Savannah 45–7
Downton Abbey (television series) 127
DreamWorks 188
Driving Mr. Albert: A Trip Across America with Einstein's Brain (Paterniti) 157
Drôle de Félix (Adventures of Felix) (film) 40, 99, 153
Dropbox 93

Dr. Seuss' The Lorax (film) 2
Ducastel, Olivier 40, 65, 81–2, 89, 98–9, 153
Dumb and Dumber (film) 43, 112
Dumb and Dumber To (film) 112
Duplass, Jay & Mark 42
DuPont, Akil 21–2

Earl of Hackensack, The (film) 109
Ed Wood (film) 83, 98, 110
ego 14, 59–60, 66
Egri, Lajos 144–5; *The Art of Dramatic Writing* 138
Einstein, Albert 84
Election (film) 13, 102, 139–40, 156
Elliott, Ted 1, 11, 14, 47, 53, 62, 66, 146, 154, 165, 172
email 47, 93
Emmerich, Toby 108
Encyclopedia of Bad Taste, The 103
endings 149–50
Entity, The (film) 108, 175–7
Ephron, Henry & Phoebe 43
Ephron, Nora & Delia 42–3, 113, 205
Epps, Jack, Jr. 1, 4, 7–9, 17–21, 24–6, 29–31, 41, 57–61, 72, 92–3, 96, 100–2, 105–8, 117, 122–3, 134, 138, 144, 150, 164–5, 179, 190, 200, 203–4, 232; *Screenwriting Is Rewriting: The Art and Craft of Professional Revision* 184
Epstein, Julius J. & Philip G. 201
E.R. (television series) 127
Everybody Comes to Rick's (Burnett and Alison) 201
expenses 224–5

FaceTime 93
fairness 62–3
Falwell, Jerry 124
Fargo (film) 1
Farmiga, Vera 197–8
Farrelly, Bob 43
Farrelly, Mariann 43
Farrelly, Peter & Bobby 1, 4, 12, 42–3, 112, 153–4
Faulkner, William 185
Fault in Our Stars, The (Green) 106
feature writing 19–21
Field, Sally 196

Field, Syd: *Screenplay* 141–2; *The Screenwriter's Workbook* 146–50
film schools and classes 17–33, 46
Final Draft (computer program) 176
first drafts 166–8
Flaherty, Joe 39
Florida State University Film School 18, 21–2, 30
Fluffer, The (film) 106
Flynt, Larry 124, 148, 194
focus, partnership and 13
Foote, Horton 49
Forman, Milos 124, 194
forums, scriptwriting 46
1408 (book; King) 110
1408 (film) 110
Fraser, Brendan 53
Friday Night Lights (television series) 1, 6, 30–1, 123, 129–32, 143, 158–60, 177, 199–200
friendship 37–9, 61
Friends (television series) 1, 37–8, 97, 158–9, 172–4, 224–6, 237
Frolov, Diane 14–15
Froug, William: *The New Screenwriter Looks at the New Screenwriter* 9
Fuqua, Antoine 202

Gaines, Charles 39, 50, 133–4, 151, 177–8, 186, 202–3; *Stay Hungry* 196
Ganz, Lowell 9–10, 16, 86, 117–18, 137, 189–90, 211
Gasmer, Alan 211–13, 229
Geisel, Audrey 2
Geisel, Theodor Seuss 2
Gelbart, Larry 41, 48–50, 54–5, 58, 63, 71, 74, 77–81, 114, 138, 166–9, 204
Geller, Stephen 205
Geltner, Stuart 192–3, 217–18
Genova, Lisa: *Still Alice* 106–7
genre 99–102
Geronimo (screenplay) 39, 133–4, 177, 186–7
Get Smart (television series) 170
Gevedon, Steve 79, 117–18, 193
Giamatti, Paul 128
Gilbert, Jack 112
Gilligan, Vince 200

Glatzer, Richard 106–7, 135
Godfather, The (film) 123
Gods and Monsters (film) 48
Goldman, William 50, 188, 201; *Adventures in the Screen Trade* 145–6, 154; *Which Lie Did I Tell?* 12, 137, 153–4
Gomer Pyle (television series) 170
Good, Jennifer 211–12
Google Docs 93
Google Plus 46
Goosebumps (book; Stine) 110
Goosebumps (film) 110
Gordon, Larry 38, 107
Gould, Peter 200–1
Gould, Stephen Jay: "Counters and Cable Cars" 142
Goyer, David 178
Grand Budapest Hotel, The (film) 127
Gravity (film) 1, 44–5, 119, 138
Grazer, Brian 106, 156, 211
Green, John: *The Fault in Our Stars* 106
Greylist 111
Griffiths, Peter & David 42
Groundhog Day (film) 71
Gruber, Howard: *Creative Collaboration* 6
Guay, Paul 11, 87, 113, 235–6
Gyllenhaal, Jake 39

Hairspray (film) 45
Hamlet (Shakespeare) 71
Hangover, The (film) 127
Happy Accidents (film) 193
Harry Potter (film) 43
Hawaii Five-O (television series) 29
Hawke, Ethan 39, 50, 133–4, 151, 177–8, 186, 196, 202–3
Hayes, Chad & Carey 1, 13, 30, 41–3, 60, 69, 89, 100–1, 108–11, 121–2, 126–8, 135, 141, 144, 148–50, 155, 167–8, 175–7, 180, 183, 188–9, 193–8, 201–6, 229–30
Hay, Phil 14–15, 35, 46, 52, 64–6, 73–4, 80–1, 87, 90, 98–9, 102–4, 112, 130–1, 139–41, 148, 154, 171–3, 185, 212, 224, 229–31, 235
Heartbreakers (film) 11

Hebrew Hammer, The (film) 213
Hemingway, Ernest 168
Herrguth, Jack 8–9
Hollywood Hotline (magazine) 201
Hollywood Reporter, The (newspaper) 44–5
Holzman, Winnie 45–7
Homewreckers (film) 29, 98
home, writing at 81–2
honesty 74
Hope, Bob 77, 113
Horton Hears a Who! (film) 2
House of Cards (television series) 123
House of Wax (film) 229–30
Huffington Post, The (website) 45
Huge (television series) 45
Hughes, Albert & Allen 42
humor, sense of 47–8
Hustler (magazine) 124

ideas: connecting to 102–5; generating 111–14; story 118–20; viability of 99–102
Illumination (production company) 118
I Love Lucy (television series) 170
ImagineNews.com 205
Imagine That (film) 8
index cards 176–7
Indiana Jones and the Last Crusade (film) 95
Indiewire.com 140, 158, 178
industry perceptions 210–13
In Memory's Kitchen (screenplay) 51, 63
In Motion (magazine) 26
inner logic, of characters 140–1
Insidious (film) 141
Institute for Psychoanalytic Training and Research 10
intentions, of characters 138
Internet 46–7

Janvey, Dan 85
jealousy 62
Jeanne et le Garçon Formidable (Jeanne and the Perfect Guy) (film) 40
Jeunet, Jean-Pierre 1, 50
Job, The (television series) 48

Joffe, Charles H. 37, 54
Johnson, Claudia 24, 35–7, 47, 62, 65, 77, 82, 88–91, 104, 113–14, 122–3, 128, 134, 151, 158, 165, 170, 179, 180, 185–6, 191–2; *Crafting Short Screenplays That Connect* 22, 138, 142
joint copyright 215
Jolie, Angelina 107, 195
Jurassic Park III (film) 13
Jurassic World (film) 27–8

Kallas, Christina 25
Kanin, Fay 37, 40, 50, 60, 65, 73–4, 78, 81, 109, 111–13, 170–4
Kanin, Garson 109
Kanin, Michael 37, 40, 50, 60, 73–4, 78, 81, 111, 172–4
Kanter, Hal 41, 78, 170
Karaszewski, Larry 8, 11–13, 28–9, 58, 61, 64–8, 82–9, 98–100, 103, 110, 121, 124–8, 147–50, 156–7, 162, 165, 170–1, 180, 184–5, 194, 229–31
Katims, Jason 6, 131, 159–60
Katzenberg, Jeffrey 107
Katz, Margo 51
Kaufman, Andy 148
Kazan, Nicholas 7, 11, 51, 59, 63, 66–7, 72–3, 113, 152–3, 162, 168, 227–8, 231; "True Beauty" 188
Keane, Margaret 103, 126
Keane, Walter 103, 126
Keller, Sheldon 114
Kellogg, Ronald T.: *The Psychology of Writing* 91
Kenney, Douglas 1, 39, 54
Kesselman, Jon 213
Kightlinger, Laura 213
King, Stephen: *1408* 110
Knife and the Rose, The (screenplay) 192–3, 217–18
Koch, Howard 201
Kovach, Seanne Kemp 8–9

Ladykillers, The (film; 1955) 113
Ladykillers, The (film; 2004) 113
Lady Under Glass (screenplay) 68–9
Lamott, Anne: *Traveling Mercies* 10

Landers, Ann 28
Lara Croft: Tomb Raider (film) 107, 195–6
Larry Sanders Show, The (television series) 103
Last of Robin Hood, The (film) 106
laughter 10–11
Laurant, Guillaume 1, 50
Lawrence, Martin 106
Leary, Denis 48
Lee, Roy 108
Legal Eagles (film) 29
LeGuin, Ursula 142
Leto, Jared 119
Liar Liar (film) 11, 87, 113
Life (film) 105–6, 127, 132–3
LinkedIn 46
Linklater, Rick 50
literature, adaptations of 113
Livingston, Ron 197–8
locations, for writing 77–94
Loco for Lotto (screenplay) 113, 231
London Times, The (newspaper) 84
loneliness 14–15
long-distance collaboration 92–4
Longstreet, Harry & Renee 40–1, 63–4, 68–73, 79–82, 86, 113, 120–1, 137, 140, 172–4, 191, 228, 232
Lord of the Rings, The (film) 127
Los Angeles Times (newspaper) 7–8, 135, 166, 200–1
love 40–1

Magnificent Seven, The (film; 2016) 202
Making a Good Script Great (Seger) 184
MakingOf.com 92
Mandel, Babaloo 9–10, 86, 117–18, 137, 189–90
Manfredi, Matt 14, 35, 46, 64–6, 73–4, 80–1, 87, 90, 95, 99, 102–3, 130–1, 139, 148, 154–6, 171–3, 185, 211–12, 224, 229–31
Manhattan (film) 37, 127, 132, 151–2
Manhattan Murder Mystery (film) 37
Man on the Moon (film) 110, 150
Mansfield, Jane 83
Mark, Larry 43

marriage 23, 40–1, 71–2
Martineau, Jacques 40, 65, 81–2, 89, 98–9, 153
Marx Brothers (screenplay) 110, 126, 156–7, 184–5
*M*A*S*H* (television series) 79
Massett, Patrick 1–3, 6, 15, 18–20, 25, 30–1, 38, 107, 129–30, 143, 158–61, 177, 190–1, 195–6, 199–200, 228–9, 232
Mastras, George 140, 158–9
material, connecting to 106–9
Matheson, Chris 8, 60, 93, 216, 227
Matilda (book; Dahl) 113, 153
Matilda (film) 7, 72–3, 113, 153
May, Elaine 37
Mazur, Stephen 11, 87, 113, 235
McCarthy Era 111
McCollum, Ruby 49
McConaughey, Matthew 187
McKean, Michael 200–1
McKee, Robert: *Story* 138
Meledandri, Chris 118
mental health 10–11
message boards 46
Michael (film) 43
Microsoft Surface 176
Midnight Riders (screenplay) 75
Miller, Carolyn 46–7, 58–60, 69, 73, 81, 90, 109, 165, 174, 191, 212, 217, 225–8, 232
Miller, Chris 1, 39
Milmore, Jane 9
Minor Adjustments (television series) 97
Mr. Rhodes (television series) 97
money matters 223–4
Monkey Exchange (screenplay) 149–50
Moore, Julianne 107, 135
moral support 14–16, 232, 235
Morgan, Henry 81–2
Morreall, John 11
Moss, Bettina 23
Mothers and Daughters (film) 120–1
motivation 13
Movie Magic Screenwriter's iPartner 93
Murphy, Eddie 105–6, 132–3, 156
Murray, Bill 39

Murray, Brian 39
music 86–7
My First Movie (film) 44
My Pal Gus (film) 37
My So-Called Life (television series) 45

names, for characters 122–3
narratives 123
National Lampoon 39, 53–4
National University in Los Angeles 23
Nelson, Willie 42
Network (film) 127
Neustadter, Scott 7, 92, 106
New Screenwriter Looks at the New Screenwriter, The (Froug) 9
Newsweek (magazine) 43
New Yorker, The (magazine) 40
New York Times, The (newspaper) 106, 112, 204
Next Stop Wonderland (film) 79, 118, 130, 193
Nichols, Mike 37
nine-to-fivers 58, 162
Nolan, Christopher & Jonathan 42, 178
non-pair paradigms 23–32
notes and notebooks 112–13, 156–8, 176–7
notes, studio 187–93, 201
Nothing But the Truth (film; 1920) 113
Nothing But the Truth (film; 1929) 113
Nothing But the Truth (film; 1941) 113

objects, significant 85–7
Obscenity (screenplay) 48–9, 86, 96, 102, 122, 128, 134, 138, 142, 158, 170, 191–2
office space 82–4
Once and Again (television series) 45
OneNote (computer program) 176
Oppenheimer, Jess 170
Opposite Sex, The (film) 37
original scripts 105–6
original writer, deferring to 69–70
Osborn, Alex 5
Osborn, Ron 13

Other Side of Silence, The: The Untold Story of Ruby McCollum (film) 49
Ouija boards 192–3
outlines 154–8

Pablos, Sergio 118
Palumbo, Dennis 75
paper teams 23
paradigm, the 146–50
Paramount 188, 195
Parkes, Walter 188
partner, finding the right 35–56
partnerships *see* collaboration
passion, deferring to 70
Paterniti, Michael: *Driving Mr. Albert: A Trip Across America with Einstein's Brain* 157
Paul, Cinco 1–2, 39, 118–19, 175, 190, 196–7, 203, 230
Paul, Norman 170
Payne, Alexander 1, 13, 63, 71, 102, 123–4, 135, 155–6, 216
PBS 112
People vs. Larry Flynt, The (film) 100, 110, 124–5, 148, 194, 231
Perlman, Rhea 113
perspective 72–3
phone calls 92
Pirates of the Caribbean franchise (films) 1
pitching 228–32
pitch sheets 231
pitfalls 57–9
Play It Again, Sam (play) 88
Poetics (Aristotle) 147
point of view, of characters 141
Poltergeist (film) 203
Poor White Trash (film) 46–7, 93, 179
predictability 153
premise 144–5
prenuptial agreements 216
preproduction, rewriting during 193–6
Prestwich, Dawn 4, 8, 14, 64–5, 69
Price, Jeffrey 109
Prime of Miss Jean Brodie, The (film) 235
Problem Child (film) 98–100
production, rewriting during 196–201

productivity 13
programs, scriptwriting 17–33, 46
projects, choosing 95–115
Psycho Bitch (screenplay) 113, 138, 142, 145, 179
Psychology of Writing, The (Kellogg) 91
PsychologyToday.com 75
Psychology Today (magazine) 11
public places, writing in 79–81
Pulp Fiction (film) 102, 117

quality 22–3
Quinceañera (film) 106

Radner, Gilda 39
Rafelson, Bob 196
Ramis, Harold 1–2, 5–7, 15, 39, 53–4, 66, 71, 78, 90, 152–3, 161–2, 179–80
Ramsey, Robert 4–6, 13, 46–8, 59–62, 71–5, 80–6, 89, 105–10, 127, 132–3, 154–6, 169–70, 180–1, 189–91, 210–13
RandomHouse.com 43
Reaping, The 135, 205–6
Reddit 46
Reich, Andrew 1–2, 10, 37–8, 46, 52, 55, 59, 65, 80–1, 90–1, 97, 159, 172, 198–9, 224–6, 237–8
Reiner, Carl 168
Reiner, Grace 215–18, 223
remakes 113
Reno, Jeff 13
reputations 18
research 125–8
respect 53–5, 60–1
restaurants, writing in 79–81
revision 183
rewrites 183–207
Rhapsody (film) 111
rhythms, writing 90–1
rights 113, 215
Risky Business (film) 98
Robert-Houdin, Jean 97
Roberts, David 39
Roberts, Julia 104, 105
Robeson, Joel 113
Robin Banks and the Bank Roberts (web series) 1

Robinson, Casey 201
Rocky (film) 1
Rollins, Jack 37, 54
Romeo and Juliet (Shakespeare) 142
Rose, Mickey 37
Rose Tattoo, The (screenplay) 78
Ross, Herb 165
Rossio, Terry 1, 11, 47, 62, 66, 146, 154
Roth, Joe 104
Ruben, Aaron 10, 74, 81–2, 168
Ruby (screenplay) 49, 179, 185–7
Rudin, Scott 43
rules, for relationships 71–2

Safety Not Guaranteed (film) 28
San Andreas (film) 128, 201
Saw (film) 141
scare moments 100, 194
Scenario (magazine) 15, 70, 102, 123–4, 139, 147
scheduling 77–8, 87–94
Schiff, Robin 45
Schneider, Andrew 14–15
Schumacher, Joel 110
Screen Credits Manual (Writers Guild of America [WGA]) 225
Screenplay (Field) 141–2
Screenwriter's Workbook, The (Field) 146–50
Screenwriting Is Rewriting: The Art and Craft of Professional Revision (Epps) 184
Screenwriting on the Internet: Researching, Writing, and Selling Your Script on the Web (Wehner) 93
Script Lab, The (online magazine) 7, 50
SCTV (television series) 161
Seaman, Peter 109
Second City 39
Secret of My Success, The (film) 29, 165
Seger, Linda: *Making a Good Script Great* 184
Seinfeld (television series) 43
sensibilities 47–9
Session 9 (film) 79, 117–18, 193
setting 127

seven *P*s 32
sex, lies, and videotape (film) 112
Shakespeare, William 145; *Hamlet* 71; *King Lear* 145; *Macbeth* 145; *Romeo and Juliet* 142
Shamberg, Michael 15
Shining, The (film) 127
Shop Around the Corner, The (film) 113
short scripts 21–2
showing and telling 66–7
Shrek (film) 146
siblings 41–4
Sideways (film) 1
silence 80, 87
Silver, Joel 135
Simon, Neil 114
Simpsons, The (television series) 38, 55
Sister Act (film) 203–4
Sixth Sense, The (film) 188
sketch comedy 26–7
Skype 75–7, 92–3
SlantMagazine.com 103, 126
Slaughterhouse-Five (film) 205
Sleeper (film) 37, 81
Smith, Evan 22–5
Smoke and Mirrors (film) 97, 110–12
Soderbergh, Steven 112
Solomon, Ed 8, 60, 93, 216, 227
Some Like It Hot (film) 1
Sonnenschein, David 192–3, 217–18
Sopranos, The (television series) 123
Spader, James 143
specs 95–8
spitballing 137; *see also* brainstorming
Spragg, Mark 150
Sprecher, Jill & Karen 42
Stay Hungry (book; Gaines) 196
Stay Hungry (film) 196
stereotypes, characters as 129–32
Stevens, Matt 24, 35–7, 47, 62, 65, 77, 82, 88–91, 104, 113–14, 122–3, 128, 134, 151, 158, 165, 170, 179, 180, 185–6, 191–2
Stewart, Michael 114
Still Alice (book; Genova) 106–7
Still Alice (film) 106–7, 135
Stine, R.L.: *Goosebumps* 110
Stockwell, John 148

Stone, Matthew 4–6, 15, 46–8, 59–62, 71–2, 75, 80–6, 89, 105–10, 127, 132–3, 154–6, 167–70, 180–1, 189–91, 210–11
story, co-creating 137–60
story ideas 118–20
Story (McKee) 138
Streep, Meryl 111
strengths, complementary 49–52, 150–3
structure, co-creating 137–60
studio notes 187–93, 201
Sturgeon, Scott 213
Sundance Screenwriters Lab 184
"Sunday Punch" (story) 40
Swank, Hilary 135, 206
Swicord, Robin 7, 66–7, 72–3, 113, 152–3, 162, 227, 231
sympathetic characters 123–5

table reads 24–7, 193, 198
Tarantino, Quentin 102
Taylor, Jim 1, 13–15, 63, 71, 102, 124, 135, 147, 152, 155–6, 184, 216
Taylor, Lili 30, 194
Teacher's Pet (film) 37
10 Things I Hate About You (television series) 45
There's Something About Mary (film) 1
TheWrap.com 120
third voice 7–8
thirtysomething (television series) 45
This Is My Life (film) 43
three-act structure 146–50
time commitments 58, 88–90
To Kill a Mockingbird (film) 49
Tolan, Peter 1–2, 48–53, 74–5, 78, 81, 98, 103–4, 134–5, 152–3, 162, 178–80, 191, 224–6
Tolkin, Mel 114
Tonight Show, The (television series) 88
Tootsie (film) 10, 41, 138, 145
Top Gun (film) 1, 4, 9, 29, 92, 102, 107–8, 122, 134, 138, 144, 150
"Top Ten Film Writing Partnerships" (article) 50
Transiberian (film) 79
Traveling Mercies (Lamott) 10

treatments 154–8
Trevorrow, Colin 27–8
"True Beauty" (Kazan) 188
Twain, Mark 189
Twitter 46

Underground (film) 21–2
unequal dynamic 71
U.S. Copyright Office 215
University of California, Los Angeles (UCLA) 19
University of Southern California (USC) 17–21, 25–6
Urban, Tony 46–7, 93, 179

Van Dyke, Dick 161
Van Zandt, Billy 9
Vaughn, Vince 211
Vaus, Lyn 79, 118, 130, 193
veto power 69
Vidor, Charles 111
Vimeo 32

Wachowski, Andy & Lana 42
Wallack, Melisa 1, 15–16, 119–20, 186–7
Wallis, Quvenzhané 193
Walter, Richard 19
Wan, James 30, 141, 194, 197–8
Warner Bros. 97, 174, 201
Warner, Daryl 58, 73, 165, 211, 217, 232
War of the Roses, The (film) 98
Warren, Ed 141, 197, 198
Warren, Lorraine 127, 141, 197
water, creativity and 84–5
Watty, Ariya 21–2
Wayans, Shawn & Marlon 42
wearing your partner down 68–9
Weber, Michael H. 7, 92, 106
web series 32
websites 46
Wehner, Christopher: *Screenwriting on the Internet: Researching, Writing, and Selling Your Script on the Web* 93
We Interrupt This Life (television pilot) 113, 232
Weissmann, Eric 212–7, 223, 227
Weitz, Chris & Paul 42

Welles, Orson 113–14, 166
Werb, Mike 157–8, 175
Westmoreland, Wash 106–7, 135
West, Simon 195–6
West Wing, The (television series) 127
WGA (Writers Guild of America) 11–13, 23, 45–7, 71, 87, 158, 175, 201, 214, 218, 223–6
Wharton, Brooke A. 210–17, 223–5; *The Writer Got Screwed (but didn't have to): A Guide to the Legal and Business Practices of Writing for the Entertainment Industry* 209
What Goes On (television series) 45
When Harry Met Sally (book; Ephron) 205
When Harry Met Sally (film) 43
Which Lie Did I Tell? (Goldman) 12, 137, 153–4
Wicked (musical) 45
Wilder, Billy 1
Wilder, Gene 70
Wilder, Thornton 134
Williams, Eric R. 22–3
Williams, Tennessee 78
Wilson, Mara 113
Wilson, Patrick 197–8
Wired.com 46
Wizard of Oz, The (film) 42
Woman of the Year (film) 73
Wood, Ed 98, 148
Woodroof, Ron 119, 138, 186–7
Woody Allen: A Documentary (film) 112–13

Wordplayer.com 11, 14, 146
work avoidance 78–9
workshops 24–5
workspaces, objects in 85–7
Writer Got Screwed (but didn't have to), The: A Guide to the Legal and Business Practices of Writing for the Entertainment Industry (Wharton) 209
writer's block 11–13
Writer's Collaboration Agreement 218–23, 227
Writers Guild of America (WGA) 11–13, 23, 45–7, 71, 87, 158, 175, 201, 214, 218, 223–6; *Screen Credits Manual* 225
writers' room 25–6, 158–60, 198–9
writing skills 22
Written By (magazine) 8–10, 15, 65, 117, 187–8

Yellin, Bennett 43, 112
Yorkin, Nicole 4, 8, 64–5, 69
Young Frankenstein (film) 70
YouTube 32
You've Got Mail (film) 43, 113
Y Tu Mamá También (film) 153

Zeitlin, Benh 1, 84–5, 103, 193
Zimmerman, Gloria 75
Zinman, John 1–3, 6, 18, 25, 30–1, 38, 107, 129–30, 143, 159–60, 177, 190–1, 195–6, 199–200, 228–9, 232
Zucker, Jerry & David 42

Taylor & Francis eBooks

Helping you to choose the right eBooks for your Library

Add Routledge titles to your library's digital collection today. Taylor and Francis ebooks contains over 50,000 titles in the Humanities, Social Sciences, Behavioural Sciences, Built Environment and Law.

Choose from a range of subject packages or create your own!

Benefits for you
- Free MARC records
- COUNTER-compliant usage statistics
- Flexible purchase and pricing options
- All titles DRM-free.

Benefits for your user
- Off-site, anytime access via Athens or referring URL
- Print or copy pages or chapters
- Full content search
- Bookmark, highlight and annotate text
- Access to thousands of pages of quality research at the click of a button.

REQUEST YOUR FREE INSTITUTIONAL TRIAL TODAY

Free Trials Available
We offer free trials to qualifying academic, corporate and government customers.

eCollections – Choose from over 30 subject eCollections, including:

Archaeology	Language Learning
Architecture	Law
Asian Studies	Literature
Business & Management	Media & Communication
Classical Studies	Middle East Studies
Construction	Music
Creative & Media Arts	Philosophy
Criminology & Criminal Justice	Planning
Economics	Politics
Education	Psychology & Mental Health
Energy	Religion
Engineering	Security
English Language & Linguistics	Social Work
Environment & Sustainability	Sociology
Geography	Sport
Health Studies	Theatre & Performance
History	Tourism, Hospitality & Events

For more information, pricing enquiries or to order a free trial, please contact your local sales team:
www.tandfebooks.com/page/sales

Routledge Taylor & Francis Group | The home of Routledge books | **www.tandfebooks.com**